WHITE ON BLACK

v

WHITE ON BLACK

*Images of Africa and Blacks
in Western Popular Culture*

Jan Nederveen Pieterse

Yale University Press
New Haven and London · 1992
in association with Cosmic Illusion Productions, Amsterdam

Original edition published in Dutch as *Wit Over Zwart: Beelden van Afrika en Zwarten in de Westerse Populaire Cultur* Copyright © 1990 by Koninklijk Instituut voor de Tropen, Amsterdam

Copyright © Pictures: Cosmic Illusion Productions Foundation, Amsterdam

For works of visual artists affiliated with a CISAC organization, copyright by permission of Beeldrecht, Amsterdam (© 1992, c/o Beeldrecht Amsterdam)

This English language translation © 1992 by Jan Nederveen Pieterse

First published in paperback 1995

Reprinted 1996

Set in Goudy Old Style by SX Composing Ltd., Essex, England
Printed in Hong Kong through World Print Ltd.

Library of Congress Cataloging-in-Publication Data

Nederveen Pieterse, Jan.
 [Wit over zwart. English]
 White on black: images of Africa and blacks in western popular culture / by Jan Nederveen Pieterse.
 p. cm.
 Translation of: Wit over zwart.
 Includes bibliographical references and index.
 ISBN 0-300-05020-8 (hbk.) ISBN 0-300-06311-3
 1. Africa in art. 2. Blacks in art. 3. Arts – Themes, motives. 4. Popular culture. 5. Stereotype (Psychology) I. Title.
NX653.A35N413 1992
700–dc20 91–41603
 CIP

A catalogue record of this book is available from the British Library.

CONTENTS

Epigraph

This was the image laid
upon the dark skin of
the black people by
those who had the
power to do it.

Philip Hallie, 1982

I see our brothers and
sisters, mothers and
fathers, captured and
forced into images they
did not devise, doing
hard time for all of us.

Alice Walker, 1982

Je est an autre.
[I is an other.]

Arthur Rimbaud

They won battles that
were universal in their
meaning.

Julian Bond, *Eyes on the
Prize*

Introduction

In a world that is becoming smaller and societies that are becoming multicultural, it may be time for western culture to examine itself critically in terms of its view of other cultures. For how much of western culture is made up of prejudices about other cultures, how much of western identity is constructed upon the negative identity of others? Past fears and antagonisms are encoded in images and symbols, in sayings and rationalizations, which set self and other apart, in ways which may no longer be part of our mentality but which do form part of our ambience and cultural baggage. Is it not time, then, for a spring cleaning of intercultural images, of alienating images between cultures and 'races' which have long since outlived their relevance?

Decolonization in a political sense has occurred, and a process of intellectual decolonization has also taken place, in the sense that critical perspectives on colonialism have become more and more common (even though there are countercurrents to this trend as well)[1]. What remains to be addressed, however, is cultural decolonization. The legacy of several hundred years of western expansion and hegemony, manifested in racism and exoticism, continues to be recycled in western cultures in the form of stereotypical images of non-western cultures.

Since the rise of the American civil rights movement many stereotypes of blacks are no longer acceptable in the United States and have vanished from advertising and the media. Although no European country has ever experienced such a movement, or had so large a minority of blacks within its borders, this has begun to change since the postwar migrations. This does not mean that the problem is new to Europe or that Europeans have been justified in thinking that it was only an American problem. In a sense, America has all along been the arena of European racism: for it was the slaves of Europe who were put to work in the West Indies and America, in European colonies and on plantations. The racism that developed is not an American or European problem but a western one.

Momentous and tragic turns in history are often marked by monuments or commemorations which serve as beacons in social consciousness. What of the tragic episodes in relations between the West and the non-western world, notably in relations between Europe and Africa and between whites and blacks? Does the absence of any such commemoration mean that our awareness of our common humanity has simply not developed far enough?

White on Black

It has often been observed that 'race' is not a reality but a social construct. That is the point of departure of this book. In his study of the 'Jewish question', Jean-Paul Sartre wrote, 'Do not ask what the Jews are, but what we

have made of the Jews'.[2] This applies equally to images of Africa and blacks. This book, to be precise, is not simply about images of blacks, but about white people's images of blacks. Blacks might say of such images, they are about us, but from outside us. It is not that the images provide no information about blacks, but that the information is one-sided and distorted. They convey allegories of the relations between Europe and Africa, and between whites and blacks, viewed from the standpoint of Europeans and whites. The relations depicted are not those of dialogue but of domination.

The title of the present book takes off from that of Winthrop Jordan's classic study, *White over Black*,[3] about relations between whites and blacks in America from 1550 to 1812, one of the episodes considered here. The term 'Africa' in the subtitle refers to sub-Saharan Africa. Of course, as with 'blacks', the concept of 'Africa' is in many ways a western construct.

'White on Black' indicates a relationship, and the order of the terms identifies the dominant partner, the producers and consumers of the images in question. Accordingly, this study is quite different from what one titled 'Black on White' or 'Black on Black' would be. Images produced by Africans and blacks of Europeans and whites are occasionally mentioned, but not covered systematically in the discussion. Those are completely different topics.[4] They require an entirely different treatment, for they concern an altogether different type of historical relationship, which cannot be equated with white-black relations. The images produced by the subordinate party are of a different order from those of the dominant party; they too are stereotypes, but they carry different weight and meaning. Africans did not traffic in European slaves for three hundred years, nor have they occupied the dominant place in the world's political, economic and cultural system. Several hundred years of western hegemony lends western images a range, complexity and historical weight which images stemming from Africa and from blacks do not possess.

The question that keeps arising is, what interests of whites are being served by these representations? This refers not merely to measurable economic and political interests but also to relations of a subtler nature in cultural, emotional and psychological spheres, and to the various ways in which these relations figure in the phenomenon of subordination. Generally, in examining images of 'others', one has first to ask, who are the producers and consumers of these images, and only then to question who are the objects of representation. The key that unlocks these images is what whites have made of blacks, and why.

The phrase 'White on Black' refers to the whole spectrum of relations in which western interests were dominant – the trans-Atlantic slave trade, master-slave relations on plantations in the Americas, colonialism, the postcolonial era, and majority-minority relations in the western world. In each of these situations Europeans constructed images of Africa and blacks on the basis of selective perception, expedience, second-hand information, mingled with reconstructed biblical notions and medieval folklore, along with popular or 'scientific' ideas that were current at the time.

That this book concentrates on images rather than solely on ideas or discourse gives it a different focus from that of other studies. On the one hand, images are situated in the midst of historical processes, of ideas and discourse; on the other, they tend by their visual character to be bold, telegraphic evocations by which many layers of meaning and cross-references are conveyed.

From time immemorial, as religious art testifies, images have played a key role in communication, instruction and the general transmission of culture.[5] In an age of communications media the role of images has become all the more potent.

A Study in Stereotypes

In the 1930s in the United States, white children were tested by being shown a picture of a library. After glancing at it they had to answer a number of questions, among them: What was the Negro doing? In fact, there was no negro in the picture, but the answers all ran: He is busy scrubbing the floor, He is dusting the bookcases. No one answered: He is reading a book.[6] From the same period dates an experiment in which the social psychologist Kenneth B. Clark gave black children two dolls, one white and one black, and asked them which they preferred. A large majority chose the white doll. In 1989 in Atlanta a follow-up research took place, in which black children were shown pictures of identically dressed children, one black and one white. Asked to say which of the two was clever and which was stupid, ugly or handsome, dirty or clean, the greater number pointed to the black children as the ugly, dirty and stupid ones.[7]

These are examples of the consequences of stereotyping. The first example illustrates the unconscious consequences of role expectations; the second relates to consequences of the self-image of black people in white society. The follow-up study sought to measure the effect of the 'Black is Beautiful' episode, and the results seem to indicate that in this regard little has changed in the United States.

In cognitive psychology stereotypes are taken to be schemas or sets which play a part in cognition, perception, memory and communication.[8] Stereotypes are based on simplification and generalization, or the denial of individuality; they can be either negative or positive. Though they may have no basis in reality, stereotypes are real in their social consequences, notably with regard to the allocation of roles. They tend to function as self-fulfilling prophecies. The targets of stereotyping are manoeuvred into certain roles, so that a vicious circle develops, in which social reality seems to endorse the stereotype. Social representation echoes social realities which are in turn modelled upon social representation.[9] A kind of societal typecasting is set up from which it is difficult to escape. Thus, as long as women are stereotyped as being more emotional than men and devoted essentially to child-rearing and cooking, they will not be given much leeway in social relations and institutions outside these role patterns. The present study is concerned with visualized prejudices held in the West about Africans and blacks, for instance that they are 'closer to nature', more emotional, sexually uninhibited, more musical, childlike, superior athletes, and so forth. Obviously, what is at stake in these representations is not just the images themselves but also their social ramifications.

Emancipatory movements are concerned not just with changing social realities but also changing representations. Women's movements oppose not merely inequality in social opportunities but the stereotypes that accompany and sanctify it. By the same token, the resistance to emancipation tends to be of two kinds: resistance to change in the present distribution of roles, on the

grounds that certain stereotypical features are 'inherent' in group X; and dismissal of any criticism of the stereotypes by referring to the social realities which confirm them.

It is sometimes conceded that a particular stereotype or prejudice exists, but that it is widespread, that it has any effect, or that one subscribes to it oneself, is denied. Often the existence of stereotypes is denied, for from the point of view of the mainstream stereotypes appear to be 'normal' and the resistance to them as 'abnormal'. In as far as stereotypes form part of the psychological and cultural furniture of those in society's mainstream, to criticize them is to undermine the comforts of mainstream existence. From the point of view of the comfortable strata of society, and those who aspire to join them, no problem exists; there is a problem only from the point of view of those on the margins.

Sometimes stereotypes are held to be true, and in fact a kind of primal image or archetype, in other words, not an expression of prejudice but rather a reflection of the inherent essential characteristics of the group in question. Thus, as some would say, is it not true that black people are musically and rhythmically gifted, can dance well, are cheerful, and are as it were closer to nature, which is logical in view of their tropical origins? Is it not true that blacks are different, not better or worse, but different? This kind of reasoning has peculiar consequences. In the first place, it transforms a negative stereotype into a positive one. A difference is promoted from being a stigma to becoming a badge of honour, but it remains a stereotype, based on simplification and generalization. In the second place, European images of Africa have, as we shall see, undergone numerous drastic modifications. In view of the multiplicity of stereotypes, which would be the archetype? The Ethiopian Eunuch or Superspade? The King of the Moors or Uncle Tom? Saint Mauritius or the Golliwog? To equate stereotypes with archetypes is to remove them from history; to do so means that the social conventions, the clichés of the day, must be taken to be profound truths. According to this logic, pin-ups and magazine centre-folds of women attest to the fact that seductiveness is the essence of femininity. Another fallacy of the view that equates stereotypes with archetypes is the same that holds for theories of race: while it is true that there are differences among groups, the differences *within* a group or category are greater than those *among* groups or categories.

Social representations arise out of a multiplicity of historical contexts and configurations, and therefore cannot be reduced to a few simple schemas. If one were to try to discern an underlying structure – for instance, 'nature and culture' – in the variety of images, the structure itself would turn out to be made up of many historical constituents, the meaning of which has been changing over time. For these reasons, in order to dispel the 'enchantment' of stereotypes, I emphasize in this study not their durability but their changeability, the historical relativity of social representations, and the fact that images of blacks, like ideologies of 'race', are social constructions.

This book is a study of images and power, an enquiry into the social rhetoric of images. It is concerned with such questions as, how are relations of dominance constructed and reproduced in popular culture, how are they normalized and routinized in word and image? By what means are they marginalized and subjected, identified, labelled, kept in their place? How do caricature and stereotype, humour and parody function as markers of social boundaries and devices of domination?

Stereotypes are but one link in the multiple chains of social hierarchy. Decoding social representations is a necessary but not sufficient condition for improving the position of stereotyped groups. The elimination of stereotypes in the public realm in the United States has shifted public norms, but social relations *vis-à-vis* racism have not radically changed. To achieve that will take more than a sanitisation of social representations.

The Structure of this Book

Because this book deals with a wide variety of issues in the context of three continents and over two hundred years of history, a few words about its logic and structure may help to make it user-friendly. This book is about images, and in order to interpret images it is necessary to provide them with a context and situate them within the historical process, together with the history of mentalities and ideas, and of iconographic conventions. On the other hand, this is not the place to enter into a detailed discussion of historical developments, of African colonial history, or of theories of race; these are discussed here only so far as is necessary to shed light on the dynamics of social representation. The range of this work is such that it cannot deal exhaustively with particular episodes; rather, it must provide an overview and refer the reader to specialized sources for more detailed treatment. The book consists of three parts: one about images of Africa, one about images of blacks in the West, and one about images and social representation in general. Chapter 1, on the imagery of Eurocentrism, discusses European images of Africa as part of a wider world view which includes images of Asia and America, and Europe's images of itself. This is followed by a bird's-eye view of representations of Africa from ancient times onward, which serves to situate the two hundred years of African and black images on which the book concentrates, from *circa* 1780 to the present, in a larger historical context.

Chapter 2 is concerned with the development of European thought on the subject of 'race', situating it in the wider context of early European ideas about 'savages' and Christian beliefs about the 'curse of Ham'. Chapter 3 develops the argument that race-thinking arose, not so much as a justification of slavery, but as a reaction to it, having rather prospered after the movement for the abolition of slavery took hold. The chapter illustrates the polemical nature of social representations: images serve as cultural devices in settling social conflicts.

This sets the stage for a chronological discussion of western images of Africa from the early nineteenth century onwards. Chapter 4 deals with the image-production of European explorers and missionaries who, in paving the way for European colonialism, exercised a decisive influence on the western imagination. Chapter 5 sketches the development of colonial representations against a backdrop of the main trends of colonialism in Africa. South African images and the culture of apartheid are discussed in a separate chapter. This part is rounded off with a chapter on European fantasies about Africa as the land of the safari, of adventures and of cannibals, as depicted in fiction, comic books and films.

Part Two concerns images of blacks in the West, the African diaspora in America and Europe. In this section the framework is not chronological but thematic, based on the main clusters of popular images of blacks. The key

images of blacks in modern history are of servants and entertainers, and this series opens with these. Chapter 10 reviews the most popular black archetypes in various western countries, affording an opportunity to examine the variations in images of blacks from one western culture to another. Chapter 11 deals with images of blacks and of Africa in children's books and the nursery. Chapter 12 is concerned with the representation of blacks in the context of sexuality, and looks further, into the differences in and the similarities between the European and American images of blacks. The closing chapter of the section deals with images of blacks in western advertising, and offers an opportunity to review current tendencies in the representation of blacks.

Part Three comprises a reflection on the basic problem of social representation. Chapter 14 is about 'White Negroes' – groups which, at certain junctures, have been viewed in ways similar to blacks. Thus, from images of blacks we shift the focus to the 'niggering process', i.e., the process by which negative and subaltern identities are constructed. We can look at this in terms of certain types of social situation, and of certain ways of thinking; among the latter, Aristotelian thought and Victorian anthropology have both been influential intellectual constructions of heirarchies. More generally, what are the overlaps and what the differences among historical imageries of race, gender and class?

This final Part addresses the wider question of the relationship between social representation and social hierarchy, or image and power. This is the theme of the closing chapter, which first offers an account of the methodology followed in this work, and then concludes with a number of general observations and reflections on social representation.

For various reasons the discussion pursued here is open-ended. Stereotypes of Africa and of blacks are still in circulation; old images fade away or acquire new meanings or inflections, and new images arise. It is more difficult to assess contemporary images than the imagery of the past, on which the passage of time has provided some perspective. In the second half of the twentieth century 'race' is no longer the primary key to difference; it has been succeeded by systems of differences founded not upon biology but upon culture. (Still, in the United States ethnic stratification retains many 'racist' characteristics; since the days of slavery, stratification on the basis of class has been substituted for stratification on the basis of pigmentation.) The hierarchies of culture are not necessarily different from those of race – the rhetoric of 'race' used to be embedded in a wider culture of hierarchy, and many of the same features survive in contemporary representations of otherness.

'Race' discrimination has increasingly yielded to discrimination along cultural lines, bringing with it different sets of images and discourses. Hence 'racism' is no longer a satisfactory term to understand the changing realities.[10] Culture as a new basis for differentiation is much more diffuse in its ideological claims than race theory, but is in some ways equally effective in establishing boundaries and demarcations. Five hundred years of occidental expansion and hegemony have left a deep imprint. The hierarchical culture instituted as part of colonialism is being reproduced and reworked in the framework of postcolonialism, along with discourses of 'development'.[11] While the logic of 'othering' has a history as old as representation itself, its dynamics are multiplying and being intensified in the media age. Multiculturalism and the question of national identity have become the main

frontiers of friction and conflict both in Europe and the United States. National identity has been referred to as racism's last card.[12]

How does modern pluralism deal with the legacy of the culture of heirarchy? This is the problem examined in this work. Western hegemony continues and along with it the hegemony of western culture. Its complexities, past and present, thus set off a worldwide echo. Social representation is a process and to this process there is no end.

The Negrophilia Collection

This study was given its original impetus in 1987, when I was asked to do research on a collection of images of Africa and blacks in preparation for a museum exhibition. My report served as the blueprint for the exhibition, which was held in the Tropical Museum in Amsterdam in 1989-90. The Dutch edition of this book accompanied the exhibition. More recently the collection has been exhbitied in Brussels (in 1991) and will travel to other cities in Europe and North America in future seasons.

The collection – named, not without sarcasm, the 'Negrophilia' collection – documents popular representations of Africa and blacks in the West from the eighteenth century to the present. It consists of visual material – prints, drawings, illustrated magazines, books, comic books, posters, advertising material, packaging, decorative objects, statues, figurines, toys, and other items. For the most part the collection consists of popular representations and objects from a period not far behind us. It includes objects which many people remember from their youth and items still around us. Because the material is visual, ordinary and everday, the effect of viewing the collection is direct and dramatic. Two hundred years of racist notions and practices are made visible in this collection, which makes it an important historical and cultural artefact.

What does Europe look like if seen through the eyes of American civil rights activists? The collection was started when Rufus Collins, an African-American theatre director, then working in Europe, to his astonishment came across many caricatures of blacks which had long been taboo in the United States. He began to collect such items as Golliwogs in England and images of Black Peter in the Netherlands as aids to consciousness-raising. Subsequently the collection was adopted and enlarged by the Cosmic Illusion Productions Foundation, a collective of film and theatre makers of Dutch-Antillean origin. In time the collection has taken on more of an historical and documentary character. It does not extend to images of Africa and blacks in western art, which is a field by itself,[13] but concentrates on popular culture and thus highlights the importance of everyday images in the reproduction of stereotypes.

What makes the collection outstanding in an international context is the range of material, which extends from western Europe to the United States. There are extensive collections of 'black memorabilia' in the United States, but valuable as these are they contain hardly any European items. For European collections the opposite is true. In addition, collections on this subject in France, Germany and Belgium tend to be predominantly national in scope, while the Negrophilia collection ranges across most of western Europe. As a trans-Atlantic collection it documents the similarities in and

differences between European and American imagery, and enables us to view white-on-black images in a comparative framework, and as a problem of the western world.

Acknowledgments

The English edition has been translated from the Dutch original and revised by the author. Many more people helped with this project than I can acknowledge here; some of them are referred to in the notes. Vernie February and Raymond Corbey were kind enough to read and comment on the Dutch edition in manuscript. I would also like to thank Robert Ross, Tony van der Veen and Samten de Wet for information on South Africa; Frans Bontinck for information on the missions in Africa; the Institute of Race Relations in London for information on the Golliwog; Gerd and Regina Riepe for documentation on German material; Jean-Pierre Jaquemin and Edouard Vincke for information on Belgian and French images; and Felix de Rooy and the Cosmic Illusions Productions Foundation for the commitment expressed in the Negrophilia collection. I am grateful to Catharine Carver of Yale University Press for her careful editing of the English language. My special thanks to Lisa Chason for her ideas, her help in processing the material and in grooming the English text.

I AFRICA

1 IMAGERY OF EUROCENTRISM

Images of the World

Europa e prima e
principale parte del
Mondo.
Cesare Ripa, *Iconologia*
(1593)

In summa
Europa is a Queene over
Asiam Africam
and Americam.

Johan Picardt, *Korte
Beschryvinge* (1660)

During the Middle Ages the predominant representation of the world in Europe was the *orbisculum* or earth sphere, which was divided into three parts. This tripartite division was often equated with the three sons of Noah: Sem, corresponding to Asia, Japheth corresponding to Europe and Ham to Africa. It also corresponded to the image of the Three Kings, or Wise Men, who came to worship the Christ child. The image of the Adoration of the Magi, a demonstration of Christianity's claim to universality, became increasingly prominent in European iconography from the thirteenth century onward.

In the sixteenth century, in the wake of the exploration of America, this representation of the world gave way to the image of the *four continents*, which remained the iconographic framework through the centuries to come. The Church produced a variation on this theme in the symbolism of the four rivers (as in Bernini's fountain in Rome), but Christianity no longer occupied the central place in this framework. In medieval maps Jerusalem was often depicted as the centre of the world; but now Europe occupied the central place. This was a Europe divided by the Reformation, which no longer found unity in Christianity but mirrored itself in the reconstructed imagery of antiquity – in the Roman Empire rather than in the Roman Church.

Classicism having become the secular identity of Renaissance Europe, its iconography followed an imperial matrix – classical in style and imagery, imperial in mentality and perspective. Even where empire was not at issue and representations concerned commerce rather than rule, mercantile relations were depicted in an imagery of power and control.[2]

There is a logical development in the European representations of the world. First there were the navigation charts which emphasized the sea routes, then the continents themselves came into view. On sixteenth-century maps and representations of the world the continents were filled in in the way Jonathan Swift described:

> Geographers in Afric-Maps
> With Savage-Pictures fill their Gaps,
> And o'er inhabitable Downs
> Place Elephants for want of Towns.

Gradually the coast and peoples appeared on the European horizon. The continents were personified as female and were represented along with their products as stylized characters upon a stage dominated and defined by Europe.

In Cesare Ripa's *Iconologia* (1593), the standard encyclopaedia of personifications, this sign language took further shape. Europe was represented as a queen with crown and sceptre, flanked by a horse; Asia as a woman in fine

garments adorned with gold, pearls and other precious stones, carrying spices, herbs and fragrant incense, accompanied by a camel; Africa as a dark woman with loose and curly hair, almost naked, who wears a coral necklace and earrings, has an elephant's trunk on her head, and is holding a scorpion in her right hand and a cornucopia containing ears of corn in her left. On one side of her is a ferocious lion and on the other are vipers and venomous serpents. The cornucopia is a reference to the time of Hadrian, when Carthage was one of Rome's bread baskets; the scorpion and lion refer to classical sources as well.[3]

Seventeenth-century allegories of the continents followed Ripa's handbook and this iconographic matrix remained intact well into the nineteenth century. Also in the Protestant countries of mercantile capitalism in northern Europe – the Netherlands, England, Germany – classicism was the uniform of civilization.[4] Time and again the same motifs recur: Europe, or a European country or city, personified as a queen and depicted with classical features, in a toga. She dominates the image as the continents kneel before her throne. Often the continents are shown from the back and in quasi-profile, and portrayed not with classical facial features but looser in style. Often a book is prominently displayed in which, presumably, commercial transactions are being recorded (in an earlier iconography the book represented knowledge). Ships in the background and the presence of Mercury (commerce) and Neptune (the sea) indicate the setting is maritime commerce.

In the seventeenth century the Dutch Republic was Europe's leading power and foremost trading nation. The central figure in the world image developed in the Republic is the City Maiden (*Stedemaagd*) of Amsterdam. On the high reliefs of the Royal Palace in Amsterdam, which was originally built as the town hall, this world view was recorded by the sculptor Quellinus the Elder, or in his workshop, in 1656. The theme of the east tympanum over the façade of the town hall is 'The gods of the sea bring tribute to the City Maiden', and of the west tympanum on the rear, 'The four continents bring their tribute to the city Amsterdam'.[5] The allegories follow Ripa on most points. Thus on this central monument of the Dutch Golden Age the contemporary image of the world is immortalized.

Similar images of the world are reproduced in numerous *Descriptions of the City of Amsterdam*. Amsterdam presents itself as the city to whom the continents turn. In each frontispiece the central figure is the City Maiden, with regal or imperial attributes. She is the *ryke Zeevorstin* ('rich Queen of the sea') to whom the four quarters of the globe, 'enchanted by her fame', come to 'dedicate their tribute', and offer her treasures, produce, and artefacts.[6] She is 'Europe's Capital' and 'draws the four quarters of the universe/ to dedicate their treasures to Amsterdam'.[7] These odes were paraphrased by the country's leading poets such as Joost van den Vondel and Jacob Cats. The regal imagery and imperial or feudal discourse ('dedicating tribute') are striking for a nation that is so self-consciously republican and on record as the first world state to be governed by the bourgeoisie.[8]

On another occasion the City Maiden is depicted sitting under a canopy of fishnet on a throne of a shell and an anchor. Putti carry a flag, sword, Roman fasces, caduceus, and the papal cross – dominion, commerce and Christianity apparently go together. River gods in the background represent the Ij and the Amstel, while kneeling before Amsterdam in humble postures, Asia offers her jewellery and silk, Africa ivory and Arabia cloth.

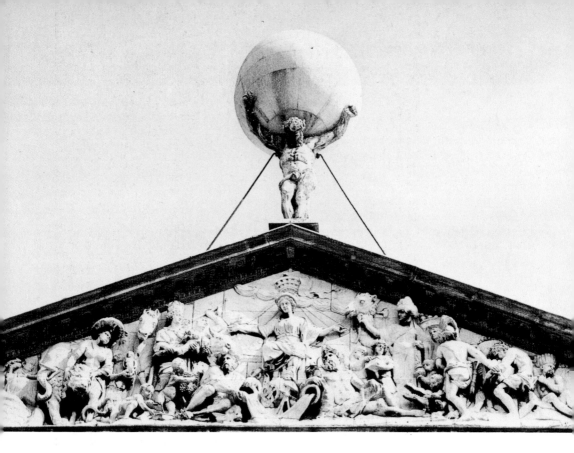

The four continents offering their wares to the City Maiden Amsterdam. High relief, west side Royal Palace at the Dam, Amsterdam, Quellinus the Elder, 1656.

Facing page: Maiden Amsterdam with the continents offering their wares. Frontispiece by Reinier Vinkeles (1741-1816).

In the frontispiece of an English book probably dating from the late eighteenth century, each continent is associated with an animal – a horse, an elephant, a camel and a beaver. A Native American woman is holding tobacco leaves, an Arab woman is flanked by a fragrant vat of incense, and the African woman, a palm tree by her side, holds ivory and a slave chain. Casually the caption mentions '*Europe by Commerce, Arts, and Arms obtains The Gold of Afric, and her Sons enchains . . .*'

In the frontispiece of a nineteenth-century book entitled *The British Colonies*, not commerce but rule is the central theme.[9] Britannia in a toga wearing the helmet of Athena-Minerva and holding the trident of Poseidon is enthroned upon the globe – her very physical position suggests world rule. A virgin by her side with a horn of plenty, agricultural tools and produce in the foreground suggest a world economy founded upon agriculture, as if industry were irrelevant. This rural idyll exemplifies a traditional rustic self-image of British rule. It matches England's self-image, which was equally mythical at the time – the 'southern metaphor' with the undulating green hills and sunny villages of 'Merrie England', rather than the blackened cities and factories of the north.[10]

The imagery of Eurocentrism succeeded the imagery of Christendom and passed over into the imagery of European colonialism. As a reconstruction of the Roman Empire, the iconography of Eurocentrism from the outset followed an imperial framework. Accordingly, the imagery of empire in Europe preceded the actuality of empire by several hundred years. The hierarchical logic and tenor of this iconography remained basically unaltered into the

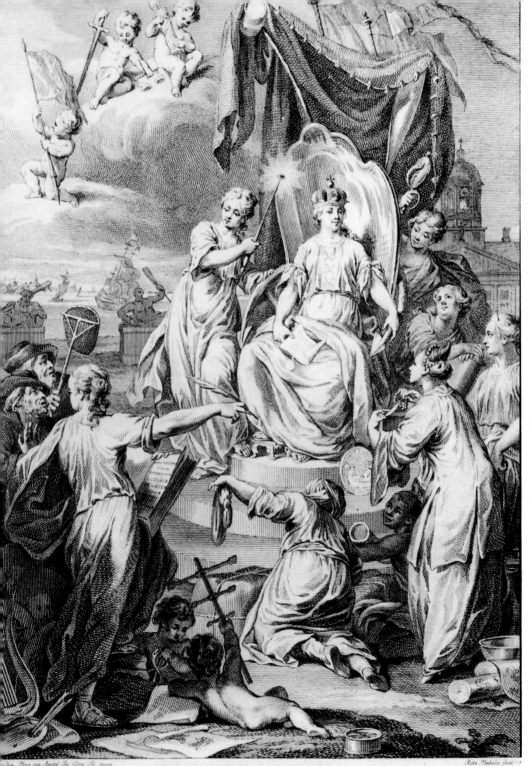

Te AMSTERDAM,

By YNTEMA en TIEBOEL.

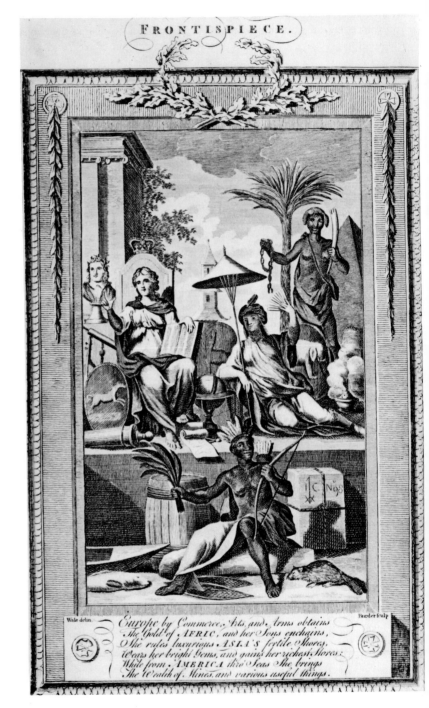

The continents personified in the frontispiece of an eighteenth-century English book; the caption explains: 'Europe by Commerce, Arts, and Arms obtains The gold of Afric, and her Sons enchains. She rules luxurious Asia's fertile Shores, Wears her bright Gems, and gains her richest Stores: While from America thro' Seas She brings The Wealth of Mines, and various useful things.'

twentieth century, when European monuments commemorating empire and colonialism continue to display a similar view of international or intercontinental relations.[11] The hierarchical character of this iconography is transmitted by means of a pictorial architecture of power, both blatant and subtle: in contrasts of high and low, centre and margin, foreground and background,

body languages of dominion and submission, in addition to the symbolic repertoires specific to particular settings. This architecture of power echoes throughout the imagery of White on Black as a set of iconographic codes recurring in the depiction of slavery, missions, colonialism, and up to contemporary advertising.

These displays of civilizational narcissism and representations of Europe as the world's centre are a fitting entrée to this collection of images of Africa and blacks: we now enter the world of Eurocentrism. While zeroing in on images of Africa, we do so in the awareness that they are related to images of Asia and America and to a self-image of Europe, and that this is Africa viewed from and represented by Europe. The myths of Africa and other continents correlate with a myth of Europe itself.

Europe's Africa

There have been so many changes in Europe's images of Africa over the course of time that it is worthwhile to sketch some of these developments, if only from a bird's-eye view. It gives us an insight into the historical depth of images as well as their situation in a wider historical context.

The earliest images of black Africans are significant in the genealogy of European images we encounter in ancient Egypt. The oldest representations of black Africans, dating from 2500 BC, show them well integrated into society and intermarrying. They indicate also that black beauty is appreciated. Black as a colour is valued positively in Egyptian culture, as the colour of fertility (dark as the silt of the Nile). Gradually the imagery changes in a way which presumably correlates with the changing relations between Egypt and the Nubian kingdoms in the south, Kush, Moroë and Napata. After 2200 BC black Africans are especially represented as *warriors*. During the 11th dynasty Nubian archers formed part of the Egyptian army. When tensions along the southern border increase we see them depicted as *enemies* and during the 18th dynasty, after the conquest of Kush, as *defeated enemies*, bent under the foot of the Pharaoh. In this period representations of Nubians, mostly young, as *servants* and *entertainers*, especially dancers, come to the fore.

Subsequently the iconography turns round once again, in the era of the hegemony of Kush, Moroë and Napata, from 800 BC to 300 AD, and after Kush conquered Egypt in 700 BC and controlled the entire Nile valley, which resulted in the 25th or 'Ethiopian' dynasty.[12]

In other words, in ancient Egypt alone (a period of almost 3,000 years) we witness a virtually complete cycle of images of blacks: ranging from normal (in the sense of everyday) and warrior images to enemy images and images of defeat, images of servants and entertainers, and finally, at the other extreme, to images of black or 'mixed' Pharaohs.

Generally the world of antiquity, not only in North Africa but also for example in Minoan Crete, was a mixed culture and one in which differences in skin colour did not play a significant role, or rather, in which black carried a positive meaning. 'When the Greeks and the peoples of the Roman Empire wanted to represent a far-off, prestigious but different land, they used the black as the sign of differentiation: he became one of the forceful images in the 'stylized' way of picturing Egypt.'[13] With Homer 'Æthiopia'

was the ideal site for the banquets of the gods, where a negro guarded the entrance to their retreat. In the Old Testament black African kingdoms such as Kush (Saba may also belong in this category) are described as powerful and prestigious and important allies, for instance to Solomon.[14] These are among the elements of an *Ethiopianism* of antiquity, that is a love or preference for things Ethiopian.

Beyond Egypt and the Nubian kingdoms, however, there was yet another, unknown Africa: this is the Lybia described by Herodotus as a 'land of wild beasts'. A land which Aristotle believed brought forth monsters because so many different animals mingled at the scarce watering holes. The monstrous beings described by Pliny the Elder in 77 BC, the 'Plinian races', like the Cyclopes, Amazons and Cynocephali, were thought to dwell at the border of the known world, and this too was often held to be Ethiopia.

So already at an early stage, in ancient Greece, we witness the phenomenon of a composite image of Africa, or multiple Africas: the Africa of Egypt and the Nubian kingdoms ('Ethiopia'), and a 'wild', unknown Africa. On some old maps Egypt was shown as separate from Africa, and at times Africa was thought to be part of Asia.[15]

In the Roman era after the wars with Carthage, 'Africa' was incorporated as a province of the Roman Empire – at that time the term referred to a part of North Africa. In Rome, Carthage and Alexandria black Africans were no strangers; they formed part of the armies of Ptolemy, Aurelian and Hannibal. In the iconography they are represented positively, both as a type and as individuals. That Rome also maintained contacts with Africa further afield is apparent from depictions of pygmies in mosaics in Pompeii.[16] The appellations Aethiopia, Libya (Greek), Africa (Latin) came generally to be used interchangeably.

In the Christian period a significant break occurred with the views of antiquity. In the writings of several of the church fathers of western Christendom (not Byzantium) the colour black began to acquire negative connotations, as the colour of sin and darkness. Origen, head of the catechetical school in Alexandria in the third century, introduced the allegorical theme of Egyptian darkness as against spiritual light. The symbolism of light and darkness was probably derived from astrology, alchemy, Gnosticism and forms of Manichaeism; in itself it had nothing to do with skin colour, but in the course of time it did acquire that connotation.[17] Black became the colour of the devil and demons. Later, in the confrontation with Islam, it came to form part of the enemy image of Muslims: the symbolism of the 'black demon' was transferred to Muslims – in early medieval paintings black Saracens, black tormentors and black henchmen torture Christ during the Passion. This is the tradition of the devil as the Black Man and the black bugaboo. During this period Europe had lost direct contact with Africa because of the advance of Islam, when the Mediterranean became a 'Muslim lake' and Arabs, Berbers and Moors controlled the area from Byzantium to the Pyrenees. One might say that under conditions of ignorance of Africa a negative image came to predominate.

In the late Middle Ages, however, there was another turn-around in European images of black Africans, a revaluation which leaves a salient trail in European iconography from the twelfth century onward. This reappraisal coincided with the spread of the legend of Prester John (John the Presbyter, Prêtre Jean, Pape Jan), alleged to be the king of a Christian kingdom in Eth-

iopia, on the far side of the lands of Islam. Prester John, so the legend had it, was the guardian of the gates of paradise, but he was also a prince who really existed and the descendant of one of the Three Kings who came to worship the child Jesus. The apocryphal 'Letter' of Prester John which came into circulation in 1165 was to be the most widely disseminated falsification of the Middle Ages. This was the occasion for a Christian Ethiopianism – a love for black Africans and a preoccupation with a fabulous prince somewhere in Africa. In fact, this preoccupation was more than just a fable (although that is rarely mentioned in some of the literature).

Ethiopia had come back into view during the Crusades when Europeans were in possession of Jerusalem (1099-1189 and 1229-44). There they encountered monks and pilgrims from Syria, Egypt and Ethiopia, who visited the Church of the Holy Sepulchre and maintained a monastery there. 'When the Crusaders lost Jerusalem in 1244 and their last strongholds in Palestine and Syria in 1291, Ethiopia became even more important as a potential ally against the Moslems.'[18] Thus in 1300 plans were made for a joint crusade with 'the beloved black Christians of Nubia and the countries of Upper Egypt'. At the time the borderland comprising what are now Egypt, Sudan and Ethiopia was a battlefield between Christian kingdoms and Muslims. From the reign of the Ethiopian king David I (1382-1411) onward, there were intensive diplomatic and ecclesiastical contacts between Europe and Ethiopia. Ethiopians were present at the Council of Constance in 1418, Ethiopian envoys were received at the court of Aragon in Barcelona in 1407 and in Valencia in 1427. Duc Jean de Berry sent emissaries to Ethiopia in 1430. The sultans of Cairo, wary of an attack on two fronts, tried to disrupt contacts between Ethiopia and Europe by intercepting travellers from and to Ethiopia and by persecuting the Copts in Egypt.[19]

The legend of Prester John must be placed alongside other European attempts to find allies outside the circle of Islam, for instance in rulers of the Mongol empire. Europe was weak in relation to Islam, the Crusades were driven back and Europe's encirclement continued. In this context the legend of Prester John served as a European myth of liberation, inspired on the one hand by actual contacts with Ethiopia and inflated on the other out of frustration and hope. Marco Polo, who managed to break through the Muslim encirclement in an eastern direction and who, thanks to the Mongol empire, made direct contact with Cathay, searched for traces of Prester John even there. What is significant in all this is the late-medieval motif of a Christian Africa – part real, part imagined – as Europe's helper in need and ally in the confrontation with Islam. This manifested itself in an iconography in which black Africans were represented in a positive light and which was centred, besides Prester John, on two figures, both of whom took on a black guise in this period: the Queen of Sheba and Caspar the King of the Moors.

The Queen of Sheba was depicted for the first time as a black woman in 1181, in the monastery of Klosterneuburg.[20] In the cathedral of Chartres in 1230 she was portrayed as a European woman with a small African at her feet bearing gifts. In 1245 in Magdeburg a beautiful stately statue was erected of Saint Maurice, a legendary African Christian officer in Rome's Theban Legion, here in the armour of a Crusader knight, as the patron saint of the Crusade against the Slavs, of which Magdeburg was the spiritual and military headquarters. International Gothic, a style which dominated from 1360 to 1420, included a stylistic revaluation of black, which was no longer seen as a

demonic colour. In Sicily and elsewhere in the Mediterranean black saints made their appearance, among them San Benedetto of Palermo (the son of freed slaves and a saint who later became popular in Brazil) and black Sara of the gypsies in Saintes-Maries-de-la-Mer (in the French Camargue). The fifteenth century saw the high tide of popularity of Caspar the King of the Moors. In Rogier van der Weyden's *Adoration of the Magi* (1460), one of the Three Kings was depicted as black and this has remained the tradition since.

The general context of this reappraisal of Africa and blacks between the twelfth and fifteenth centuries was Europe's re-conquest of the Mediterranean and the attempts either to break through or to circumvent the encirclement by Islam. A second dimension was the friction then at work within Europe between the German Emperor of the Holy Roman Empire and the Pope. One of the forms taken by this struggle between Emperor and Pope was a rivalry between Cologne, as the imperial headquarters, and Rome, the papal seat. The legend of the King of the Moors played a part in this contest as H. W. Debrunner notes: 'The legend took an elaborate form in the book about the Three Kings written by Johannes von Hildesheim between 1364 and 1375 in order to propagate the idea of Cologne as a religious, internationally important centre.'

The Queen of Sheba represented as a black woman. Conrad Kyeser, *De Bellifortis* (1405).

Right: Saint Maurice, patron saint of the Crusade against the Slavs. Magdeburg, 1245.

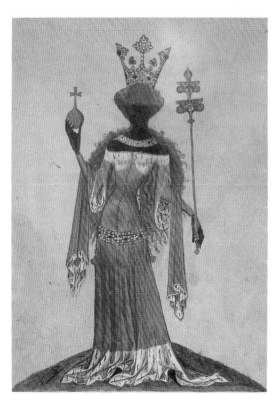

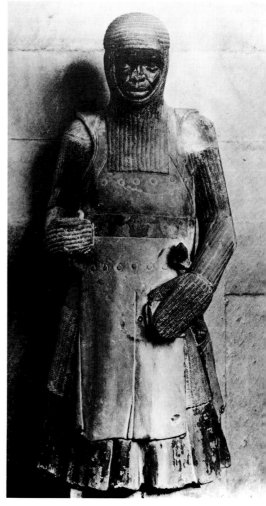

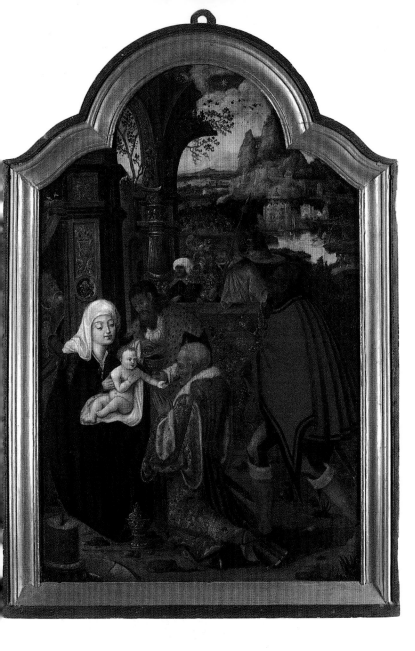

A black Caspar as one of the Three Kings worshipping the Christ child. Anon. Antwerp c. 1540.

This may be the background for the difference in the representation of Africans north and south of the Alps. South of the Alps blacks were depicted only as followers of the Three Kings, as in the cathedral at Siena where, in 1268, two blacks are shown among their train. Earlier, in the Pala d'Oro of San Marco in Venice, two blacks represent the ends of the earth, India and Africa. According to Debrunner, 'The first known representation in European art of the king of the Moors as an African was at the porch of the cathedral church of Thann in Alsace in the fourteenth century. The African king soon became immensely popular north and west of the Alps.' And he continues:

The elegant, young, eager, well-dressed, exotic King Caspar has endeared himself to popular imagination. Since he was well dressed, he became a patron saint of the tailors' guild (e.g. in Berne 'Zunft zum Mohren'); his exotic appeal made him the public's darling in religious drama.

In the late 14th and all through the 15th century actors blackened their faces as Caspar. Caspar was the spokesman of the Three Kings. Inns adopted the Moorish kings and Saracen head as trade mark.[21]

In one of Schaffhausen's main squares the *Mohrenkönig* figures as the emblem of the *Mohrenbrunnen*, one of the many remnants of the popularity of the African king in countries north of the Alps.

The fifteenth century may be regarded as Europe's African century, just as the sixteenth century was the 'American century'. The fifteenth century witnessed the first renewal of direct contacts between Europe and black Africa since the era of Islamic control. In addition to the contacts between Ethiopia and Rome and various Christian princes, there were the explorations of Africa's west coast by the Portuguese, initiated by Prince Henry the Navigator. Christian Ethiopianism and the cult of the King of the Moors, which were then at their peak, were the context of this development.

In 1415 the Portuguese conquered Ceuta as a Christian bridgehead in North Africa. As Governor of Ceuta, Prince Henry received information from Arab sources about the contours of the African continent. Back in Portugal, as governor of the Algarve and Grand Master of the crusading Order of Christ, he organized a series of journeys to explore the coasts of Africa from Fortaleza, his fort in Sagres, located next to Cabo de São Vicente, Europe's westernmost point.

This was also the beginning of an entirely new relationship between Europe and Africa, when in 1441 ten Africans from the northern Guinea coast were shipped to Portugal as a gift to Prince Henry. They were captured not for sale but simply to be shown to the Prince. By 1444 one of the subsequent expeditions had brought back 235 African men, women and children, who were taken ashore at the port of Lagos and parcelled out in lots under the benign eye of the Regent of Portugal, who 'with great pleasure' 'reflected upon the salvation of the souls that before were lost'.[22] Soon slaves from Africa were being traded at the small slave market in Lagos, the port from which Prince Henry's ships sailed.

Ethiopianism continued to occupy European minds for a long time to come – diplomatic missions between Ethiopian kings and European courts and religious contacts with Rome increased from the fifteenth century on. Queen Helena of Ethiopia sent an emissary to the Portuguese king Manuel I in 1509 and a Portuguese mission reached Ethiopia in 1520. In 1543 Ethiopian and Portuguese troops undertook joint military operations against the Imam Gran of Egypt. In Rome the hospice of San Stefano degli Abissini was available to Ethiopian pilgrims and travellers. In 1634 a school for Ethiopian and Oriental languages was established next to it, which numbered among its scholars the well-known Jesuit Athanasius Kircher. The Ethiopian language was considered the closest relation to the 'original language' of paradise and lexicons and grammars of Ethiopian were published in the seventeenth century as far afield as Germany. Likewise the Ethiopian Church was considered as one of the original churches, which was of the greatest importance in the ecumenical reunification of the churches.

What is striking in all this is that there were drastic changes and differen-tiations in European images of Africa which were related mainly to changes which took place *in* Europe. There were drastic changes in the imagery even in periods when Europeans had no contact whatever with black Africa.

From antiquity to the early Middle Ages the dominant image changed from positive to negative, while the early to late Middle Ages saw the trans-formation of the black from an infernal demon to the highly honoured repre-sentative of a remote Christendom – Europe's redeemer and help in distress. The principle that the image-formation of outsiders is determined primarily by the dynamics of one's own circle, and not because the people in question themselves change, is a recurring refrain in this study of image-formation.

The developments described above are significant also against the back-ground of later developments, when gradually a negative image of Africans comes again to predominate. The significance of the extremely negative image of blacks and of Africa which predominated in the eighteenth and nineteenth centuries becomes apparent only if placed against the extremely positive images predominating from the twelfth to fifteenth centuries. During the sixteenth century the focus shifted to America as the new exotic con-tinent and to native Americans, who played the leading role in the debate on the savage, a notion that later would be applied to Africans as well. With re-spect to Africans, the sixteenth and seventeenth centuries were a period of transition, in which we encounter positive or 'normal' images (Ethiopianism; diplomatic relations; the Africans painted by Rubens, Rembrandt and Van Dyck) side by side with condescending, denigrating images and tales (of African 'beastliness' and savagery).

2 SAVAGES, ANIMALS, HEATHENS, RACES

Long before the science of race of the nineteenth century, non-western peoples had been the subject of discussion. The sixteenth-century debate about the savage played a key part, along with other themes – the comparison of these peoples with animals, the biblical curse of Ham, the concept of race – in the formation of European images of Africa and of blacks. These themes form part of the 'hidden text' of the images, part of the cultural assumptions built into them. They supply the underlying texture and mental horizon of western imagery, echoing far beyond their formative period into the present.

Europe's savages

The prehistory of the savage belongs to Europe itself. The underlying idea seems to refer to the distinction, not so much between town and country as between cultivated and uncultivated land or 'nature'. To nature belong the forests and mountains, areas which are important to Europe geographically and historically. The Mediterranean, as Fernand Braudel remarks, is 'above all a sea surrounded by mountains'.[1] Also, in the north, mountains and highlands form an important part of the European landscape. Extensive forests dominated the landscape and until the tenth century Europe was normally characterized as a wilderness: 'Western Europe at the dawn of the ninth century can best be visualized as a vast wilderness thinly populated by Europeans living in family groups huddled together in clusters of small feudal villages, separated by expanses of natural vegetation.[2] With the gradual expansion of population, the introduction of new crops and the cultivation of 'wild areas', this began to change. Until the twelfth century, the forests remained the principal source of Europe's products for export – wood, fur, along with iron and slaves – to the much more highly developed worlds of Islam and Byzantium.[3]

The symbolic significance of these areas matched their importance. As regions dominated by the forces of nature they were mysterious, numinous – the domain of Pan and Bacchus for the Greeks.[4] In the non-European Mediterranean world, where the wilderness is primarily the desert, that desert is the dwelling-place of prophets, saints and monks – Moses, John the Baptist, Jesus, Mohammed. The prophet is one 'crying in the wilderness'. The Middle Ages were Europe's time of transition from wilderness to cultivation ('culture'), and the forests were the domain of beings on the border-line between human and animal, myth and reality, like the *homo ferus* who was raised by wolves, and the *homo sylvestris*, or man of the woods. The latter was also referred to as the Wild Man, a quasi-mythical figure often depicted as a giant with a club: a kind of abominable snowman of medieval Europe who, like the yeti, was represented alternately as terrifying or benevolent.[5]

This background is reflected in the dictionary definitions of 'wild', 'savage'. According to *Webster's*, 'wild, savage, *sauvage*' is derived from the Latin: '*silvaticus* of the woods, wild, fr. *silva* wood, forest', and it means: 'not domesticated or under human control: untamed; lacking the restraints normal to civilized man'. As a noun: '1: a person belonging to a primitive society; 2: a brutal person; 3: a rude or unmannerly person'.

These definitions also refer to another aspect: the distinction between *civilitas* and *barbaries*. The latter term referred originally to a difference in language: the *barbaroi* were non-Greek speakers; it then acquired the wider meaning of 'strangers' and later negative connotations such as 'baseness' and 'rudeness'. In time these meanings merged with the notion of savageness, which referred originally to a frontier within a culture, the distinction between cultivated and uncultivated land (and behaviour), to people under law and those not under law, while the distinction between civilization and barbarity referred to a difference between cultures.

Initially these terms played a part in relations within Europe. To the Greeks the peoples to the north, whom we now call Europeans, were the barbarians; for the Romans the barbarians were the peoples outside the Empire. In the Middle Ages Hungarians were referred to as ogres and savages, the English spoke from the twelfth century on of the 'wilde Irish', and Abraham Ortelius, the sixteenth-century mapmaker, referred to the Highland Scots as savages. The relations between England and the 'Celtic fringe' reflected differences in geography (highlands), in methods of production (husbandry as against agriculture), and in culture and language. In many respects these relations and attitudes pioneered and prefigured the kind of relations which developed later between Europe and the non-European world.[6]

Europe's nation-states came into being through a process of subjugation of regions, in which missions and Christianization, pacification and exploitation formed a colonial scenario similar to that of the later imperialism overseas. To put it differently, the nation-states were the first empires. It follows that for virtually all the complexes which arise in relation to non-Europeans we can find precedents in Europe itself.[7]

By the sixteenth century there were not many savages left in Europe. One might say that the European notion of savagery was exported, along with its ambiguities, and transferred to non-Europeans. The transition coincided with the spread of the Renaissance in Europe. Winthrop Jordan interprets this as a process of becoming emancipated from the Middle Ages and its fables of monsters and wondrous beings, and entering the realm of 'real savages' – a transition from heaven to earth, a process of secularization.[8] But is it not more apt to say that a myth was translated into a fiction?[9]

The debate on savages which took place in the sixteenth century was to figure in European thought well into the nineteenth century. The discussion was focused on Native Americans. Black Africans, who had come on to the modern European horizon at least a hundred years earlier, were not discussed in these terms, although in time the term 'savage' did come into general use to characterize virtually all non-European peoples. By the nineteenth century it had become a routine concept in descriptions of Africa. A recurring point in these discussions is that the status of outsiders is an arena for polemics and negotiations about internal relations. I will recapitulate the discussion here, not because it refers to Africa but because it illustrates how the formation of images of non-Europeans is conditioned by internal European concerns.

An influential contribution to the debate was an essay by Michel de Montaigne (1533-92), *Des Cannibales*, written in 1580 on the basis of several works on South America and interviews he had conducted in Rouen with Tupinambá Indians who had been brought from Brazil. Montaigne's opinion of the Indians was mild and positive by comparison with his views on many European customs. His essay was one of the first expressions of European cultural relativism.[10] It belongs to the literary tradition of the Paradoxa, a favourite genre among humanist thinkers to which, for instance, Erasmus' *In Praise of Folly* (1515) also belongs. Its object was to provide the reader with amusing subjects of conversation and to supply arguments which went against prevailing judgements and opinions.[11] In other words, cultural self-criticism was the *portée* of these expositions.

Montaigne's playful idealization of the Tupinambá concerned among other things their methods of warfare: 'Their conduct of war is so perfectly noble and generous . . . the war has no ground amongst them but the contest of virtue.' It was observations such as these which gave rise to the concept of the 'noble savage'. It is worth noting that the passage concerns chivalrous warrior virtues, viewed in the light of the Renaissance ideal of virtue and that Montaigne was writing in a period when these qualities were no longer much in demand in Europe itself, now that the use of violence was increasingly claimed as a monopoly by the monarch. Accordingly, the comparison with the noble savage in his 'natural state' served a nostalgic and implicitly political purpose, as a recollection of an era that within Europe was past.[12]

That Montaigne came from a patrician family of Bordeaux may have influenced his perspective. His thinking was also shaped by classical inspirations. In his words: 'In my opinion, what we actually see in these nations not only surpasses all the pictures which the poets have drawn of the Golden Age and all their inventions in describing the then happy state of mankind, but also the conception and desire of philosophy itself.'[13] In the same way Thomas More (1478-1555) had found in the New World a confirmation of the Golden Age of the Latin poets, a vindication of Ovid, and a Utopia on the horizon which confirmed the cultural project of the classical humanists, in particular their critique of the Church.

A totally different perspective on the New World was advanced by Thomas Hobbes (1588-1679) in *Leviathan* (1651), where he characterized the state of nature as a chronic 'warre of all against all'. Life in the state of nature, according to Hobbes, was chaos and anarchy and from this he deduced the necessity for a strong, authoritarian state. This primitive state of nature and war of all against all he too situated in America. His point of departure was an image of human beings as aggressive by nature, the familiar *homo homini lupu* – a reminder of the medieval motif of the *homo ferus* or wolfman.[14]

If Hobbes's view was a sobering reaction to the utopian humanists, it was contradicted in turn by John Locke (1632-1704). Locke too saw America as a wilderness, a land in its natural state, uncultivated. Hence his striking formulation, 'Thus in the beginning all the World was America' – that is, untilled and undeveloped. Locke's point of departure was likewise the state of nature, but his view of that state was one which conjoined Nature and Reason:

> The state of Nature has a law of Nature to govern it, which obliges everyone, and reason, which is that law, teaches all mankind who will but consult it, that being all equal and independent, no one ought to harm another in his life, health, liberty, or possessions.[15]

Locke is commonly referred to as the spokesman for and theoretician of the emerging bourgeoisie, and his thinking as the quintessential philosophy of liberal democracy. His *Essay on Civil Government* was to serve as the philosophical foundation of the Constitution of the United States. As secretary to the Lords Proprietor of Carolina and later to the Council of Trade and Plantations, Locke was well informed about the colonies and had a personal interest in their development. Although he opposed slavery, he invested in a slave-trading monopoly, the Royal Africa Company.[16] Actual Indians he classed with children, idiots and illiterates in their inability to reason in abstract, speculative terms, but this was not a question of permanent inferiority, for reason was innate and given the proper upbringing an Indian might become as good a scholar as any Englishman.

Thus we come to the figure of the 'good savage', the *bon sauvage*. Locke's views inspired Montesquieu (1689-1755) and other influential thinkers who found in the American Indian a convenient antithesis with which to highlight and criticize Europe's vices, in particular those of the court of Versailles. This armchair perspective generated its own ethnology when by the close of the seventeenth century Jesuit missionaries were describing the Hurons, in what is now Canada, in similarly admiring terms. Jean-Jacques Rousseau (1712-78) took a relatively neutral position in the argument and reproached Hobbes as well as Locke for exaggerating the vices or the virtues of the Indian, whom he characterized rather as amoral. Nevertheless it is Rousseau's view of the *bon sauvage* that has remained the best known.

In these discussions the State of Nature served as a political *tabula rasa* (to stretch Locke's term) and the savage as a kind of human degree zero. The imaginary or impressionistic figure of the savage was what was at stake in the confrontation between different European views of humanity, a clash of cultural projects which had political ramifications. In this context advocates of revolutionary change (in the case of Locke, the Glorious Revolution of 1688; in the case of the French *philosophes*, the revolution to overthrow the *ancien régime*) shared an optimistic anthropology, while a pessimistic anthropology went along with a plea in support of the status quo or of absolutism (as in the case of Hobbes). The theme of the 'noble savage', with its classical-aristocratic overtones, implied that the humanists were striving for autonomy from clerical authority, and possibly the uneasiness of nobles over their loss of status in relation to absolutism; the 'good savage' on the other hand was a theme with primarily bourgeois overtones which implied a criticism of both feudalism and absolutism.

The point is, what was really at stake in all these perspectives on 'the savage' was European positions and programmes. Meanwhile, of course, the very notion of an original state of nature, of the savage as a human degree zero or 'humanity minus culture', has long been superseded by the awareness that *all* human behaviour, regardless of the type of society, is cultural in character.

The function of the New World as a philosophical and political counterpoint to Europe had expired by the end of the eighteenth century. In the 'age of the democratic revolution', of the American and French Revolutions, the figure of the savage was no longer relevant, either philosophically or politically. 'There was a pattern in late-eighteenth-century attitudes towards the savage', a progression from curious even admiring interest, to disillusion; from disillusion to anxious, even guilty, concern.'[17]

Attention shifted towards other non-European worlds as counterpoints to

Europe. The vogue for chinoiserie was based among other things on the idea that China possessed a rational political system and was practicing enlightened despotism. The interest of the British and Germans turned towards India and of the French towards Egypt. Besides, after 1800 European attitudes became more self-confident and less ambivalent *vis-à-vis* other cultures, a change from the eighteenth century which first and most clearly manifested itself in England. Succinctly articulated in the *Edinburgh Review* in 1802: 'Europe is the light of the world, and the ark of knowledge: upon the welfare of Europe, hangs the destiny of the most remote and savage people.'[18] In this new context savagery finally acquired, after a zigzag pattern of 250 years, a single and utterly negative meaning, stripped of its ambivalence. It was this concept of savagery that became common currency in the nineteenth century, and that has been applied to Africa.

Africans as savages

Superior condescension now became the tone which predominated in European discourse. In this vein G. W. F. Hegel (1770-1831) discussed Africa in his lectures at Jena in 1830, and the students noted:

> The Negro represents natural man in all his wild and untamed nature. If you want to treat and understand him rightly, you must abstract all elements of respect and morality and sensitivity – there is nothing remotely humanized in the Negro's character. . . . Nothing confirms this judgement more than the reports of the missionaries.[19]

Africa, according to Hegel, does not form a part of the historical world, it shows neither movement nor development. This is the familiar theme of the

'The Hottentot was in olden times wild;
The European has made him mild:
Although still coarse and unschooled,
And his skin smeared with grime.

This man named Kaffir, Causes much harm to the Dutchman;
Often driven by rapacity,
He remains the fear of Cape-land'

'peoples without history' which we also encounter in the work of Marx and Engels. Naturally the thought would arise, was Africa not an ideal continent for Europeans to come to and make history?

The basic principle of this description is that of the 'negative comparison', the pattern of which had been established in the sixteenth century, for instance with Montaigne and Louis Le Roy, also known as Regius. Most often mentioned at the time as part of this negative mode were: 'no letters; no laws; no kings or magistrate, government, commonwealth, rule, commanders; no arts (or occupation); no traffic (or shipping, navigation); husbandry (or agriculture, tillage, tilth, vineyards, sowing or planting); no money (or no exchange, gold, riches); no weapons (no war, knives, pikes, swords, etc;); no clothes (naked); no marrying (no wedding, no respect of kindred); no bourne or bound. . . .'[20] However, at the time the negative comparison served a critical and utopian function, in the same way in which the Latin poets Ovid and Lucian had described the Golden Age as a world abstracted from history and defined by negatives; but in nineteenth-century discourse negative comparisons simply served to affirm European achievement and supremacy. They had become self-contragulatory.

The icon of the nineteenth-century savage is determined by *absences*: the absence, or scarcity, of clothing, possessions, attributes of civilization. The *Sunday Reading for the Young* (1877) showed a drawing of Africans huddled together amidst dark, wild vegetation and commented: 'They are but one degree removed from the level of brute creation – the sole trace of civilization about them is that they cook their food, and that, it may be assumed, in the crudest manner'.[21]

'Blacks. The Negroes and Hottentots, the two peoples of the Ethiopian race which are the best-known'. Netherlands, 1880. *Picture Magazine for Youth*, No. 69.

What Africa did have and in abundance, also according to Europeans, was nature. The iconography of Africans as savages was determined by the association with nature and flora – often the kind of wild and overwhelming landscape which makes human beings appear small. To the image of Africa as wilderness belongs the tropical rain forest with its lush vegetation, and the jungle which is proverbially 'impenetrable'. Explorers with machetes, lianas resembling serpents and the cries of monkeys and birds in the background complete this nineteenth-century cliché. This explorer imagery suggests the theme of *terra nullius*, that is, vacant land, essentially uninhabited or at least uncultivated, and therefore rightfully available to colonization. The assimilation of the African interior to 'nature', the denial of African history, the marginalization of African peoples in discourse and imagery – all formed part of a rhetoric that was to culminate in colonialism.

The 'impenetrability' of the rain forest is itself a misrepresentation – first, it is wrong to equate rain forest with jungle, which is denser; second, rain forests were inhabited and cultivated; third, tropical agriculture has been misunderstood and misrepresented. Cultivation taking place in the rain forest is often not perceived by Europeans, even today, because it looks so different from agriculture in the temperate zone.[22]

Striking as well is the rural character of Europe's new image of Africa: whereas European travellers and scholars in the sixteenth and seventeenth

A representation of 'good savages' in Romantic style (turn of the eighteenth century).

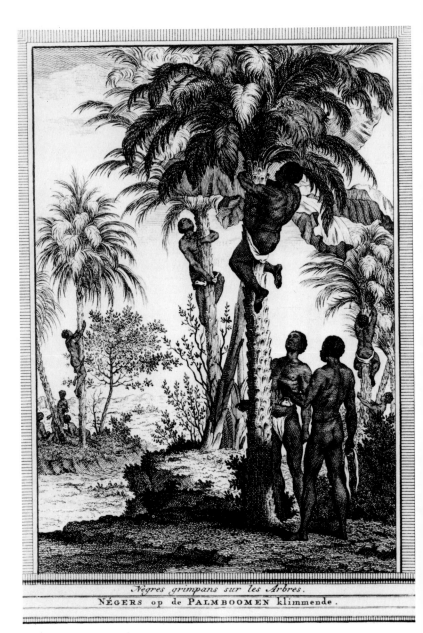

Nègres grimpans sur les Arbres.
NÉGERS op de PALMBOOMEN klimmende.

centuries reported with praise and admiration on black Africa's rich courts and extensive, well-laid-out cities, as in Olfert Dapper's classic study of Africa (1668),[23] this feature vanished, peculiarly, from the later European iconography. This is remarkable also if we consider that Africa's urban history may be older than Europe's. Even today Africa's cities and city-dwellers tend to remain invisible in the mainstream western imagery of Africa, which prefers scenes in the bush, or the lone baobab tree against an empty sky with the occasional savage in picturesque outfit. Another traditional association is the African with the palm tree: but the coconut tree, now ubiquitous, was a European importation from the Indian Ocean.

The meaning of 'savagery' underwent further redefinition during the colonial era. In anthropology it acquired a more specific meaning, as one of the stages of social evolution: primitivism – savagery – barbarism – civilization. This placed savages on a higher rung of development than primitives. This evolutionist schema also served as a manual for imperial management of societies at different stages of development. It was both the perfect explanation of and justification for European colonialism, which according to this view was a kind of evolutionary assistance from the more advanced to the less developed – *noblesse oblige*. An imperial panorama was transformed into a vision of history.

Through the work of the American anthropologist Lewis Morgan, social evolutionism influenced Engels and Marx, so that it forms part of the marxist heritage. Marxist orthodoxy itself took the shape of a theory of stages (primitive communism – feudalism – capitalism – socialism). How deeply evolutionism is anchored in socialist thinking is apparent, for instance, in the slogan which, from Karl Kautsky to Rosa Luxemburg, and later, sums up the socialist programme: 'Socialism or Barbarism'.

A view commonly held by anthropologists in the colonial era was that primitive peoples were Europe's 'contemporary ancestors'.[24] According to Haeckel's Law the development of the individual recapitulates that of the species (ontogeny recapitulates phylogeny). In different ways these perspectives contributed to a further redefinition of savagery which began to take shape towards the close of the century: savagery as an inner disposition common to *both* civilized and primitive humanity – in a word, the thesis of the Wild Man within. Hayden White interprets this development as a side-effect of colonialism:

> From biblical times to the present, the notion of the Wild Man was associated with the idea of the wilderness – the desert, forest, jungle, and mountains – those parts of the physical world that had not yet been domesticated or marked out for domestication in any significant way. As one after another of these wildernesses was brought under control, the idea of the Wild Man was progressively despatialized. This despatialization was attended by a compensatory process of psychic interiorization.[25]

Savagery thus acquired another meaning, as an image of the instinctive. This view was at the heart of psychoanalysis; in the works of Freud and Jung and the post-Freudians, primitives were equated with children and the mentally disturbed, in accordance with the idea that earlier stages of human consciousness were recapitulated during childhood. Thus the myth of the Wild Man, which had become a fiction, again became a myth, 'a projection of repressed desires and anxieties'.[26]

This episode formed part of a wider 'recovery of the unconscious' in European thought, apparent, for instance, in so-called crowd or mass psychology, which developed from the 1870s onward; in the reappraisal of Nietzsche's work; in the *élan vital* philosophy of Henri Bergson; in Emile Durkheim's approach to religion.[27] The keynote of this 'recovery of the unconscious' is a certain ambivalence – an ambivalence which is inherent in psychoanalysis (where ambivalence is one of the key themes) and in the attitudes towards primitive and colonized peoples. D. O. Mannoni put his finger on this ambivalence when he observed that in European writing about Africa,

the savage . . . is identified in the unconscious with a certain image of the instincts. And civilized man is painfully divided between the desire to 'correct' the 'errors' of the savages and the desire to identify with them in his search for some lost paradise (a desire which at once casts doubt upon the merit of the very civilization he is trying to transmit to them).[28]

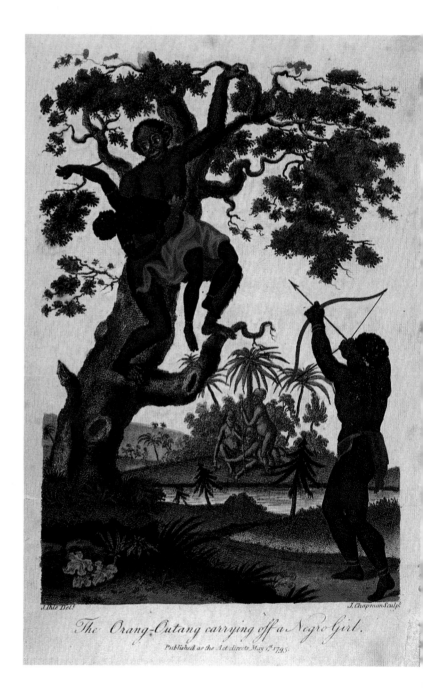

'The Orang-Outang carrying off a Negro Girl.' The eighteenth-century fable of intercourse between apes and African women represented as fact. Beings between apes and humans appear in the background as the offspring of such relations and suggest the missing link in the scale of creatures. Britain, 1795.

The Orang-Outang carrying off a Negro Girl.

Published as the Act directs May 1st 1795.

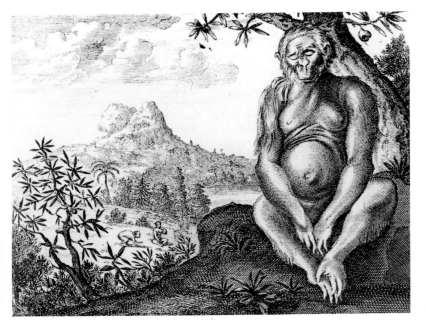

An engraving from the work of Olfert Dapper, who places the orang-outang wrongly in Africa, and confuses it with the medieval Wild Man. 'In the forests of this kingdom,' writes Dapper, 'also dwells the animal Quojas Mormou, which the Indians call Orang Autang, that is Man of the Woods, and which is found in the kingdom of Quoja as well as on the island of Borneo in the East Indies . . . This animal resembles man . . .'. *Accurate Description of Africa* (Amsterdam, 1668).

Indeed it is no coincidence that during the same *fin de siècle* a revaluation of values set in, in which non-western cultures were called *sauvage* in a new admiring sense. Gauguin in Tahiti exemplified the trek of western artists to preindustrial paradises. In Henri Matisse's fauvism this revaluation became explicit. 'Wild' and 'primitive' became terms of praise and appreciation, as in Picasso's statement: 'primitive sculpture has never been surpassed'. *Webster's Dictionary* of 1934 defined 'primitivism' as 'belief in the superiority of primitive life'.[29] 'Wild' became a term of honour and avant-garde artists presented themselves as 'new savages' – if wildness equalled the unconscious, then was it not also the wellspring of inspiration, the muse of innovation, and the antipode of the bourgeois? With this the western evaluation of the savage had come full circle.

Africans and animals

'Englishmen were introduced to the anthropoid apes and to Negroes at the same time and in the same place,' Winthrop Jordan remarks with some stylistic license.[30] Travellers' reports, in particular from Angola, had begun to mention chimpanzees and gorillas in the early 1700s – although for a long time they would pass for orang-utans. Orang-utans had made their appearance in the literature decades earlier, on the basis of the Dutchman Bontius's observations in Indonesia in the 1650s. In 1699 appeared an influential study by the British anatomist Sir Edward Tyson, entitled *Oran outang, sive Homo sylvestris; or, The Anatomy of a Pygmie Compared with That of a Monkey, an Ape, and a Man*. The similarities between orang-utans and human beings were according to Tyson undeniable; in one of the lithographs in this volume an 'oran outang' is depicted standing upright, with a staff.

The comparison forms part of a changing climate of opinion in which with increasing frequency Africans are likened to animals. The 'beastliness' of

Africans had been a theme in earlier reports by voyagers who spoke of the native peoples as 'like to bruite beasts', or as 'rude and beastlie', or as 'bestiall without foresyght'.[31] But at the time these reports were still offset by admiring descriptions by diplomats and various travellers. What began to change was that the views expressed became more monotonous.

In 1725 James Houston, a physician for the Royal Africa Company on the West African coast, wrote in his notebook: 'their natural Temper is barbarously cruel, selfish and deceitful, and their Government equally barbarous and uncivil, and consequently the Men of greatest Eminency among them are those who are most capable of being the greatest Rogues. . . . As for their Customs they exactly resemble their Fellow Creatures and Natives, the Monkeys.'[32] Here the basis for the comparison of Africans with monkeys is not their physique but their customs.

On the basis of reports such as these the Swedish botanist Carl Linnaeus revised his scheme of classification in the tenth edition (1758) of his *Systema Naturae*. This schema still forms the basis of contemporary biological classifications. He now distinguished as sub-categories of *homo sapiens*, the 'wild man' ('four-footed, mute, and hairy') and the orang outang. The latter he equated with *Homo sylvestris*, the 'man of the forest or of the trees', who differed from monkeys in lacking a tail and in having emotions.[33] Other varieties of *homo sapiens* defined by Linnaeus were the 'American', the 'Asiatic', the 'African' and the 'European'. *Homo africanus* he characterized as follows:

> black, phlegmatic, lax; black, curly hair; silky skin, apelike nose, swollen lips; the bosoms of the women are distended; their breasts give milk copiously; crafty, slothful, careless, he smears himself with fat. He is ruled by authority.[34]

It is remarkable that the medieval myth of the Wild Man and *homo sylvestris* is reproduced intact in this scientific classification, although with altered antecedents. From the European forests the Wild Man and associates have moved overseas, and been promoted from fables to scientific phenomena of nature.

Antiquity and the Middle Ages discerned a border zone between human and animal, populated by mythical and monstrous beings such as the satyr and the centaur. What remained unchanged in later times was the assumption, formulated four centuries before Christ by Aristotle, no less, of a *scala naturae* or Great Chain of Being: a hierarchical ordering of organisms from the lowest to the highest, from micro-organisms to the gods. This implied a transitional zone between human and animal, and hence began a search for the missing link between humans and apes. Speculation among naturalists about the missing link dated from the beginning of the eighteenth century. Edward Tyson proposed the pygmie, whom he identified with *homo sylvestris*, as that missing link.

Comte de Buffon, reknowned scholar of the Enlightenment and a rival of Linnaeus, praised Tyson's work and championed his views. In Buffon's *Histoire naturelle* black Africans are described as 'crude, superstitious and stupid'. Bory St. Vincent produced another classification of 'man' in 15 species, each of which was subdivided into a number of varieties. His first and most elevated species was the 'Japhetic', which was divided into four races including the German race. The sequence then descended through, among others, the 'Arabian' (no. 2), the 'Hindoo' (no. 3), the 'Sinic' or Chinese (no. 5), the 'American' (no. 10), and the 'Hottentot' (no. 15 and last on the list). And it

was the Hottentot (i.e., the Khoi-Khoi of southern Africa) that Bory St. Vincent, and many others, considered to be the missing link between apes and humans.[35]

In this way took shape the unChristian notion of polygenesis, or multiple creation of human beings. It was pointedly formulated by David Hume (1711-76) in a frequently cited passage:

> I am apt to suspect the Negroes, and in general all the other species of men (for there are four or five different kinds) to be naturally inferior to the whites. There never was a civilized nation of any other complexion than white, nor even any individual eminent in action or speculation. No ingenious manufactures amongst them, no arts, no sciences. . . . Such a uniform and constant difference could not happen, in so many countries and ages, if nature had not made an original distinction betwixt these breeds of men.[36]

In his study of British attitudes vis-à-vis blacks at the time of the slave trade, Anthony Barker argues that before 1770 blacks were regarded as inferior more on grounds of cultural traits, and the traditional association in Christian culture of blackness with evil, than on those of any theory of in-bred racial inferiority.[37] In the 1770s several works were published in England which gave a different turn to the discussion. In 1772 two pamphlets appeared which voiced a racial argument. Samuel Estwick, assistant-agent in London for the Barbados planters, argued in Considerations on the Negro Cause that Negro slaves brought to England remained private property, and supported this with a racial interpretation of the Chain of Being. Negroes differed 'from other men, not in kind, but in species'. Edward Long, a former planter and judge in Jamaica, adopted Estwick's argument, first in a pamphlet (Candid Reflections upon the Negro Cause) and subsequently in his monumental History of Jamaica (1774). Also significant was the contribution of James Burnett, Lord Monboddo, a Scottish philosopher who was so preoccupied with the problem of the Chain of Being that he devoted six volumes, over a period of twenty years, to the question. In the first, which appeared in 1773, he counted the orang-utan among the species of humanity.

As a one-time planter and administrator in Jamaica, Edward Long was supposedly an authority on African slaves, and his work, cast in pseudo-scientific form, was highly regarded. Long argued that Europeans and blacks do not belong to the same species. Black children, like animals, matured more rapidly than whites; mulattos in his view were infertile – a belief widely held at the time, though already clearly at odds with the known offspring of interracial unions in England. Long divided the genus homo into three categories: Europeans and other humans, blacks, and orang-utans.

> [The Negro's] faculties of smell are truly bestial, nor less their commerce with the other sexes; in these acts they are libidinous and shameless as monkeys, or baboons. The equally hot temperament of their women has given probability to the charge of their admitting these animals frequently to their embrace. An example of this intercourse once happened, I think, in England. Ludicrous as it may seem I do not think that an oran-outang husband would be any dishonor to an Hottentot female. [The oran-outang] has in form a much nearer resemblance to the Negro race than the latter bear to white men.[38]

'Luke-The Baboon Boy.' Postcard from South Africa, 1920. On the back: 'When a small baby he was stolen by baboons while his mother was hoeing mealies and remained untraced till years afterwards, when a police patrol rescued him from a troupe of baboons. He was eventually handed over to a farmer in the Port Alfred District, with whom he has been over 20 years. He has been trained to give up his simian habits and become a useful farm hand.'

This added several new elements to the discussion – it was an encounter of the slavery debate with the naturalist debate, in which medieval fables and lewd anecdotes of slavers, sailors and planters were mingled with naturalist questions.

Around the turn of the eighteenth century interest increased in comparative anatomical research concerning human differentiation. Georges Cuvier (1769-1832), the Swiss anatomist who is regarded as the founder of palaeontology, took up the comparison of blacks with apes, expanding on it with anatomical observations (and opinions about culture):

> The Negro race is confined to the south of mount Atlas; it is marked by a black complexion, crisped or woolly hair, compressed cranium, and a flat nose. The projection of the lower parts of the face, and the thick lips, evidently approximate it to the monkey tribe: the hordes of which it consists have always remained in the most complete state of utter barbarism. [39]

Comparisons between savages and apes also played a part in the later work of Charles Darwin (1809-82). Darwin opposed slavery and made such comparisons in order to demonstrate, rather, that slavery was impractical and uneconomical. [40]

In 1850 Professor Robert Knox, after a visit to the Cape Colony, described the Hottentots as follows: 'Of a dirty yellow colour, they slightly resemble the Chinese, but are clearly of a different blood. The face is set on like a

Luke-The Baboon Boy.

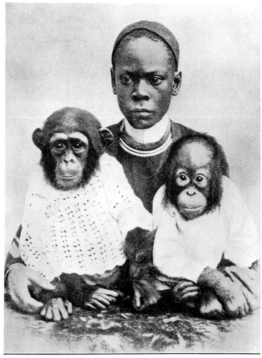

Fig. 4.—Negro Boy and Apes.

On the left side of the figure there is a young Chimpanzee, and on the right a young Orang-utan. This is a wonderfully interesting comparison.

W. Schermelé, *Het
Groote Negerboek*
(Amsterdam, 1939).

Left: 'Negro Boy and Apes . . . This is a wonderfully
interesting comparison.' A comparison between
blacks and apes was revived in the US to dehumanize
blacks and turn the tide of emancipation. Shufeldt,
America's Greatest Problem: The Negro (1915).

baboon's. . . .'[41] It is as if time had stood still: in a picture postcard from South
Africa of *circa* 1920 we see the face of an adult black man, and the caption
reads: *Luke – The Baboon Boy.*

This prehistory of racial thinking in natural history, in which blacks were
compared with animals, has a lasting echo also in attitudes towards blacks in
the west, to which we shall return.

In addition to representations of Africans *as* animals there are repre-
sentations of Africans *and* animals, brought together in a single picture. They

Dutch paperback cover
of the 1950s in which
the association of
Africans with animals
lives on, and the
dividing line between
human and animal is
unclear.

also suggest the assimilation of Africans and blacks to nature and a low place on the ladder of evolution. For instance, Africans and crocodiles together within a single frame appear to be the European counterpart to the morbid American myth that crocodiles are particularly fond of black flesh.[42] Indeed the oft-repeated association of Africans with animals may easily lead to confusion between humans and animals.

Children of Ham

While science thus marched forward, popular thinking in Europe still followed Christian modes of thought. Christian Ethiopianism had faded into the background and another tradition emerged – the medieval tale of Africa as the continent of Ham's descendants acquired another dimension.

Genesis (9:18-27) relates that Noah drank wine and fell into a slumber while naked. Ham, his youngest son, saw him but did not cover his shame, whereat his brothers Sem and Japheth covered their father with a cloth. Awakened, Noah praised Sem and blessed Japheth, but he cursed Canaan, Ham's son – *Cursed be Canaan, a servant of servants shall he be unto his brethren.* The curse of Canaan was destined to have a long and notorious career.

In the early Church of Augustine the curse of Ham or Canaan was regarded as an explanation of slavery, but not of blacks, simply because slavery at the time was 'colourless'. The association of the curse of Canaan with *blackness* arose only much later in medieval Talmudic texts.[43] In the sixteenth century it became a Christian theme and by the seventeenth it was widely accepted as an explanation of black skin colour. From here it was but a small step to the interpretation of the curse of Canaan as an explanation of and justification for the slavery of black Africans.[44]

This transition occurred at the very time when the European slave trade had assumed considerable proportions, as we shall see. What was at stake in the evaluation of Africans was nothing less than the moral and religious status of the Europeans themselves, even leaving aside the legal and political implications: for Christian society, imbued with the idea of the equality, or at least the latent equality, of human beings before God, the slave trade posed a considerable moral problem. The view of Africa as a continent condemned to eternal servitude was eminently suited to a theological assessment of slavery. Its attractiveness was that the unity of creation remained intact while an exceptional position was yet justified for Africans. While it was true that all human beings were descended from Adam via Noah (the so-called monogenesis), the continents peopled by the descendants of Japheth (Europe), Sem (Asia) and Ham (Africa) were ranked in a master-servant relationship. Until well into the nineteenth century, even after the development of the theory of race, this remained the most popular explanation of slavery.

In eighteenth-century scientific classifications certain scriptural categories and metaphors were reproduced, as we have seen. The enquiries of natural science came to the same answer as had theological enquiry at an earlier juncture. Faith and reason ultimately arrived at the same answer, a verdict regarding the status of Africans perfectly convenient to Europeans, Christian or otherwise. As the authority of the verdict of religion waned, the verdict of science, in the form of the so-called 'science of race', rose to prominence along with the tide of secularization.

The science of race

Racial thinking means attributing inferiority or superiority to people on the basis of their racial characteristics, that is on the basis of biological traits. This is a modern notion, because thinking in biological terms only took shape in the eighteenth century. The science of race is a late development. The common view is that racial thinking developed as a justification and rationalization of slavery and that the histories of slavery and of racial thinking run parallel. This is implied for instance in a remark by Nancy Stepan:

> A fundamental question about the history of racism in the first half of the nineteenth century is why it was that, just as the battle against slavery was being won by abolitionists, the war against racism was being lost. The Negro was legally freed by the Emancipation Act of 1833, but in the British mind he was still mentally, morally and physically a slave.[45]

Here the reverse argument will be explored: that racial thinking developed not in spite of abolitionism but rather because of its success, and in response to the situation created by the questioning of the legal status of slavery.

A closer analysis shows that the science of race developed *after* the first battle had been won in the struggle against slavery, with the British prohibition of the slave trade in 1807. Or, more precisely, the formative period of the science coincided with the period from about 1790 to 1840 in which abolitionist propaganda predominated.[46] The period in which the science took shape was also the time when the image of the 'noble negro' was at its most popular and when some of the best 'anti-racial' tracts were published.[47] Racial theory, that is, the application of the science of race to history generally, is of still later date, after 1840 and thus after the British abolition of slavery. What is the explanation for this coincidence of the development of the science of race, that is the development of racism (in a strict sense), and abolitionism?

In the first place, the main justification of slavery was never scientific but religious: the biblical curse of Ham. Secondly, many scholars who contributed to the development of the science of race were in fact opponents of slavery. Apparently the development of the science and its subsequent popularity were not determined by slavery but followed a different logic – for instance, the superiority of European civilization in the era of European world hegemony, and, in the wake of the 'industrial revolution', the same technological revolution which made slavery a backward form of labour exploitation. This is one of the 'paradoxes of progress'.

The era of the Enlightenment confronts us with several contradictions. It is on record as the 'age of reason', when scientific thinking advanced – but this also meant the rationalization of old prejudices. It was the time when the debate on slavery was taken up and human rights were first mentioned – but the science of race took shape in this period as well, and not all the opponents of slavery were devoid of racism. Enlightenment thinking was also interwoven with European expansion and as such imbued with cultural arrogance and coloured by political and economic interests. The Enlightenment was in reality a far more heterogeneous period than the image of 'enlightenment' allows for.

Polygenism and geographical determinism (according to which a people's attributes are determined by place and climate) were two different routes by

which one could reach the same destination: the justification of slavery on the grounds of human differentiation. If some of the Enlightenment thinkers rejected polygenism, they still accepted climatic differentiation, as did Buffon who formulated a climatological theory of race by which slavery could be justified. Montesquieu opposed slavery and observed sarcastically: 'It is impossible for us to assume that these creatures are men; because if we suppose them to be men, one might begin to think that we ourselves are not Christians' (1748).[48] Yet he also maintained that 'There are countries where the heat so exhausts the human body and undermines morale that people can be brought to undertake heavy physical labour only through bodily punishment'. He saw Europe as a 'progressive' continent in which science flourished owing to the temperate climate, and his assessments of Asia and Africa were less favourable. Rousseau and Voltaire were also outspoken opponents of slavery though not devoid of prejudices.[49] Voltaire believed that the gap between white and black could not be bridged and furthermore he was intolerant vis-à-vis Jews.

Such a remarkable combination of views we encounter also with Pieter Camper (1722-89), professor of anatomy at Groningen in the Netherlands, who made a fundamental contribution to anthropometry with 'Camper' facial angle', a measurement of physiognomic proportions. Derived by looking at the human head in profile, it was one of the first occasions on which scientific instruments were used to measure, or were believed to measure racial differences. The wider the angle the smaller the degree of *prognathism* and a prognathic head (with the profile of a large jaw and small cranium) resembled the shape of an animal's head. According to this theory Africans were supposed to have the smallest 'facial angle' and therefore to be the lowest human variety. Yet Camper was a convinced monogenist on religious grounds, and an opponent of slavery, who believed that 'We are white Moors, or rather, we are human beings in every way similar to the Blacks.'[5]

Camper's findings were put to further use at the University of Göttingen in the kingdom of Hanover, where in 1775 Johann Friedrich Blumenbach (1752-1840) wrote an influential dissertation. He arrived at a classification of humanity in three groups: the Caucasians (named after the Ark of Noah which was stranded in the Caucasus on Mount Ararat), the Ethiopians and the Mongolians. 'Caucasian', with its biblical reference, as a term for Europeans or whites has appealed to many; in the United States it is part of official terminology down to the present. Of Caucasians Blumenbach wrote that they 'have in general the kind of appearance which, according to our opinion of symmetry, we consider most handsome and becoming'. His description of Ethiopians reads like a caricature:

Ethiopian variety: colour black, hair black and curly, head narrow, compressed at the sides; forehead knotty, uneven, molar bones protruding outwards; eyes very prominent; nose thick, mixed up as it were with the wide jaws; alveolar edge narrow, elongated in front; upper primaries obliquely prominent; lips very puffy; chin retreating. Many are bandy-legged. To this variety belong all the Africans, except those of the north.[51]

Blumenbach in fact had a peculiar career, as Debrunner relates. In 1786 or 1787 he saw a painting with 'four African heads by Van Dyck' and recognized a remarkably wide 'facial angle'. A few months later (Debrunner, 142) in Switzerland he met a 'zum Verlieben schönen Négresse' ('a Negress so beauti

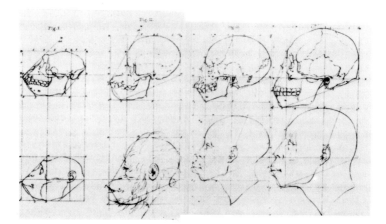

Facial angles sketched
by Camper, ranging
from a small angle with
a large ape-like jaw to a
Greek profile.
Fragment, Petrus
Camper (1791).

Petrus Camper,
engraving by Renier
Vinkeles (1778).

ul as to fall in love with'). After these experiences, according to Debrunner, Blumenbach changed his views about Africans and took every opportunity to come into contact with them. Having carried out further anatomical research, he arrived at a thesis which undermines the very science of race of which he is considered one of the principal founders:

> Individual Africans differ from other Africans as much as Europeans differ from Europeans, or even more so. This can be seen from the difference in pigmentation of the skin, and especially from the great differences in Camper's facial angle.

In addition Blumenbach maintained that Africans are not inferior in 'sound understanding and good natural talents and mental capabilities', and in support of this he composed a list of renowned Africans and their achievements.[52] Thus 'the founder of modern racial theories' became 'an ardent admirer of the Africans'.[53]

When Blumenbach met real Africans he did not recognize his own caricature. This happened more often to Europeans travelling in Africa who failed to recognize the European stereotypes of negroes, and therefore denied that the Africans they met were negroes. In time the theory of the facial angle, like all others claiming to measure racial difference, was disproved.

At the University of Göttingen race became a subject for scientific specialization. Around 1810 Barthold Niebuhr introduced race as 'one of the most important elements of history'. In later years Niebuhr was praised by the historian Jules Michelet as the 'discoverer of the ethnic principle of history'. Nazi scientists rated him as the 'founder of critico-genetic historiography'.[54] This honour, by the way, has also been claimed for Immanuel Kant – in 1967 the anthropologist Wilhelm Mühlmann referred to Kant as the 'founder of the modern concept of race'.[55])

The emphasis placed on race theory in Germany has been explained by frustrated nationalism – a nationalism *manqué* sublimated in racial thinking.[56] Because the *German nation* did not exist, there was much ado about the *Germanic race*, a concept which combined notions from Romanticism, from biology, and ideas borrowed from British thinkers. Romanticism emphasized the local and the rooted. The language and folk-songs of a people, according to Johann Gottfried Herder, reflected its essence, and the nation (*Volk*) was the source of all truth. Race and kind (*Geschlecht*) were in fact 'scientific'

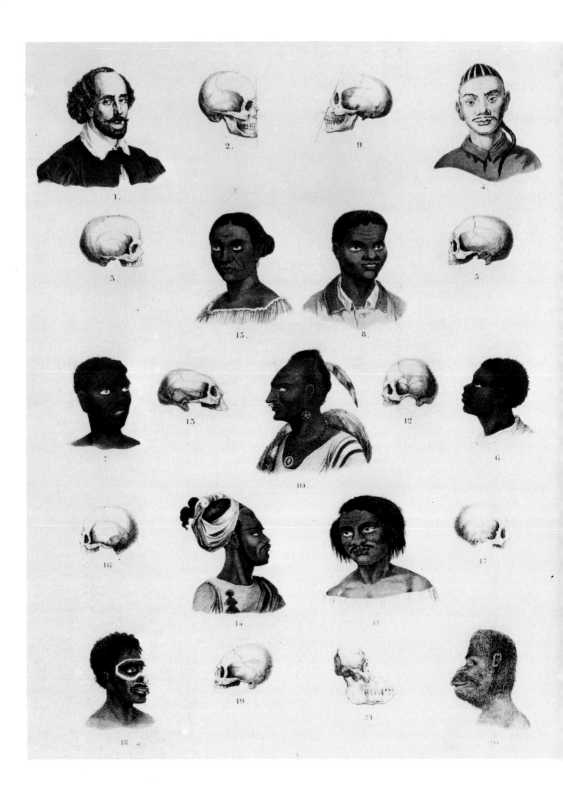

rms for people, nation or community. In general, the terms 'race', 'nation' nd 'people' were synonymous in European discourse until the 1930s.

After 1815 the word 'race' was 'on everyone's lips'[57] and by 1850 race think-ng was generally a commonplace. Increasingly race began to be viewed as the aster key to history. In the 1840s Thomas Arnold, Regius Professor of listory at Oxford, formulated a view of world history as governed by a succes-ion of creative races. Thomas Carlyle's work was permeated by a Romantic cism and the idolization of Nordic peoples, their sagas and legends. In Ben-min Disraeli's *Tancred* (1844) Niebuhr's truth, now voiced by the wise Sido-ia, had become the *sole* truth: *All is race, there is no other truth.* In 1850 the natomist Dr Robert Knox – Poliakov refers to him as 'the first "racist" scho-ar'[58] – stated:

> That race is everything, is simply a fact, the most remarkable, the most comprehensive, which philosophy has ever announced. Race is every-thing: literature, science, art – in a word, civilization depends on it.

n France in 1853-5 Joseph Arthur, Comte de Gobineau published his *Essai ur l'inégalité des races humaines*, a four-volume ode to the Germanic race as he aristocratic race *par excellence*, and a litany on lost racial purity. That urity according to Gobineau was the hallmark and the necessary condition of civilization: a mixture of races was the cause of decadence, of the decline of ivilization, for in every mixture the lower race would predominate.[59] A lepressing vision which turned civilization itself into a labour of Sisyphus.

Gobineau's view was also a thesis held in classical times: it had served the ater Romans, such as Tacitus, as the main explanation of the decline of the Roman Empire. This élite conservative view had been adopted by Edward Gibbon in his *Decline and Fall of the Roman Empire* (published between 1776 nd 1788), and was common in aristocratic circles in the eighteenth century. n the France of Louis XV, nobles such as Comte de Boulainvilliers advanced he superiority of the Frankish or Germanic race as a political argument in heir counter-attack on the claims of the 'third estate'. The French aristoc-

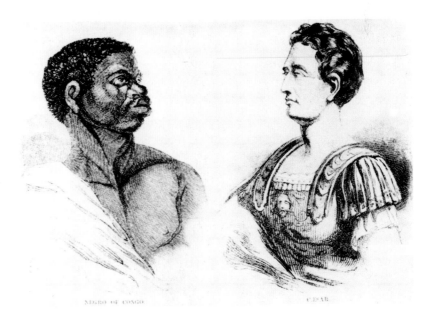

Comparison of the physiognomy of a Congo Negro and Caesar': twentieth-century rhetoric. Shufeldt, *America's Greatest Problem: The Negro* (1915).

Left: The science of race n a nutshell. Profiles and skulls of various races' showing facial angles, from a European (top left) through various peoples to a savage' African *vis-à-vis* an ape (*bottom*). A single plate suggesting evolution as well as hierarchy (1850).

NEGRO OF CONGO

CÆSAR

racy, it was held, had originated in Germany, in the 'forests of Franconia', a a conquering master race, while the French bourgeoisie were descended from Gallo-roman stock; and the thesis – of a 'Germanic nobility' and a 'Celtic bourgeoisie' was revived after the Restoration.[60]

This is the background of Gobineau's passionate praise of the German among the Nordic races. Having been secretary to Alexis de Tocqueville and having served as a diplomat in Hanover and Frankfurt for a number of years the Comte held Germany in higher esteem than France. There was greater racial purity north of the Seine. 'The Aryan German is a powerful creature.'

Gobineau's views were not exceptional among his contemporaries; on the contrary, his influence stems from the fact that his work is a forceful synthesis of widely held views. The liberal historian Michelet noted the fascination which the 'Frankish' aristocracy exercised on the 'Gallic' bourgeoisie, and he too expressed himself in racial terms. As early as 1827 he had written of the 'long struggle between the Semitic world and the Indo-Germanic world' Taine also believed firmly in the superiority of the 'Germanic nation', and Ernest Renan, another contemporary of Gobineau, wrote: 'The process of civilization can now be recognized in its general lines. The inequality of the races has been established'.[61] Renan, moreover, joined the ranks of those who posed 'Semites' against 'Aryans' in a decisive *division du genre humain*.[62] *Gobinisme* became one of the main strands of race thinking in Europe, in particular after the Franco-Prussian War. Not surprisingly, it found adherents particularly in Germany, where many Gobineau Clubs were established around the turn of the century. Adapted by Houston Stewart Chamberlain and Alfred Rosenberg, Gobineau's views became part of Nazi philosophy.

Race thinking is now so outdated that the very term 'race' is no longer tenable. The 'science of race' is routinely referred to nowadays as a pseudo-science, and rightly so. Still it may easily be overlooked that until fairly recently throughout the western world 'race thinking' was widespread, carried great authority and was widely regarded as scientific.[63]

The term 'racism' came into popular usage in the 1930s as a reaction to National Socialism in Germany. Magnus Hirschfeld's *Racism*, an examination of Nazi racial theory as a doctrine of 'race war', was published in English in 1938.[64] A major concern at the time was anti-Semitism. After the Second World War, in the era of decolonization, the affinity of colonialism with racism came to the fore, while the civil-rights movement in the United States drew attention to American racism.

The notion of racism brings together under one heading very diverse phenomena which have but a single feature in common: discrimination on the basis of allegedly 'racial' characteristics. Perhaps we should speak of 'racisms', to do justice to the differences among phenomena as well as their similarities. These differences may be important also when interpreting the stereotypes prevalent in different western countries.

In France race thinking was primarily an expression of aristocratic insecurity, a symptom of the long-term crisis of the aristocracy. It was not associated with nationalism: on the contrary, it was unpatriotic and pro-German. In Germany race thinking was the product of frustrated nationalism. In England, as in Germany, race thinking was part of middle-class ethos, but this was an ethos which, as Hannah Arendt has argued, had assimilated feudalism through the notion of inherited rights – 'the English brand of race-

thinking was almost obsessed with inheritance theories and their modern equivalent, eugenics'.[65] Here an aristocracy of race was projected on a national scale and race thinking established the position of Englishmen as 'a kind of nobility among nations' (Arendt), the 'Lords of Humankind' (Kiernan). Social Darwinism, a socio-political application of the theory of evolution which became popular in late-nineteenth-century England and the United States, stated the claims of inherited privilege in the terms of bourgeois discourse. In the United States race thinking served as ideology for ranking according to ethnic status, which was the national substitute for class stratification. As such it served primarily domestic purposes, although as part of the ideology of Manifest Destiny it also endorsed American expansionism.

Several authors have warned against the 'old misconception of racism as a kind of exaggerated nationalism'.[66] In the closing decades of the century nationalism and racism were amalgamated in the context of the new imperialism, giving rise to the chauvinism and jingoism of *Volksimperialismus*, 'people's imperialism'. Also the political anti-Semitism of the later nineteenth century had strong associations with nationalism.

There are other distinctions which are papered over with the label racism. It is a composite notion. In a strict sense the term refers to race as a biological concept, but in everyday use the umbrella of racism extends over phenomena which bear little relation to race in a biological sense. The theory of the Aryan race, for instance, the most influential form of race thinking up to the Second World War, brought together elements from a variety of discourses: from biblical discourse, in which the Semites are regarded as the main counterweight to the Aryans; from philology, with its speculations regarding the 'Indo-Germanic' nexus; from the classical discourse on civilization, together with the biological discourse on race, because of the argument that the Aryan or Germanic race, as the strongest and therefore the purest, will bring forth the highest civilization.

What all these notions have in common, beyond their grounding in biology or skin colour, is a *pathos of inequality* – articulated variously through a scriptural curse, in terms of the classical distinction between civilization and barbarism, or through evolutionist discourse and the distinction between 'backward' and 'advanced' peoples. The key notion underlying these discourses is not so much that of race as of *hierarchy* based on differences in religion, ethnicity, geography, nationality, culture, or a combination of these. In the words of Benedict Anderson, 'The dreams of racism actually have their origin in ideologies of *class*, rather than in those of nation: above all in claims to divinity among rulers and to "blue" or "white" blood and "breeding" among aristocracies.'[67] The racial or biological explanation of distinctions in status and class is a virtually constant feature in theories of race, as in Niebuhr and Gobineau. It is this pathos of inequality, rather than race or racism in a narrow, shallow sense, which permeates the images of white on black and seems to be their actual subject-matter.

3 SLAVERY AND ABOLITIONISM

Slavery existed in Europe not only in antiquity but also during the Middle Ages. For a long time slaves were an important European product of export to the world of Islam and to Byzantium. In the Iberian peninsula slavery was part of Moorish society. What changed in the course of the sixteenth and seventeenth centuries was that slavery acquired a colour. The first African slaves were imported by Portugal in the fifteenth century, but the trade in African slaves took on significant proportions only when sugar cultivation in Brazil and the West Indies became substantial. Estimates vary of the number of slaves involved in the transatlantic trade, but recent research on how many were imported into the Americas in the period 1451-1870 settles on a figure of approximately 15 million.[1] This is not the only indication of magnitude; David Brion Davis observes: 'Until the 1820s the transatlantic flow of African slaves was at least four times greater than the total flow of white immigrants to the New World.'[2]

The transatlantic slave trade marked a clash between divergent cultural traditions and concepts of slavery – African slavery, in which slaves were integrated into society; Iberian slavery, shaped by the traditions of Moorish Spain and by the laws of the Catholic Church (here, as early as the thirteenth century, a statute, *Las Siete Partidas*, defined the slave's rights and duties); and the slavery practised by northern European, predominantly Protestant countries, where there were no social or legal traditions and where slavery was not subject to any restriction. Slavery in the New World has been described as a degradation of the slavery traditional in both Africa and Europe.[3]

Drawings showing how a ship can be utilized to transport the maximum number of slaves.

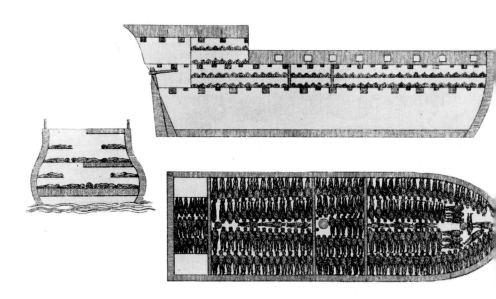

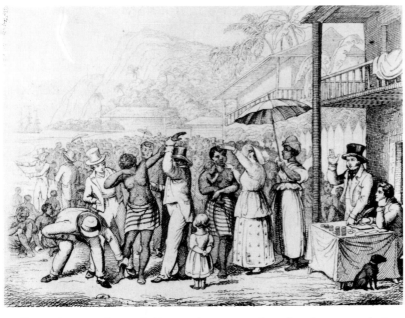

'Sale of Negroes'. A slave auction in the West Indies, c. 1830.

Slavery happened outside Europe, but it contributed to the accumulation of capital in Europe. According to a classic thesis of Eric Williams, it was one of the factors that enabled Europe to bring about the Industrial Revolution.[4] The importance of the triangular trade between Europe, Africa and America has been contested or treated as relative in some recent studies;[5] however, there is no question that slavery was the most important link between Europe and America, on the one hand, and Africa on the other. Slavery was the basis for the development of tropical and sub-tropical America, while it also set the stage for the underdevelopment and distorted economy of the Caribbean.

Hundreds of years of lucrative trade in a 'product' of such fundamental importance in the international division of labour controlled by Europe could not but leave deep traces. And yet, in European art and iconography slavery is but scantly represented relative to its historical importance; also in modern history and the history of European colonialism it is relatively little discussed.[6] Slavery – not only the slave trade but also as a component in the revenue from colonial plantations – was one of the bases of the fortunes amassed in Liverpool and London, in Nantes and Bordeaux, in Amsterdam and Middelburg. But it was a hidden basis of that European wealth. Like every culture, European culture has a front and a back, and slavery belongs in the rear, at the service entrance of European civilization.

There are depictions of various aspects of slavery such as the shipment and auctioning of slaves, their labour and leisure, but the subject was not very prominent in Europe. If slaves were depicted it was often incidentally and as a part of some other subject represented. Invisibility was one way in which slavery was kept psychologically at bay. In illustrations with captions such as 'Cotton', 'Cotton Picking', 'Sugar Production', the product is the central theme and slaves, or black workers, are supplied as pictorial extras or décor. Descriptions of West Indian society did appear in which aspects of slavery were shown, such as John Stedman's book on Surinam and Benoit's *Voyage à Surinam*, but these were already bordering on abolitionism.

The appellations 'negro' or 'black' were once synonymous with 'slave'. Thus in 1740 South Carolina adopted a law according to which '. . . all negroes . . . mulattoes, or mestizos, who are or shall hereafter be in the province, and all their issue and offspring, born or to be born, shall be and they are hereby declared to be and remain forever hereafter absolute slaves. . . .'[7] Status and skin colour coincided, as also in the French *Code noir*, which governed slavery in the French colonies from 1685 to 1848.

The Dutch Republic was the leading power in the slave trade in the seventeenth century. At the time when that trade was undergoing its great expansion the Dutch Republic occupied the most strategically important positions. In 1621 the Dutch West India Company had been established as a weapon in the Netherlands' economic warfare with Spain. In 1630 the Dutch under Count Johan Maurits conquered Pernambuco in Brazil from the Portuguese, and from there, in 1637, nine ships sailed which successfully attacked the Portuguese fort of São Jorge da Mina (Elmina), the oldest and strongest European bulwark on West Africa's Slave Coast. The English and the Danes operated there as well, but the Dutch controlled the coast. In 1641 the Dutch were also trading in slaves from Luanda in Angola. Curaçao, another stronghold of the West India Company, became the most important slave depot in the Americas. Thus the Republic controlled the three most vital strategic terminals in the transatlantic system – the slave coast, Brazil and Curaçao. For a long time the contract (*asiento*) to supply slaves to the Spanish colonies was held in Amsterdam. Hence historians refer to the Netherlands in its Golden Age as the business headquarters of the slave trade.[8] In 1645 regents of the West India Company referred to the slave trade as 'the soul of the company'.[9]

Drawing of Creole lady and black slave in the West Indies.

Slaves at work in a diamond mine in Brazil, supervised by whites equipped with whips. From Everett, *Slavery*.

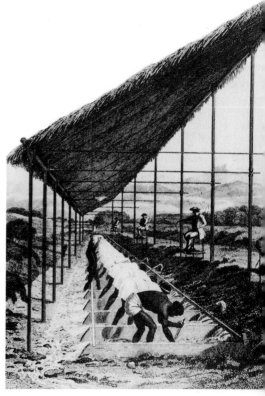

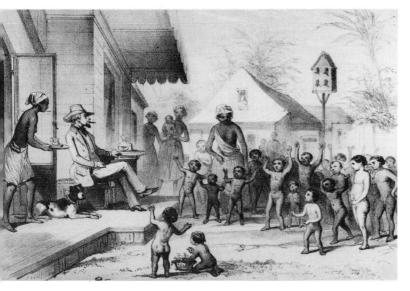

Scene from a planter's life in the West Indies with servant, concubines and offspring. The iconography exemplifies the hierarchy: the polarities between white and black, dressed and semi-nude, sitting and standing, man and women/children, consuming and serving, centre and periphery, all accord with the racial hierarchy. Illustration from a Dutch book, nineteenth century.

At the time Amsterdam was also the main entrepôt for cargo for Africa. The Dutch introduced the first slaves into North America, at Jamestown, Virginia, in 1619.[10] And they brought about the 'sugar revolution': the expansion of sugar cultivation from Brazil to the West Indies, where it was developed further by the English and the French.

How could slavery be considered consonant with the 'true Reformed religion'? In the late sixteenth and early seventeenth centuries slavery was condemned by Dutch opinion and prohibited; it was regarded as another odious practice on the part of the Spanish and the Portuguese. When the West India Company entered the trade on a large scale, however, this attitude could not be maintained. The Company sought advice on the subject from ministers of the Reformed Church, who stated that under certain conditions slavery was permitted. The matter was taken up in a hefty volume, *'t Geestelijk roer van 't koopmans schip* (The Spiritual Rudder of the Merchants' Ship, 1642), written by the Reformed minister Godefridus Cornelisz Udemans of Zeeland and dedicated to the Lords XVII and XIX of the East and West India Companies. It was not permitted, according to Udemans, to sell Christians as slaves, but 'Heathens and Turks' might be used as slaves by Christians 'provided that they have been caught in a just War; or purchased for a correct price from their Parents, or other competent Masters, as is related that this ordinarily occurs in Angola. For this accords with the Divine law'.[11] Expounding on the standard Christian justification of slavery, the curse of Ham, Udemans adds another variation by arguing that Calvinist slavery would further benefit the incorrupted heathens, for it would keep them from 'popish mischief'.

A hundred years later, when Jacobus Elisa Joannes Capiteijn (1717-47), an African who studied theology in the Netherlands, became an advocate of slavery on biblical grounds, the arguments had hardly changed.[12] As Capiteijn relates in the preface to his treatise, he was sold in West Africa at the age of seven to a Dutch sea captain, who gave him as a present to a Dutch merchant who brought him to The Hague. At Leiden University he completed his studies in theology. His thesis, published as a book in 1742, became an instant success.[13] One of the biblical references which supported his reasoning

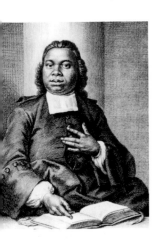

Jacobus Elisa Joannes Capiteijn, minister and graduate of Leiden University (1742).

was 'Where the Spirit of the Lord is, there is liberty' (2 Cor. 3:17). Thus the freedom of the Gospel, spiritual freedom, could well be combined with physical bondage. For another hundred years the Dutch, French and English would use Capiteijn's arguments to defend slavery.

Capiteijn, by the way, also advocated the introduction of slavery among white Christians in order to relieve society of its idlers. He later became a minister at Fort Elmina. A contemporary and British counterpart of Capiteijn was Philip Quaque, from Cape Coast, who after an education in England returned to Africa in 1765 to become a minister at nearby Cape Coast Castle.[14]

For centuries the Catholic Church took part in slavery, keeping black slaves in large numbers on sugar plantations and as domestic servants in Spanish and Portuguese America, the Philippines and Portuguese Asia and Africa. For centuries the stipends of the bishop and the ecclesiastical establishment in Angola were paid out of revenues from the slave trade. When the climate of opinion finally changed and turned against slavery, the Church remained aloof until 1839, and its attitude hardly changed between that year and 1888, when slavery was finally abolished in Brazil.[15]

Under the Treaty of Breda, the island of Manhattan was exchanged in 1667 for Guiana, or Surinam. In 1682 the West India Company took control there, and by 1684 the colony had more than 2,000 slaves. Surinam acquired a particularly bad reputation for its treatment of slaves,[16] as is mentioned in Voltaire's *Candide*. Captain Stedman's report on his years in Surinam confirmed this reputation.[17]

John Gabriel Stedman (1744-97) was born in the Netherlands of a Scottish father and a Dutch mother. He joined the Dutch army and departed for Suri-

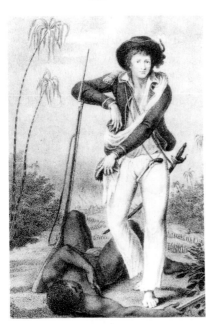

'Punishment of a Samboe slave'. Engraving by Wm. Blake in Stedman, *Narrative* (1796).

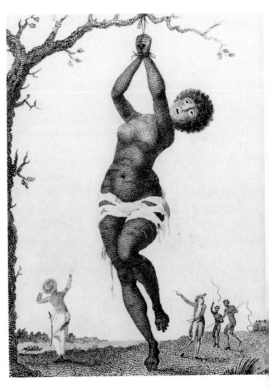

nam in 1772 with the rank of captain. His task was the suppression of slave revolts and to carry out operations against the Maroons, the communities of runaway slaves. He developed a relationship with Joanne, a young slave girl of fifteen. A good observer and writer, Stedman wrote an extensive report on his stay in Surinam which, in the fashion of the time, dealt with flora, fauna and social relations. In 1791 he arrived in London with his manuscript and sketches which were to serve as a basis for illustrations. Most of the engravings in his two-volume work are by William Blake – these forceful drawings, which give an intense impression of the treatment meted out to the Surinam slaves, are among the most often reproduced and most familiar images of slavery. Stedman's work represents slaves as human beings and with sympathy. Some of the later editions of his work carried abolition proposals as a supplement. The frontispiece was a self-portrait with a caption in the Romantic mode:

> From different Parents, different Climes we came,
> At different Periods; Fate still rules the same.
> Unhappy Youth while bleeding on the ground;
> 'Twas *Yours* to fall – but *Mine* to feel the wound.

Opposite page: frontispiece of Stedman's *Narrative* (London, 1796). Captain Stedman and a defeated Maroon: 'From different Parents, different Climes we came . . .'

Abolitionism and Racism

The period of abolitionism coincided with the rise of racism. The humanization of the image of blacks in abolitionist propaganda went hand in hand with the hardening of that image through the application of the category 'race'. To understand this paradox of progress we should look more closely into the processes taking place at the time. Again important shifts occurred in western images of blacks – shifts in opposite directions simultaneously – and again this was based, not on the fact that Africans had changed, nor on a changed relationship between whites and blacks (although this is debatable), but, chiefly, on processes within western culture. The same principle is at work as in previous shifts but now the situation is more complex.

Criticism of the excesses of slavery was common enough, but was not the same as the rejection of slavery in principle. In the words of the ex-slave Frederick Douglass: 'It was *slavery*, not its mere *incidents* that I hated.'

The tide began to turn in the eighteenth century. In 1700 the Boston judge Samuel Sewell turned against slavery in his *The Selling of Joseph*. Anti-slavery sentiment had its beginnings in the evangelical movement in England and America, starting with the eighteenth-century Quaker revival, followed by the Baptists and Methodists in the 1770s and 1780s.[18] The cause of humanity was aided by competition between the denominations, between established and dissident Christianity. It was no coincidence that the evangelical movements rose among people of simple background. The anti-slavery cause was a means of exposing the opportunism and placidity of the established churches, such as the Church of England, and a platform from which Dissenters and Nonconformists could address a larger audience. Anti-establishment feeling of a more general kind also chimed in; political radicals, supporters of religious freedom and parliamentary reform joined the movement.

Abolitionism was also a manifestation of the Enlightenment. In France the *philosophes* opened the debate on slavery. The movement to end slavery

Am I not a man and a brother?
Am I not a woman and a sister?

Anon.

They are not my men & brethren, these strange people. . . .
Sambo is not my man & my brother.

William Makepeace Thackeray

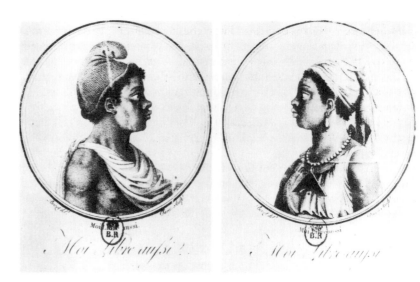

'Moi Libre Aussi'. Abolition medallion from the period of the French Revolution. Sometimes '1789' also appears. An example of an abolition emblem where the black is *not* kneeling.

belongs to the 'age of the democratic revolution' with its revolutions and rebellions in America, France, Ireland, Santo Domingo and in South America, with the Declaration of the Rights of Man, the ideas of equality and fraternity, the sovereignty of the people and democracy.[19] With the anti-slavery movement was interwoven the general social momentum of the emancipation of the bourgeoisie, the working class, women, Catholics and Jews. The rhetoric of freedom extended from free trade, free labour and free nations to free people. 'Moi libre aussi' was the motto, in petit nègre idiom, of a French abolition emblem.

The material basis for the abolition of slavery was the process of industrialization. In the light of industrialization the slave colonies acquired the reputation, as early as the eighteenth century, of being backward and reactionary.[20] How abolition would have proceeded without industrialization is hard to imagine. On the other hand, the fact that the impulse towards abolition preceded industrialization by fifty to a hundred years, suggests that abolitionism cannot be simply reduced to material factors.

The abolition movement had an enormous cultural effect. If images of slavery from the pro-slavery point of view were scarce, the image production of abolitionism was abundant. Almost all the images of slavery with which we are familiar are in fact abolitionist images. The typical iconography of abolitionism displays the movement's Christian pathos: the recurring image is that of blacks kneeling with hands folded and eyes cast upward.

Abolitionist art is poised on the cusp of classicism and Romanticism, and abolitionist poetry was a Romantic genre.[21] Even if abolitionist art was often neo-classical in form, the pathos of the oppressed subject who is better, more human, more Christian than the oppressor was a Romantic pathos par excellence. The oppressed black slave became the emblem of a spirit of rebelliousness, symbolizing more than slavery alone.

Abolitionism as a counter-force engendered the pro-slavery propaganda of the planters' lobbies. Besides, abolitionism itself involved certain limitations. These circumstances stamped the process of image-formation, which alternated between propaganda and counter-propaganda. This sheds light on the paradox of progress, the simultaneous career of abolitionism and racism;

but there is also a more fundamental reason for it. It was 'at the very point in time when large numbers of men and women were beginning to question the moral legitimacy of slavery' that the idea of race came into its own.[22] *Race* emerged as the buffer between abolition and equality.

The English Abolition Society, founded in 1787, was directed against the slave trade, not against slavery. In 1807, after twenty years of agitation and parliamentary debate, the slave trade was prohibited by English law. Not until 1823 was the organization founded which is known as the Anti-Slavery Society, although its full name, The Society for the Gradual Abolition of Slavery, gives a little more insight into the situation. The American and French movements for the abolition of slavery came into being in the 1830s.

In the Netherlands the parliamentary debate on slavery had begun earlier, notably over the preparation of the new Constitution by the National Assembly in 1797. The Report on the matter drawn up by the Floh Commission argued that in principle of course every civilized and enlightened human being is against slavery, but that one must manoeuvre

> 'between pure philosophy and true Statesmenship; between Humanitarian feeling, and concern for the maintenance and reputation of the Civil State; between the claims of the heart and the prescriptions of reason; and finally between the duty of the natural, moral man, as an independent being, and the duty of the Lawgiver of a Society, as bound by compelling circumstances, which are in no way under his control'.[23]

Here Enlightenment rhetoric ('Civil State, prescriptions of reason') is deployed in a subtle way in the *defense* of slavery. The 'compelling circumstances' refer to Surinam. Here planters argued that emancipation would not only threaten the colonies but that, through the loss of the colonial trade upon which everyone's prosperity was based, the existence of the mother country itself would be gravely endangered. They also pointed at the danger of Santo Domingo, where a slave rebellion had resulted in an independent republic: a beacon of hope for blacks in the western hemisphere and the writing on the wall for colonial and planters' interests.[24]

Slavery lobbies were active in America, England, France. For the planters in the West Indies and the American South large interests were at stake. Sugar, tobacco and cotton, the most important products of slave labour, were the result of labour-intensive cultivation. Unless labour costs remained low the plantations would not be cost-effective. 'Sugar would be too expensive', noted Montesquieu, 'if the plant that produces it were not cultivated by slaves, or if one treated them with some humanity.'[25] Economic gain was the essential argument of the slavery lobbies, but to reinforce their point of view everything was brought in, from biology to the Bible. 'Complex justifications of various kinds were offered for the continuance of the slave trade: African barbarism, biblical support and comparisons between happy slaves and miserable European peasants.' The counter-propaganda was well organized.[26]

In the first instance the lobbies resisted attempts to prohibit the slave trade; in the second round they turned against Emancipation legislation; in the third they tried to bind Emancipation itself to conditions. For England there were 26 years between the prohibition of the slave trade and the emancipation of the slaves. The British planters in the West Indies were paid compensation of £20 million and emancipation was linked to an official transition

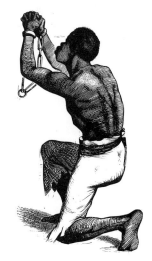

Detail from a drawing in
Punch, 1876.

period of four years, the apprenticeship period of 1834 to 1838, during which free negroes had to remain on the plantation and continue to work as before.

The slavery lobby never managed to appeal to the public imagination and to make its cause popular, as did abolitionism; but it did have its cultural radius and a considerable influence on the climate of opinion. In the United States pro-slavery arguments were imported from Europe – Edward Long's *History of Jamaica* was reprinted in New York in 1788. Outdated denigrating ideas about blacks were revived and books republished to supply the planters with arguments. Renowned authors such as Thomas Carlyle, Anthony Trollope, William Makepeace Thackeray, and Charles Dickens acted as the lobby's spokesmen or underwrote its views. Carlyle's *Occasional Discourse on the Nigger Question* (1849), one of the most virulently racist publications to appear in the nineteenth century, was written in this context.

Dickens, a 'social' author where England was concerned, regularly raged against 'Sambos', 'natives' and 'ignoble savages'. In 1848, in an essay on the occasion of the Niger expedition, he wrote: 'Between the civilised European and the barbarous African there is a great gulf set. . . . To change the customs even of civilised . . . men . . . is . . . a most difficult and slow proceeding; but to do this by ignorant and savage races, is a work which, like the progressive changes of the globe itself, requires a stretch of years that dazzles in the looking at.'[27]

Abolitionism itself, no matter how well intended, was not the same as the victory over racism. The abolition of slavery was not the same as black emancipation. Abolitionism promoted new stereotypes of blacks – the movement humanized the image of blacks but also popularized the image of blacks as victims. The Christian tenor of abolitionist imagery underlined this. The central icon of abolitionism, the figure of a black kneeling, hands folded and eyes cast upward, carried a clear message. It made emancipation conditional – on condition of conversion, on condition of docility and meekness, on condition of being on one's knees. This imagery was more an affirmation of Christianity than of the emancipation of blacks. It is an image in the tradition of *Philip's Baptism of the Eunuch*, also of a kneeling Ethiopian, and for centuries the symbol of the Christianization of the non-European world.

'Am I Not a Woman and a Sister?' Female version of the well-known emblem of the English Abolition Society. The posture is one of Christian prayer.

'L'esclave affranchi' (The freed slave). Again the posture of prayer. Sheet-music cover, Paris, 1849.

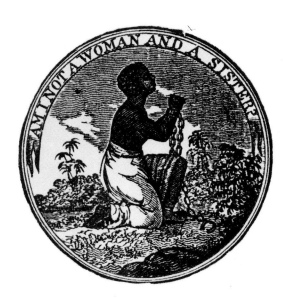

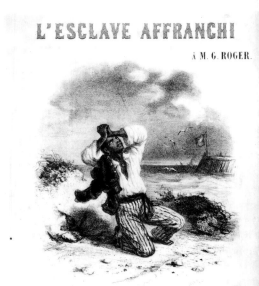

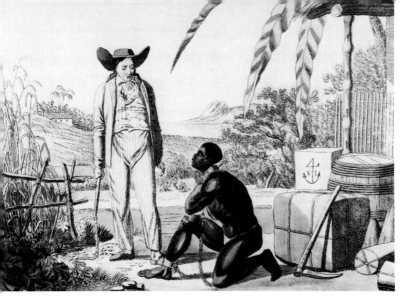

'The Negro in the West Indies'. German print of a planter about to punish a slave. Accompanied by a poem in which God is passionately invoked: 'Thou in heaven, O help me poor Black Man!' German print, n.d.

The most popular abolitionist book, Harriet Beecher Stowe's *Uncle Tom's Cabin* (1853), created a new and henceforth proverbial stereotype. Uncle Tom is the docile black who sacrifices himself for his master and is supposed to generate sympathy because he does *not* resist or revolt. The black whose name was invoked by whites to generate sympathy for blacks soon became a term of abuse among blacks.

Uncle Tom is *black and yet* a Christian. This echoes a trusted theme in western perspectives – *black and yet*, or *black but*, as in 'black skin but white soul', and in *nigra sum sed formosa*, 'I am black but beautiful' of the Song of Solomon. Or as in Blake's 'The Little Black Boy':

> My mother bore me in the southern wild,
> And I am black, but O! my soul is white;
> White as an angel is the English child,
> But I am black, as if bereav'd of light[28]

The abolition of slavery was in fact made subject by some abolitionists to conditions – in America these were, notably, emigration: Back to Africa. Harriet Beecher Stowe joined this current, one with which many slave owners too would agree, but which was fiercely opposed by the American abolitionist movement.[29]

The process of emancipation itself was also accompanied by much racist grumbling. A Yankee battle cry in the American Civil War was: 'We ain't for the nigger but we are for the war'.[30] The Emancipation Proclamation in 1863 inspired the *Cincinnati Enquirer* to comment: 'Slavery is dead, the negro is not, there is the misfortune. For the sake of all parties, would that he were.'[31] In the British press as well there was no dearth of wry comments and sick jokes.[32] In England the debate on 'race' flared up two years later in the wake of Governor Eyre's bloody repression of the Morant Bay revolt in Jamaica. Five hundred Jamaicans were killed and countless more severely punished. Eyre found enthusiastic support for his actions from, among others, Ruskin, Tennyson, Carlyle and Dickens. *The Times* wrote that the English had been deceived by the abolitionists into thinking that 'the world was made for Sambo, and that the sole use of sugar was to sweeten Sambo's existence'.[33]

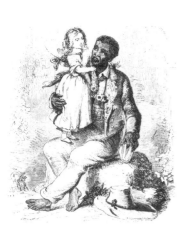

Four editions of Harriet
Beecher Stowe's *Uncle
Tom's Cabin*: France,
1853; Belgium, 1940;
Netherlands, *c*. 1950;
Great Britain, 1852.

The American Emancipation of the slaves took place in 1863 – 68 years after Denmark, 30 years after England, 15 years after France, 2 years after the abolition of serfdom in Russia. The Netherlands abolished slavery in the same year as the United States.

Race established new social boundaries at the very time the old ones were annulled. As George King, a free man from South Carolina, said: 'The Master he says we are all free, but it don't mean we is white. And it don't mean we is equal.'[34] Race was the answer to the 'problem of freedom'. Since then this field of tension has remained the arena of image-formation of white on black.

Freedom as a gift of Christ: Plate commemorating the freeing of the slaves in Suriname, by C. Jetses (1913).

4 IN THE DARK CONTINENT

It was a good time to be white, British, and Christian.

H. A. C. Cairns

As the prohibition of the slave trade took effect Europeans increasingly turned to Africa itself. For three hundred years the European presence had been confined to the coasts, the settlement of Dutch Boers at the Cape being the chief exception. The African interior remained insulated from European traffic, a zone of operation for slave raiders, and the scene of recurrent warfare the captives from which soon turned into slaves.[1] The journeys of exploration into the African interior went together with shift of emphasis in European perspectives – from slavery to Africa, from the African coasts to the interior, and from Europeans as slavers to the Arabic slave trade. It was this inner Africa that Europeans, particularly the British, came to refer to as 'dark'.

'Dr Livingstone, I presume?'

These two pioneers of civilization – Christianity and commerce – should ever be inseparable.

David Livingstone

The systematic exploration of the African continent, which began in 1795 with the Niger expedition of Mungo Park, and the modern missionary work in Africa started around the same time. The journeys organized by the Royal Geographical Society in search of the source of the Nile, those of David Livingstone and of the journalist Henry Morton Stanley in search of the missing Livingstone, met with enormous interest in the popular media of the day, in newspapers and the illustrated magazines of the middle class. As journeys of heroic Europeans venturing into the mysterious interior of Africa, into areas pregnant with danger and promise, they appealed so strongly to the imagination that, immortalized in popular literature, they rank among the 'primal scenes' of western expansion.

The journeys of exploration are on record, in recent literature as well as that of the past, as a 'pushing back of the frontiers of ignorance' and as 'adding to the store of knowledge of the world'.[2] This is an extremely Eurocentric view. The journeys of exploration did not simply produce 'knowledge', they were also large-scale operations in myth-making, and they unfolded in a kind of western 'tunnel vision' that was to culminate in European colonialism. The myth of the Dark Continent put forth by explorers, exculpated the West of the slave trade, which was redefined as a manifestation of African primitivism; and it shifted attention to the Arabic slave trade, reports of and complaints about which were to function more and more as an alibi for European intervention. Since antiquity Africa had been the land under the sun, as traditional names such as Aithiop ('in the eye of the sun') indicated. The myth of the Dark Continent came into being only in the nineteenth century as an appropriate stage décor for European exploration.[3]

The journeys of exploration were themselves a significant source of myth formation about Africa. They completely ignored the fact that the continent

'The Livingstone aid exhibition; crossing a river in East Africa.' Iconography of the European exploration: African porters, porters, porters. *Illustrated London News*, 15 Nov. 1873.

had for centuries been criss-crossed by trade routes. Long-distance trade is so deeply rooted in and of such importance to the political economy of the continent that it has been referred to as the basis of an 'African mode of production'.[4] It is not just that the explorers 'could simply have asked the way';[5] they did. But, while on the home front the explorations were celebrated as fantastic triumphs of European knowledge and daring, with Africans as dumbfounded bystanders, in reality the success of the journeys was owed to African help, not only as porters (as the iconography suggests), but as guides, intermediaries, interpreters, and so forth.[6] The European penetration of Africa was also in competition with the Arab presence and involved a revival of older anti-Arab prejudices.

The contributions to knowledge were limited also because the explorers were so full of racial and patriotic superiority that they hardly got round to Africa itself. 'There is nothing interesting in a heathen town', according to Livingstone in 1867.[7] He was convinced that it is 'on the Anglo-American race that the hopes of the world for liberty and progress rest'. In his instructions to an assistant on the Zambesi expedition he explained: 'We come among them as members of a superior race and servants of a Government that desires to elevate the more degraded portions of the human family. We are adherents of a benign holy religion and may by consistent conduct and wise patient efforts become the harbingers of peace to a hitherto distracted and trodden-down race.'[8]

This combination of Christian and racial arrogance typified the era of the *mission civilisatrice*. The explorers regularly gave evidence of racism. Thus Livingstone spoke of 'the low negro character and physiognomy' and (about the Kgatla in 1844) 'They seem to have fallen as low on the scale of humanity as human nature can'. Here the images of the savage and the heathen merged in a Christian vision of 'fallen creatures'; the terminology of 'degeneration' expressed the same nuance in a scientific, biological discourse.

The explorations were a prelude to Europe's late-nineteenth-century imperialism. The 'medley of aims and feelings' of imperialism was already im-

plicit in the mixture of missionary, commercial and strategic consideration in the name of which the explorations were undertaken.

The British obsession with the 'source of the Nile' was an attempt to take up again where the antique geography of Herodotus and Ptolemy had left off Eighteenth-century Egyptophilia and the orientalism that came in the wake of Napoleon's invasion of Egypt in 1798 contributed further to this preoccupation.[9] The intense national rivalries that would characterize the 'scramble for Africa' were already implicit in the explorations. David Livingstone concealed the fact that his most important achievement, that he was the first European to penetrate into southern Central Africa, had been anticipated by several years by Portuguese traders, Rodrigues Graça and Silva Porto. To maintain the claim that he was the first European to see the upper Zambesi Livingstone made it seem that the Portuguese who had been there before him were half-castes.[10] He was disgruntled at the inability of the missionary council to recruit British rather than German missionaries to man the mission post in the hinterland of Mombasa. Stanley met with a cold and ungenerous reception in England after his successful expedition to find Livingstone, for i had shown that an American newspaper, the *New York Herald*, had displayed greater ingenuity and determination than the British. The chairman of the Royal Geographical Society stated that 'it was not true that Stanley had discovered Livingstone, but that it was Livingstone who had discovered Stanley'.[11] The British explorers laid the basis for the later British aspiration to 'paint the map of Africa red'. The names they gave to African waters made them into tributaries of British royalty such as the Victoria Falls of Livingstone, Lake Albert of Samuel Baker and Victoria Nyanza of John Speke. The explorers dedicated their books to the royal couple. From the moment it came into Europe's view the interior of Africa was turned into a conduit for the aspirations and tensions of the European interior.

The scene is classic: 'Dr Livingstone, I presume?' These words, with which Stanley approached Livingstone on 3 November 1871 in Ujiji, after a difficult and uncertain journey of many months, typify the explorations. The theme is the exploration itself and the relations between Europeans. Africans and Arabs are mere bystanders, passive spectators. Here Africans have been

Based on a sketch by the explorer Sir Samuel W. Baker, who commented: 'Altogether I never saw a more unearthly set of creatures, they were perfect illustrations of my childish ideas of devils – horns, tails, and all, excepting the hoofs; they were our escort! . . . furnished by Kamrasi to accompany us to the lake.' Baker, *The White Nile*.

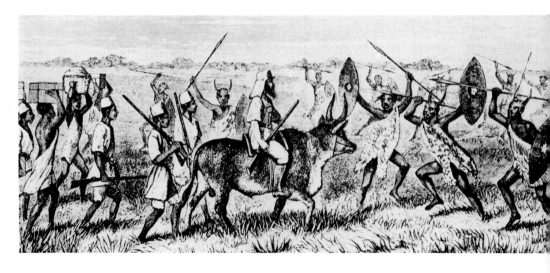

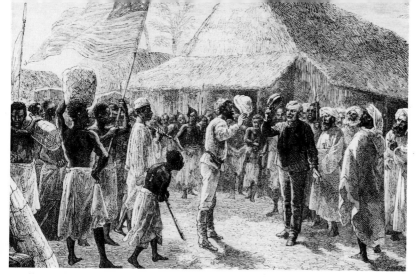

'Dr Livingstone, I presume?' The classic scene of the European exploration of Africa. In this imagery Africans have been reduced to bystanders, extras in their own continent. Piquant detail is the Stars and Stripes carried by an African in Stanley's procession. Frost, *Modern Explorers*, 1884.

turned into extras on their own continent, into stage props that do not matter in the great undertaking being performed by Europeans. The Stars and Stripes carried in Stanley's procession refers to the national identity which, next to racial identity, begins to count in the heart of Africa. The Arabs standing next to Livingstone are those about whom he complains so bitterly in his reports and whose influence should be replaced by a European presence. They are the 'barbarians' among the 'savages'. The insecure Stanley had carefully studied his lines, in a deliberate imitation of the aloof British upper-class style. His words at once became a standing joke, a classic exhibition of bathos and pomposity.

Neither of the two Europeans who performed this peculiar English rite on the shore of Lake Tanganyika was English, and both were marginal figures. Livingstone, like many British missionaries, was a Scotsman; he mistrusted the English and remained in Africa because he did not feel at ease with Europeans. He could get on well with Stanley, they spent five months together. Stanley, the illegitimate child of a Welsh woman, had after a difficult youth set sail for New Orleans, where he was adopted by an American businessman, Henry Morton Stanley, whose name he took. Thus both Livingstone and Stanley hailed from the 'Celtic fringe', from lands which had been colonized by England in not so distant memory, and both were marginal figures. Stanley went on to propagate the myth of the noble, saintly Livingstone in his books and reports, even though after a few months he knew better; but his own myth stemmed from Livingstone's.[12]

The Africa of the explorers is a stage décor consisting notably of the absence of that of which the Europeans held themselves to be the representatives. Central in the explorers' view, along with the land and its geography, was the exploration itself, just as, in the missionary perspective, the mission itself formed the centre. Both exploration and missionary work produced myths, not only about the areas in which they operated but above all about themselves. In western literature the lies produced in this context are still, out of piety, referred to as inaccuracies. In the literature of exploration Africans are mentioned mainly as part of the landscape, or as obstacles to the exploration. Time and again there is mention of 'difficulties in obtaining porters', of chiefs demanding a high toll for the travellers' passage and of local wars and skirmishes causing delays for the travellers. The emphasis in this

'An exploration journey. The Congo.' African nature so represented as to dwarf people. *Stanley's Reizen* (1886).

Movement of French colonial troops in Madagascar. 'Evenement de Madagascar.' *Petit Journal Supplément Illustré*, 1892.

Go ye therefore, and teach all nations, baptizing them in the name of the Father, and of the Son, and of the Holy Ghost, teaching them to observe all things whatsoever I have commanded you.

Matthew 28: 19-20

The faith is Europe Europe is the faith

Hilaire Belloc

literature lies entirely on landscape and nature, of which we are given extensive and fervent descriptions. The course of the rivers, the expanse of the lakes, the imposing height of the mountains is what this literature is about. Africans tend to be mentioned in passing either as obstacles or as hospitable and helpful. The geographical knowledge gathered by the explorers, for instance about the course and navigability of rivers, is strategically and commercially important, and the network of long-distance trade routes, the existence of which is denied on the one hand (in the very imagery of 'darkest Africa'), is yet being carefully studied on the other. In the eyes of Africans the journeys, not unjustifiably, generally gave the impression of espionage.[13]

Mission

The Mau Mau in Kenya put it this way: 'Formerly we owned the land and the whites had the Gospel. Then the missionaries came, they taught us to pray and close our eyes, and in the meantime the whites took our land. Now we have the Gospel and they have the land.'[14]

The metamorphosis of Europeans in Africa from explorers and missionaries to colonizers meant a transition from an attitude of diplomacy to an attitude of domination. Explorers had to act with tact, missionaries were still vulnerable but already less tolerant. There were often close ties between the Church and the colonial state. In the home country there were family connections between the officer corps and the Church. In England the churches were decorated with the regimental flags. The missionaries were often passionate advocates of an expansionist policy. For the Church, just as for colonial enterprises, it meant the opening up of new territory. According to a missionary in Lagos in 1892: 'Often war is the means to open the gate through which the Gospel can be brought into the country. The spiritual sword is often preceded by the steel sword.'[15] Four years later the British marched into Ashantiland.

Officials and administrators came and went, but religious orders, ministers and priests remained in the colonies. Sometimes, as in Angola in 1854, the

bishop acted as deputy governor.[16] David Livingstone, the explorer-missionary, made his first journey (1848-53) in the service of the London Missionary Society; the objective was to keep the so-called missionary road open: the route whereby missionaries from the British Cape Colony moved north into the interior. (Years later Cecil Rhodes would proceed via the same route towards Matabeleland and there establish Rhodesia – now Zimbabwe.) Livingstone's next journey was sponsored by the British Foreign Office, which gave him the rank of honorary consul.

King Leopold II of Belgium hired Henry Stanley to found a colonial empire in the Congo and then turned to a Belgian congregation, the Scheutisten, for assistance in this great enterprise. Colonial administrations generally strove towards 'national' missions, on the principle that 'whose land it is, to him belongs also the religion' (*cuius regio illius et religio*). Hence certain areas were reserved for Protestant and others for Catholic missions, and a change of colonial authority in Africa might also mean a change of missionaries.[17] In mature colonialism the Church, side by side with the state and the colonial enterprises, formed the 'third pillar of the Colonial Bloc'.[18]

Missions occupied an important place in the colonial ensemble, since the Church was the civil side of empire and as such could penetrate much more deeply into society. It fulfilled a pacifying role. 'Where the seed of Christianity fell the will to resistance was weakened.' Health care and education had a great impact on local culture, and this was also politically relevant because missionary education created a new élite. Besides, the churches were an important channel of colonial propaganda in the home country. Throughout this whole period the churches also carried out their own agendas, so they cannot be regarded under all circumstances as a mere extension of the colonial state.

The missionary as hero and the evil witch doctor

In the sequence of explorer to missionary to colonizer the European image-formation of Africa shows a distinct decline. To a significant degree the missions were responsible for the transition from the image of the 'noble savage' and the 'noble negro' – which set the tone in the closing decades of the eighteenth century and the early years of the nineteenth, the joint expression of Romanticism and abolitionism – to the stereotype of the 'ignoble savage'. This also meant a turn-around, sometimes sudden and drastic, in pictorial styles.[19]

Terrifying tales about heathen rituals, idolatry and human sacrifice traditionally play an important part in missionary image-building about the non-western world. For centuries, the Ugandan anthropologist Okot p'Bitek notes, missionaries have spread horror stories about African peoples. As far back as the sixteenth century one Duarte Lopez wrote about 'a large mass of devil's images cut in wood, in all kinds of horrible shapes: many worship wingéd dragons, others worship snakes as their gods, others again bucks, tigers or other abhorrent and loathsome animals'.[20]

This image-building was operative even before the missionaries themselves left for Africa. In Bremen in March 1852, Cornelius Rudolf Vietor began writing a four-volume illustrated description, drawn 'in true colours', of 'Africa, the field full of skeletons', swarming with satanic butcheries and per-

Images of the evil witch doctor. From a recent Dutch missionary book for young people. Illustration by Ben Horsthuis in Mol, *Koningin Zingha* (1960s).

British colonial propaganda emphasising idolatry. Illustration for an article about the Ashanti. *Illustrated London News*, 1873.

Festish worship of 'Banza Ouvana'. *Le Congo Belge en images*, (1909).

versities. Only he had never himself set foot in Africa. This account on behalf of the Norddeutsche Missions-Gesellschaft reads like an inventory of repressed anxieties.[21] This infernal Africa resembles certain descriptions in the Old Testament, for instance Jeremiah's [texts] on the 'valley of death', duly projected on to contemporary Africa.

Contrasted with this was a romantic image of the missionary as hero, as, for instance, that of the Dutch priest Van Rijckevorsel: 'A missionary calls up before our mind the image of a Christian hero, who, armed with the cross, preaching and baptizing, journeys through remote lands.'[22] 'The missionary stands alone among those black heathen idolators as the solitary and exiled hero, as a modern Robinson Crusoe who journeys, armed with the cross, preaching and baptizing, teaching and healing.'[23]

Precisely because this kind of wishful thinking was unrealistic and the missions often made very little impact of any kind, it was only logical that a further degradation of the image of the native population took place. That the missions failed was due, according to a widely accepted explanation, to the fact that one was dealing here with the domain of the devil. In 1854 the missionary Mallet stated in a report to the Norddeutsche Mission in Bremen that the heathen were not only ignorant and weak but above all unregenerate: 'the devil has exercised unlimited dominion over them for so long that they have become his slaves and have sunk into beastly and hellish conditions'.[24] Such explanations were essential to maintaining the missionary's identity. Besides, they were a safeguard against his 'going native' in interaction with the heathen. In this way an enemy image was projected of the very population that was to be converted. Themes that keep recurring in this enemy image are those of the evil witch doctor, the fetish and human sacrifice.[25]

It is revealing that the missionary process is often presented in military metaphors: it was a matter of 'battling', of 'conquering' for Christ, by 'soldiers'

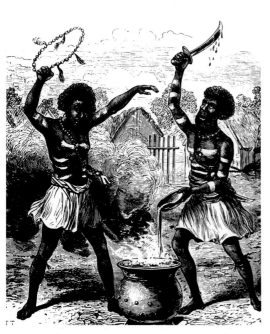

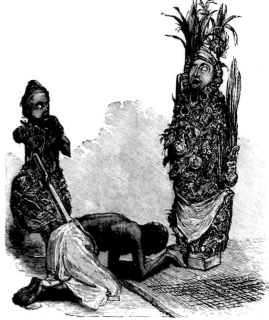

of Christ.[26] This was not entirely out of place, for the traditional African re-
ligions and societies were often the nucleus of the resistance against colonial-
ism.[27]

Thus missionary image-building consisted of a Manichaean double face,
with on the one hand the demonized image of the heathen under the devil's
spell, and on the other the romanticized self-image of the missionary in the
role of saviour. These two stereotypes were interdependent: for the missions
to justify themselves the heathen *had to be* perceived and labelled as degraded
creatures sunk deep in darkness who needed to be brought to the light. The
glory as well as the fund-raising of the missions were in direct proportion to
the degradation and diabolism of the heathen.[28] A similar dynamic, the for-
mation of enemy images to justify European aggression, was at work in
colonial propaganda.

The *portée* of these tales and depictions is that the African interior is hell.
Stanza two of the missionary narrative concerns the process of conversion.
Then the missionary himself steps into the picture: in confrontation with the
wizard, as a white paternal figure amidst the natives, as the distributor of
Bibles and the performer of exogenous rituals. The discourse shifts from that
of military conquest to saccharine kitsch.

Often the position of the missionaries themselves was not particularly plea-
sant. Many came from simple peasant families in poor rural areas of Europe.
Their background was rural and provincial and their culture was the culture
of the Church which imposed a severe regime. This discipline, the culture
and hierarchy of the Church, is noticeable in the missionary documents.

Striking instances of a peculiar cultural contact: in a series of postcards
with pictures of the Missionary Sisters of Our Lady [Our *Dear* Lady] of Africa,
the White Sisters are engaged in catechizing, educating and nursing. The
pious nuns are depicted alongside regimented, usually downcast Congolese
youths.

In the missionary iconography it is the missionaries who occupy the central
and dominating position. They are representations displaying the world of
the mission as a self-involved, self-enclosed world, which has the Church and
the mission itself for its centre. What is remarkable, furthermore, in drawings
as well as photographs, is a certain *absence*: representatives of the native
population are excluded. Dignitaries or elders with authority, African priests
or traditional healers do not figure in the missionary iconography, unless
segregated and stigmatized as demonic heathen. All these aspects and repre-
sentatives of popular culture have been banished, eliminated. Hence we see
the missionaries and nuns operating in capacities traditionally performed by
the local culture: as transmitters of knowledge, as healers, as authority
figures, usually surrounded by children rather than by adults.

In the home country this missionary world was reflected in a subculture of
missionary actions, missionary societies, missionary letters, missionary maga-
zines and missionary films. From 1926 the Catholic Church held an annual
World Mission Day in October. This missionary subculture brought along its
own iconography, with statues of African children provided with a slit and
the word 'Thanks', the German *Nickneger* which nodded when a coin was
thrown in, etcetera. Before the Second World War in Europe one could 'buy
heathen children', through 'slave societies' (*slaafkensmaatschappijen*), a prac-
tice dating back to the slave trade when missionaries could buy children and
raise and baptize them in mission homes. Also when there were no more slave

'Soeti destroys the idol.'
The turning-point in
the missionary
narrative. From a Dutch
Catholic missionary
novel. Spoor, *Soeti, de
katechist* (1949).

Jezus, Die mij spijst en voedt
met Uw eigen Vlees en Bloed.
Maak mijn hartje blank en rein
schoon mijn huidskleur zwart mag zijn

Dutch Catholic
devotional picture
(Elwa series 720).

markets one could still purchase a heathen child for 21 DM, to whom one could give a baptismal name and as a receipt receive a photo of, for instance, an African boy in a straw skirt.[29]

Striking is a little picture of the Mission Action Congress Exhibition in Amsterdam, 1927 (page 75). In a *Jugendstil* drawing the peoples of the world kneel before a European priest while the Holy Ghost comes down as a dove from a dark cathedral which towers over all.

In the missions Christianity manifested itself as the fulfilment of a European dream. Meanwhile in Europe secularization was gradually gaining ground. Thus in the course of the nineteenth century religion was relocated, leaving the heart of the metropolis for the periphery: while at home doubts were on the increase, overseas 'muscular Christianity' was in the ascendant. Were the missionary activities also a reaction to the churches' loss of ground in the West? Perhaps this applies less to the evangelical and Protestant missions, which got their start after 1790 and in the early nineteenth century, than to the Catholic Church. The Congregation for the Propagation of the Faith was established in 1822. 'The nineteenth century, the century of Catholic losses and trials in all the Catholic countries of Europe, is then, at the same time, the century in which the Faith has at last been carried to every part of the earth.'[30]

In Germany in the 1870s the *Kulturkampf* was taking place and in France restrictive laws were adopted which affected the monasteries. As a consequence many monastic and missionary orders took refuge in the south of the Netherlands. This made the Netherlands in the period between 1915 and 1940 one of the most active mission countries, after Belgium which held the lead.[31]

For the Catholic Church the missionary culture was a rejuvenation cure. It created an impression of the Church as the way of the future and as expanding irresistibly, at a time when in Europe the Church was on the defensive against the advance of secularism and socialism, and maintained itself either through

'A numerous audience'. In the missionary iconography the mission itself is the centre. This is a photomontage, the White Father (Society of Cardinal Lavigerie) superimposed, and no one is looking at him. But contrasts in colour, clothing, number and posture all make the same obvious point. From a Dutch missionary book. Suasso de Lima de Prado (1955).

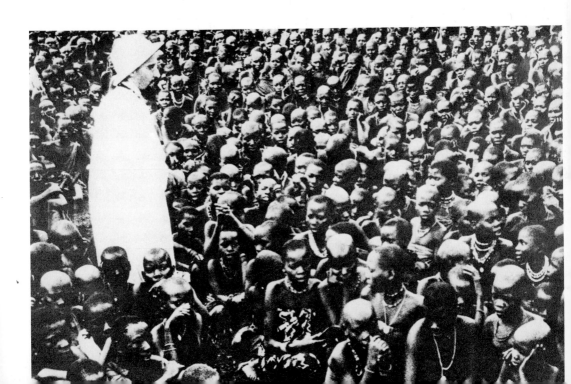

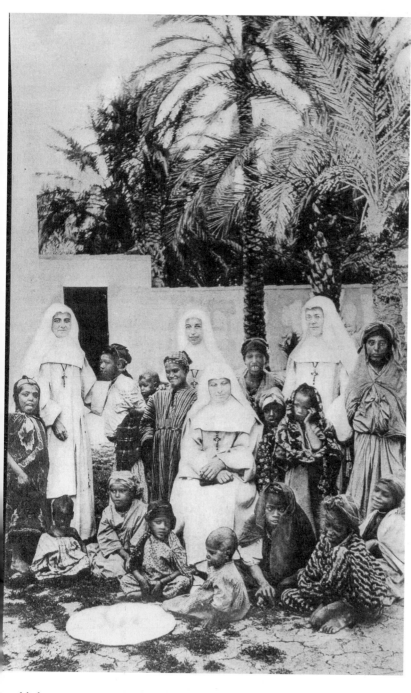

Sisters of Our Lady of
Africa, Biskra (Africa)
(*Pierre Verhoeff*).

establishing new 'miracle centres' (Lourdes, Fatima) or through the adoption
of modern methods of mass mobilization.[32]

In the African churches one sang 'Save, save France in the name of the
Sacred Heart', while in Belgium seminarists in mission performances as imitation negroes in black-face and straw skirts sang the apostolic refrain: 'Have
pity, have pity, I have a soul like thee.'[33]

It is questionable whether the Christian missions were successful. Considering the expenditure the results were modest.

> Christianity of any and all denominations failed to become a serious competitor to the only genuinely expanding religion, Islam. This continued to spread irresistibly, without benefit of missionary organization, money or the support of great powers, through the backlands of Africa and parts of Asia, assisted doubtless, not only by its egalitarianism, but also by a consciousness of superiority to the values of the conquering Europeans.[34]

Christianity in Africa was effective mainly in combination with colonialism. As a religion it gained greatest access in combination with 'nativist' elements, as in the independent 'Ethiopian' and 'Zionist' churches (that is African churches) which developed in many African countries. These independent churches played an important part in the emerging nationalist resistance, in contrast to the established churches which were appendices to the mother church and, to a certain extent, to the colonial state. The actual configurations were complex. Sometimes Christianity was on the African side – in the camp of Emperor Menelik in Ethiopia, with the Reformed Boers in South Africa, and with some of the resistance movements. The missions also played a significant part in the development of anti-colonial movements.[35]

Much has changed since decolonization. In its wake a gradual indigenization of the churches has taken place; in missiology development problems have become a more central concern, and an African theology and liberation theology have been taking shape. For some time a new evangelical mission, with headquarters in the United States, has been active which reproduces, in a neo-colonial setting, many of the alienating practices of the colonial mission.[36]

Holding up a tin of shoe polish: 'Now you know why I am so black.' Mission calendar of the Mill Hill Missionaries, Belgian Congo, 27 May 1938.

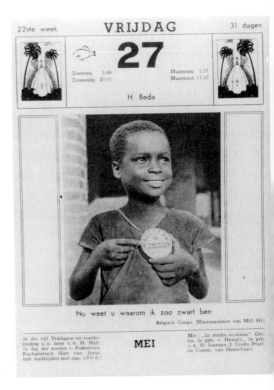

Missionary pictures:
The Mission Action
Congress Exhibit,
Amsterdam, 5-13 Nov.
1927; Prayer Action for
the S.P.L. (Saint Peter
Labour of Love, a papal
organization for the
training of native
priests); an African
priest gives baptism,
1947; and pictures of
the Annual World
Mission Days of 1959
and 1960 ('Pray and
sacrifice'). Different
emphases illustrate
different aspects and
changing views of the
mission.

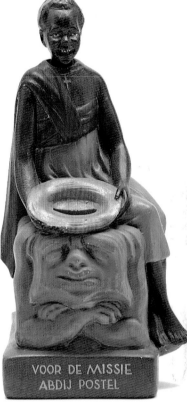

The explorers created the image of the Dark Continent, the churches
created the images of the fallen heathen and the ignoble savage, stereotypes
which colonialism would build on and elaborate. The demonization of Africa
sanctioned the missions. Europe's light shone brighter by virtue of the
darkening of other continents. The churches refreshed themselves on the
new territory and reinforced their position in the cultural confrontations
taking place in Europe itself thanks also to the prestige and glamour of the
missions. Again the changing imagery of Africa was determined by changing
relations within Europe and the West.

5 COLONIALISM AND WESTERN POPULAR CULTURE

'I know their game', explained the Ethiopian Emperor Tewodros II shortly before he was defeated in a British invasion and committed suicide. 'First traders and missionaries, then ambassadors, then the cannon. It's better to get straight to the cannon.'[1]

In 1800 Europeans controlled 35 per cent of the earth's surface: in 1878 this had increased to 67 per cent, and between 1878 and 1914, the period of the 'new imperialism', European control extended over 84.4 per cent of the earth's surface. The expansion took place mainly in Africa, so that continent is fresh in Europe's colonial memory. The question that concerns us here is, what light does European popular culture shed on the era of imperialism?

Through most of the nineteenth century the general climate of opinion in Europe was anti-colonial. Africa could be taken advantage of commercially without having to be conquered and colonized. On the African coasts European traders made greater and greater inroads on the trading monopolies of African kings, and appealed again and again for military assistance from their home governments. This gunboat diplomacy led to several incidents but not much more than that. There were earlier European incursions into Africa south of the Sahara, but the first colonial operations were the French conquests of Gabon (1843-4) and Senegal (1854-65), the British war against the Ashanti (1863-4), and the Abyssinian campaign (1867) which occasioned Tewodros' remark. In the 1870s and 1880s, however, a combination of circumstances started off a new imperialist era.

Brief chronology of the partition of Africa

1869	Opening of the Suez Canal.
1874	Second British war against Ashanti.
1878-9	Zulu war. British defeat at Isandlwana. Start of French operations against the Mandingo empire. Stanley enters the service of Leopold II.
1881	French invasion of Tunisia.
1882	British occupation of Egypt.
1883-5	Germany claims Protectorates over Togoland, the Cameroons, East Africa, South West Africa.
1884	Battle at Omdurman. England claims Somaliland.
1884-5	Berlin Congress.
1885	Foundation of Congo Free State by Leopold II. British South Africa Company claims Bechuanaland. England claims Kenya. Italians seize Massawa in Ethiopia.
1887	Expansion of English influence in Nigeria.

1888-91	Cecil Rhodes's British South Africa Company creates Rhodesia.
1889-1906	Herrero and Khoi rebellions against German colonialism.
1893	French conquest of the Tokolor empire in West Africa. Conquest of Matabeleland by the British South Africa Company.
1895-6	French annexation of Madagascar. England claims Uganda.
1896	Battle of Adowa, at which Menelik II of Ethiopia defeats the Italians.
1896-7	Third British war against Ashanti. British conquest of Benin. Matabele rising. French conquests of Dahomey and Ivory Coast.
1898	Fashoda incident between France and England. Conquest of Sudan by a British–Egyptian army.
1899-1902	Anglo-Boer War.
1905	Maji Maji rising in Tanganyika.
1906	Zulu rising in Natal.
1908	Sovereignty over the Congo transferred to Belgium.

Warriors versus soldiers

In the 1890s imperialism for the first time became a popular cause in western countries. Before that it had been an affair of state, a matter for elite or colonial interests. Now popular imperialism (*Volksimperialismus*) went along with mass-scale patriotic propaganda and chauvinism. This was brought about to a considerable extent by propaganda which sought to make nationalism and imperialism popular, although this period also saw the harvest and culmination of all the prejudices which the century had accumulated.

In the era of colonialism popular culture became more than ever before an instrument of political propaganda, infused with nationalist and patriotic feeling, modulated if not directed from above. 'Popular' acquired another meaning. Rivalries between European states and the forces of nationalism, political anti-Semitism and racism were concerns in and of themselves, as well as manoeuvres to neutralize the class struggle and transform class solidarity into national and racial solidarity, which would be controllable from above.[2] (How controllable would appear during the World Wars.) So part of the background to the expansionist epoch in Europe and in the United States was the momentum of the workers' movement, which in the 1880s and '90s appeared to be pressing forward irresistibly. To ruling élites nationalism seemed a way of neutralizing the class struggle and of stemming the tide of social revolution. The beginnings of modern political propaganda, often dated from World War I,[3] can probably be considerably advanced.

Press reporting of colonial conflicts raised issues of national prestige and military morale, against a backdrop of intensifying rivalries in Europe itself. The boulevard press also stepped into the fray. As regards the press, there was a distinction between the news magazines such as, in England, the *Illustrated London News* and its competitor, the *Graphic*, and satirical periodicals such as *Punch*, *Judy* and *Fun*; in France *Le Rire*, *Pêle Mêle*, *L'Assiette au Beurre*, *Fantasio*; and in Germany *Simplicissimus* and *Lustige Blätter*. The news magazines sent special correspondents and artists to the 'small wars' and campaigns which were sufficiently remote for the public almost to view them as a form of entertainment'. The war artists worked in 'death or glory' style, depicting

Whatever happens, we have got
The Maxim Gun, and they have not.

Hilaire Belloc

C is for Colonies
Rightly we boast,
That of all the great nations
Great Britain has most.

Mrs Ernest Ames, *An ABC for Baby Patriots* (1899)

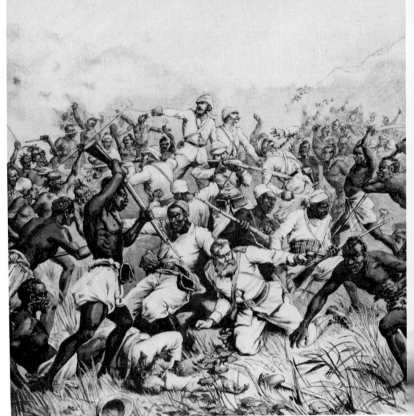

'H. Melville and Coghill Saving the Colours of the 29th Regiment, 22 Jan. 1879', by Alphonse de Neuville. The battle of Isandlwana of January 1879, one of Britain's historic defeats, is glorified in this painting in the 'death or glory' style of the heyday of imperialism.

'Destruction of a German Expedition in Africa.' *Le Petit Journal Illustré*, 1897. A French view of a German campaign, in which Africans are shown taking the initiative.

heroic battle scenes in which cavalry charges and hand-to-hand conflict were copiously displayed, but they also produced accurate drawings of troops in the field.[4]

Satirical periodicals operated in a different fashion. Since they could not afford to send correspondents into the field, they had to excel in their caricatures, which were a kind of pictorialized editorial. Many of the grimmest enemy images of the colonized peoples are to be found among the caricatures of these periodicals which could not afford to depict reality. The readership of the illustrated magazines was the middle class; for workers their prices were too high (sixpence per issue for the *Illustrated London News*).

The basic colonial image of the *native* is, as far as Africa is concerned, an enemy image. The first episodes of colonialism were of battle and bloody violence, and these remained the fundamental reality of colonialism, even after colonial authority had been established. Rebellions were ruthlessly suppressed. Rudyard Kipling gave a classic formulation of the *enemy image* of the new imperialism, in sharp contrast to the noble *self-image* of the imperialist

> Take up the White Man's burden –
> Send forth the best ye breed –
> Go bind your sons to exile
> To serve your captives' need;
> To wait in heavy harness
> On fluttered folk and wild –
> Your new-caught, sullen peoples,
> Half devil and half child.

This poem was written in 1899, on the occasion of the American invasion of the Philippines. This is the profile of the 'ignoble savage', sighted earlier by explorers and missionaries. Nobility had shifted position.

The ignoble savage of colonialism was first of all a warrior. Virtues which earlier determined the image of the 'noble savage', such as proud aggression, were now revalued to signify cruelty, beastliness. Nudity, earlier a token of purity, now formed part of the profile of primitivism and stood for lack of control. The contrast between the warrior and the soldier, the colonial enemy image and self-image, is a version of the rhetorical contrast between savagery and civilization. Soldiers are sometimes referred to as warriors, but not the other way round. The stereotype of the warrior is a virtually naked native, ferocious, equipped with archaic arms, shown more often as an individual than in a group (but if a group is shown it is a disorganized group). The soldier, on the other hand, wears a uniform, belongs to an army and is subject to army discipline.

This contrast was a misrepresentation because African warriors were not simply acting as individuals or in hordes, but operated in organized fashion and in some cases formed armies. A similar and related fiction was that African societies were 'stateless' and existed in a state of 'natural anarchy'. Nevertheless, several African societies managed to keep European armies at bay for decades and in some cases inflicted costly defeats.

Frightful warriors in the tradition of colonial ethnography. Specimen of the colonial enemy image. 'Warrior from Wagogo'. *Stanley's Travels* (1886).

'On the war path in Masai land.' Bettany, *The World's Inhabitants* (1888).

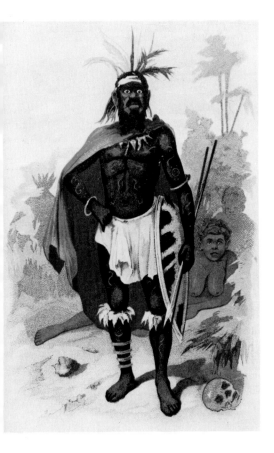

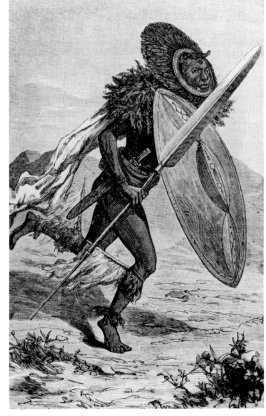

The main excuse for European aggression was *savagery* and the recurren[t] pretext was the practice of human sacrifice. Colonial campaigns were ofte[n] preceded or accompanied by articles in the illustrated press which dealt ex[-] tensively with human sacrifice. The *Illustrated London News* on 26 July and o[n] 8 and 29 November 1873 devoted a series of articles to the Ashanti, under th[e] headline 'The Gold Coast and Ashantee War'. Sinister witch doctors an[d] rituals were depicted in word and image, along with a dark 'Ju-ju house' sur[-] rounded by human skulls. A drawing showed a beautiful woman (with mor[e] or less western features) tied to a pole on a river bank, with a crocodile in th[e] background slouching towards her. These articles preceded the British cam[-] paign of 1874 by less than a year. In an article about Dahomey in the sam[e] year, 1873, human sacrifice was again the main theme and prominently por[-] trayed.[5] Abolishing human sacrifice was the pretext for the British invasio[n] and subjection of Benin in 1897 – 'Stop African savagery! Abolish huma[n] sacrifice!'[6] – and again the subject of human sacrifice was extensively covere[d] in the British press.

A sensitive episode in the British expansion was the Zulu war. In January 1879 at the battle of Isandlwana the British lost 1,600 men. Nowadays the battle is on record as 'one of Europe's dramatic defeats' and 'the heaviest British defeat since the Crimean war'[7] but *Judy* wrote on 26 February 1879: 'Never was there a finer example of steadfast valour.' At Rorke's Drift i[n] February the British again suffered defeat by the Zulus. The tide turned only on 3 and 4 July with the British attack on the Zulu headquarters in Ulundi. This was the first time that machine guns were used in Africa. Two Gatlings mowed down the Zulus, who lost 473 men, though the press at the time di[d] not report this.[8]

The British admired the Zulu *impis* for their martial character, their dis[-] ciplined organization and methods of war, but while the conflict lasted the propaganda element predominated and produced enemy images of degener[-]

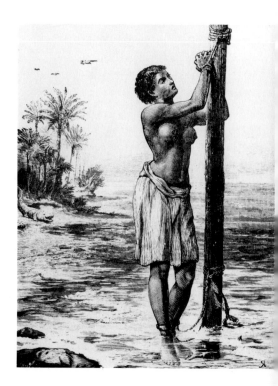

'The Sacrifice of a Ju-Ju Girl'. Insinuating illustration accompanying an article about the Ashanti. An example of British imperial propaganda. *Illustrated London News*, 29 Nov. 1873.

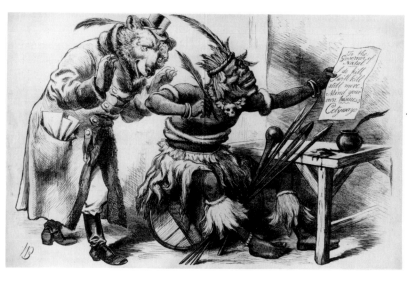

Cetshwayo, king of the Zulus, caricatured during one of the Anglo-Zulu wars. Caption: 'A lesson in diplomacy – of a certain sort. Experienced Despatch Writer to Untutored Savage. That will never do! Say that you have no intention of hurting anyone, and then do just what you please.' On the sheet of paper is written: 'To the Governor of Natal I do kill I will kill still more. Mind your own business. Cetshwayo.' *Judy*, 1879.

A 'normal' portrait of Cetshwayo kaMpande, appearing years after the war. *The World's Inhabitants* (1888).

ate, bedevilled Zulus. Cetshwayo kaMpande, king of the Zulus from 1873, was caricatured in beastly images as long as the war lasted. Only when the war was over and the Zulus were defeated did 'normal' portraits of Cetshwayo appear again in British media, so incisive was the psychology of antagonism.

European images of African warriors reflect the dominant rural and pastoral image of Africa. European depictions usually show martial types whose technological equipment is unimpressive. Although many African peoples had been equipped with firearms for several centuries, in Europe they were still portrayed, as in the trade cards of the soup manufacturer Liebig, for the instruction of youth, with rustic and archaic weapons.

Fetishism was one of the classic ingredients of the enemy image of Africans, but the way in which European protagonists were represented often displayed European fetishism. John Hobson saw this mentality in England during the Anglo-Boer War: jingoism in his view was the 'quintessence of savagery'. Fetishism took the form of a 'reversion to belief in England's God, a barbarian tribal diety who fights with and for our big battalions'.[9] H. G. Wells observed this disposition in the worship of Britannia as one of England's 'tribal gods'.[10] In popular imperial iconography Britannia often stands in for the English self-image.

European national hero-worship moved from the explorers, headed by Livingstone and Stanley, to the generals and commanders – Gordon, Wolse-

ley and Lord Kitchener for England, Marchand and Bugeaud for France – and empire-builders like Cecil Rhodes and Lord Cromer. They were the European counterparts of the caricatured African leaders like Cetshwayo, King Ja-Ja of Opobo, Menelik II and Mohammad Bin Abdullah Hassan, alias the Mad Mullah of Somaliland. These, and figures such as Britannia, graphically represented reality in the iconography of empire, *uncaricatured* and therefore 'true'.

The deployment of machine guns decided matters in Africa. Gatlings played a key part in the battle for Tel-el-Kebir in Egypt in 1882, although this does not appear from the drawings and paintings of the battle. The most significant and devastating turning-point was the battle of Omdurman (1884) in which 28 British and 20 others on the British side fell as against 11,000 Dervishes, mowed down by the Maxims. Africans were usually not afraid of the European rifles, but the machine gun changed the situation. A Matabele reacted thus to the conquest of Matabeleland: 'And the white man had come again with his guns that spat bullets as the heavens sometimes spit hail, and who were the naked Matabele to stand up against these guns?' A Fulani in the battle for Hausaland in 1903 described it as follows: 'It was Sunday when they came. The guns fired "bap-bap-bap" and many hundreds were killed.'[11]

The machine gun was vital to the colonization of Africa. Automatic fire enabled small units of soldiers to eliminate native resistance and to control enormous areas. Reputed to be a weapon that 'is specially adapted to terrify a barbarous or semi-civilized foe', according to the *Army and Navy Journal*, it was effective, in the words of the inventor Hiram Maxim, 'in stopping the mad rush of savages'. Colonial contempt and dehumanization went together: the machine gun depersonalized violence and turned combat into a technical rather than a human affair. It is significant that this technological turning-point coincided with the onset of the scramble for Africa.

Africans in European uniform

The Europeans carried out their conquest of Africa with forces made up mainly of Africans. The recruiting of Africans dates back, in modern history, to the sixteenth century and the *guerra preta* or 'black army' of the Portuguese in western Angola. Early in the 1800s France recruited Africans through local chiefs, who now supplied as troops the prisoners of war whom they had earlier sold as slaves. Thus in 1828 the French sent two companies of Wolof soldiers to fight in Madagascar. Out of this came in 1857 the multi-ethnic *Tirailleurs Sénégalais*. The troops of the Italians in Ethiopia and Tigray were for the most part Eritrean *ascari* under Italian officers. The Germans bought slaves and turned them into soldiers to serve in Cameroon; these soldiers received no wages. African armies also made use of mercenaries, sometimes, ironically, of the same ethnic origin as the forces they opposed. Two native regiments who marched under Wolseley against the Ashanti in 1874 were partly Hausa, while the Ashanti army also included a Hausa unit.

Ethnic soldiers are a phenomenon familiar from the imperial chronicles of antiquity as well as modern times. The 'Gurkha syndrome', or joining the conqueror's army, is a classic form of ethnic political adaptation.[12] In the annals of European imperialism ethnic soldiers play an important part. What was more economical than recruiting men from a colonized people to deploy

Warrior and soldier – enemy and recruit. *Above*: 'A rebel follower of the Mahdi'. *Facing page*: 'A Sudanese or loyal black soldier.' Telling contrasts in dress, equipment and posture. *The Graphic*, 5 Jan. 1884.

them against the next target and to suppress revolts? This is how a young officer in the King's African Rifles, Richard Meinertzhagen, based in Kikuyu territory in 1903, described the situation: 'Here we are, three white men in the heart of Africa with twenty nigger soldiers and fifty nigger police . . . administering a district inhabited by half a million well-armed savages who have only recently come in touch with the white man. The position is most humorous.'[13]

In the colonies all the European powers used native soldiers. 'Old servitudes had simply acquired a new form', as Basil Davidson has remarked. In West Africa the British recruited 25,000 troops, many of whom were deployed in the war against the Germans in East Africa. The German forces in Tanganyika at the end of the First World War consisted of 3,000 Europeans and 11,000 Africans.[14] But to deploy African soldiers in Europe was another matter. France, with the longest colonial history in Africa, led the way. In the Crimean War (1854-6) 40 per cent of the French forces were Africans; Africans fought in the French army in Mexico in the 1860s and in the Franco-Prussian War of 1870-1. During the First World War France deployed 211,000 African troops (including North Africans). Blaise Diagne, the *député* from Senegal in the National Assembly, served as mediator in this recruitment and justified his doing so with the argument, which never came to anything, that if Africans fought in the war they would have a say in the peace. Some 170,000 African soldiers were deployed on the deadly Western Front where in the end 24,762 were reported killed (and yet others missing). In 1920-2 France deployed African soldiers in the occupation of the Rhineland.

'L'armée coloniale'. The colonial army of the French empire. From left to right: Officier de tirailleurs sénégalais, Cipahis des Indes, Tirailleur algérien, Legion étrangère, Tirailleur annamite, Tirailleur de Madagascar, Spahi sénégalais, Spahi algérien. Cover of *Le Petit Journal Illustré*, 7 March 1891.

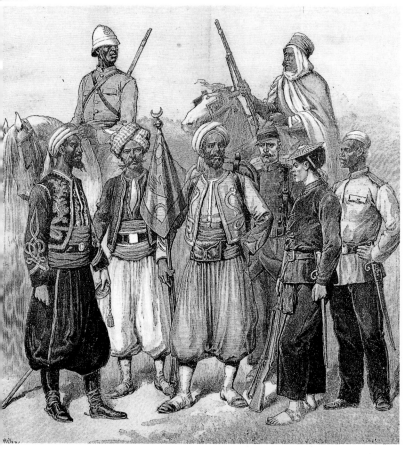

The deployment of non-European forces in Europe led time and again to racist reactions. When the French prisoners of war were brought to Munich in 1871 a German newspaper commented that the Africans, Turcos, Zouaves and Zephyrs among them were but 'armselige Burschen' (miserable chaps) and that they would have been as cruel as wild animals had they won – but, fortunately, the German people were victorious.

In a booklet published during or soon after the First World War, *Der Völkerzirkus unserer Feinde* (The Circus of Peoples of our Enemies), the famous ethnologist Leo Frobenius mocked the non-European soldiers deployed by Germany's enemies. John Bull is caricatured as a tamer of peoples and the metaphor of the circus and the training of peoples is maintained, in other words the non-Europeans are presented as trained animals. And then, announces Frobenius, the performance begins: He prints a series of photographs of allochthonous soldiers in a style suggesting a police dossier. Some scenes carry denigrating captions such as: 'Coloured Frenchmen in the field during a combat break'; 'White and coloured Englishmen at a dance behind the front lines'.

When the French deployed African troops on the Rhine in 1920 a campaign of protest was started in England by, of all people, E. D. Morel, who had earlier founded the Congo Reform Association to protest the cruelties in Leopold's Congo. Now Morel, an influential voice in progressive and humanitarian circles in England, argued: 'The African race is the most developed sexually of any. These levies are recruited from tribes in a primitive state of development. They have not, of course, their women with them. Sexually they are unrestrained and unrestrainable.' H. W. Massingham in the Liberal newspaper *The Nation* complained about 'the parading of the coloured troops in the time-honoured shrines of German state patriotism' and 'the lordship of half-savage soldiers over the culture and civism of the Rhine.'[15] The fear of 'racial mixture' was also the basis for the curbs on the immigration of black sailors to England and elsewhere.

In the American Republic blacks were deployed in the Union forces during the Civil War, but it was not until the Second World War that the US armed forces were desegregated. The presence of black GI's in Europe was also the theme of caricatures and propaganda.[16] The Nazis (and the Axis powers generally) made it a propaganda theme during World War II, again referring to the spectre of racial mixture and invariably suggesting collusion between black Americans and Jews.[17]

'The Little Chocolate Soldier'. Poster by Will Owen, Great Britain.

Senegalese riflemen wage war on the French fronts, but are marginal in French society. 'Ça tombe bien.' The Senegalese soldier says in 'African' French. 'No matter, Mademiselle! It fell on the right side! . . . It didn't stain my paper.' The soldier is being exposed as rude and uncouth in the army magazine A la Baïonette.

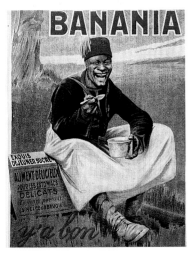

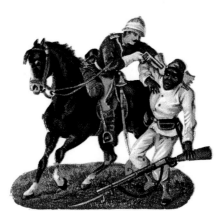

'Banania. Y'a bon.' The original advertising poster of the breakfast dish Banania, showing a Senegalese rifleman in the field. The poster dates from the war year 1917. *Négripub* (1987).

Kid's print (n.d.)

Italian propaganda poster suggestion: how black American GIs handle art. A black GI as a brute with the Venus de Milo. 1943. Treviso, Museo Civico Luigi Bailo.

The scramble for Africa

The scramble for Africa, the race among European states to acquire territory in Africa between 1880 and 1910, involved a medley of motives: (1) Strategic considerations – to keep open the sea routes to India, England had an interest in the Cape and in Egypt.[18] (2) National grandeur – to compensate for its defeat in the Franco-Prussian War France turned to conquests outside Europe. (3) National grandeur and economic gain – Leopold II wanted to turn Belgium into an empire (*'la capitale d'un immense empire'*) by acquiring territory outside Europe. The small Netherlands, which seemed large and prosperous through the possession of the huge Indonesian archipelago, served as one of his examples.[19] (4) Economic fluctuations and domestic politics – in a period of economic decline Bismarck ushered in a policy of expansion, to establish political cohesion between different interest groups in the Reich and to try to neutralize the forward march of the workers' movement.[20] (5) Instability in Africa and pre-emptive imperialism, along with domestic political considerations, further played their part, in varying combinations, in all the imperial initiatives in Africa.

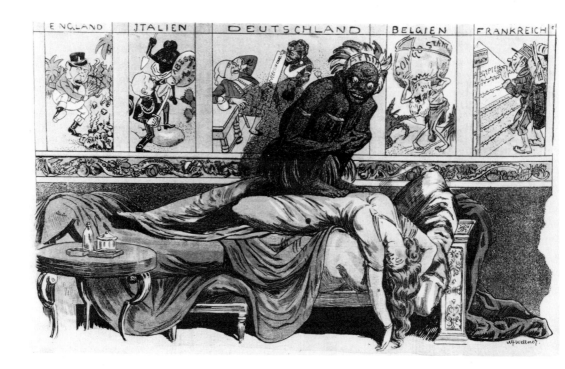

ENGLAND | JTALIEN | DEUTSCHLAND | BELGIEN | FRANKREICH

Rivalry among European states, with Africa as the main arena, was the key issue, according to one school of interpretation of the new imperialism.[21] The cartoons and caricatures of the period (after 1885), which invariably put a greater emphasis on diplomatic conflicts among European states than on the colonial expansion itself, confirm this. They show graphically the projection of the European balance of power on to the map of Africa. In popular imagery those diplomatic conflicts weighed more heavily than the confrontation with the African population.

While the colonialism of one's own country was generally, aside from mild satire, depicted in patriotic colours, the colonialism of other states was viewed critically. That the French press mocked German colonialism, and the Germans and French criticized the British, and so forth, was itself a reflection of European rivalries.

What place Africa had in all this was not always clear. 'Like a succubus Africa weighs on Europe's repose . . .' In this illustration in Le Rire (18 April 1896) Europe is represented as a young woman asleep.[22] The caption speaks of 'One of the numerous *malaises* (but perhaps the heaviest) now burdening the Old Continent. Each European power has here its obstacle or hornets' nest.' The representation is peculiar. If the Continent is old then why is it depicted as a young woman? Why is Europe represented in human form and as female, and Africa as a demon and male? And above all, when Africa is the victim of European aggression, why is it represented as the aggressor, as the nightmare of swooning Europe? It's the world upside-down: blaming the victim. As an image of Africa it harks back to the gargoyle of the early Middle Ages.

Under the influence of the Boer War the popular enthusiasm for imperialism and racial patriotism was waning. The British Empire, which some European countries had implicitly supported and identified with earlier in the

nineteenth century, lost prestige and credibility through its bloody war against the Boers. Barbarous methods of warfare used against a white people in Africa created aversion in Europe, and in England itself. In the early years of the twentieth century the imperial mission looked too much like 'British bullying of smaller nations'. Besides, there was the problem of the Congo.

The most infamous of all European regimes in Africa was the Belgian King Leopold's Congo Free State. It inspired Joseph Conrad's *Heart of Darkness* (1899) and Mark Twain's sardonic *King Leopold's Soliloquy* (1907). The state established in 1885 under Leopold's personal rule was set up as a financial and economic enterprise rather than a political entity. The state claimed the land that was not effectively under cultivation and prohibited the population from starting new cultivation, while imposing heavy taxes and forced labour. According to a popular image the savages were only good for work. King Leopold had invested most of his personal fortune in developing his African empire, which, however, lacked exportable commodities, apart from ivory and raw rubber. Large companies were given concessions, covering huge areas; faced with the increasing demand for rubber throughout the world after 1895, they recruited forced labour and imposed quotas upon the population to harvest rubber. If the quotas were not met cruel punishments ensued, to the point of chopping off hands and feet. The result was a reign of terror.

After 1900 more and more reports of the 'Congo atrocities', from Protestant missionaries and from the British Consul Roger Casement, filtered through. The campaign against the abuses in the Congo was a humanitarian campaign, but it also argued that the Congo gave European colonialism a bad name. This argument was reminiscent of the earlier charges of abuses and mistreatment of slaves, which implied that slavery itself was acceptable. On behalf of the Congo Reform Association E. D. Morel and Harry Johnston published *Red Rubber* (1906), in which they warned that in the absence of reforms in the Congo, African resistance to European hegemony in Africa would increase.[23] In response to mounting public pressure, sovereignty over the Congo was transferred in 1908 from King Leopold himself to the Belgian state.[24]

'In the Rubber Coils.' Leopold the Rubber King of the Congo Free State. Satire of Leopold's colonialism in *Punch*, 28 Nov. 1906.

'The New Congo Hymn.' 'Hail to thee in victor's laurels, Ruler of Congo land, Hail Leopold! Ivory we bring, rubber we win, and for that our head rolls.' *Simplicissimus*, 11 Dec. 1904.

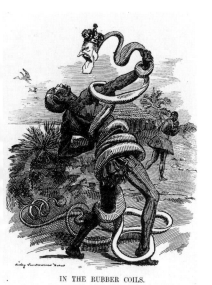

IN THE RUBBER COILS.

Scenes of colonialism

After the smoke from gunpowder lifted and the colonial situation became stabilized, colonial imagery shifted from the enemy image to the colonial psychology of superiority and inferiority. The colonial superiority complex was a political and psychological necessity to enable a tiny minority of foreigners to control the local majority. 'It is suicidal for Europeans', noted an English observer, 'to admit that natives can do anything better than themselves. They should claim to be superior in anything and only allow natives to take a secondary or subordinate part.'[25] Prestige, intimidation, a show of power were the cornerstones of imperial psychology. These came with definite views on those who were no longer enemies but subjects.

A new mythology of Africa took shape which met the needs of established colonialism. Savages had to be turned into political subjects. The paternalistic aura of the White Man's Burden required subjects who would fill the bill. Gradually the imagery shifted and Africans were characterized, no longer as savage or primitive, but as impulsive and childlike – the second part of 'half devil and half child'. The character of the African, according to a colonial observer, is 'as plastic and impressionable as a child's – a blank sheet whereon we may write at will, without the necessity of first deleting old impressions'.[26] Virtues they did possess, although not of the kind which Europeans cared to

Kaloderma Shaving Soap. German advertising poster by Ludwig Hohlwein (1874-1949) depicting colonial relationships of servitude.

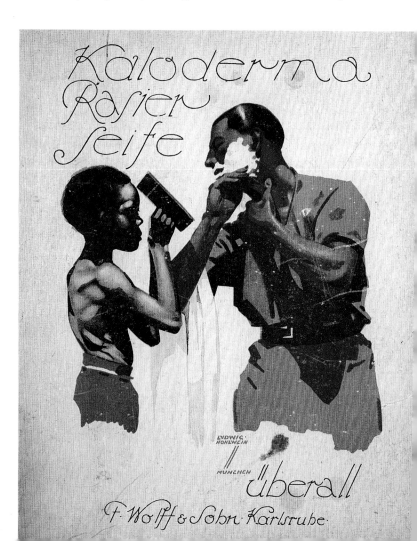

88

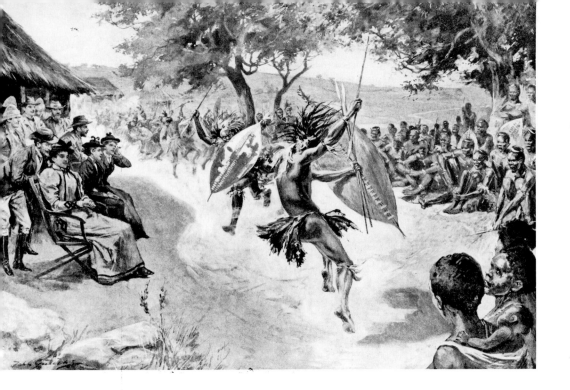

claim: kindness, compassion, humour – they were 'soft' virtues, not the hard, manly ones.

Thus the images of the savage warrior made way for the stereotype of the African as a child: the miraculous metamorphosis of the ferocious savage into the child-savage. North American society, where social relations were in some respects comparable to those of colonial Africa, produced a similar image of the black child/savage.[27] Colonial paternalism engendered as its counterpart the infantilism of the colonized. A Belgian colonial novel of 1896 described the metamorphosis thus: 'Once he [the Negro] comes in touch with the white man, he loses his barbarian character and only retains the childlike qualities of the inhabitants of the forest.'[28] Surinamese Creoles on display at the Colonial Exhibition in Amsterdam in 1883 were described in the same terms: 'The appearance of these groups of Creoles had something kind and childlike, that is naturally appealing; real children of tropical nature, carefree, enjoying life without worries, restless, keen on movement, noise, colour, light, but also kind and sweet.'[29] Meanwhile the stereotype of the ferocious savage did not simply vanish, but was relegated to a subsidiary role – that of the rebel, Simba, or later, the Mau Mau terrorist.

Among the primal scenes of colonialism are scenes of subjection – native dignitaries throwing themselves down in the dust before the representatives of European authority. Or, in a system of indirect rule through the local élite, the rituals of the official state visit and the displays of élite pomposity. Attractive to Europeans and psychologically reassuring, in what back in Europe was a time of social insubordination and transformation, was the tight social hierarchy inherent in colonialism. It was a hierarchy based on the colonial 'colour bar', but other distinctions such as between European and native dress counted as well.

'Entertaining visitors in Matabeleland: A native dance at Bulawayo.' Scenes of established colonialism – the enemy has become a spectacle . . . : 'When all was ready, first came two splendidly made Matabele warriors, of pure blood, dressed up fully in war costume, with ostrich feather headdresses and shoulder capes, skin waist dresses, armlets and leglets, shields, assegais, and battle-axe, who went through an immitation battle, accompanying their easily understood actions with war cries, shouts and horrible noises.' *The Graphic*, 27 July 1895.

Personal service by natives forms an essential component of the colonial ambience which is also psychologically satisfying. Being *carried* by natives sums up the symbolism as well as the reality of European hegemony. The *tipoye*, the carrying hammock or seat, is one of the basic relics of colonialism. Nevertheless, an image that gained currency in the colonial situation was that of the *lazy native*.

Early in the nineteenth century the profile of the simple 'good savage' out of the repertory of the Romantics still ran as follows:

> Gifted with a carelessness which is totally unique, with an extreme agility, indolence, sloth and great sobriety, the negro exists on his native soil, in the sweetest apathy, unconscious of want or pain or privation, tormented neither with the cares of ambition, nor with the devouring ardour of desire. To him the necessary and indispensable articles of life are reduced to a very small number; and those endless wants which torment Europeans are not known amongst the negroes of Africa.[30]

The poet J. Montgomery mused in 1807:

> . . . Is the Negro blest? His generous soil
> With harvest plenty crowns his simple toil
> More than his wants his flocks and fields afford . . .

The carrying hammock, one of the symbols of colonial hierarchy. 'Travel in Sierra Leone'. *Das Buch für Alle*.

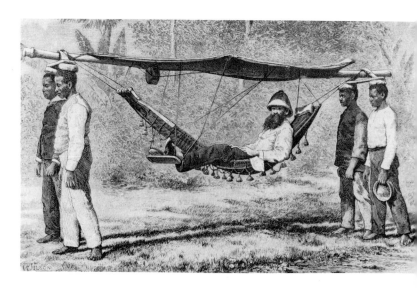

'The world's workers. A British Museum official returning to England with a dead bargain.' *Punch*, 9 Aug. 1911.

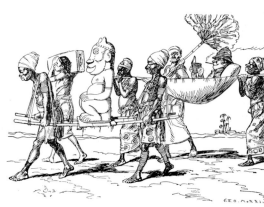

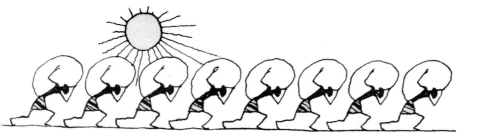

The very qualities which at the start of the century evoked images of paradise were revalued by the latter part of the century, in conjunction with industrialization, neo-Puritanism and the Protestant ethic in Europe, and colonialism in Africa, to give rise to the image of the lazy native, indolent and without ambition in the midst of tropical plenty. Emptiness had become a curse. That these images were both devoid of reality is not the issue here: they served as an echo of alternating desires and strivings of occidental culture. They helped shape Europe's regime of truth. The stereotype of the lazy native was inherent in colonialism and not specific to Africa. American images were of the lazy Injun and the slumbering Mexican. Surinamese Bush-negroes were described thus in 1883: 'In general they are inert and lazy, and only work when they are compelled by necessity . . .'[31] The stereotype of the lazy native dovetailed with the expansion of capitalism, served as an alibi for forced labour and exploitation, and thus formed a lucrative component of the civilizing mission. Marx referred to the creation of 'universal industriousness' as one aspect of 'the great civilizing influence of capital'.[32]

The image of the lazy native performed yet another function in justifying colonialism. Back in the eighteenth century the philosophy had been formulated that the possession of foreign land by Europeans was rightful if it was unoccupied, so-called empty land or *terra nullius*, which was defined as 'uncultivated'.[33] The claim of native laziness therefore was simultaneously a claim to the legality of colonialism. In another way the endlessly reproduced images of natives as hunters, in decorative poses with rustic arms, spear and bow and arrow, carried as their subtext that the people were only hunters and not cultivators – again an implicit endorsement of European colonialism bringing native lands to fruition.

The leitmotiv of colonial propaganda was economic gain. The favourite image of the colony, in the home country, was of a place being made productive through European discipline and ingenuity, where under European management natural resources were being exploited, where order reigned so that labour could be productive. 'Useful products' and (cheap) labour therefore play an important part in colonial iconography. The cheerful image of productive colonies was disseminated by means of postcards, advertising and packaging of colonial products. An Englishman remembered his youth in the 1930s: 'Empire was all around us, celebrated on our biscuit tins, chronicled on our cigarette cards, part of the fabric of our lives. We were all imperialists then.'[34]

The image of the colonies as sources of prosperity was prevalent in Europe. As the loser in the First World War, Germany had lost its colonies, but the colonial idea lived on, also as part of the National Socialist programme. Köhler's Kolonial-Kalender (*Die Wildnis Ruft*, The Wilderness Calls) summed up the idea in 1934: 'Ohne Kolonien, Volk in Not,/ Kolonialbesitz, Arbeit und Brot' (Without colonies, people in distress/ With colonies, work and bread).[35]

'Strong negroes carry our peanuts in bags to the coast.' Drawing by Jo Spier in recipe booklet for salad-oil products by Calvé (Delft, Netherlands), 1920s.

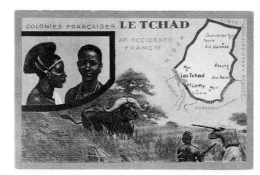

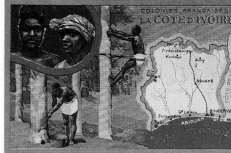

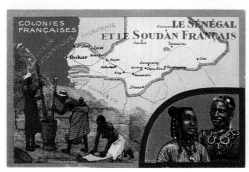

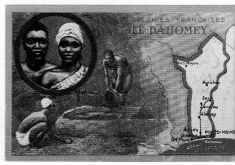

Four postcards out of a series of eight from the French African colonies, following a fixed pattern: a map, African engaged in typical activities, and typical inhabitants (inset). France, 1950s.

In a set of picture postcards of the French African colonies after World War II the standard composition includes a little map which situates the colony geographically, Africans labouring on some useful product, and 'typical natives'. Shares in colonial enterprises were likewise illustrated with views of orderly plantations carved out of the wilderness and natives at work under European supervision.[36] The key image was that of natural abundance harnessed through European discipline and control.

'Useful plants of the Congo.' The cocoa tree and the oil palm. The 'usefulness' of the colonies popularized in advertising cards, from a series distributed by the Belgian soup manufacturer, Liebig, 1941.

figures of the world's non-western peoples: rarely do they have a name, always are they typical, the typical representative of their people. Image after image is facing us, with instructive captions such as: Congolese, Guinéen, Galla. This is the encyclopaedia of the nineteenth century, the census of imperialism, the parade of the vanquished. Their figures and faces populate volumes with panoramic titles such as *The World's Inhabitants, or Mankind, Animals, and Plants; Le Tour du Monde* or *Journey Around the World: Description of the Different Countries and Peoples, Customs and Habits*. They fill illustrated works of ethnography and are popularized for the enlightenment of the young in the advertising cards of soup or cheese manufacturers.

In various ways the figures depicted were turned into objects. They were isolated from their environment or their environment was presented in a schematic fashion. Placing the figure in the foreground reinforced the observer's sensation of having an overview and control over it. 'Otherness' had to be conveyed within the framework of Victorian aesthetic conventions. Classical examples from antiquity determined the posture and expression with which the natives were represented, while exotic attributes served to convey their 'otherness'. Over a hundred years there was not much change – the figures portrayed were not individualized; individuality is an attribute of civilization and a western privilege. But the emphases here and in popular representations did shift: the physiognomy alone was no longer sufficient and 'typical activities', like the hunt or preparation of food, or 'typical attributes', like tattoos or headgear, were emphasized.

The ethnology of the first half of the century was largely racial in conception. The objective was to map *races* and knowledge, or the illusion of knowledge, was not yet detailed enough to distinguish *peoples*. And even if this was the case the pretension often was that a certain people stood for a more general type. Colonial ethnography of the latter part of the century

Colonial power produces the colonized as a fixed reality which is at once an 'other' and yet entirely knowable and visible.

Homi K. Bhabha[37]

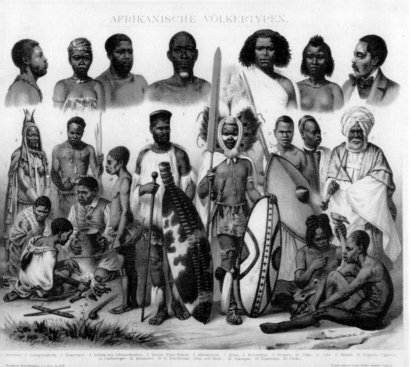

AFRIKANISCHE VÖLKERTYPEN.

'Afrikanische Völkertype.' Colonial ethnography popularized. The figures are numbered and identified as belonging to various African peoples. *Brockhaus' Konversations Lexicon* (Leipzig).

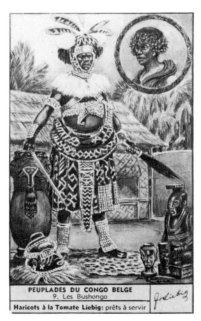

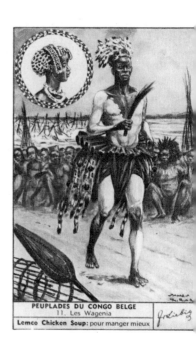

'Peuplades du Congo Belge.' 'Les Bushongo. Haricots à la Tomate Liebig: ready to serve'. 'Les Wagenia. Lemco Chicken Soup: pour manger mieux'. Liebig chromos, 1955.

PEUPLADES DU CONGO BELGE
9. Les Bushongo
Haricots à la Tomate Liebig: prêts à servir

PEUPLADES DU CONGO BELGE
11. Les Wagenia
Lemco Chicken Soup: pour manger mieux

Cigar bands, Washington brand. 'Senegambian, Ugogoer, Senegambian.'

went beyond this stage in some respects. From an administrative and other points of view it had different knowledge requirements and illusions, as it existed according to a different regime of truth. *Knowing* the colonized is one of the fundamental forms of control and possession. One application of this knowledge is that the subject peoples are turned into visual objects. The knowledge circulates by means of images – the availability of ethnological images in scientific, aesthetic or popular form is a basic feature of imperial cultures.

Was the first Playmate after Aphrodite, the Hottentot Venus, the anthropo-erotic sensation of nineteenth-century Europe? Was she a Creole beauty or the Black Venus? In the course of the century, early on in the case of orientalism, ethnographic images took on the additional function of ersatz pornography. For many young men in the West pictures of scantily dressed native women, or African women with bare breasts in decorative poses, brought them their first visual familiarity with female nudity, through magazines such as the *National Geographic* in the United States, illustrated encyclopaedias and postcards.[38] The world of colonialism is a men's world.

This forms part of the ambivalence in western attitudes *vis-à-vis* non-western peoples, the mixture of attraction and repulsion. Part of this is the pattern of attraction by the 'feminine', sensuous, seductive element, and repulsion by the 'masculine', threatening, primitive element. On the one hand the native beauty and on the other the cannibal. The recurring tale of Beauty and the Beast.

Colonial exhibitions

'The web of world exhibitions that was extended over the economic fault lines of American society between 1876 and 1916', notes Robert Rydell, 're

ected the attempts of America's intellectual, political, and business leaders o forge a consensus over their priorities and their vision of progress as racial upremacy and economic growth.'[39] The American exhibits are part of a world-wide trend – a measure of western industrial capability since the Crystal Palace Exhibition in London of 1851 and of western colonial and racial upremacy since the Paris World's Fair of 1889, the first in which African and Asian colonies were noticeably represented. The colonies were first represented by their products only. The World's Fair in Antwerp in 1894 was the irst at which Africans were present. A Congolese village was reconstructed or which sixteen Congolese were brought over: three of them died during the air and four fell seriously ill.

Expositions are the timekeepers of progress.

President William McKinley

The principle of peoples on view goes back to the empires of Egypt and Rome and the triumphal processions in which prisoners of war were paraded along with the war booty; to the American Indians brought to Spain and Portugal in 1500 by Amerigo Vespucci and Gaspar Corte-Real to be shown not only at court but also as a kind of fair attraction.

In 1845 Captain Louis Meyer of the Magalhaes offered the Royal Society or Zoology in Antwerp a negro boy ten years old. Should he turn out to be too wild for the zoo, he could be sent back. The boy, Jozef Moller, popularly called 'Jefke of den Zoölogie', was allowed to walk around uncaged and for many years was a major attraction at the Antwerp zoo.[40]

Exhibits of non-western peoples were first organized by zoos, apparently on the grounds that with exotic animals went matching people, and probably making use of the same trade connections. In Germany such exhibits were organized by the Hamburg animal trader and zoo director Carl Hagenbeck. In his memoirs he refers to them as 'anthropological-zoological exhibits'. Groups of Lapps, Nubians, Eskimos, Kalmucks, Bella-Coola Indians, Sinhaese, Ethiopians, Somalis and so on followed one another in a motley parade from the 1870s onward. LaGrange in Paris in 1881 staged ethnographic shows in the Jardin d'Acclimatation of the Bois de Boulogne. Godefroy brought an ethnographic collection from Angola to the Netherlands in 1888 with a group of twenty-three slaves, selected in such a way that they would be 'wild customers'.

Thus during the heyday of imperialism many exhibits of peoples were organized: at a price, the public were shown Negroes, Indians, Asians, situated in their own dwellings. In colonial ethnography the colonized were turned into objects of knowledge, in the colonial exhibits they were turned into spectacles. The peoples on display were the trophies of victory. After the battle was done with, the image of the native warrior, prior to that so threatening and repulsive that it had to be exorcized by means of horror stories and gruesome caricatures, became *decorative*. This is one of the origins of exoticism – *turquerie* was à la mode *after* the Turks were no longer a threat to Europe; images of Noble Indians decorated shops and advertisements when the Indian Wars were past and they had been defeated for good; images of frightful African warriors, with spear or assegai, became ornamental once machine guns had done away with African resistance. Exoticism is a luxury of the victors and one of victory's psychological comforts. The Other is not merely to be exploited but also to be enjoyed, enjoyment being a finer form of exploitation.[41]

Colonial exhibits catered to the voyeurism of the victors of civilization, they were 'allegories of European hegemony' and demonstrations of racial

Entry ticket 1883.
'Surinamese Natives.
On view daily from 10
to 5.30: Different
Human Races of
Surinam'.

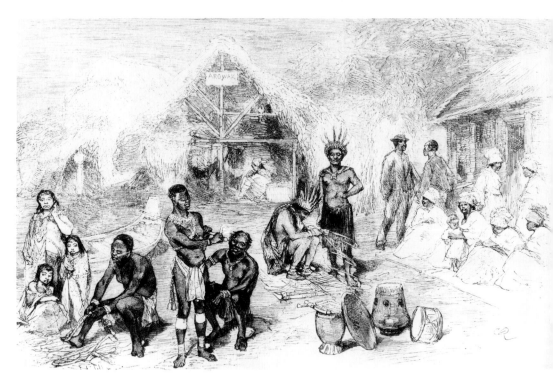

'The Surinamese natives
at the Exhibition in
Amsterdam. Drawing by
Ch. Rochussen'. 1883.

supremacy in which imperialism seemed to be transformed into 'natural history'.[42] Besides, they were 'a powerful means of propaganda for national self-elevation' which laid the basis for the rapid development of colonial and ethnographic museums in Europe. The museums themselves became manifestations of colonial power, 'in which not the essential value of the collections determined their significance but rather the pompous way in which they managed to express national power'.[43]

The Colonial Exhibition in Amsterdam in 1883, which covered a vast terrain of what is now Museum Square, included in its West Indies section a group of twenty-eight Surinamese who had been told that the King of the Netherlands was giving a party for 'all nations' to which they had been invited. For the Paris Exposition of 1900 several African villages were reconstructed. Dahomey stole the show with a replica of the tower of sacrifice of Abomey, complete with skulls and gruesome descriptions of the procedure for royal human sacrifice. But the main attraction was the *Ethnographie en nature*, prepared by African soldiers in French colonial service in Porto Novo.

Visitors to the fair could let themselves be carried in a hammock by strong Africans. The carriers did a brisk business.[44] In this way one could get the 'colonial feeling' without leaving the metropolis.

Merely exhibiting non-western peoples in a reconstructed environment was not interesting enough after a while. Action and drama were needed, especially wild action, like war dances, cannibal dances, battle scenes and so on. Between 1895 and the First World War large-scale spectacles were organized, elaborating on existing clichés. The development of film out-flanked this kind of exhibit. Film was to be still more effective in reproducing stereotypes and transforming them into spectacle.

Westernization humour

Typical is an illustration with the caption 'The Roller and the Coconuts': 'Proof of the fact that the Negroes are receptive to progress is the excellent re-ception accorded to the first steamroller in Timbuctu' (*Pêle Mêle*, 3 July 1913). We might call this kind of representation westernization humour:

Programme of the colonial exhibition in Paris, 1931.

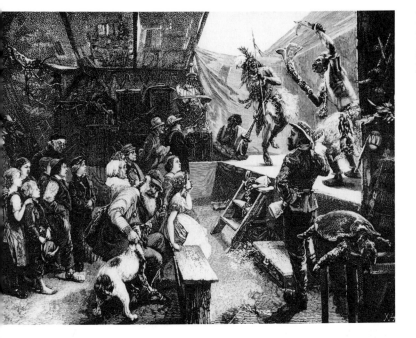

'The Savages', by Paul Friedrich Meyerheim, 1873. Aachen, Suermondt-Ludwig Museum.

Europeans mocking the way Africans react to western customs or technology. The point is usually that the western look is only superficial, underneath Africans remain what we originally defined them as: savages. The main feature of such humour is contempt. This kind of humour serves as part of the culture of domination. Laughter stigmatizes and thus demarcates the frontier between cultural worlds.

Westernization humour arose out of the gap between colonial ideology and reality. Colonial ideology was about the White Man's Burden and his civilizing mission, but colonial realities were about profit and power. Until after World War II no more than a tiny percentage of the colonial population had received any western education and then chiefly through mission schools. Colonialism was referred to as a 'school for democracy', but the colonial system was essentially autocratic. Before 1945 less than 1 per cent of the African population had any political and civil rights or access to democratic institutions.[45] The ideology of the civilizing mission was not compatible with colonial realities and was contradicted by other European ideologies, in particular racism. The explosion of European imperialism was rooted in exaggerated and largely misplaced economic expectations, at a time when the economic advantages of colonial possessions were doubtful. Articles regularly appeared with titles like 'Is Central Africa Worth Having?' The propaganda extolling colonies as profitable areas could be realized only after a considerable investment in infrastructure and if a colony would earn its own keep, thus with minimal expenditure on administration and services. This bookkeeping left no place for civilizing labour.

JanMohamed argued, in the wake of Frantz Fanon, that it is not ambivalence but Manichaeanism that characterizes western attitudes towards the non-west. The basic structure of colonial literature, then, is the 'Manichaean Allegory' according to which the conqueror and the conquered are separated by an unbridgeable gap between worlds. 'If such literature can demonstrate that the barbarism of the native is irrevocable, or at least very deeply ingrained, then the European's attempt to civilize him can continue indefinitely, the exploitation of his resources can proceed without hindrance, and the European can persist in enjoying a position of moral superiority.'[46]

Westernization humour functions in a similar way in popular culture. Among different European fictions and ideologies there are irreconcilable antinomies: How can savages be civilized? Is the gap between nature and civilization not unbridgeable and, according to racial thinking, indeed biologically grounded? The frictions which flow from this self-made European dilemma are resolved in westernization humour, which articulates the Manichaean image of irrevocably separate worlds with liberating laughter: at the expense of the natives.

Popular cartoons harp on this dilemma and the theme of civilization, reproducing over and over again the incorrigible native and the perennial savage whom no degree of western mannerism can change. Thus a cartoon with the caption 'The Benefactions of Civilization' shows elegant African gentlemen in top hats, with a monkey standing next to them, also in a top hat (Le Rire, 28 July 1900). And how is the 'good old English Christmas' celebrated among the Zulus? With human sacrifice (Punch, December 1912). So the contradictions between divergent European expectations are short-circuited, and resolved in a self-fulfilling colonial fantasy world.

In the '50s and '60s cartoons appeared in magazines like *Simplicissimus* and *Paris Match* which made fun of the African desire for independence and of post-colonial conditions. The cannibal jokes are part of what we might call decolonization humour. A specimen is a cartoon, 'Welcome to the USA!', in which ministers of a newly independent African state come to spend a credit of $20 million and show interest in everything except agricultural tools. Of a German politician on a state visit in Africa it is observed, 'How rapidly he has acclimatized': the cartoon shows him changed into a monkey. The *portée* of these jokes is that the savages are incorrigible and development aid is a waste of money. Colonial propaganda has matured into neo-colonial propaganda.

From the standpoint of Africans the Manichaean schema of savagery versus civilization may look the other way round. Many Africans experienced European imperialism as the destruction of African civilizations and their replace-

'In the black country. All sports!' 'Election sport.' Fragment, *Le Rire*, 1904.

The roller and the coconuts.' Illustration mocking the reaction to western technology in the colony. 'Proof of the fact that the negroes are receptive to progress is the excellent reception accorded the first steamroller in Timbuctu.' *Le Pêle Mêle*, 3 July 1913.

Image-building of neo-colonialism. 'Welcome to the USA!' Ministers of a newly ('day before yesterday') independent African country come to spend a credit of $20 million. They are interested in everything except agricultural tools. Caption: 'Life gave nothing to mortals without hard labour. Horatius.' Still the lazy natives. Fragment, *Simplicissimus*, 22 July 1961.

ment by western barbarism. 'The Christian disaster has come over us/ As a cloud of dust', ran a poem from Salaga in northern Ghana, written in Arabic in 1900.

African intellectuals who criticized European clichés in the '20s and '30s put forward several arguments: (1) European conquest itself was barbaric. There was wide agreement about the barbarism of the 'civilizing hordes', from the West African essayist Tovalou Houénou to Rabindranath Tagore ('You build your kingdom on corpses'). (2) The colonial system was dehumanizing. Under cover of civilization the colonized were reduced to savages. (3) There is no necessary relationship between a people's level of technological development and the level of its civilization. Terms like "high" and "low" can be applied to technological and economic development but not to civilizations. This is the argument of cultural relativism and a rejection of evolutionism. (4) Africa's modernizing potential has been blocked and sabotaged by European intervention: by the slave trade and by incursions targeted against modernizing forces such as Mohamed Ali in Egypt and Samory Touré in West Africa.[47]

These arguments have since been elaborated in several directions: in a socialist direction by Kwame Nkrumah, in psychological terms by Aimé Césaire, Frantz Fanon and Albert Memmi, in terms of political economy by thinkers of the dependency school such as Walter Rodney and Samir Amin, in cultural terms by Claude Ake and Valentin Mudimbe. Their assessments match those of critical Europeans. There is general agreement about the barbarism of European colonialism if we consult not the colonial propaganda but the documents, reports, letters and diaries of Europeans in the colonies: then it is the savage side of real colonialism which often speaks loudest.[48]

Several European witnesses held few illusions about this. Marx remarked: 'The profound hypocrisy and inherent barbarism of bourgeois civilization lies unveiled before our eyes in the colonies, where it goes naked.' Sartre noted: 'In the colonies the truth stood naked.' Joseph Conrad referred to colonialism as 'the vilest scramble for loot that ever disfigured the history of human con-

science'. Western popular culture, however, has largely followed the pattern of colonial propaganda.

In the early 1900s John Hobson and Rosa Luxemburg warned that imperialist militarism and barbarism would come back on to Europe like a boomerang. After the trench warfare of 1914-18 a question arose, also in the colonies, as to what made civilization so appealing. When in the land of 'poets and thinkers' six million human lives were sacrificed the question arose as to what made complacent western jokes at the expense of the colonized peoples so funny. Césaire and Fanon took up where Hobson and Luxemburg had left off and interpreted fascism and Nazism as 'imperialism turned inward'. It follows that the western jokes likewise reflect and boomerang on their source.

6 IMAGES OF APARTHEID

When in 1652 Dutchmen founded a settlement at the southern tip of Africa, the Cape area was inhabited by Khoi and San peoples, speakers of 'click' languages. The Europeans condescendingly referred to them as 'Hottentots' and 'Bushmen'. In the eighteenth century contact with speakers of Bantu languages began to play a role.[1] Bantu speakers include the Nguni (Xhosa, Zulu, Swazi and Ndebele), Sotho, Tsonga and Venda language groups. These peoples were usually lumped together under the label 'Kaffirs', after the Arabic word for unbeliever.

Glimpses of the prehistory of apartheid

For a long period 'Hottentots', 'Bushmen' and 'Kaffirs' figured prominently among Europe's images of Africa, repeatedly depicted in lithographs and described in books such as those by Olfert Dapper and Bernard Picard.[2] Descriptions of the Khoi and San form the basis of the early European ethnography and 'science of race' of Africa. From the seventeenth to the nineteenth centuries Ethiopia and Southern Africa were the two parts of Africa best known in Europe; but European contact with Ethiopia decreased and that with Southern Africa, the half-way station on the sea route to the East Indies, increased.

In 1795, during the Napoleonic wars, the Cape was occupied by the English, restored to the Dutch in 1803, but occupied anew in 1806 and has from then on remained in British hands. For a century it was the scene of intermittent warfare. From the outset the Cape had a mixed society – European women rarely emigrated, and relationships with Christianized indigenous women or women from Asia had to form the basis of any stable community. In Cape Town it was common for Boer men to have relations with Asian female domestic slaves, in the outlying districts with Khoi women. The latter pairings gave rise to the Griquas, a mixture of trekking Boers and Khoi women.[3] Slaves were kept until 1834, but they were only a minority, and slave masters were never as dominant socially and culturally in the Cape as in the southern United States.

This was the context of the first outpost of European anthropology in Africa. A precursor of later colonial societies in Africa, the Cape was also a laboratory of European anxieties, where prejudices were indulged to their ultimate extent. The economic, political and legal aspects of apartheid have repeatedly been discussed, but studies of the 'culture of apartheid' and of the South African popular culture in which the discourse of apartheid was shaped, imagined and transmitted are rare.[4]

There is no question that the pre-industrial 'prehistory of apartheid' is relevant to later developments in South Africa.[5] The familiar European clichés

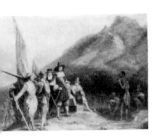

The landing of Jan van Riebeeck and company at the Cape in 1652. Painting by C. Bell, 1850. Just arrived, the newcomers are portrayed as lords and masters, obviously superior to the feeble 'natives' they encounter, as evidenced by their garments, symbols (flag) and body postures.

about black Africa first circulated at the Cape. Until well into the nineteenth century the 'curse of Ham' was the dominant formula applied to the indigenous peoples. There were the usual frictions of a frontier society, and indigenous peoples were routinely spoken of in such terms as 'the idle and thieving Bosjesman', and 'the cattle-lifting Kafir' (W. A. Newman, 1855).[6] Francis Galton, the famous anthropologist, travelling in the region in 1851 described an encounter on the coast of South West Africa as follows: 'A row of seven dirty, squalid natives came to meet us. . . . They had Hottentot features, but were of darker colour, and a most ill-looking appearance; some had trousers, some coats of skin, and they clicked, and howled, and chattered, and behaved like baboons.'[7] The emphasis on 'animal' features and the comparison with baboons is typical of European attitudes in this period. When a leading European scholar expressed himself in such terms, the way local Boers looked on the 'natives' can readily be imagined.

Europeans viewed the Khoi and San much more negatively than the Bantu speakers. The Khoi and San were regarded as lazy, thievish and ugly. In a South African ethnological pamphlet of 1935 a close-up of the lined face of an old Khoi man is captioned, 'The Carefree Hottentot'. In contrast, a photograph of 'A Zulu Warrior' shows a man at full length and in the prime of life, and the caption explains: 'Except for skin colour and the structure of hair, the Bantu race is very close to the Caucasian type of man, and in the above picture one might take the half-naked Zulu warrior with his noble and dignified bearing and his well-shaped limbs for an eminent bronze figure of a Roman swordsman'.[8] Striking here are the insinuating difference in representation between Khoi and Bantu, the remark that Bantus are close to the 'Caucasian type of man', and the characterization of the Zulu warrior, shown in classical pose, as a 'noble savage'. For Europeans the animal world and the classics (along with the Bible) serve as the main points of reference.

Ethnic hierarchy in South Africa in the 1930s. On the one hand, 'The Carefree Hottentot' – a stereotype belied by an old man's lined face – and on the other, 'The Zulu Warrior', whom one might take 'for a bronze figure of a Roman swordsman'. Uys, *Die levenswijze van die Suitd-Afrikaanse inboorlinge* (1935).

This division between, on the one hand, 'Hottentots' and 'Bushmen' as ignoble, degenerate savages and, on the other, Bantus, in particular Zulus, as noble savages had taken shape early on and was only to deepen with the course of time. The British admired the Zulus as a 'martial race'. Elsewhere in Africa the Masai, Matabele and Galla enjoyed a similar reputation. The Zulus were represented in idealized form in noble classical style, as in the famous lithos of George French Angas, *The Kafirs Illustrated* (1849).[9] During the Zulu wars, as mentioned above, an animal-like enemy image temporarily predominated, but afterwards the 'noble' image again prevailed.

The Boers shared the British cliché of the Zulus as a 'warrior race', but they also had their own adversary image of the Zulus. The murder on 6 February 1838 of Piet Retief and his company by King Dingaan's Zulus is recorded on the Retief Monument. None the less, Retief and Dingaan are depicted as equals on a frieze of the Trekkers Monument at Pretoria.[10]

What was termed the 'racial question' in early-twentieth-century South Africa referred not to relations between Europeans and Africans but to the relationship between the Boers and the British. Relations with Africans were termed the 'native question'.[11] In the conflicts between the Boers and the British, which came to a head in the Anglo-Boer War, stereotypes held by the British and the Boers about each other turned into enemy images. Lord Kitchener, the last of the British military commanders in South Africa, characterized the Boers as 'uncivilized Afrikaner savages with a thin white veneer'.[12] Lord Randolph Churchill drew the following portrait of 'the Boer': 'It may be asserted . . . that he never plants a tree, never digs a well, never makes a road, never grows a blade of corn. . . . He passes his days doing absolutely nothing beyond smoking and drinking coffee. . . . His simple ignorance is unfathomable', and so forth. In novels, from those of Pauline Smith to those of Doris Lessing, Boers were characterized as 'slow-witted', 'fatalistic', 'childlike' and a 'simple race'.

Interestingly, similar epithets were applied by Boers and British alike to the indigenous population. This confirms our general finding that images of 'others' depend not upon ethnic differences but upon particular types of hierarchical relationships (of which colonialism is one). The image of the 'child savage', familiar to colonial societies as well as to the plantation society of the southern United States, occurs also in South Africa. While there are marked differences between the historical patterns of South Africa and the American South,[13] there are striking similarities as well. There is for instance the 'Hottentot' as cluck or clown – 'Yes, it's true the Hottentot is short of hair and short of brains' – personified in Jacob Platjie, the 'Hottentot Sambo', a figure from the turn of the century who still lives on.[14]

Jan Christiaan Smuts, a general in the Boer War and afterwards twice Prime Minister of the Union of South Africa, formulated it thus in the Rhodes Memorial Lecture he gave in Oxford in 1929: 'The negro and the negroid Bantu form a distinct human type. It has largely remained a child type, with a child psychology and outlook'. However, as he explained to his English audience, 'A child-like human cannot be a bad human, for are we not in spiritual matters bidden to be like unto children?' This colonial paternalism – 'they are just like children' – has survived into the present in South Africa.[15]

In 1910 the Union of South Africa came into being on the basis of an alliance of the British and the Boers. The later apartheid policy took

embryonic shape in this period.[16] The Land Act of 1913 reserved 87 per cent of the land for the whites and 13 per cent for the black majority of the population. 'Race' was only one element in the discourses of difference in South Africa; there were many ways of negotiating differences in status between 'Europeans' and 'natives'.[17] Still, in the period between the World Wars popular image-building in South Africa was dominated by racial thinking, and during the 1930s it was under the influence of National Socialist ideas from Germany. The Afrikaner self-image was that of a *Herrenvolk*,[18] while the indigenous population were regarded as 'natives'.

Apartheid

After 1948, when the National Party came to power in South Africa, apartheid or 'separate development' took shape as the official policy. Pre-war ideology became policy. At the time the antagonism of the Afrikaners was directed first against the Indian South Africans who, with their retail chains, were their closest economic competitors.[19] The policy of apartheid was in many respects an institutionalization of practices which had existed previously. A booklet put together for Dutch people interested in emigrating to South Africa, *Zuid-Afrikaanse Vraagbaak* (1958), describes apartheid as follows: 'The guideline which is at the basis of this policy comes down to this, that the less developed non-white population, particularly the Bantus, are to be brought by the whites to self-development and to self-government, within their own communities and in their own areas.'[20]

The latter refers to the 'Homelands' or Bantustans, which became established policy in 1959 when the Self-Government Act was adopted. The Bantustans are generally infertile rural areas with scant opportunities for employment, comparable to the American Indian reservations. They act as labour reserves for a migratory African work-force, thus lowering the cost of labour and making possible low wages and minimal working conditions.

The image-building of apartheid is encapsulated in a single sentence in the *Vraagbaak*: 'Each tribe has its own characteristics and customs'. Colonial

Ndebele, southern Africa. Source: *Reisen in Süd-Afrika*. 'Natives' pictured as a tourist attraction in a German travel guide of the 1950s. White and black, modern and traditional dress, subject and object, active and passive, technology (camera) and ornaments (glass beads) – all these contrasts indicate metaphorically that this is a relationship not of communication but of annexation.

105

Een Bantoe huisbediende Kleurling Visser Kantoorbediende uit India

Ethnic division of labour under apartheid. The captions read: 'A Bantu domestic servant'; 'Coloured Fisherman'; 'Clerk from India'. *Zuid-Afrikaanse Vraagbaak* (1958).

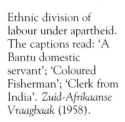

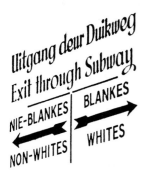

anthropology, in which ethnic groups are the object of study, is here institutionalized as the basis of national policy. Apartheid is a matter of 'ethnicity from above'. This is elaborated in an ethnically based division of labour, expressed in many different forms – for instance, in a series of photographs in the *Vraagbaak*, with revealing captions such as 'A Bantu domestic servant', 'Coloured Fisherman', 'Clerk from India'.

A recurrent image of the Bantu as miner or worker is as one of the 'able-bodied men' whom the labour-recruitment agencies select for the mining corporations. But Bantus as workers are relatively less prominent in South African public imagery than as servants – shoe-shine boys, waiters, or especially as domestic servants; although by the 1970s, with the rise of Black trade unions and the formation of COSATU, this had begun to change.

Sport and the security services are other terrains where Africans can make their presence felt under white management. Another and conspicuous image of African is that of the 'terrorist' – frequently in association with the hammer and sickle of Communism – disseminated in the propaganda material of the police. These are the two poles of white-on-black image-building in South Africa: the domesticated African and the 'terrorist'. The irony of the current situation is that these two extremes in imagery are no longer as neatly separated as previously. Servants can manifest themselves as freedom fighters, as a fifth column in white suburbia.[21]

Another image of Africans which circulates in South Africa is that of the black middle class of Soweto and its comfortable life-style, as portrayed in advertising. Designed not to reflect reality but to appeal to aspirations, these images are rosier than reality.[22] That also applies to the 'dream factory' of the South African film industry, which entertains blacks with fantasy images of 'black Rambos', South African versions of 'Superspade'.[23] An advertising analyst, Carol Nathanson-Moog, notes:

> When members of a particular ethnic group never see anyone who really looks like them in ads, they develop a sense of being non-persons in the larger society. In their neighborhoods they may be the greatest, but when it comes to participating in the images and symbols of success and happiness held up as cultural standards by ads, they're often nowhere to be seen. Even their money doesn't count. They simply don't exist.[24]

This was written apropos the ghetto population in the United States, but it is equally valid for South Africa. The image-building of apartheid seeks to render the majority of the population, the millions of African labourers and miners, invisible – just as the architecture and the road signs of South Africa make the black townships virtually invisible. The picture postcards show the skyscrapers and the prosperity of Johannesburg and Pretoria, but not those who built them.

The back of a South African Kellogg's packet, 1987. Master-and-servant relations, with handy tips for masters.

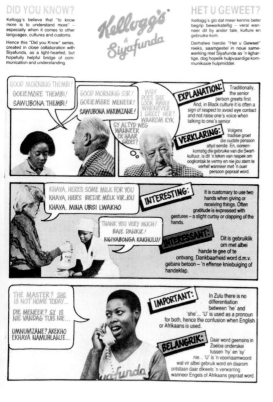

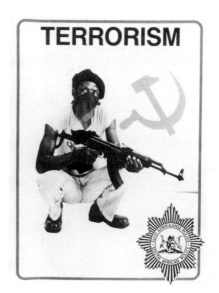

'Terrorism.' A stereotype of the black South African opposition on the cover of an information brochure of the South African police (late 1980s). Violence, criminality and communism are the key symbols in this profile.

7 ON ADVENTURE IN AFRICA

A recent volume opens with the enthusiastic sentence: 'Victorian Africa was an exciting land of gold, ivory, slaves and big game.'[1] Besides the actual and official presence of Europeans in Africa there was the imagined and the unofficial presence. Unhampered by reality the fantasies and tales of adventure reveal with stark clarity the logic of European patterns of expectation. In the adventure stories stereotypes are elaborated into scenarios. Among recurring themes are the fantasy of fear: the European as prisoner of the savages, and the fantasy of power: the European as king over the savages, with secondary roles for the savages themselves, either threatening or servile. The characters we encounter in western juvenile fiction remain largely the same: antagonistic savages, usually cannibals, the African chief, who is either noble or cruel, the faithful servant. But the scenarios and the mixture of characters change, in some respects at least, as the position of Europeans on the world scene changes. Between the classic adventure of the shipwreck and the colonial fiction lies a world of difference.

From Robinson Crusoe to Tarzan

In eighteenth- and nineteenth-century tales of shipwreck the victim was entirely at the mercy of nature and of fate, which determined whether the savages he encountered were 'good' or malicious. A shipwreck begins *The Adventures of Robinson Crusoe*, whose hero's path crosses with both man-eating and a 'good' savage. Many of the themes that were to recur time and again in western literature we find prefigured in Daniel Defoe's novel of 1719: the theme of cannibals, the rescue of a victim of cannibals, Man Friday as the good savage, saved, Christianized and domesticated. Being a savage, Friday is deemed not to possess any culture and is treated as if he were a clean slate: he may not keep his own name but is given a new one, which makes him part of Robinson Crusoe's calendar. In a prophetic way the novel is a microcosm of the self-image of European colonialism and its civilizing mission in the world of savages. Robinson Crusoe is a merchant travelling on a slave ship and his outlook shows many bourgeois traits as well as deeper western preoccupation – the lonely Christian, subduer of nature and creator of culture in the wilderness.[2] This adventure, by the way, takes place not in Africa but on an island in the Caribbean.

Shipwreck plays a central part in the novella by Bernardin de St. Pierre *Paul et Virginie* (1787), a romantic tale about the sorrows of a pair of lovers from French planter families in Mauritius. Africans do not figure importantly in the story, but they are described humanely; when the young lovers lose their way in bad weather, they are brought home by helpful slaves. At the

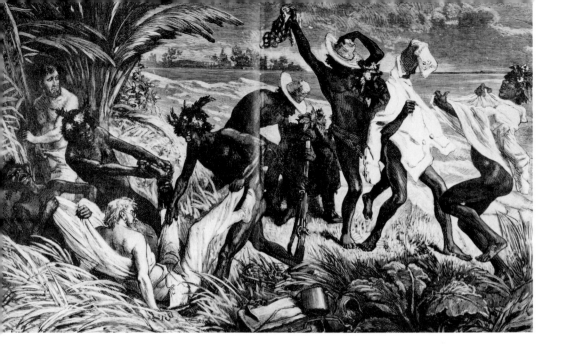

me the book had a strong impact on the climate of opinion in France,
dding momentum to the anti-slavery movement.

Paul et Virginie ends tragically when Virginie dies in a shipwreck, as Paul
ooks on. At the time shipwrecks were dramatic events, like the sinking of
he *Médusa* in 1816 off the coast of Senegal. This caused as great an upheaval,
nd a political scandal besides, as later the sinking of the *Titanic*, and found
choes in art, such as Théodore Géricault's painting *The Raft of the Médusa*
1819),[3] and in literature.

Romanticized stories for popular consumption and for the young followed
1 the footsteps of the explorers. In their turn came narratives of colonial con-
uest and empire-building. Colonial novels were in vogue around the turn of
he century. Boys' books which narrated the famous deeds of British or
rench heroes were regarded as pedagogically highly suitable. Women hardly
ppeared in them, the plots were sexless. Of his own *King Solomon's Mines*
I. Rider Haggard said, 'There is not a petticoat in the whole history'. The
ulu War, the Boer War, the experiences of British settlers in the Cape,
hodesia, Kenya, Uganda, and international intrigues provided raw material
or these stories. To a large extent they were white-settler myths, fantasies of
ower on the part of white settlers and colonizers.[4] A number of these books
re still being read and several have been popularized through films and comic
ooks. They have become metaphors for the place of the West in the world.

A class apart in the genre of African colonial fiction are the Tarzan stories
y the American author Edgar Rice Burroughs. His first book, *Tarzan of the
Apes*, dates from 1911 and the last from 1944. Tarzan is the son of Lord Greys-
oke, a British colonial official who is stranded during an inspection tour of
West Africa as a consequence of a shipboard mutiny, and dies along with his
oung wife; Tarzan is left behind, an orphan, and is raised by a tribe of mon-
eys. Gradually he succeeds in establishing dominance over the tribe – not
ecause he is human but, according to the author, because of his English aris-
ocratic blood. This is the red thread which meanders through the novels –

'The outcome of a
shipwreck: They found
themselves surrounded
by eight pitch-black
negroes.' *Journal des
voyages*.

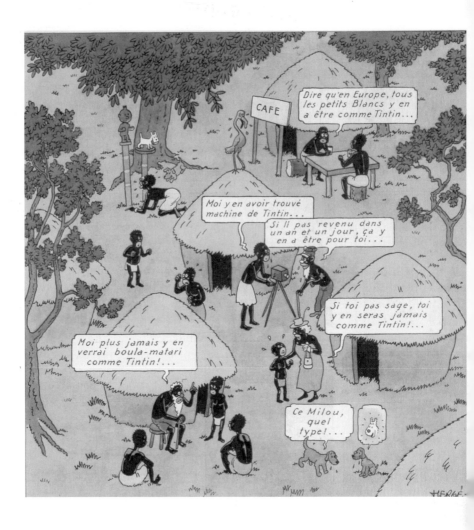

Tintin-worship in the Belgian Congo. Final page of *Tintin in the Congo*, a comic book by Hergé (Antwerp, 1947), copyright Hergé/ Casteman.

left behind in the wilderness Tarzan, the son of an English lord, becomes the *Lord of the Apes* and *Lord of the Jungle*.

For their author these books were speculation concerning 'the relative value of heredity, environment and upbringing' in the mental, moral and physical development of a newborn child.[5] They provide a discourse in narrative form on Social Darwinism and heredity, in which sombre reflections about racial mixtures and degeneration hang like dark clouds over the thick forest. Lost civilizations which have been swallowed up in the 'African darkness', a land in which blacks are ruled by a tribe of gorillas, a tribe of black Amazons who yearn to become white, ruthless Germans who involve Africa and Tarzan in the First World War, communist agents sent to Africa to incite war and revolution – the Tarzan books are a veritable compendium of western obsessions and fantasies.[6]

The first Tarzan film was made soon after World War One, and since then the genre has remained popular. It is a forum in which ideas about culture and sexuality ('Me Tarzan, you Jane') can be worked out, but above all it is a white-settler myth, a white-power fantasy of the type 'Rambo in Africa'.

By the twentieth century variations on the theme of power, rather than on the fantasy of fear, had begun to predominate in western fiction, more or less echoing the stabilization of colonialism in Africa after *circa* 1914. Dangers were under control and Africa came more and more to resemble a vast re-

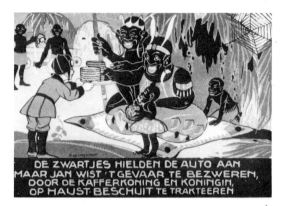

Caption:
'The blackies stopped the car
But Jan managed to avert the danger
By offering the Kaffir King and Queen Haust Biscuits.'
Advertising card of Haust Biscuits (Netherlands) in the series 'Around the globe, The wondrous adventures of Loekie and Jan'. Drawing by M. Güthschmidt.

reational area, an ideal setting for boys' adventures. Fiction for entertainment and for the young follows the colonial matrix. The colonial and racial hierarchies remain intact. From Tarzan to Tintin, dumbfounded and servile Africans have populated western fiction. The pattern is familiar: the white adventurer and the Third World 'third wheel' – like the Lone Ranger and Tonto, Old Shatterhand and Winnetou, and the many variations on the white hero and his black sidekick.[7] In fiction for young people decolonization seems either not to have taken place or to have made little difference.

Image of the world from the point of view of European boys' adventures – Africa lies at their feet. Cover drawing by Hans Borrebach, The Hague, 1950s.

Safari

For adults the African adventure *par excellence* is the safari. In 1909 Theodore Roosevelt, President of the United States, spent several months in British East Africa. According to his own report he and his son Kermit shot 512 animals, not including the game for the pot. As regards the 'big four', this included 17 lions, 12 elephants, 11 buffalos and 20 rhinoceroses (including 9 of the then already virtually extinct white rhinoceros). Roosevelt's book *African Game Trails*, which appeared a year later, became a bestseller.[8] Two years earlier Winston Churchill had published *My African Journey* (1908), with himself depicted on the cover with hunting rifle and slain rhinoceros. 'Africa was the sportsman's paradise.'[9]

Big-game hunting, like the fox hunt, was of upper-class origin but over the years had become a bourgeois obsession[10] – for the bourgeoisie, to imitate aristocratic culture was the pathway to heaven. In British India the *shikar* was an upper-class sporting occasion, but from the outset the African safari had a different character. It attracted European professional hunters for one simple reason: ivory. Friction between the commercial hunt and the hunt as semi-aristocratic pastime lingers on. But above all the safari is a demonstration of European mastery, of the superiority of western technology, and a crucial symbolic episode in the colonization of Africa – the 'dark continent' is manageable. A feudal privilege, big-game hunting, was displaced from rural Europe to colonial Africa, and this gives one pause, particularly as the safari perspective on Africa marginalizes people. Wild animals are literally the centre of attention. In this respect the safari perspective is in a direct line

Winston Churchill, My *African Journey* (London, 1908).

Cover of 1930s book, *A Hunting Adventure in Africa*.

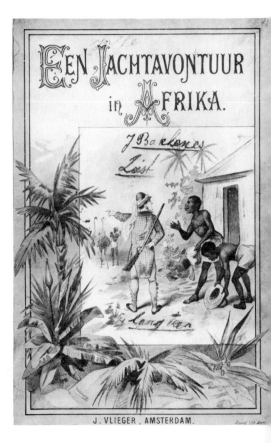

with Herodotus' view of Africa as the 'land of wild beasts'. In the safari perspective, and the nature films and safari tourism it inspires, Africa appears as a world of nature, not as a cultural or human-made world. This is the Africa displayed and advertised in the West, so that average westerners are more familiar with Africa's wild animals than with Africa's people.

In 1987 *Time* magazine devoted a cover story to Africa – from the cover a lioness stares resolutely out at us. The featured article is about wild animals, and those interviewed show scant regard for people: Hugh Lamprey of the World Wildlife Fund is quoted as saying: 'If there was one species you could remove to the benefit of the earth, it would be man.'[11]

Descriptions of nature reserves, however recent, often reminisce about the days of colonialism. Thus Patrick Marnham opens a chapter on the game parks with the observation: 'As the African state and its game parks become more independent, they fall to pieces'. His description of a reserve that is still managed by a European is nostalgically lyrical: 'And so, for a brief period, Victorian Africa was recreated with its wealth of game and hostile natives and the European's private army.'[12] Those were the days – in British East Africa an ordinary individual could hunt like a nobleman, maintain his own army, and besides make money off the hunt. 'Hostile natives' were the only problem, but also a kind of sport.

European picture postcards of Africa often show a European on safari, always on the point of making the decisive shot and ever flanked by a servile African. The safari is now a luxury pastime for Texas oil magnates and New York investment bankers – 'businessmen who find stalking big game a fitting relaxation after tension-filled corporate hunting.'[13] The hunt has remained an élite metaphor.

Cannibals

The rediscovery of the classics during the Renaissance also brought the histories and geographies of Herodotus and Pliny back into circulation. The world of antiquity was a world circumscribed by monstrous beings and phenomena. Thanks to culture heroes such as Hercules, Theseus, Odysseus, these dangers were averted and culture's frontiers were extended from time to time. Europe's Middle Ages also knew culture heroes such as Saint George and Saint Michael, the dragon-slayers. Yet despite the efforts of the knights of Christendom, not all monsters were extirpated. The Renaissance was a rebirth not merely of classical knowledge but also of classical myths.

Thus in England in 1556 appeared a popular work. A *Summary of the Antiquities and Wonders of the World . . . out of the Sixteen First Books of . . . Pliny*, which was an inventory of wondrous creatures, among these the cyclopes, cynocephali or dog-headed creatures, man-eaters, troglodytes or cave-dwellers, spermatophages and antipodes were only the least disquietening. Thus about the Ethiopians we are told:

> Of the Ethiopians there are divers forms and kinds of men. Some there are toward the east that have neither nose nor nostrils, but the face all full. Others that have no upper lip, they are without tongues, and they speak by signs, and they have but a little hole to take their breath at, by the which they drink with an oaten straw. There are some called Syrbote that are

. . . the Cannibals
that each other eat,
The Anthropophagi,
and men whose
heads
Do grow beneath
their shoulders.

Shakespeare, *Othello*
(I.iii)

eight foot high, they live with the chase of elephants. In a part of Affrick
be people called Ptoemphane, for their king they have a dog, at whose
fancy they are governed. . . . Etc.[14]

What is striking is how few of these creatures survive the sixteenth and seven
teenth centuries. It is mainly the cannibals that persist, the others are rarely
heard of again, except perhaps the man with a tail or *homo caudatus*
Eighteenth-century Europe set little store by mythical-monstrous creatures
Hence it would appear that the theme of cannibalism enjoyed exceptiona
popularity. The question arises: why cannibals, and not people without head
(whom Shakespeare mentions as late as 1604), the cyclopes, or the troglo
dytes? Is this perhaps because tales of cannibals have more basis in reality than
tales of other creatures? Recent literature on the subject points out that can
nibalism has never actually been observed, has always been a matter of hear
say.[15]

Beer mats. Oranjeboom
(Netherlands) and
Zipfer Bier (Germany).

The literature has become more sober in the course of time. A standard
account runs as follows: When a remote and strange people is questioned
about this – 'Are you man-eaters?' – the answer given, after consultation with
the eldest present, is usually: 'No, only a long time ago. But those people' –
mentioning the name of a remote and strange people – 'those are peculiar
people.' In this way, or approximately so, most cannibal tales would have
come into circulation, through the transmission of regional enemy images
collective intimidation and ethnological gossip. This is to discount cannibal
ism as an extreme measure in emergencies such as famines and disasters. A
distinction must also be made for human sacrifices on ritual occasions (where
the victims are not eaten) or occasions when a small part of the flesh of a slain
enemy (particularly the head or the heart) is ritually eaten, to ingest its
magical force. This is cannibalism not as a popular custom but as a form of
warrior magic, and has little or nothing in common with cannibalism as
popularly represented in the West.

The problem of the persistent popularity of the theme remains. What
psychological needs does this folk myth satisfy, that it has persisted for so
long? Cannibal humour is the most worn-out cliché about non-western
peoples. The white explorer or missionary in the cooking pot is a constant
image from 1870 to 1970.[16]

In fact, the man-eating motif has a much longer history in western culture,
in the course of which it has carried different meanings and taken different
forms. In antiquity and the Middle Ages, narratives of man-eating refer to
Europe itself, either as an unpleasant custom among neighbouring peoples or
in emergency during famines.[17] Throughout European history man-eating re
curs as a mythological literary topos, from the primal father Chronos who
devours his children to Dante's *Inferno*, and to countless fairy stories and folk
tales such as those of Hansel and Gretel and Little Red Ridinghood, in which
the eating of people forms an important motif.[18]

The sixteenth and seventeenth centuries bring the first tales of man-eating
situated outside Europe, in the New World, and this generated the term 'can
nibals' through a bastardization of Caribals, or inhabitants of the Caribbean
islands. Europe's Middle Ages were a sacred realm of miracles, fables and
demons, and the encounter with 'savages' on new continents enabled
Europe, according to Winthrop Jordan, to make the transition 'from miracles
to verifiable monstrosities: from heaven to earth'.[19]

The most common explanation for the accusation of cannibalism is that it served, above all, as a justification for conquest – as it did in the conquest of the Americas, for instance in the discourse of Cortés.[20] It forms part of an enemy image which colonialism fashions of the colonized. While this explanation seems valid, it also appears to be incomplete; the cannibalism motif may be an allegory carrying wider meanings.

At a time when the cosmography of Christendom had been visibly shaking by the encounter with the 'New World', the new continent evoked profound ambivalence, ranging from Utopianism (Montaigne, Thomas More) to aversion (Shakespeare, Hobbes, Defoe). At this juncture the 'new cannibalism' inserted itself as a strategic topos. Perhaps there is a parallel in the 'blood libel' of the Jews in medieval Europe, as a group whose place in the hierarchy of the estates was based on a series of exclusions which served to fix its place in

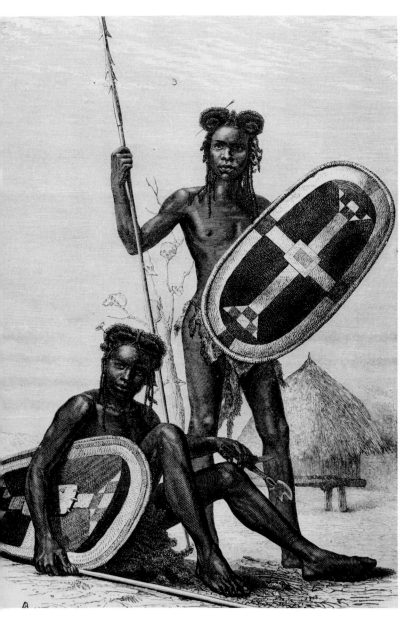

Caption:
'Appearances are deceiving.'
'Far from here, in Africa, these blackies dwell,
They look kindly, you may think,
But O dear, appearances again deceive,
Because, you see, I know better,
They're called Niam-Niam and that's the same as "man-eater".
Now are you afraid? What foolishness!
They'll never eat you;
The road to the far-off Netherlands,
None of the Niam-Niams can know.'

the overall scheme of things. When new lands were found and strange peoples encountered, whether in America, the Pacific or the African interior, the accusation of cannibalism served to affirm and secure the central place of Christian civilization. The same accusation has been a central rhetorical device in defining relations between heathen and Christian, savage and civilized worlds. What is at issue in the question of whether savages are 'good' or 'bad', noble or ignoble, creatures of Eden or fallen heathen, is a moral hierarchy in cultural models. Cannibalism is an allegory which establishes a centre and a periphery within a moral geography.

In the eighteenth and nineteenth centuries cannibalism was revived in the vocabulary of missionaries and explorers – the culture heroes of expansionist Europe, the dragon-slayers of the Enlightenment. The cannibalism metaphor occurs during two other periods: the era of cannibal humour, from the late nineteenth century onwards; and 1980 to the present, that of mechanized cannibalism.

As the 'frontiers of knowledge' shifted once again, themes from the 'first period of discovery' (of the New World) were transferred to the 'second period of discovery' (as the interior of Africa), and again the visage of the unknown showed Europeans its frightful features and peculiar creatures, with cannibals in the leading role. One story told of a man-eating people with tails in Central Africa, the Niam-Niams. In T. H. Huxley's *Man's Place in Nature* (1863), a scholarly work by a renowned anthropologist, we suddenly come across a passage on 'cannibalism in the Congo in the sixteenth century', based on an earlier Portuguese account and illustrated with a frightening engraving of a 'human butcher shop'. Winwood Reade's *Savage Africa*,

Illustrations in a Dutch comic book of 1929. Caption: 'A man-eater'. A.M. de Jong, *De wereldreis van Bulletje en Bonestaak* (Amsterdam, 1929, 1957). Drawings by George van Raemdonck.

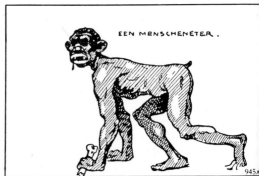

published in the same year, confides that 'the mob of Dahomey are *man-eaters*; they have cannibal minds; they have been accustomed to feed on murder'. In a volume on *Stanley's Travels* (1886), a drawing of an unremarkable figure is casually labelled 'Cannibal'. Stanley was carried away in his zealous horror of anthropophagy and repeated every tale of cannibal tribes that he heard in addition to creating quite a number of his own. Winwood Reade sprinkled cannibals about West Africa rather like raisins in a cake. . . . Lady Flora Lugard postulated the existence of "a belt of cannibalism . . . across the whole breadth of Africa"'.[21]

Stories about cannibalism in Africa concentrated mostly on the Congo and the Niger basin. Accounts such as Henry Ward's *Five Years with the Congo Cannibals* (1890) were popular and in great demand. Such sources are still referred to in current popular studies; thus Nigel Davies states, 'We are also indebted to Herbert Ward for a classic and oft-quoted account of the human flesh markets of the region.'[22] According to the Revd Holman Bentley in his two-volume work *Pioneering in the Congo* (1900), all the tribes from the confluence of the Congo and Mobangi rivers to Stanley Falls were enthusiastic man-eaters. The German ethnologist G. Schweinfurt lived among the Mangbetu of the Congo and made them famous as the 'people who had no graves', not because they burnt their dead but, according to the ethnologist, because they ate them up. He relates that the chief of the Mangbetu ate a young child daily, but admitted that he never actually saw him breakfasting thus, saying merely that 'the general rumour was current' that this occurred.[23] A French boys' book of the inter-war period opens with a chapter titled 'Prisoner of the Cannibals'.[24] The logic of the popularity of this metaphor is, according to Patrick Brantlinger, that 'The more Europeans dominated Africans, the more "savage" Africans came to seem.'[25]

Another aspect of the cannibalism motif is its function as a counter-utopia. Since an undercurrent in western views associated primitive, 'natural' life with paradise – the closer to nature, the closer to Eden – this was a tendency to be avoided, especially in the Victorian era, and brought under control.[26] At times it seemed the Scottish missionaries, Bible in hand, were turning directly against the Romantic poets and their idyllic images of life in the tropics, to produce counter-images of the Pacific and Africa as scenes of pandemonium and devil-worship, with cannibalism as the main signifier. In the process they also turned against the underlying Christian romanticism which sought the lost paradise, the biblical Eden, in far-away places. The explorers' and missionaries' reports on the dark continent had, it seemed, to affirm over and over that the existence of the savages is *not* appealing, paradisiacal. Cannibalism in a single shorthand icon represented 'the other side of paradise'.[27]

This is the moral that was echoed in nineteenth-century popular prints, for instance *The Adventures of Cyprien Grenouillot* from the French Imagerie d'Épinal. Cyprien Grenouillot is an apothecary's assistant who dreams of far-away places, like the land of the Wild Man on the signboard hanging outside the pharmacy where he works (also a reference to Europe's 'wild' past). He boards a ship in Nantes, is abandoned on an island in New Caledonia, meets a savage, is generously received and fattened for six months, in order finally to be put to the knife by the tribe's cook. Then Cyprien awakes, startled out of his dream. A year later he is sitting in front of the pharmacy, married to the daughter of his boss. Moral: Better stay away from savages.

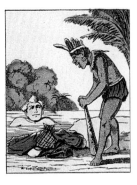 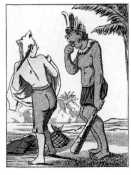 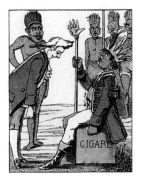

'. . . because all of this had been only a dream which cured Grenouillot entirely of his longing to travel . . .' Moral: wild fantasies are unwholesome. Imagerie d'Épinal print no. 51.

'. . . And so it happened that Narcisse Aventurex, instead of becoming the famous traveller he had dreamt of being, ended his career prematurely in the intestines of famished cannibals. Why then had he forgotten the proverb which is based on long experience and which says: "Chase away the savage, he will return with a vengeance".' Imagerie d'Épinal.

Another adventurous young man, with the ominous name Narcisse Aventureux, does not take this counsel to heart. Thus in the series *Le Naufrage*, the shipwreck, by the same printmakers, he ends up on the savages' roasting spit. Here the cannibalism motif serves to endorse the European labour ethic and bourgeois morality. Adventures in remote and strange places end fatally. One had better forget 'wild fantasies'. Victorian strictness and the petit bourgeois tradition of the printmakers Épinal, established in 1796 by Jean-Charles Pellerin, make a solid match.[28]

Even so, by the late nineteenth century a 'return of the repressed' did take place, although initially mainly among avant-garde artists, in a milieu sheltered from the everyday world of labour and bourgeois standards: a revival of nature worship along with a rehabilitation of the 'good savage' and a pattern of identification with 'savages'. Among the signs of this revaluation, termed 'primitivism', are Gauguin's migration to Tahiti, the fauvism of Matisse, the work of le Douanier Rousseau, *l'art nègre* which became *en vogue* in Paris, and subsequent movements such as the German Wandervögel, followed by

nudism. The *fin-de-siècle* is witnessing a reactivation of European ambivalence, a theme which Sigmund Freud addressed in his *Civilization and its Discontents*(1930).[29]

The metaphor of cannibalism now operated on a cultural and psychological frontier which had become more fluid. This coincides with the fact that around the same period the iconography of cannibalism changed character. Fear and loathing gave way to humour and the tone became lighter and ironic. Nineteenth-century intimidation retreated and the pattern of light cannibal humour as we still know it took shape. In this regard Winwood Reade was a precursor. In the chapter he devoted to 'The Philosophy of Cannibalism', Reade drew a distinction between ritual cannibalism, allegedly practised by certain West African peoples, and another form which is 'simply an act of gourmandise'. 'A cannibal is not necessarily ferocious. He eats his fellow-creatures, not because he hates them, but because he likes them.'

Here we see the beginning of the ironization of the cannibalism motif, the beginning of the modern cannibal myth, which is gastronomical in nature. By 1900 most of the bitter colonial conflicts in Africa were over; there were still rebellions but these were no longer really threatening to Europeans. The pacification and domestication of Africa had begun, and accordingly the image of the African 'savage' was domesticated as well.

The point of the new cannibal humour is usually the contradiction of the savage gourmand. A savage, *therefore* a cannibal, but a cannibal with refined manners, with the attributes (chef's hat, implements) and attitude of European cuisine. Thus the cannibal gourmand becomes the icon of the colonized savage and of a pacified Africa. It displays westernization in the attributes of cannibalism, stating in the same breath that basically nothing has changed: under their western dress the Africans are still savages. Hence this icon serves as a bridge between old and new images of Africans and as an endorsement of the colonial civilizing myth; it reconciles contradictory European fantasies and confirms Europeans in their belief that Africans are still savages, still inferior, thus legitimating ongoing western supremacy.

In *Fred, Mile et Bob*, the precursor of *Tintin in Africa*, Bob while being cooked in the pot remarks that it's sad indeed: 'They didn't even put in some

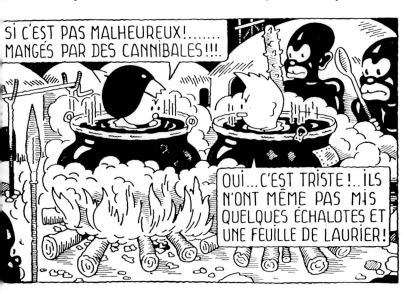

'If that's not unfortunate! Eaten by cannibals!' 'Yes, it's sad! . . . They didn't even put in some shallots and a bay leaf!' *Les Aventures en Afrique de Fred, Mik et Bob.*

shallots and a bay leaf!' Here the young adventurer is asking to be eaten at least by *civilized* cannibals. This sets the tone for later jokes.

Are these reasons sufficient to explain the continuing popularity of cannibal humour? It has survived through several epochs – colonialism, two World Wars, decolonization and the era of the 'Third World'. Since 1900 its tenor has hardly changed. What also has hardly changed during this period is western hegemony over the Third World and Africa.

It is significant that the accusation of cannibalism has come from both sides. Thus slavery could be experienced as a form of cannibalism; as in an anonymous poem of 1793 by a slave:

> Here de white man beat de black man
> Till he's sick and cannot stand.
> Sure de black man be eat by white man!
> Will not go to white man land.[30]

Africans and Third World peoples generally have often experienced and described western domination as a form of cannibalism. W. Arens gives several examples; thus in Tanzania 'bloodsucker' would be a common epithet for Europeans.[31] For Jack Forbes, a Native American scholar, this is the true face of western expansion: *A World Ruled by Cannibals*, and underlying it a serious form of psychosis.[32] Bob Marley sang 'Babylon is sucking the blood of the poor'. Not surprisingly, this counter-accusation from the standpoint of the colonized has not often been aired in the West.

Even so, Europeans too have expressed themselves in this way. In 1899 Herbert Spencer (who introduced the concept of 'struggle for survival') condemned European imperialism in these terms: ' . . . the white savages of Europe are overrunning the dark savages everywhere . . . the European nations are vying with one another in political burglaries. . . . [Europe has

IK ZAL HAAR MISSEN..."

(zei de kannibaal)

'I will miss her . . .' (said the cannibal). *Funny Moments*, No. 4 (Leuke Ogenblikken, Netherlands).

'Menu.' In the foreground 'Pieds à l'huile'. *Le Journal amusant*, 13 Dec. 1902.

The Explorer: Have you perchance seen my companion? *The cannibal*: Yes, I dined with him last night. Cartoon by Jean Dratz, Belgium.

.L'EXPLORATEUR: avez-vous vu par hasard mon compagnon!...
.LE CANNIBALE: oui, j'ai diné avec lui hier soir...
DE ONTDEKKINGREIZIGER
– hebt gy soms myn kameraad gezien?...
— DE MENSCHENETER: ja...ik heb gisteren avond nog met hem gedineerd......

entered upon an era of social cannibalism in which the stronger nations are devouring the weaker.' In an essay on 'Re-Barbarization' Spencer held the culture of 'savage imperial society' responsible for this: Literature, journalism, and art, have all been aiding in this process of re-barbarization.'[33]

L'Assiette au Buerre, a few years later, turned the myth of cannibalism around in a drawing of a black woman being roasted over a fire, with the caption: 'The only cannibals in Africa are the whites.'[34] This reversal is also the theme of a two-part cartoon in *Le Rire* (4 November 1911) in which (1) Africans cut a white man into pieces, in 1860, and (2) Europeans cut the Congo into pieces, in 1911. A cartoon in the Belgian magazine *Hooger Leven* in 1937, at a time when there was mention of the Belgian Congo being ceded to Hitler's Germany, also uses plain language: 'Any takers for Negro soup?'[35]

Viewed in this light, western cannibal humour takes on a still different character. It forms part of a traffic in Hobbesian images of humanity – *homo homini lupus* – in which the image-building of the most powerful side prevails. The logic of the powerful is to blame the victim. There's nothing wrong with western attitudes and practices in relation to economically underdeveloped countries, because if they were given the chance they would devour us. . . . This is the subliminal message of cannibal humour, which has a legitimating and reassuring function, reconciling western consciences troubled over the status quo. If, however, we follow the logic of projection back to its source, what meaning can this perennial attribution of cannibal urges to foreign peoples have, other than that Europeans subliminally consider themselves as cannibals?

Cannibalism as a cultural metaphor still lives on. A pop group with the name 'Fine Young Cannibals' and a 1980s bestseller by Tama Janowitz, a young author from New York, entitled *A Cannibal in Manhattan*, illustrate the potency of the image as a means of social posturing or 'critical utopia'.

The metaphor lives on in relation to Africa as well. Belgians in the Congo after the war were wondering whether 'civilization' would be possible at all among 'grandsons of authentic man-eaters'.[36] The struggles for decolonization witnessed a revival of nineteenth-century imagery (the English referred to Jomo Kenyatta as 'a leader of darkness and death'). Idi Amin's regime has

'A scene of cannibalism in the Upper Congo (in 1860, and in 1911).' The tables of cannibalism were turned in fifty years – the European powers cutting the Congo into pieces. *Le Rire*, 4 Nov. 1911.

been described as a form of 'ritual cannibalism' and 'refrigerated cannibalism' – it is characterized in such terms in African sources as well.[37] It is a different matter, however, when in a recent English volume of modern history the chapter on Africa is entitled 'Caliban's Kingdoms'.[38]

In jokes and cartoons cannibal humour seems to be on the wane in most western countries over the past decade. An exception is Germany, where cannibal cartoons in popular periodicals like *Wochenende* and *Quick* up till now are not only flourishing but also generating new variations. Remarkable, for instance, is what one might call mechanized or techno-cannibalism. Europeans are being grilled in a giant toaster positioned in the bush – caption, 'Now you see what they're doing with all those things for the Third World' (*Bild am Sonntag*, 7 December 1987). A machine in the middle of the jungle grabs the innocent white man, after which tins come rolling out and a black man rushes from the bush with a tin opener – caption, 'Development Aid' (*Report*, 26 October 1980). An electric grill is carried in by whites to modernize the cooking pot, in which in the meantime a white man is steaming. The message is obvious: western development aid and technology are being used *against us* by *incorrigible* savages.[39]

The political *portée* of this kind of bar-room humour is evident. It is a significant example of the general problem at issue in all white-on-black iconography. It illustrates how a particular imagery, which took form in the nineteenth century (handed down from the sixteenth century and adapted from the classics), has been perpetuated, at first as a justification of colonialism, and then of neo-colonialism and conservative attitudes *vis-à-vis* the Third World. What this type of humour wants to suggest is that Africans haven't changed in all that time. What it really demonstrates is that Europeans haven't.

'Now you see what they're doing with all those things for the Third World.' Techno-cannibalism as a new mode of cannibal humour, directed against development aid. *Bild am Sonntag*, 7 Dec. 1987.

II IN THE WEST

We now leave Africa and follow Africans on their passages across the Atlantic. What was the fate of the African diaspora in America and Europe? This account is different in structure and content from the preceding chapters, which could for the most part be chronological. Part I was concerned with showing the Africa imagined in Europe to be 'Europe's Africa'. This principle of course applies even more strongly to the images of blacks held in the West. What is at issue now is not western culture in relation to Africa, but western culture itself and the various ways in which it incorporates blacks. Part Two is structured thematically, and each theme is treated chronologically. The themes range from servants and entertainers, the two characteristic roles assigned to blacks in western society, and black types popular in different western countries, to images of blacks in the context of sexuality, images of blacks in advertising, and in the culture of the nursery.

Two settings are merged in this account: America and Europe, which together form 'the West'. The differences are obvious: in America there is a large black minority, and the background to white-black relations is slavery and the Civil War, Emancipation and the civil rights movement; in Europe the presence of blacks is more recent and they are fewer in number, and the historical background is shaped by relations with Africa and the West Indies. A comparison between white-black imagery in America and in Europe is drawn in the discussion of popular types, and also in the chapter on images of blacks in the context of sexuality.

Also in Part II there remains an interface with Africa. Thus there are parallels between the imagery produced by colonial Africa and images of blacks in America during and after slavery. The numerical relations are reversed (in colonial Africa whites were a minority, in the West blacks are a minority), but there are parallels in terms of prejudices and role patterns, not only because images of Africa have had an historical influence on images of blacks, but also because of underlying similarities in the patterns of power, and in their psychological ramifications. Besides, Africa returns as a backdrop for the advertising of colonial products.

8 SERVANTS

Minorities often find a place in society in certain specialized occupations. These occupations say less about the minority itself than about the circumstances under which it came into contact with the society. In pre-war America the Chinese owned laundries, in the West Indies grocery shops and in western Europe restaurants, where originally they came as sailors, or, in the case of the United States, as railroad workers. The niche a minority occupies in the labour market is usually based not on preference on the part of that minority but on its exclusion by the majority from other jobs. A familiar case is the specialization of Jews in Europe since the Middle Ages in trade and money-lending, because they were barred from owning land and from holding public office. No matter how unreal and how dependent on circumstances its position in the labour market is, it is often extremely difficult for a minority to overcome the stereotyping that goes with that position; from the standpoint of the majority it seems not only the ideal but even the only possible, the 'natural' situation.

The occupational roles allocated to blacks in western society are an example of an ethnic specialization which has been in existence so long that it seems to reflect the 'natural' order. Virtually the only occupations open to blacks have been those of service, of all varieties, and forms of entertainment and sport. The sole exception, oddly enough, was under slavery, when skilled occupations were open to blacks in America. Because of their status as slaves, they did not pose a threat to whites in those occupations; after Emancipation, however, they were excluded from such jobs. Images of blacks as servants and entertainers are virtually the only ones we encounter, then, in western representations. What we see of them as popular types, in advertising and other forms of popular culture, is largely based on these two roles, and the images are impressive mainly in terms of their monotony.

'Sometimes a Moor'

The figure of the black servant has a long history in Europe. Black servants are not only often depicted as small, denoting their subordinate status, but also in Moorish, in the sense of Arabic, costume. The 'oriental' garb suggests that the servant has been adopted in Europe from Oriental examples, via Moorish Spain, Sicily and the Ottoman Empire. This shows the extent to which Europe's relationship to black Africa has been shaped and mediated by Arabic and North African culture. The black African servant in Europe was in all likelihood originally a form of orientalism: a European imitation of an Arabic example.[1]

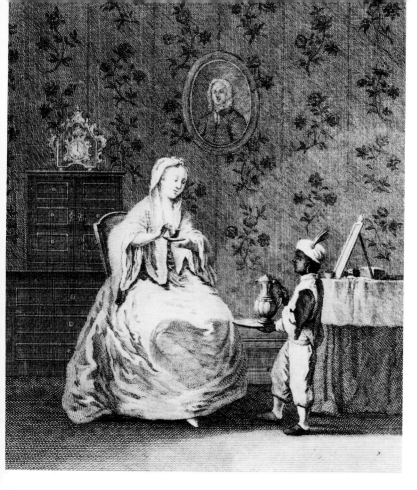

'Die Bedienung' (service). Black page in oriental costume serving coffee or chocolate. (Germany, 1795).

In sixteenth-century Portugal and Spain, and in Naples and Venice the Moor as servant was a familiar figure. The term 'Moor', by the way, was for a long time applied to both Arabs and black people in Europe; in England in the late sixteenth century the term 'blackamore' introduced an element of differentiation, but 'Moor' continued to be used for blacks. At first seen in ports and among sailors, and then among noble and wealthy families in northern Europe, who were in their turn copying the luxuries of Mediterranean Europe, the black servant recurred as a status symbol, often depicted in portraits at the side of some prominent gentleman or, especially, lady. The presence of the servant suggests wealth and luxury, and sometimes indicates the colonial connections of the persons portrayed.[2] In the eighteenth century the Moorish costume gave way to European dress or livery; in the nineteenth and twentieth centuries the oriental outfit returned, probably as a by-product of the revival of orientalism.

The black servants portrayed in the paintings were not necessarily servants of the family in question. In some cases portraits of different ladies by the same painter show the same Negro. By the seventeenth century the Moorish servant had already become a stylistic feature, a decorative element, recognized as such in the literature on art of the period:[3] a feature added to provide contrast in colour, pictorial variety and extra lustre, for the same reasons that a scene would be enriched with, for instance, domestic animals. Sometimes a

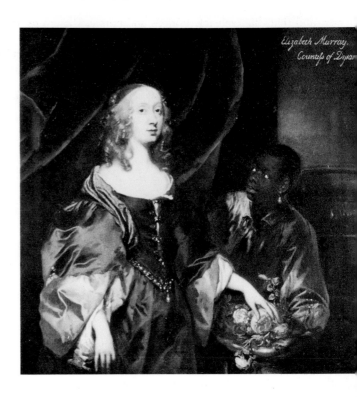

Elisabeth Murray,
Countess of Dysart.
(England)

black and a dog are depicted together in such portraits, in similar postures
(both looking up admiringly at the master or mistress) and with the same
attributes (a collar of identical design). The Moorish costume of the black
page was itself a stylistic feature. Lucas Schorer, governor of the West India
Company and commander of Saint Eustatius and Saba, was painted by Fon-
taine (1720) with a black page, apparently a West Indian slave but dressed up
as a Moor or a Turk, with a turban.[4]

In oil paintings the contrast in skin colour which the Moor provides is also
a contrast between light and dark. The fair skin of the lady portrayed seems
radiantly fair by comparison to the Moor's dark skin. This effect plays a visible
role in certain paintings,[5] at a time when ladies' fairness of skin inspired fer-
vent odes of praise.[6]

Wealthy Europeans were especially interested in the services of African
children, to the point where 'the fashion of the eighteenth century [resulted
in] a demand for African children in Europe as a minor branch of the slave
trade. Advertisements for such children on sale in London, Liverpool and
elsewhere were printed in the newspapers.'[7] The advertisements would spec-
ify the age, state of health, character, proficiency in language, and colour
('for colour, an excellent fine black'). In the treaty between the Dutch Re-
public and Prussia covering the handing over of Prussian possessions on the
Gold Coast to the Dutch, 'a special paragraph demanded that the Dutch
should regularly supply the Prussian court with young Africans to serve as
attendants to princes and noblemen. The Dutch West Indian Company was
charged with the supply of these African children.'[8]

A German source notes that at eighteenth-century German courts Moors
could not be done without, any more than Afghan greyhounds or Arab

horses, and that, like valuable hounds and horses, they were treated with care, since they had been expensive enough to procure. 'Moors had no individuality. No one was permitted to keep his own name. One called them Apollo or Caesar, Augustus or Socrates, Amsterdam and Copenhagen, Thursday or Saturday. Only rarely were they allowed to marry.'[9]

Thus there had been drastic changes in the image of blacks since the religious art of the late Middle Ages and Renaissance, in which the king of the Moors was the dominant figure. The proud and dignified figures of St. Maurice or of Caspar had given way to the little servile Moor. In the words of David Dabydeen:

> The image of the black Magus attending the Madonna in an attitude of human equality is debased into the image of the black slave-servant attending the secular White Mistress in an attitude of inferiority and humiliation. He has become a diminutive creature, either standing behind his Mistress or kneeling at her feet, his impotence in art being an accurate reflection upon his real physical and psychological emasculation in English and colonial societies.[10]

Many later popular representations are variations on the tradition of the black page as decorative element. A cover of *La Vie Parisienne* (29 April 1922) is an obvious pastiche of the cliché from earlier oil paintings, of the Moorish page who offers his mistress flowers or fruit. (Compare Van Dyck's painting of Henrietta of Lorraine.) The conventions of the genre have hardly changed since then. The blackness of the servant highlights the lady's fair skin, his smallness sets off her tall bearing. The little black still does not stand in range of her vision and he is still dressed as an idiot, made a spectacle in a combination bellhop or *piccolo*'s uniform and Moorish costume. But the flowers are now accepted, whereas in seventeenth- and eighteenth-century paintings the mistress hardly acknowledged the tributes which lay entirely outside her field of vision.

Cover of *La Vie Parisienne*, 29 April 1922. Pastiche, with the figure of the black page in *piccolo* uniform, but with oriental ornaments and exaggerated facial features.

Black page as fantasy harem servant – tiny, marginal, decorative. Stefano, advertisement for 'Indra' artificial pearls, *Art Déco Fashion*, 1913.

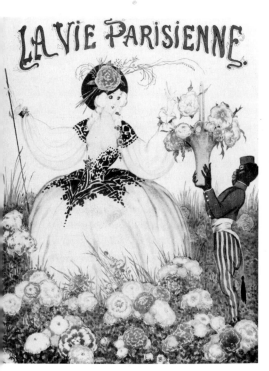

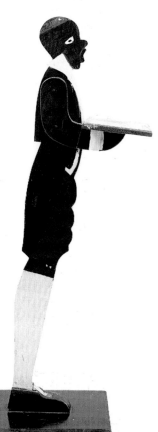

Wooden figure of a servant (1920).

'There's no peace for a lady of fashion – Even if it isn't always to her liking.' Two types of black servant, in oriental and occidental costume, attending white lady (Netherlands, 1931).

The Moor in rich European households also carries an erotic meaning, as in Crébillon's eighteenth-century novel *Sopha*. 'One of the black servant's central functions in the visual arts of the eighteenth and nineteenth centuries', according to Sander Gilman, 'was to sexualize the society in which he or she is found.'[11] A well-known instance is Hogarth's *A Rake's Progress* (1733-4) and *A Harlot's Progress (1731)*, analysed by David Dabydeen. Another example is the little black servant in Strauss's opera *Der Rosenkavalier* (1911). In these cases the little black servant serves as a code to denote illicit sexual relations.[12]

In the wake of Napoleon in Egypt and of the French invasion of Algeria (1830), orientalist paintings made their way into French salons. In paintings by Delacroix, Ingres, du Nouy, Benjamin Constant, and in novels by Flaubert, the cultural incorporation of the Maghreb and the Middle East (a less ethnocentric term is West Asia) into Europe was consummated. Black servants are rarely absent from these canvases. A prominent orientalist genre is the harem scene, with languishing odalisques and black eunuchs as guards or servants.[13] Popular culture imitated art and trivialized this pattern, and in the course of the 1800s the black servant in oriental costume made a come-back. By the *fin de siècle* there was a marked increase in this kind of white-black representation, usually in oriental décor. Oriental luxury, decadence, sensuality, 1,001 nights, Turkish baths and seraglios are the scenes suggested. A recurrent fantasy is a harem-like situation, in which languid, European, but orientally-adorned women are served by a black page. Art deco fashion was inspired by this kind of scene.[14] *Salomé* (both Wilde's play and Strauss's opera), was performed in such a *fin-de siècle* setting,[15] and the work of Diaghilev's Ballets Russes and the orientalist costume designs of Léon Bakst reflect it.[16]

The black servant in these fantasies is essentially the *eunuch*, the emasculated harem servant or slave. The languid, pining ambience highlights the females' sexual availability, for the sake of someone absent from the representation – the sultan, now a white man, who is the actual unseen prince of these fantasies. The black eunuch in an imaginary harem may be the basis for figures such as the Sarotti-Mohr (discussed further in Chapter 10). In all likelihood this is the key to the success in European culture of the formula of the little black servant who brings the ladies chocolate or coffee.

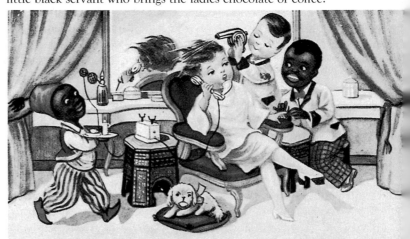

'n Modedame heeft nooit rust — Ook al is 't niet altyd haar lust!

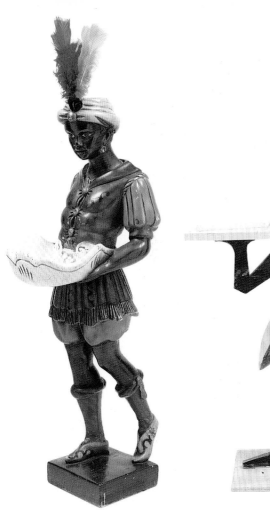

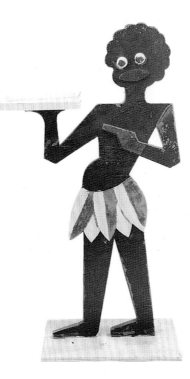

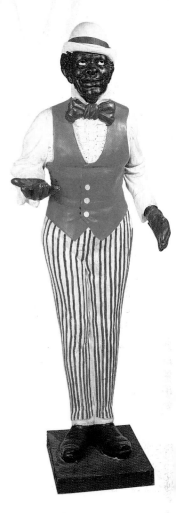

The play *Moortje* (Little Moor, 1617) by the Dutch poet Bredero was based on the play *Eunuchus* by Terentius of Carthage (195-159 BC); In the key role of the eunuch Bredero substituted a black: 'since this kind of people [eunuchs] are not very well known here, I have taken the liberty of changing him into a Moor'.[17] Thus even in seventeenth-century Europe there was a link between the Moor and the eunuch, the emasculated black servant. This association had become familiar from the biblical story (in Acts 8) of the baptism of the Ethiopian Eunuch, an officer in the service of Queen Candace, by the evangelist Philip; a story frequently depicted in European art from the seventeenth century onward.

The main avatar of the black servant was, of course, the slave. With slavery came an ideology which declared either that the slave (along classical lines, following Aristotle) was 'born to serve', or (along Christian lines) was destined for the same purpose as the 'children of Ham'. This ideology found its champions also in the nineteenth century, on the cusp of emancipation, for example in Thomas Carlyle: 'That, you may depend on it, my obscure Black friends, is and was always the Law of the World, for you and for all men: to *be* servants, the more foolish of us to the more wise; and only sorrow, futility and

Black servant, oriental variety, sweet-shop figure (De Gruyter, Netherlands, 1930s).

Wooden servant (1920s or '30s).

Black servant outfitted in the colours of the American flag (recent replica of a statue of c. 1910).

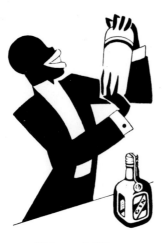

Mr. Mix.

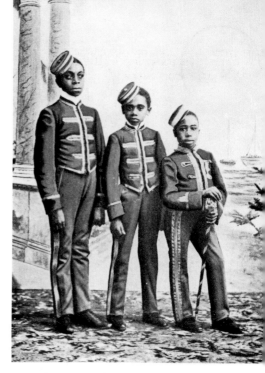

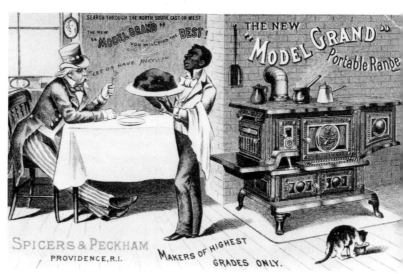

American types of black servant. Bartender in dinner jacket. Advertisement for Saturnus Gin. '101 Cocktails', Malmö (1931).

Postcard with bellhops (USA, 1905).

Black servant waiting on Uncle Sam. Advertisement for Model Grand cook-stove, (USA, 1900).

disappointment will betide both, till both in some approximate degree get to conform to the same.'[18] Here being a servant is not an occupation but a vocation, a destiny and a continuation of slavery by another name.

In America the status of black servant was the key to what has been termed 'hierarchical integration'. As the ex-slave Frederick Douglass observed 'while we are servants we are never offensive to the whites. . . . On the very day we were brutally assaulted in New York for riding down Broadway in company with ladies, we saw several white ladies riding with *black servants*.'[19] Hierarchical integration permits physical proximity on condition that a clear relationship of superiority-inferiority is maintained.

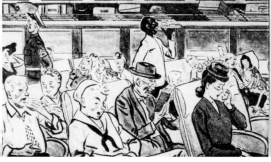

The black servant in oriental costume is not a familiar image on the American side of the Atlantic (or rather, it is regarded as a 'European' type of black image; although the metaphor of the harem is not unknown in the United States).[20] Here the black servant wears the uniform of a bellhop or *piccolo*, shoeshine boy, porter, doorman, train steward or waiter, or the tuxedo of the bartender or waiter in a nightclub. The oriental costume suggests an invisible sheik while the European livery carries aristocratic associations; the American tuxedo on the other hand is urbane and civil.

Thus in western culture we see blacks depicted in either oriental or occidental costume – in either case they are Africans incorporated into another culture; what is missing is indeed the African as African, in African clothes. As Roland Barthes remarked, 'the only really reassuring image of the Negro is that of the *boy*, of the savage turned servant'.[21]

What the varying depictions of black servants, oriental or occidental, have in common is the iconography of servitude, the sign language of subordination and servility, such as
- the smile expressing availability;
- the servant depicted as smaller, lower or in the background;
- a slight stoop in posture which makes his body seem shorter or smaller and which suggests subjection;
- a bend in the knees which, as in reverence, expresses subjection;
- watching the eyes of the person being served – a look which does not have to be reciprocated; on the contrary, the person served usually looks past the servant;
- a physical distance between the servant and served which denotes social distance and status difference.

Servitude is not merely a status, it is a way of being.

'The Journey Home. Vivid Picture of the Home Front'. Black train steward in the United States during World War Two. *The Bulletin* (USA, 1940s).

Illustration from *Après la pluie le beau temps* (France, 1880).

9 ENTERTAINERS

One of the few roles available to outsiders in European culture (and many others) is that of the performer.

Roger D. Abrahams and John F. Swed, 1983

Slaves were expected to sing as well as to work. A silent slave was not liked, either by masters or overseers.

Frederick Douglass, *Autobiography of a Slave* (1846)

That some blacks have become famous as entertainers or athletes is sometimes presented as an argument to the effect that there is no real discrimination against blacks, that western societies are integrated and that every opportunity is open to blacks if only they make an effort. It does not require too much imagination however to realize that this kind of success is a marginal phenomenon and can very well go along with a pattern of discrimination in society at large.

From early on Europeans have shown an interest in African music and dance. On the 'Middle Passage' slaves were encouraged to dance and sing for the sake of their physical as well as moral condition. 'Dancing the slaves' was the usual term, and it often involved the use of the whip. In plantation society entertainment served as a means of reducing friction. Were cheerful slaves not happy slaves? 'Marster lak to see his slaves happy and singin' bout the place. If he ever heard any of them quarrelin' wid each other, he would holler at them and say: "Sing! Us ain't got no more time to fuss on dis place. . .".[1] Performing thus was an essential part of slave existence. The 'merry nigger' also served as an argument in defense of slavery. Blacks, so the reasoning went, are 'mirthful by nature'. When slaves staged entertainments on their evenings off the whites often watched. The interest in black entertainment was, according to Frederick Douglass, a way of keeping rebelliousness at bay. This may well have been true at certain periods. In the West Indies, however, where there were many more blacks in proportion to whites, the reverse was often held, that festivities could be the prelude to rebellion.

Minstrels

Old Massa to us darkies am good
Tra la la, tra la la
For he gibs us our clothes and he gibs us our food. . . .

E. P. Christy

One of the first black figures to achieve popularity in modern western culture was the Minstrel – a white imitation of black culture. Or, more accurately, in the words of Kenneth Lynn, 'a white imitation of a black imitation of a contented slave'. The minstrel was in the North of the American Republic what the slave entertainer who performed in his master's house, in church, at fairs, horse-races, dances and so on, was in the South. In the North the stage replaced these venues, and whites in black-face replaced the performing black slave – as they did after slavery had been abolished in the Northern states. Thus the Minstrel tradition had its origin in a kind of imitation slavery, with imitation blacks, for Northerners who had to manage without slaves or slavery.

Minstrel shows became popular in the period when slavery was being exposed to mounting abolitionist criticism and to slave resistance. Blacks were parodied in songs like 'The Bonja Song' (c. 1820):

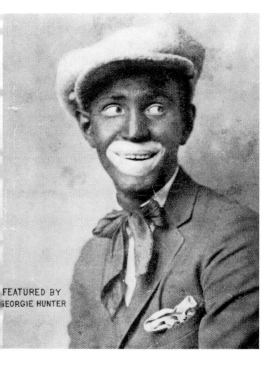

FEATURED BY
GEORGIE HUNTER

A minstrel in black-
face. Georgie Hunter on
the cover of 'In the
Town where I was
born'. (USA)

> Me sing all day, me sleep all night
> Me have no care, me sleep is light
> Me tink, no what tomorrow bring
> Me happy, so me sing.

A genre was born. In 1828, in Kentucky, Thomas D. Rice performed 'Jim Crow', a song he had heard earlier from a black performer in the South (see illustration, page 153). He performed in black-face and tattered clothes and sang in 'negroe' dialect:

> Wheel about, turn about
> Do jis so
> An' ebery time I wheel about
> I jump Jim Crow!

'Daddy' Rice was a gifted performer and 'Jim Crow' a popular jig, 'which could be adapted to fit the circumstances. When *Uncle Tom's Cabin* appeared, Daddy Rice immediately did a Jim Crow version of Uncle Tom, in the pro-slavery minstrel tradition. 'Jim Crow' became a household word, destined for a peculiar career. The segregation laws introduced in the South in the late nineteenth century – the American form of apartheid – are known as 'Jim Crow' laws.[2] (As Langston Hughes wrote in 1943 in 'The Fun of Being Black': 'In the far West a Negro can sometimes eat in a Mexican restaurant but he cannot eat in a Chinese restaurant – so it is fun figuring out just where you can eat.')[3]

The ideological background of 'Jim Crow' was the white backlash against abolitionism. Minstrelsy helped whites to come to terms with the problem of slavery. In Minstrelsy there was room for criticism of the 'excesses and abuses

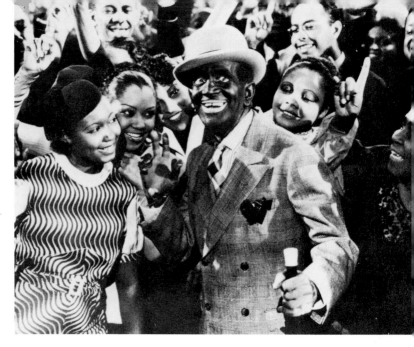

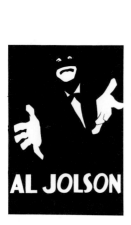

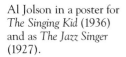

Al Jolson in a poster for
The Singing Kid (1936)
and as *The Jazz Singer*
(1927).

of slavery' but not of slavery *per se*. The overall attitude was pro-slavery, and abolitionists were made out to be stupid, hypocritical, subservient to England and committed to 'racial mixture'.[4] 'Minstrel shows contained not only explicitly pro-slavery and anti-abolitionist propaganda; they were in and of themselves a defense of slavery, for their main content came from the myth of the benevolent plantation.'[5]

The minstrel show or 'Ethiopian Opera' remained America's most popular form of entertainment until, towards the end of the century, vaudeville theatre emerged and later film. Minstrel songs derived much of their character from African musical elements, such as looseness of style, rhythm and dance movements. These were part of their appeal, but instead of being acknowledged as African they were merely considered 'primitive'. Thus minstrel music, copied from black music, has been considered America's own music *par excellence*, and the minstrel show, with whites imitating blacks, America's 'national' entertainment.

Popular entertainment easily produced popular stereotypes. The types who played the comic leading parts in minstrel shows were the rural plantation Negro (Sambo or Bones) and the urban dandy (Tambo). The dandy with his would-be classy clothes and pompous language caricatured the new figure of the free black. The plot consisted of the 'plantation niggers', the simpler and homelier characters, mocking and denigrating the bombastic pretensions of the dandy. In that sense the shows were about debunking élite pretensions, with the license all the greater because it took place behind black masks. Making fun of urban blacks who were actually in the process of becoming assimilated, in dress and in speech, was a way of undermining black emancipation. Thus while the minstrel show seemed a 'democratic' form of popular art, it was not the real upper strata that were the target of derision but instead the would-be social climbers, the black dandies, who were actually among society's more vulnerable types. Thus the minstrel show was a populist and ultimately anti-emancipatory theatre.

In England, where American minstrel shows toured early on, the phenomenon caught on; witness for instance the BBC's 'Black and White Minstrel Show'. A reviewer of an act playing at the Palace Theatre in London in 1905 commented: 'Grotesque comedy is more effective when accompanied by a black face. . . . The coon is as inevitable as ragtime.'[6] In the 1920s with Al Jolson, the world's most famous imitation black, the minstrel show arrived at its apogee.[7] The minstrel visage – broad whitened lips in a blackened face, the caricature of a caricature – has become the most enduring of black caricatures. It has inspired another enduring entertainment figure: the clown type of 'dummer August', modelled on the minstrel. One clue to the lasting popularity of the minstrel show is no doubt the principle of role-reversal: in blackface whites can play their black alter egos. It permits identification in the context of segregation.

The 'darky melodies' of minstrel shows were largely sentimental, but the 'coon songs' which were popular from the 1890s onwards were bawdy, burlesque songs. 'Coon' was a denigratory term for blacks common in the South; it carried the double connotation of cluck and fool, and an unreliable, thievish character (the Zip Coon). Originally the term derived from the raccoon, with its large white eyes in a dark snout. The sheet-music covers of coon songs were aggressively racist, showing blacks with lips like watermelons, eyes like saucers, wild curly hair and elongated bodies. The refrain of 'Four Little Curly Headed Coons' went:

Four little curly headed coons,
Four little crazy headed coons,
Their little hearts were broke
They'd like to take and choke
This smart curly headed coon.

American Coon Songs. Sheet-music published in Amsterdam.

'A pair of Coons'. From Edward W. Kemble, *Kemble's Coons* (New York, 1896). Association of black boy with raccoon. The basis for 'coon' as a term of abuse for blacks would seem to be the white eyes in the dark snout and the alleged slyness of the night creature.

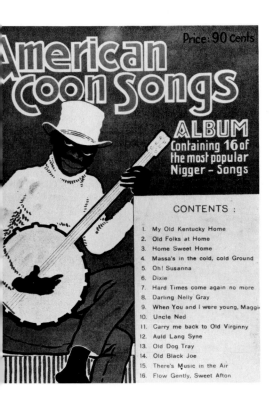

Another song made an attempt to bring together all the stereotypical ele ments: 'The Coon's Trade-mark: A Watermelon, Razor, Chicken and Coon' (1890s). The popular illustrator Edward Kemble published a book *Kemble's Coons*, with little blacks depicted as coons.[8] Denigrating blacks and equating them with animals had been elevated from regional folklore to a form of art. While the context of the minstrel tradition had been abolition ism, this phase of popular entertainment unfolded as a reaction to Emancipa tion and to Reconstruction in the South. It went together with brutal ex pressions of racism and violence. Books such as Charles Carrol, *The Negro a Beast* (1900) and R. W. Shufeldt, MD, *America's Greatest Problem: The Negro* (1915), expressed the racist backlash.

The cliché of the minstrel, the blackened face with broad whitened lips, the black caricatured as clown, is still in wide circulation, as a decorative feature on posters and a hieroglyph for musical entertainment. In 1961 in the British House of Lords, Lord Brabazon of Tara remarked, after attending a session of the United Nations: 'As I went to it [the UN] I really got the im pression that there was a convention of nigger minstrels going on. . . .'.[9] The imagery of minstrels has been so potent as literally to blind westerners to real black people functioning in other roles.

'Song and dance'

Eef, gaff, mmff, dee-bo, dee-la-bahm,
Rip-rip, de-do-de-da-do, do-de-da-de-da-doe,
Ba-dode-do-do, ba-ro-be-do-be-do,
Geef-gaf, gee-bap-be-da-de-do, d-dda-do,
Rip-dip-do-dum, so come on down, do that dance,
They call the heebie jeebies dance, sweet mammo,
Poppa's got to do the heebie jeebies dance.
Louis Armstrong, 'Heebie Jeebies'

The first role blacks were permitted to perform in white society, after that of slave or servant, was that of entertainer. Indeed entertainment, as men tioned above, was itself one of the functions of slaves. In eighteenth-century Europe it was the fashion to include a Moorish percussionist in a military band and in virtually all European countries Moors performed in military and court orchestras as percussionists. As such they had an influence on European music.[10] Blacks were also welcome as clowns and jesters.[11]

In white-on-black imagery this is a recurring theme: the special musical gifts, the gift of emotional expression attributed to black people. Even in the most rabidly racist view there is always a special place for black musical apti tude. This was a commonplace as early as the eighteenth century. In 1793 Bryan Edwards remarked: 'An opinion prevails in Europe that they [Negroes] possess organs peculiarly adapted to the science of music; but this I believe is an ill-founded idea.' Missionaries saw in black musical ability an excellent opportunity for converting them to Christianity; for instance, John Wesley: 'I cannot but observe that the Negroes above all the human species I ever knew, have the nicest ear for music. They have a kind of ecstatic delight in psalmody.'[12]

Thomas Carlyle interrupted his bitter racial diatribe, 'The Nigger Question' (1849), to observe: 'Do I, then, hate the Negro? No; except when the soul is killed out of him, I decidedly like poor Quashee; and find him a pretty kind of man. . . . A swift, supple fellow; a merry-hearted, grinning dancing, singing, affectionate kind of creature, with a great deal of melody and amenability in his composition.'[13]

This opinion was then and is now shared in Africa and by many black people themselves. Equiano told his English readers in 1789: 'We are almost a nation of dancers, musicians, and poets. Thus every great event . . . is cele

brated in public dances which are accompanied with songs and music suited to the occasion.' For Equiano, however, as James Walvin notes, musical ability was not a racial or biological aptitude but a social trait, culturally acquired.[14] This was viewed differently in western theories of race, for instance by Comte de Gobineau, who observed, in spite of his aversion to Negroes:

> the black element . . . [is] indispensable for developing artistic genius in a race, for we have seen what outbursts of . . . vivacity and spontaneity are intrinsic to its soul and how much the imagination, that mirror of sensuality, and all cravings for material things, prepare it (1853)[15]

In America after emancipation, when many blacks trekked to the cities in the North ('one of the largest internal migrations in history'),[16] entertainment and music were among the few fields of employment open to them. Blacks who had done skilled work as slaves could not get similar jobs in the North. Businesses and trade unions turned down blacks, preferring recent immigrants from Europe to the black migrants from the South.

One of the first forms of black entertainment to become popular outside the black community was the Cake Walk, originally a plantation dance in which blacks parodied whites and their stiff forms of dance such as marches, parades, polonaises and quadrilles. It was a kind of reversal of the minstrels, who parodied blacks: now blacks mocked whites and their rigid body language. In 1898 in New York the first black musical was performed, *Clorindy*, which dealt with the origin of the cakewalk. Around this time, in 1902-3, the first cakewalk troupes toured Europe, and in Paris, London and Berlin the struts and shuffles of the cakewalk became the rage. A 'nigger fashion' promptly resulted. German operette composers recognized its potential popu-

'American Negroes'. Advertising card of the American tea firm Brandsma, featuring a dancing scene, a cake walk and a hunt for a raccoon. The text explains: 'The American Negro, at least the less developed one, is a child of nature and one of the most interesting, selfless and happiest of creatures . . . The 'cakewalk' is one of the most peculiar and attractive pleasures . . . It is simply about being the best and most gracious walker . . . the invitation to this match is accepted by most of the young negroes of a community. A jury is appointed and before it the various couples parade seriously and calmly on the best of the music. The prize, a cake, is allocated by the jury to the best couple, to the envy of the others.'

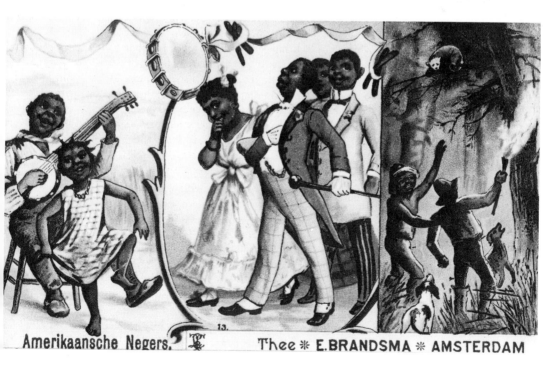

Amerikaansche Negers. 13. Thee ✳ E.BRANDSMA ✳ AMSTERDAM

'Le Cake-Walk Officiel'.
Cover of *Le Rire*, March
1903.

'La vie au Congo'.
Cakewalk taking place
in the Congo. Postcard,
France.

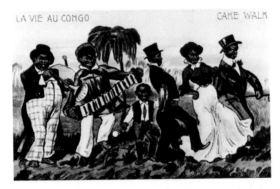

larity; the composer Paul Lincke made 'Neger's Geburtstag' (1903) a *schlager* (song hit) and his competitors reacted with 'Meine kleine Braune', 'Der Negersklave' (1904), 'Das kleine Niggergirl' (1908) and 'Molly, mein kleiner Nigger' (1910).[17] It was the first of several waves of 'Negro fashions' in Europe and the United States.

The rise of black entertainment was also a manifestation of the vitality of blacks in the cities of the American North. 'African Broadway', the stretch of New York City's Seventh Avenue between 27th and 40th Streets, was famous. This was where most blacks, mainly newcomers to New York from the South, lived in the 1890s. Their 'dress parade' was an impressive, exuberant display of fashionable elegance and dandyism, an attempt to bridge the gap between themselves and well-off whites, although it was ridiculed as a 'Monkey Parade'.[18]

Ragtime, the African-European style of piano-playing, became popular at about the same period. After the First World War the Jazz Age broke loose. After many decades of entertainment dominated by imitation blacks, blacks themselves now took the stage. The epicentre of the Jazz Age was New York

and especially Harlem, where it formed part of a wider cultural upsurge, the Harlem Renaissance or 'Golden Years'. Like calypso in the West Indies, jazz went with a broader cultural movement of black writers, poets and painters.

But how can it be fathomed that while blacks were being segregated and terrorized in the American South, they formed the core of the entertainment industry in the North? The breakthrough of jazz came after the 1914-18 War and the tumultuous years 1919 and 1920, years of social unrest throughout the western world, against a backdrop of demobilization, social revolution in Russia, and the culture-shock of the war itself. 'The longer the war, the shorter the skirts', according to a popular saying in Germany. In the United States 1919 was the year of the 'red summer', the Red Scare and race riots in Chicago. The rise of jazz has been described as the reaction to a vacuum: 'as upper-class people lost faith in traditional standards, they were left with a vacuum in their lives. In an effort to fill it they sought exposure to the values of the subcultures which seemed to offer fun, excitement, romance, a more genuine contact with reality, and identification with art.'[19] Prohibition in America (from 1920 to 1932) made for fraternization between the upper crust and the underworld, between a segment of the élite, and those in the social margins, and bohemians, which is characteristic of the jazz ambience. The Cotton Club, Harlem's most famous night-club, was run by the Mafia for a

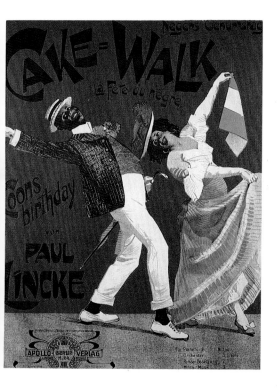

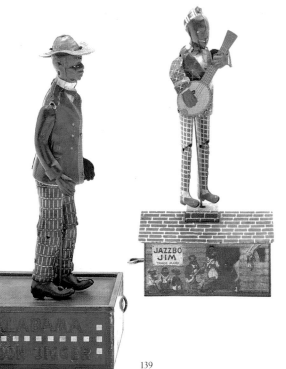

'Cake-Walk, Negers Geburtstag, Le Fête du Nègre, Coons birthday', hit tune by the German composer Paul Lincke, 1903.

Alabama Coon Jigger. Mechanical toy, USA.

'Jazzbo Jim, the Dancer on the Roof'. Mechanical toy, USA, 1921.

white clientele. 'A negro was only admitted when he was a celebrity and then given a back table.'[20] The shows at the Cotton Club were psycho-dramas in which blacks were allocated a new role in shaping white fantasies. For blacks it meant adapting to a new situation, in the cities of the North, where they were interacting with metropolitan culture while being excluded from much of the labour market.

At this peculiar juncture, the white élite went 'slumming' in Harlem, where black bands were busy parodying themselves while at the same time developing a new art form. In the words of a critic: '[Duke] Ellington . . . could use preposterous titles like *Jungle Nights in Harlem* for the benefit of the "slumming" white crowds at the club at the same time that he was expanding the sonorities, the color, the orchestrational resources of his ensemble and creating a memorable and durable music.'[21] Marshall Stearns's description of the Cotton Club is a little more revealing:

> I recall one [show] where a light-skinned and magnificently muscled Negro burst through a papier-mâché jungle on to the dance floor clad in an aviator's helmet, goggles, and shorts. He had obviously "been forced down in darkest Africa", and in the center of the floor he came upon a "white" goddess clad in long tresses and being worshipped by a circle of cringing "blacks". Producing a bull whip from heaven knows where, the aviator rescued the blonde and they did an erotic dance. In the background, Bubber Miley, Tricky Sam Nanton, and other members of the Ellington band growled, wheezed, and snorted obscenely.[22]

'Manners and modes'. Scene of the Roaring Twenties. The black musicians in the band all have the same face. *Punch*, 4 Feb. 1920.

'He whistled the "Old Zip Coon".' The white musician is visibly aggravated. Laren, Netherlands (1930s).

The black entrée into the musical world was a form of emancipation, but it took place within the confines of the existing imagery, of black segregation and of the roles alloted to blacks. Black entertainers were decorative and not necessarily emancipated figures. The figure of the black waiter or bartender melts easily into that of the black performer: the bartender's tuxedo is the same as that of the night-club musician. Entertainment is a kind of service too. Entertainers were not a threat to the status quo. Besides, entertainers were subject to restrictions. Black crooners were supposed to remain within safe limits, to perform in a desexualized style, conform to the stereotype of the 'happy Negro'. Black musicians kept their mask on – jazz and blues are replete with sexual *double entendres* and social criticism concealed in slang. The cheerfulness of jazz, according to Paul Whiteman, was the 'cheerfulness of despair'. Only with bebop in the '40s and later styles such as free jazz did the mask begin to come off.

The Jazz Age was as paradoxical as other waves of black entertainment. Blacks gave whites the 'heebie jeebies'. A 'blackening' of western music took place, a cultural renewal from the periphery and from below – but under white management. Outside New York jazz was still regarded as 'nigger music' and 'whorehouse music'. It was not until the 1930s that mixed bands could tour in the United States itself.

In America the entertainer, according to Beth Day, falls under one of the permitted black types, 'The Bright Child': 'This includes all blacks under the age of eight, most actors, comedians, and musicians. A black male may remain a Bright Child until any chronological age provided that he does not threaten the status quo. (An example of the Bright Child is the late Louis Armstrong.)'[23]

If we consider the stereotypes according to which black people are especially gifted musically and examine its fine print, we come across certain sexual references. Thus, Comte de Gobineau spoke of race in explicitly sexual or gendered metaphors. 'Whites', according to Gobineau, were essentially 'male' and 'blacks' 'female'.[24] Does this association of blacks and females, this congruence of racism and sexism, indicate that the role pattern of performing which is allocated to blacks through thick and thin is in fact a 'female' role, denoting a specialization in emotional expressivity (that is, according to certain stereotypes of 'femininity')? Does this indicate that the type of the black entertainer – who is ultimately, aside from the servant, the only black figure welcome in western culture – is basically an *emasculated* type? This would mean that the black entertainer, like the Moorish servant, is ultimately a variation on the figure of the eunuch – the functionary in a harem which is not his own. What is the Bright Child other than a eunuch under a different name?

Cartoon entitled 'Louis Armstrong's First Lesson', in *Melody Maker*, March 1931. The figure of the mouse (big eyes in a black face) is based, like Mickey Mouse, on a caricature of a black.

Sixteen bananas

Paris was the European epicentre of the Roaring Twenties and the Jazz Age, and Josephine Baker was its symbol. A black dancer from St. Louis who became a sensation overnight in Paris in 1925, she was 'the most sensational woman anybody ever saw – or ever will', according to Ernest Hemingway.

In Paris there already existed a tradition of interest in African art, as in the admiration of Les Fauves and the Cubists for African sculpture. French composers had visited Harlem; among them Darius Milhaud, who worked the new jazz spirit into the ballet music he composed for The Ballets Suédois of the impresario Rolf de Maré, a well-known figure in the history of modern dance. At the time De Maré was manager of the Théâtre des Champs-Elysées, where La Revue nègre, featuring Josephine Baker, was launched. Stravinsky's Sacre du Printemps had been given its première in the same theatre in 1913.

At the opening in 1925 Baker performed topless, in a skirt of feathers designed by Poiret. The next year she appeared in the famous skirt of bananas. The fruits of the jungle, sixteen of them, were made of rubber and the idea had come from Paul Colin, the poster designer. Baker, who was light brown in colour, had to be kept by the French manager from powdering herself a lighter tint: what would have been recommended in America would have disappointed the public here, where dark skin colour appealed to latent fantasies. Baker's talent and energy were her own, but her so-called wildness was a quality carefully constructed by impresarios and avant-garde artists: 'primitivism' as an artefact, 'wildness' as artful illusion, a new gimmick of Paris café society (which at the time was also experimenting, as we have seen, with orientalism as a theatrical effect). Taking her leopard for a stroll in a Paris

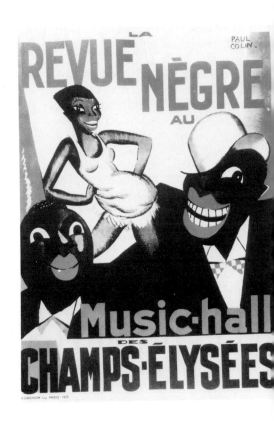

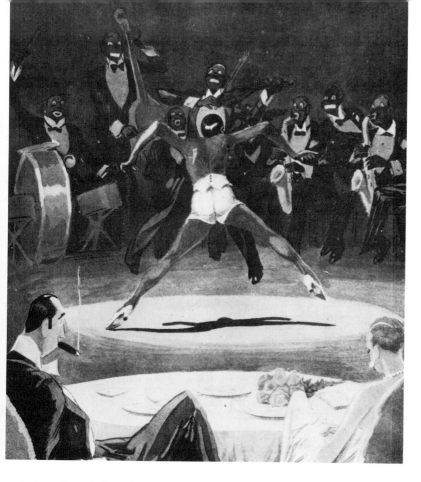

'The "Entirely in black". The last representatives of the old French gaiety.' *La Vie Parisienne*, 31 Dec. 1927. Cultural document showing interesting contrasts in body language.

park, Josephine Baker played herself with this imagery. In New York Duke Ellington and others catered for the same mentality with such numbers as 'Echoes of the Jungle' (1931).

'This dance is the triumph of voluptuousness, the return to the morals of primal times', according to the *Magazin Candide*, reviewing Baker's first performance. And according to a critic of the Paris magazine *Comoedia*, 'When Miss Baker raises her arms in phallic invocation, this pose evokes all the enchantment of Negro sculptures. We are no longer facing the frolicking Dancing Girl, but the Black Venus.'[25] Art critics such as Raymond Cogniat saw *La Revue nègre* as the culmination of French interest in African art and in American jazz. Baker, according to Cogniat, introduced an 'instinctive exoticism', departing from the banal 'boudoir eroticism' of the day. The dance critic André Levinson described her movements as 'apelike', while he also saw her as the embodiment of 'the Black Venus who haunted Baudelaire'.[26]

This ambivalent exotism that was racist and at the same time biologized by what was, allegedly, 'primitive' and 'savage', was characteristic of the epoch. It was part of Europe's emancipation from Victorian puritanism by means of a further revaluation of the clichés about savagery: the clichés remained, but from being seen as negative they were now evaluated as positive. It was a return of the repressed: with European judgements about non-western peoples returning like boomerangs to their source.

While Africans were being colonized in the name of European civilization, black entertainers from America found themselves *à la mode* in the European capitals. While rebellions in Africa were being bloodily repressed, as in Nyasaland, black Americans gained fame on European stages with their interpretations of 'African' dance and music.[27] These black interpretations of white fantasies, or of white exoticism, featured not only caricatures of Africa and of blacks but also evocations of the imaginary Orient, as in Louis Armstrong's 'Sheik of Arabie', Ellington's 'Caravan' or Dizzy Gillespie's 'Night in Tunisia'. Two contrasting scenes – one of the suppression of 'savages' in Africa and in the South of the US, and the other of a fascination with 'savages' in Europe and in the North of the US – seemed to resonate with one another: one fantasy of power created a savage *alter ego* to be repressed, and was compensated by another fantasy of power, which enjoyed the savage *alter ego*'s abandon.

The famous posters by Paul Colin announcing the *Revue nègre* and *Bal nègre* and similar events record the ambivalence of the time.[28] Black men are caricatures, with enormous red lips and bulging eyes, colossal in size; by comparison, black women – Josephine Baker and others – are shown as small, their bodies flexible, in a way which highlights the phallic reputation of black males and displays their strength, in accordance with the stereotype – which here, however, is meant not in a denigrating but in an animating way.

In Berlin, Vienna, Amsterdam, Josephine Baker's impact was as sensational as in Paris. European cities patterned themselves after New York, and the Cotton Club was the new beacon on the horizon of the entertainment industry. This meant a shift in the centre of gravity of western culture – from Paris, the cultural centre of the colonial age, to New York. Thus began the 'American Century', as Wall Street in New York also took over from the City of London , diminished by war loans, as financial centre. Paris remained the

Sketch by Paul Colin, 1925.

Poster for the phenomenon of *Entartete Musik* (Degenerate Music) in Düsseldorf, 1938. Black saxophone player with Star of David and top hat: anti-black racism and anti-Semitism coupled in Nazi exhibition.

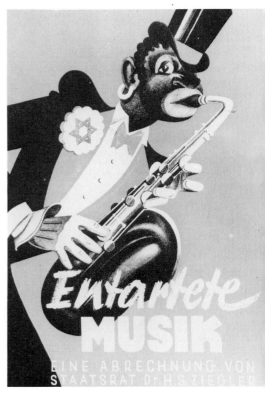

'capital of hedonistic Europe' by assimilating, as did Berlin, the New York model and by importing black jazz musicians.[29] Paris became a European rendezvous for black Americans and American bohemians. 'Cafés with Negro bands, as in Paris' became the new norm in Europe's entertainment centres. Surinamese blacks who had come to the Netherlands as sailors or students found the Dutch night-club doors wide open – as if 'coloured' or black had become a profession and a status identical with that of musician. They adopted American-sounding names like 'Kid Dynamite' (for Lodewijk Rudolf Arthur Parisius).[30]

Of course the welcome was not unanimous. In Europe, as in America, the new trend in entertainment encountered resistance. Allusions abounded to decadence and moral decay under the influence of wild Negro music and dance. The cakewalk had already led a German dance authority to observe in 1913 that the dancing couples seen 'from above gave the impression of drunken microbes'. In the same year Kaiser Wilhelm II prohibited all men in uniform from dancing the tango.[31] In England as well, polite society reacted with horror:

> With the passing of the old healthy sensual (but never sensuous) English dances came the rushing in of alien elements. Chiefest and most deadly, the cakewalk tells us why the negro and white can never lie down together. It is a grotesque, savage, and lustful heathen dance, quite proper in Ashanti, but shocking on the boards of a London Hall.[32]

In reaction to the introduction of a jazz class at a Frankfurt conservatory, the *Süddeutsche Musikkurier* reported (1927) that it was 'anti-German' and 'A laboratory for Negro blood transfusion'.[33] In 1926 the first jazz festival in Belgium took place, and of the new dance movements it was said that 'the origin lies with the barbaric Negro tribes inciting to erotic madness'.[34] Competition from white musicians was another motif in the resistance to jazz. In 1930 in the Netherlands Meyer Bleekrode designed a poster for the Dutch musicians' union which showed a Negro as a threat to the employment of Dutch musicians (see page 217 below).[35]

For the Nazis the Jews were part of a larger group of enemies which also included Negroes and Bolsheviks, along with gypsies and homosexuals, and in that context they came out against 'licentious Negro music'.[36] In 1938 as part of the Reichsmusiktage in Düsseldorf an exhibition devoted to *Entartete Musik* (Degenerate Music) featured works of Jewish composers, instances of 'dissolute Negro music', compositions by 'culture Bolsheviks' like Stravinsky, and atonal music. The display was accompanied by lectures on such subjects as 'On Germanness in Music', 'On Jewishness in Music' and 'Music and Race'.[37] A year earlier in Munich an exhibition had been devoted to *Entartete Kunst* (Degenerate Art), in which a comparison was drawn, which was termed 'revealing', between African masks and self-portraits of Jewish painters.[38] From 1937 onwards the 'Reichsmusikprüfstelle' had produced a black list; now, in addition, in every dance hall a sign appeared: 'Swing Tanzen Verboten!'

The kinds of music considered suitable in Nazi culture to bring 'joy to the people' were military marches and works by, among others, Richard Strauss and Anton Bruckner. The style of dancing recommended was stripped of erotic tension; it had to function, as an expert declared (1934) without a trace of irony, 'as if a rod went through the entire body, from the feet to the head'.

Apparently a kind of armoured dance style. And yet, in spite of all prohibitions, jazz was listened to and played with enthusiasm in Germany between 1933 and 1945, even in the Wehrmacht and the SS, and even in the Theresienstadt concentration camp, by the 'Ghetto Swingers'.[39] The difference between the Nazi marches on the one hand ('Bommenfliegermarsch', 'Es ist so schön,/ Soldat zu sein') and the Glen Miller Band on the other marked the sound barrier of the war years.

As to the role of blacks in the cinema, the early films continued in the tradition of minstrel shows, with farces of black life in the Old South and burnt cork for make-up. Black roles in the theatre and in films were initially performed by whites, while blacks themselves were allowed to play the parts of comic buffoons or faithful servants, plantation uncles and broad-bosomed mammies. *Uncle Tom's Cabin* (1903) opened with a cakewalk. *The Pickaninnies Doing a Dance* (1894) and *The Dancing Nigger* (1907) also featured blacks as dancing fools. In *King of the Cannibal Islands* (1908) the title speaks for itself, and *Rastus in Zululand* (1910) retold the classic epic of shipwreck and imprisonment by cannibals.[40] The notorious Ku Klux Klan-inspired film *Birth of a Nation* (1915) was the nadir, dominated entirely by the enemy image of the black brute (drawing on the motif of Beauty and the beast, along with the theme of rape). Animated cartoons made ample use of stereotypes of blacks and showed 'the concealment of aggression within humour'.[41] In European countries the film industry followed the pattern of colonial propaganda.[42] By reproducing stereotypes and mocking marginal social groups the new medium ingratiated itself with mainstream audiences and established its reputation.

For many years Sidney Poitier was Hollywood's token black, 'the official icon of Hollywood's allegories of race, Dignity personified'. 'I made films when the only other black on the lot was the shoeshine boy . . .'[43] In the 1950s Dorothy Dandridge was the first 'black vamp' to appear in American

Contrasting images of women, white and black. Vivien Leigh and Hattie McDaniel in *Gone with the Wind* (1939).

One of the first positive movie roles for a black. Sidney Poitier and Tony Curtis in *The Defiant Ones* (1958).

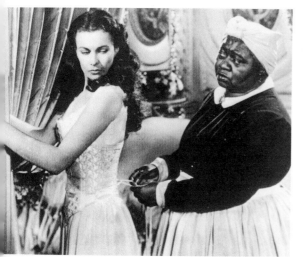

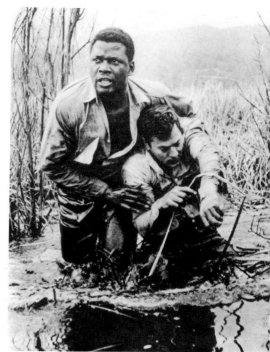

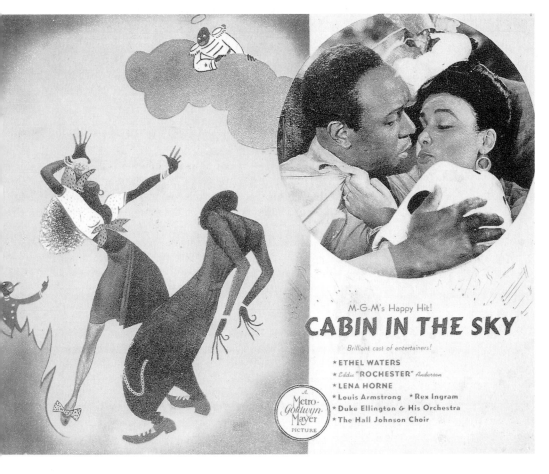

Advertisement for
Cabin in the Sky (1940s).

movies. With black actors such as Richard Pryor and black film-makers such as Spike Lee and Robert Townsend (*Hollywood Shuffle*, 1987), the horizon has begun to change in recent years.

Television has followed a similar course. In the United States blacks figured as comic relief in series featuring 'Amos 'n' Andy' (1951-66) and Stepin Fetchit. In the 1960s the Kerner Commission observed: 'By failing to portray the Negro as a matter of routine and in the context of total society, the news media have, we believe, contributed to the black-white schism in this country.'[44] 'As singers and tap-dancers, blacks sustained the image of "having rhythm"; as maids, black women were doting "Aunt Jemimas" whose obeisant manner was met with condescension; as handymen, blacks were basically slow-witted and recalcitrant misfits.'[45] Because of pressure from the civil-rights movement against stereotypes and for adequate media representation, the situation has improved in some respects; at least blacks are no longer outlaws. What has not changed is that blacks are excluded from management positions in the media. 'Over the past 15 years, less than 1 per cent of television network shows have been produced by blacks.'[46] Bill Cosby, executive producer of his own show, is the sole exception. In Europe the change has been smaller still. A social scientist recently observed, 'In the Netherlands black people on television are generally only represented as artists.'[47]

The role of black performers is too complex to show a constant pattern ove
so long a period, from the 'Nigger Minstrels' to Miles Davis, from Bessie
Smith to Jessye Norman, but there are some general tendencies. Entertainer
do not threaten the status quo but embellish it. Emotive, 'feminine' ex
pression by blacks is permitted, conforms to the rhythm myth, the stereotype
of musicality. Over the past century or so, and especially since the 1920s
blacks have become the musicians, dancers and buffoons of Atlantic culture
just as gypsies with violins occupy a similar niche – romanticized and margi
nalized – in central Europe. Also most images of blacks which prevail now in
everyday western society are images of entertainers. The imagery of the popu
lar media in which entertainment provides the sole positive role-models fo
black youth, and social reality, in which entertainment and sport are gilded
doors out of the ghetto, together form a vicious circle of stereotyping.

Even so, the entertainment ghetto on the margins of Atlantic culture ha
at times also been refashioned into an avenue of protest, and the song and
dance into a vehicle of emancipation. Blues singers sang in between the lines
Bessie Smith and Billie Holliday each gave a piece of their mind.[48] Josephine
Baker became a French national institution (she was awarded the Légion
d'honneur for services during the War) and founded her Rainbow Family
Some of the big bands made music which transcended entertainment. Bebop
and cool jazz became the music of existentialists and beatniks, part of the
abstract soundscape of the postwar world of United States hegemony, but also
the soundscape of a culture in which protest and collective action form part o
the normal social pattern. 'We Shall Overcome', the spiritual which became
the anthem of the American civil-rights movement, acquired a worldwide
echo, sung by protest movements the world over. Rock 'n' roll was a white
version of black music. Free jazz, reggae, and forms of African music are now
links in a new transatlantic popular culture, once the domain of the 'Atlantic
system', the economic system of which slavery was part.[49] In the words o
Joseph Boskin, 'the fool became an emancipator'.[50]

Sport

Another terrain on which blacks have been permitted to manifest themselve
is sport. Several sports had travelled along with Africans to the New World
and, according to a study by the tennis champion Arthur Ashe, by the mid
nineteenth century several sports were integrated. When sport was regulated
however, and became less informal, and after segregation set in, it too wa
segregated.[51] Black jockeys and cyclists were banned; the baseball leagues ex
cluded blacks in 1885. The 'black race' was viewed as being inferior in physi
cal terms as well. By the early twentieth century blacks had begun to make a
come-back in sport, first in cycling and boxing. Jack Johnson was the firs
black heavyweight champion (1908-15). Besides being a formidable boxer
Johnson was a flamboyant figure who walked all over the code of behaviour
segregation with his numerous affairs with and marriages to white women.[52]

'Racial competition' in the sports arena gave sport an exciting new dimen
sion. Isaac Israëls devoted a painting to The Negro Boxer (1914-15). The
Dadaists saw black-white boxing matches as Dada happenings. Sport was one
of the few areas in which blacks could manifest themselves in the desolate
years of American apartheid. In the 1930s and '40s Joe Louis, the Brown

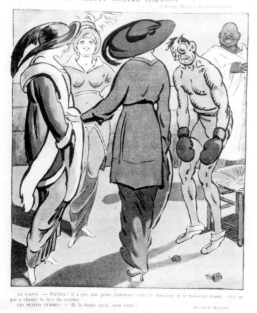

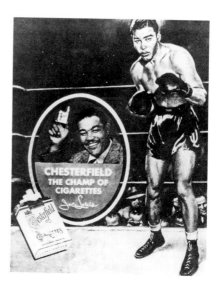

Bomber, the Dark Destroyer, was a hero and a role-model to black Americans, restoring their pride.[53] Jackie Robinson broke through baseball's colour bar when he was fielded by the Dodgers in 1947, another milestone.[54] The language of racial competition and of the *politique des races* is common on the sports pages too nowadays.[55]

The achievements of black athletes who have challenged 'white supremacy' and of blacks in the Olympics are all breaches in the myth of racial inferiority. The integration of sport is part of overall black integration. But it is also a limited kind of success. For blacks there is a place in the circus, as gladiators. Their success seems to confirm one of the stereotypes of the black as bestial brute, the 'all brawn and no brains' kind of athlete. Besides, new racial myths have been created to 'explain' the sports achievements of blacks. At first the story was that blacks were inferior to whites in every respect, physically as well, and therefore unfit to compete with whites. That some turned out to have greater physical prowess than whites, led to other stories. For instance, during the Olympic Games in Nazi Germany in 1936, which were designed to demonstrate the superiority of the 'Aryan race':

> . . . the phenomenal performance of the Blacks in Berlin worried many people besides the Führer, and in the weeks that followed the Games gave rise to agitated controversy. Unnamed 'medical authorities' were quoted as saying that the emergence of the blacks had introduced a new factor into sport; coloured athletes were claimed to have abnormal muscular qualities, different from those of white men, and in particular an 'elongated heel' which gave them extra spring and therefore an unfair advantage.

'Genty contre Johnson'. *Le Rire*, 15 March 1913. Imagery fashioned round the novel excitement of a white-black boxing match.

Joe Louis advertising 'Chesterfield the Champ of Cigarettes', 1947.

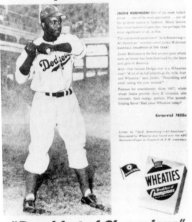

Champion of the Year

JACKIE ROBINSON! One of the most talked about ... one of the most applauded ... one of the greatest names in baseball. Many honors have been heaped upon him, but perhaps the most significant of all, is this.

The nationwide audience of "Jack Armstrong—All American" recently voted Jackie Robinson BASEBALL CHAMPION OF THE YEAR!

Jackie Robinson is the first person upon whom such an honor has been bestowed by the boys and girls of America.

And—this famous Dodger star is a Wheaties man! "A lot of us ball players go for milk, fruit and Wheaties," says Jackie. "Nourishing and swell eating the year around."

Famous for nourishment, those 100%, whole wheat flakes provide those B-vitamins, also minerals, food energy, protein. Plus second-helping flavor! Had your Wheaties today?

General Mills

Listen to "Jack Armstrong—All American", sponsored by Wheaties and heard over the ABC Network—Coast to Coast at 5:30 P.M. weekdays.

WHEATIES

"Breakfast of Champions"

Jackie Robinson advertising 'Wheaties Breakfast of Champions', 1950.

American athletes Tommie Smith and John Carlos, respectively gold and bronze medal winners of the 200 metres sprint at the Mexico Olympics in 1968, give the Black Power salute.
(*Associated Press Photo.*)

Because of this, it was suggested, future Olympiads would have to be split into two sections, one for Blacks and one for Whites.[56]

New racial myths continue to be invented even now.[57] Another factor is that integration in the field is not the same as integration at all levels of sport. In American professional football there are still no black quarterbacks; black coaches or managers in football and baseball are rare. Even though baseball has been open to black players for over forty years now, no team of any significance has a black manager.[58]

Time and again black athletes have stepped out of their roles, precisely on account of continuing discrimination inside and outside sport. Jesse Owens, who won four Olympic gold medals in 1936 in Berlin and thus disproved the racial theories of the Nazis, declined to give the Hitler salute. Cassius Clay refused the draft during the Vietnam war and his title was taken from him.

Tommie Smith and John Carlos, winners of the 200 metres in the Olympic Games in Mexico in 1968, bowed their heads on the platform of honour and gave the Black Power salute, fists raised in black gloves, and were then suspended from the American Olympic team.[59] When in 1988 in Milan Ruud Gullit received the Golden Ball, the award for Europe's best soccer player, he said in his reply: 'As you all know, I dedicate this award to Nelson Mandela, in the hope that you understand how important the struggle against apartheid is, because I believe that we all must have the right to enjoy our freedom.' The arena of the black athlete is larger than just the sports field.

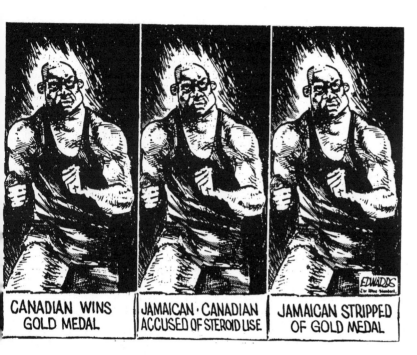

Cartoon by P. Edwards in *The Militant*, New York, 1988.

10 POPULAR TYPES

Some stereotypes of blacks have become so popular in a particular country
like the Golliwog in England and Black Peter in the Netherlands, that the
have become a household word. Why these stereotypes? What do they, in
advertently, tell us about those cultures? Examining these figures enables u
to look more closely into the politics of representation. It also provides u
with an opportunity to consider the differences in imaging and stereotypin
of blacks *among* western cultures, so that we can go beyond the bland abstrac
tion 'western culture', in some respects at least. This is the only point in thi
work at which differences among western countries in the imaging of Afric
and of blacks are addressed systematically (Chapter 12 discusses difference
between American and European representations of blacks in the context c
sexuality). A separate chapter is devoted to imagery in advertising, but som
advertising figures, such as the American uncles and mammies, Banania an
Sarotti-Mohr, are discussed here because they are so familiar that they ar
also known outside the context of advertising.

America: Sambo, Coon, Rastus, Tom, Uncle, Mammy, Buck

One of the greatest roles
ever created by Western
man has been the role
of 'Negro'. One of the
greatest actors to play
the role has been the
'Nigger'.

Henry Dumas

In 1933 Sterling Brown distinguished the following main types of blacks i
American fiction: the contented slave, the comic Negro, the exotic prim
itive, the tragic mulatto, and the brute nigger. In an overview of America
films in 1973 Donald Bogle recognized five dominant stereotypes in the wa
black Americans are represented:

> *toms* – they served their masters well;
> *coons* – funny men; all blacks are stupid;
> *mulattos* – tragic because they're not all white;
> *mammies* – sexless archmothers;
> *bucks* – bestial superstuds.[1]

Forty years on and a different medium, but what's new? These types als
people advertising and other media. Taken together they form 'a kind of cul
tural barometer of the racial climate of the past 150 years', as was noted in re
lation to the American exhibition *Ethnic Notions*.[2]

 The black type perhaps most familiar in American folklore is Sambo, th
national fool and jester. Familiar since the beginning of the nineteent
century from stories and jokes, from minstrel shows and later from films an
advertising, Sambo has been ubiquitous in American popular culture as th
prototype of the contented slave, the carefree black – 'the eternal child, th
eternal dependent, happy though given to unaccountable moods of depres

sion, lazy, enjoying the banjo and the dance, passionately religious, but passive in most other things – a rather spirited but lazy, overgrown child.'[3] The name Sambo is derived from a Hispano-American term meaning half-caste. *Webster's Dictionary* of 1831 defined Sambo as the offspring of a Negro and a mulatto.[4] In sixteenth-century Spanish and Portuguese *zambo* meant bow-legged, hence a ridiculous figure (from the Latin *scambus* and Greek *skambos*: bow-legged). In American usage 'Sambo' is a generic term for the black fool or, in Kenneth Lynn's terms, 'a white-toothed, dehumanized buffoon, impervious to pain, incapable of anger – a harmless empty-headed figure of fun'. Rastus, Jim Crow, Coon are all variations on this figure.

Why has Sambo been such a tremendously popular image? Stanley Elkin argued that slavery and the plantation system were so stultifying that blacks, in a process of 'Sambofication', did become childlike dependent creatures.[5] The main objection to this interpretation is that it mistakes the façade for the reality and the mask for the face. It is an intrinsic aspect of slavery in western culture to compare slaves to children and animals,[6] a comparison which says more about the masters than about the slaves. It was a commonplace in the South that 'slaves never grow up'. Masters talked about adult blacks as boys and girls, or 'big children'. They regarded themselves as their patrons and cherished the alleged ties of affection which existed between them and their childlike, dependent slaves. Sambo personified this comfortable idyll. He was a key figure in the theatre of accommodation. In addition, Sambo was the antidote to Denmark Vesey and Nat Turner: to the spectre of the rebellious slave. 'Here was a society which was almost hysterically fearful of slave rebellions and which needed Sambos, even imagined ones.'[7]

Viewed in this light Sambo is a complex figure. From the point of view of the slave masters, he was a cultural talisman through which they sought to choreograph reality, but who served above all to assuage their fears. From the

'Come listen all ye gals & boys
I'm just come from Jackhero
I'm going to sing a little song
My name him be Jim Crow.'

'Rastus on Parade.' A French version of Rastus, the black as fool. Here he is part of a larger parade of characters. *L'Assiette au Beurre* no. 90 (1902).

point of view of blacks, Sambo was a disguise, a device of mimicry – termed the slave's 'mask of meekness', the 'darky act'; a strategy of survival on the part of a people who in African culture were accustomed to wear masks. Sambo helped to maintain the social distance between white and black. He illustrates the role of humour both as boundary and lubricant, as a device of stigmatization and repression by turning certain groups into objects of mockery. Ridiculed as Sambo, Rastus or Coon, the black man was held at bay, emasculated and ruled out as either participant or competitor.

Family relations and parenthood were not legally recognized under slavery. Older blacks were referred to not as father or mother but as 'uncle' or 'aunt', and older black women as 'mammy'. Used by whites these might be terms of affection, which indicated that the blacks were regarded as 'family'. On the other hand, the terms may be Africanisms, deriving from African kinship relations, in which the mother's brother or father's sister can play such important roles.[8]

Uncle Remus is familiar from the folk-tales of Joel Chandler Harris, a late nineteenth-century white author in whose stories an old plantation slave acts as the narrator. The *Tales of Uncle Remus* are the kind in which Brer Rabbit outsmarts the fox and the bear: variations on the African and West Indian Anansi stories. With Harris they are also nostalgic, following the lines of the pastoral plantation myth, which idealized not only plantation society but implicitly slavery as well. Uncle Remus is the ideal 'plantation Negro': 'an old Negro who', according to his creator, 'had nothing but pleasant memories of the discipline of slavery'. Meanwhile Harris himself was regarded as someone who 'best knew and understood the Negro'. Female versions of the genre appeared as well, such as Martha Gielow's *Mammy's Reminiscences and Other Sketches* (1898).[9]

The Mammy often figured in children's stories, such as the well-known Bobbsey Twins series (from 1904), which featured Dinah the cook as 'the ultimate stereotype of the Contented Slave, the Buxom Mammy, and the superstitious, watermelon-eating, eye-rolling, thieving black'.[10] In the 1950 edition Dinah is tempered to a 'plump, good-natured Negro woman'.

Uncle Ben's Parboiled long-grain rice (Netherlands, 1986).

The Cream of Wheat Chef (USA, 1987)

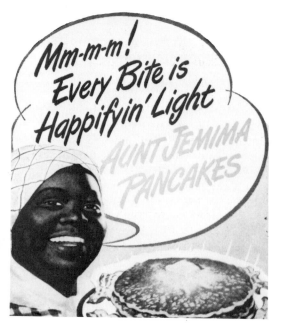

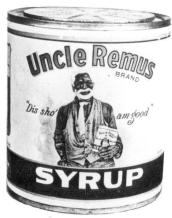

These comfortable older types also entered American advertising. Slavery deprived blacks themselves of parenthood, and in nostalgic representations of them their parental qualities are at the service of white children, who were nurtured by black nannies, aunts and uncles; meanwhile their easygoing servitude was turned into a commercial attribute. Their reassuring aura was transformed into a commercial gloss on products such as 'Aunt Jemimas' pancake mix, 'Uncle Remus' maple syrup, Uncle Ben's rice, and the 'Cream of Wheat chefs' breakfast. The mammies and uncles were comfortable, desexualized figures. They seem to have no children themselves, or else their children are invisible, or have likewise been adopted into the system of family servitude. Advertising turned these domestic servants into icons of generalized servitude: 'Always clean, ready to serve with a crisp smile, intuitively knowledgeable, and distinctively southern in their spoken words, they epitomized servility with exceptionally natural cheerfulness.'[11]

Is it any wonder that these advertisements are among the more durable successes of the trade? Aunt Jemima dates from 1890 and since 1902 she has been calling out to Americans 'I'SE IN TOWN, HONEY!' In 1917 she was drawn anew, this time after a real model. The Cream of Wheat chef dates from 1893 and in his present form from 1925. Uncle Ben's long-grain rice dates from 1946, when a Chicago *maître d'*, Frank C. Brown, posed for the portrait.[12]

'Aunt Jemima' was the stereotype of the black woman, multiplied a millionfold in advertising, cartoons, films and books – for white Americans, an easygoing, non-threatening figure reminiscent of old times; for African Americans, a symbol of the denigration and domestication of black identity and of the way blacks have been reduced to functionaries in white fantasies:

> As a child in the 1950s I could not look inside the image and see the African bones under those high cheeks. It was simply a bandana on her head not the American adaptation of the West African gele head wrap. The gleam of her teeth was only selfless accommodation – not the contrast of white against African skin, not survival. We were all children then, not

Aunt Jemima
Pancakes (USA,
1948)

Uncle Remus Brand
Syrup (USA)

so long ago, and didn't see what was behind the caricature. We felt only pain at what had been done to us in the name of white America.[13]

Since the civil-rights movement and public pressures in the 1960s and '70s, Sambo, Jim Crow, Rastus, Coon, Uncle Remus and other black stereotypes have virtually disappeared from American public life.[14] In the late-'70s picketing closed down the Sambo pancake chain (it was renamed Uncle Sam and then went bankrupt). Aunt Jemima, Uncle Ben and the Cream of Wheat chef are still in circulation, also in European shops. While they are less distorted characters they still move about wearing uniforms of servitude.

England: Golliwog

The Golliwog has been England's most popular black type from the beginning of the century, a familiar figure in the English nursery, in magazines, theatre and the circus. It remained a favourite also after the War. Enid Blyton published her popular *The Three Golliwogs* in 1969. The golliwog was the Beatles' mascot. The marmalade manufacturer Robertsons changed the name to Golly, dropping the epithet 'wog'. 'Golly it's good!' Meanwhile the firm came up with the ingenious theory that the name derived from 'polliwog', an old-fashioned term for a tadpole with its big black head and narrow tail. Celebrating its jubilee in 1980, Robertsons distributed over 20 million golliwog products through magazines and shops – golliwog emblems , T-shirts, pens, toothbrushes, dolls, teapots, and so on. About the same time the National Committee on Racism in Children's Books started a campaign to ban the golliwog as a symbol and a toy. Robertsons' marketing manager rejoined that 'the golly forms part of our national tradition and attacking it is an attack on a

GOLLIWOGG BOUND.

GOLLIWOGG TRENCHING.

Card game with the original Golliwogg and the Dutch dolls. Golliwogg doesn't always have an easy time. Two cards from the game: 'Golliwogg bound' and 'Golliwogg trenching.' (London, 1895)

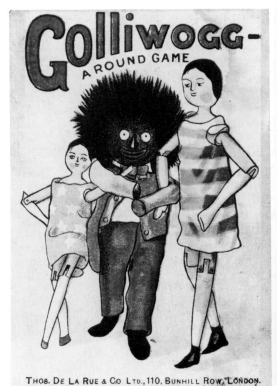

art of British culture'. The emblem was purely fictional, a 'warm and sympathetic symbol' and a 'lovable' nursery figure. It would be misplaced and 'unfounded', he said, to see any connection between the golliwog and blacks. Thus a debate developed between 'pro-golliwogs' and 'anti-golliwogs' with letters to the editor – a minor British *Kulturkampf*. Robertsons held the fort.

In 1984 the matter flared up again as part of the debate about 'race relations' and the controversial stand of the Greater London Council. The majority of the press came out in support of keeping the golliwog; blacks were reproached for 'oversensitivity' and the description of the golliwog as a racist caricature was rejected as 'exaggerated'.[15] As this debate resembles disputes which have been taking place in other countries, notably the United States and the Netherlands, it may be interesting to take a closer look at the Golliwog's history.

If the thesis of the Robertson firm that the golliwog is 'part of British culture' is taken as true, it raises another question: what kind of culture is it of which it forms part? The golliwog stems from the late-Victorian and Edwardian eras, from the heyday of imperialism and colonialism, a culture in which blacks in America and England were the routine target of popular mockery with or without mob violence. The figure is based on *The Adventures of Two Dutch Dolls and A Golliwogg* (1895), a book for which a mother, Mrs Upton, wrote the verses and her daughter made the illustrations. The Uptons had lived in New York for some time but the Golliwogg books were written in England, 13 in all, published between 1895 and 1908. The last in the series was *The Golliwogg in the African Jungle*.[16]

A black rag doll in the family, a 'grotesque nigger (minstrel) doll', was the model for the Golliwogg of the books. The Golliwogg's high white collar and bow tie, his colourful jacket and pants resemble those of the then popular Kentucky minstrel. The Golliwogg in the original illustrations wore a broad smile and was quite popular with young ladies. The Two Dutch Dolls (wooden dolls) seem to be very happy with him. In the Golliwogg card game, 'A Round Game', with drawings based on Florence Upton's illustrations, he is a not unsympathetic character but often ends up as the victim in precarious situations. (In this game, by the way, the Golliwogg is differentiated from blacks: the Black Servant and The African in the game both look quite different.)

The Golliwogg figure was not copyrighted and became a logo on all sorts of commercial items – Tuck postcards, Riley toffee, Vigny Golliwog perfume, and above all, since 1930, on Robertson's marmalade made by the Paisley jam manufacturer. Golliwogg products for children were abundant, from wallpaper and postcards to stickers, books and dolls. Gradually the Golliwogg lost its second 'g', so that the name resembled 'Wog'. Originally in Anglo-Indian parlance this stood for 'Western Oriental Gentleman', and later it became a term of abuse for coloured people (and for foreigners, as in 'the wogs begin at Calais'). In children's stories the Golliwog came increasingly to display disagreeable traits. In the book *Bo-Peep* (1911) time and again he makes a bad impression. When he enters the nursery: 'The day the Golliwog arrived he made a dreadful fuss'; when skating 'A Skating Tragedy' develops because 'The Unfair Golliwog' shows his jealous, thievish character.[17]

A recurrent feature of the definitions in various dictionaries is the grotesqueness of the Golliwog. According to the *Concise Oxford Dictionary*

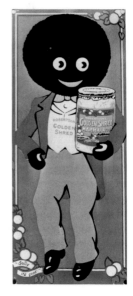

'Golly it's good!'
Enamel advertising
panel for Robertson's
Marmalade, England.

(1976): 'golliwog Black-faced grotesquely-dressed doll with fuzzy hair. [19th c.
perhaps from GOLLY + POLLIWOG].' *Webster's Dictionary* (1977): 'golliwog o
golliwogg [after Golliwogg, an animated doll in books for children written b
Bertha Upton died 1912 Am. writer and illustrated by Florence Upton die
1922 Am. portrait painter and illustrator] 1: a grotesque black doll 2: a gro
tesque person.'

The American dictionary does not explain why this doll or person is gro
tesque; the *Concise Oxford* cautiously describes the doll's clothes as grotesqu
and cites two further features, black-faced and with fuzzy hair. *Oxford i
rather circumspect and refers to the curious polliwog theory of Robertsons
Thus in a few lines rather different impressions are created.

Like the black types popular in several other European countries, thi
British type is small; like the German Sarotti-Mohr it is a doll, but not swee
like the Mohr. Unlike the French Banania, who at least was originally
human being and not a caricature, the Golliwog was originally a toy
fashioned after the caricature of the 'nigger minstrel'. A toy which, witnes
the dictionaries, carries a grotesque meaning.

Germany: Sarotti-Mohr

The most visible black figure in German popular culture is the Mohr witl
which the chocolate firm Sarotti has been advertising since 1910. The
Sarotti-Mohr has in common with Banania that it is a commercial figure an
with the Golliwog that it is a doll. Its closest resemblance is to the Dutcl
Black Peter: a small servant who in his oriental costume is reminiscent of the
Moorish servant of old. The Sarotti-Mohr's predecessor is the chocolate
Moor, an advertising figure which first appeared in Germany in 1868. The
trade mark of the company Sarotti may have been chosen because the firm
was established in the Mohrenstrasse in Berlin.[18]

The little Moorish servant who comes scurrying to offer noble ladie
chocolate is a symbol of status and luxury, traditionally associated with the
German courts and with patrician prosperity, which is being democratized i
the guise of the Sarotti-Mohr and through mass consumption. Unlike mos

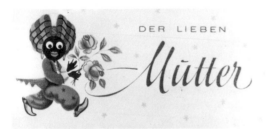

Enclosure card of the
chocolate firm Sarotti,
Berlin.

Film slide advertising
Sarotti chocolate.

black advertising figures, the Sarotti-Mohr has remained virtually unchanged through the years. When Nestlé took over the company it was decided, after consultation with advertising psychologists, to retain the emblem, with a new slogan: 'Moor, who satisfies sweet dreams'. 'The Moor's sympathetic character', according to one comment, 'is reminiscent of childish ways of satisfying the need for sweets.'[19] Energetically scurrying about in harem trousers and multicoloured turban, with his big eyes and round face the Sarotti-Mohr is a sweet figure indeed. The earlier discussion of the black servant in Moorish costume (Chapter 8) suggests, however, a different or supplementary interpretation: the Sarotti-Mohr as a character in an imaginary harem. This reading takes into account that most chocolate is bought not for children but for women; the subliminal potency of the emblem then is both that it eroticizes and that this Moor cannot be a sexual competitor because he is only a child (the alternative would be a eunuch); thus it satisfies the needs of both the male purchases and the female consumer. At the same time, with its resemblance to toy characters like Bimbo, the figure is also appealing to children.

Blacks inhabit German novels and operas as if they were a species of exotic birds. Helmut Fritz mentions a number of black figures in German works, such as Monostatos in Mozart's *Die Zauberflöte*; Soleiman, a little Moor in fairy-tale costume who serves as a mascot in Robert Musil's *Der Mann ohne Eigenschaften*; Franz Grillparzer's Negro Zanga; and the black evil-doer Congo Hoanga in Heinrich von Kleist's *Verlobung von St Domingo*.[20] From this inventory alone a pattern emerges in German representations: blacks with oriental names (that is, domesticated by or filtered through Arabic culture, often situated in Egypt), like the Sarotti-Mohr, tend to be enjoyable, decorous types; while blacks with African-sounding names are aggressive, threatening. This is an interesting bifurcation which seems to suggest some of the deeper European feelings about Africa. Again the motif of the 'two Africas' returns.

In everyday German culture blacks are figuratively consumed in the form of *Mohrköpfe* and *Negerküsse* – two different sorts of cream-filled chocolate cake; hence the term the 'edible Negro'. The principle that blacks exist to satisfy white needs has thus been well established. As porcelain flower-bearers servant types like the Sarotti-Mohr decorate German middle-class homes – another *embourgeoisement* of the nobles' black page of the past.[21]

France: Bomboula, Batoualette, Banania

A world of difference separates English and French images of Africa. The notion of Africa as the Dark Continent does not figure in France as it does in the anglophone world. The classic theme in French literature about Africa is not darkness (a loaded term in both missionary and Victorian notions) but, on the contrary, the sun. In French fiction black Africa appears, in the words of Fanoudh-Siefer, as 'terre de soleil et de mort'. 'L'Afrique noire, terre de volupté et de souffrance, terre de mystère.'[22] This striking difference may partly reflect the fact that historically French relations with Africa have focused in the Sudanic belt (overlapping with the southern Sahara and Sahel regions) rather than the Africa of the rainforests; but more important no doubt is the cultural, and not simply the geographical, background of this difference.

British relations with Africa and blacks have been strongly influenced by American white-black complexes (and vice versa), whereas for France the relationship with Africa itself and with the West Indies has been much more important. French literature includes the work of many travellers to sub-Saharan Africa, such as Arthur Rimbaud, René Callié, René Maran, Pierre Loti, André Gide, whereas British literature has been preoccupied with the experiences of gin-and-lime-drinking British colonists in Africa. England's music halls welcomed American minstrels, which was possible of course because of a common language. France on the other hand was the first European culture to open itself to *l'art nègre* (up to now a francophone concept). Paris in the *belle époque* saw several African vogues and became the European centre for African and Afro-American culture, beginning as we have seen with the *Revue nègre* of Sidney Bechet and Josephine Baker.[23] In the 1930s France was the birthplace of *négritude*, a Franco-African notion. The journal and publisher *Présence africaine* and the names of, among others, Léopold Sedar Senghor, Aimé Césaire, René Damas, and after the Second World War, Frantz Fanon and Albert Memmi, are associated with this francophone cultural mélange.[24] Paris is presently the centre for recording African music.

The French colonial ideology, like the Portuguese and in contrast to the British, was geared to assimilation. This reflected French cultural chauvinism, but it was also an attitude that was, relatively speaking, less fearful of direct contact with the local population being incorporated into the French culture and the French state. Such an attitude assumes less distance, social and cultural, between metropolis and colony than is the case under the British system of 'indirect rule' and given British racial attitudes.[25]

Bamboula shoe polish. (France, 1905)

'Are you looking for a maid? Bamboulinette comes to the rescue.' On the box: 'Sent from Martinique'. *Fantasio*, 1923.

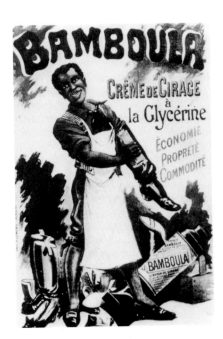

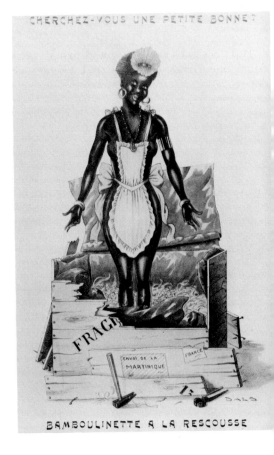

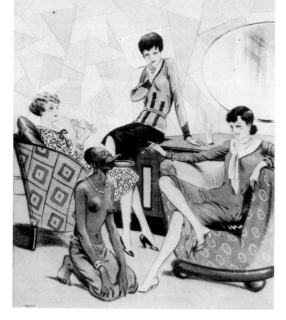

'The personnel crisis.' Caption: 'The true maid. Batoualette, very practical ashtray during drinks.' *Fantasio*, 1 Nov. 1929.

Another noteworthy difference is the place which eroticism occupies in French imagery of Africa – a prominent place, when we note the role of the *Vénus noire* in French fiction and the French imagination, the plenitude of erotic photographs and postcards out of black Africa, and the sexual allusions in the satires in *Le Rire* or *Fantasio*. These are elements which are totally or virtually absent in England, Germany or Belgium. Maybe this confirms a stereotype of the French, but even so the difference is unmistakable. Erotic photos of African women are not altogether absent in other European countries (Italy has a tradition of them), but there is a French lyricism dedicated to *Eve noire* which is missing elsewhere.[26]

This does not necessarily mean that French popular representations of Africa and of blacks are less racist, but it certainly is a *different* racism. Is the difference one of degree only, that French attitudes are less fearful and French caricatures of blacks, compared to the English and American versions, less bitter and cramped? Or is it a qualitative difference? At some stage catch-all terms such as 'racism' begin to seem inadequate. A further question is whether these relative differences are also apparent in French popular black types.

If there is a French 'proverbial' black type it is (or was) Bamboula, although this is more a common notion than an actual type. The Bamboula was originally a kind of hand-held drum and an African circle dance, which was common in the Caribbean and is still seen in Haiti.[27] A French expression for partying is '*faire la bamboula.*' As a type Bamboula is usually depicted as a cheerful African but not the cleverest, and in that way he resembles the American Sambo.

In one chromo, Zizi Bamboula is an African soldier who has come 'to France to study different systems of bleaching and softening the skin' (*c.* 1880). Bamboula shoe polish dates from 1905. There is also a female version, Bamboulinette, who hails from Martinique. The main roles in which we encounter Africans or blacks (mainly from the West Indies) in French popular culture are as soldiers, servants or entertainers – the usual western repertoire being amplified with the military role.

Recent Banania logo.
(France, 1986)

Banania tins. See also
the original image of
Banania on page 85.

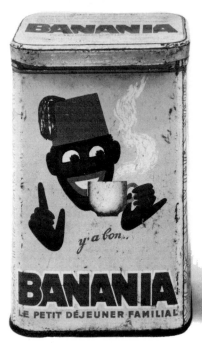

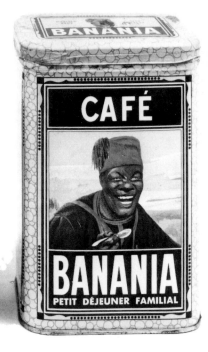

Another common name for the type is Batouala, diminutive Batoualette. *Batouala, véritable roman nègre* (1921), by the Afro-Caribbean author René Maran received the Prix Goncourt. As one of the first French pieces of writing to criticize colonialism it was a controversial work.

No doubt the most familiar French black type is Bonhomme Banania. Banania is a breakfast food which when it was launched in 1917 consisted of banana flour, cocoa and sugar. In the first poster to advertise it a Senegalese tirailleur with a broad smile sat in a field eating from a tin. The caption read '*Y'a bon*', 'African French' for *C'est bon*. As it was during the First World War, apparently the publicity piggy-backed on sympathy for the foreign soldiers, the Tirailleurs Sénégalais above all, which had been built up as part of the war propaganda. Significantly, Bonhomme Banania is not caricatured but is portrayed in a realistic style; he is consuming the product (not preparing or serving it) and the overall impression suggests identification with the viewer.[28]

The product remained popular through several generations of French children, while the advertising formula was adjusted over time. Initially the Senegalese rifleman disappeared (in the wake of World War Two he was replaced by Nanette Vitamine), to return later in stylized form. Successively Banania lost his legs, chest and arms, until in the end only his head remained, with a big smile and lively eyes, and his gesticulating hands. Then the hands disappeared and since 1980 the head has been transformed into the B of

BANANIA. Ironically enough, after all these re-stylings Banania, who was originally not a caricature, has become one. In the 1970s when black emancipation penetrated the advertising world and *'parler petit nègre'* was no longer *bon ton*, the *'Y'a bon'* was dropped. Banania still sells popular breakfast food and the firm's promotional items, like a cup and saucer with the stylized Banania, are for sale everywhere.

Among European black types Banania is the only figure who is or seems to be real (not entirely fantasized), the only adult (as is true of a number of American types) and the *only* one who is sympathetic without being an idiot. On the other hand, Banania has become less realistic over the years. A commercialized propaganda symbol of the French Empire, Banania shrank in proportion to that empire.

Netherlands: Black Peter

The first black figure to enter the public consciousness of the Low Countries is Moriaen, a black knight, son of one of the knights errant of the Round Table and a Moorish princess. We have noted a popular figure in Flemish and Dutch paintings, one of the kings at the Epiphany, who is painted as a black from the fifteenth century onward. The Baptism of the Ethiopian Eunuch is another familiar theme in the art of the Low Countries. There are striking depictions of blacks and of mixed couples in Hieronymus Bosch's *Garden of Earthly Delights*. Other black figures of the region were Gapers, *Rookende Moren* (Smoking Moors) and *Morenkopjes* (Moors' heads).[29]

But far and away the most familiar of these is Black Peter, the servant of St. Nicholas and a key figure in the popular Dutch feast of St. Nicholas, celebrated on 5 December. A small servant in oriental costume, Black Peter at first sight closely resembles the Sarotti-Mohr of the neighbouring country, but he is an older and more complex figure.

Black Peter ('Zwarte Piet') has been the subject of anti-racist campaigns and controversies. His supporters defend his traditional role as a feature of a

'Little Moriaan as black as soot.' Dutch children's rhyme.

'The awful Bugaboo.' Bogeyman coming through the chimney in an American children's book. A striking resemblance to a certain ethnic group. (Boston, 1900)

perfectly innocent family feast ('We only do it for the children') which just is a part of Dutch culture. Again the question arises, as in the case of the Golliwog, what kind of culture is this?

The most common interpretation of Black Peter derives from the Christian tradition of the early Middle Ages, in which he is the devil or a demon. Medieval appellations for the devil, such as 'the Black Man' or '*schwarze Peter*', and variations on Beelzebub such as 'Bugaboo', support this.[30] Thus, 'he [the Devil] goes down chimneys in the guise of Black Jack or the Black Man covered in soot; as Black Peter he carries a large sack into which he pops sins or sinners (including naughty children); he carries a stick or cane to thrash the guilty'.[31] The Black Man ('schwarze Mann') with whom mothers scared their children was either the devil or a Negro.

St. Teresa of Avila, mystic and mother superior of a monastery, complained of being tormented in her visions by a 'small Negro'. In fact, this was a classic figure out of monastic demonology: in the influential *Life of St. Anthony*, composed by Athanasius, Bishop of Alexandria, about A.D. 360, one of the forms taken by the devil is that of a black boy.[32] By the early Middle Ages this had become a well-established theme in demonology.

'Black Peter', the Dutch card game in which Black Peter is the card of misfortune, is no longer played (it went out of fashion after the Second World War), but the saying 'drawing the Black Peter' is still common. It denotes not merely bad luck but the fate of the scapegoat in a social or political conflict.

In traditional accounts and depictions St. Nicholas acted alone. The association of Black Peter with the St. Nicholas legend, which itself has a curious history, appears only to be recent and to date from the nineteenth century, at least as part of popular iconography. Thus a combination occurs in Heinrich Hoffman's story *Der Struwwelpeter* (1844). Here some boys mock a Moor for his black skin and suddenly a 'big Nicholas' appears who sternly admonishes the boys. ('His skin is black, yes, black as soot / But pure as snow is his soul!') When they carry on with their mockery he throws them one by one into a

Two Black Peter cards from Black Peter games.

Black Peter Schwarzer Peter Pierre noir Pedro nero as a servant in livery.

On the back of the second card the rules of the game are explained: '. . . until all cards have been drawn and one of the players ends up with the Black Peter, because this card cannot form a pair. The face of the Black Peter may be blackened with burnt cork, or he must give up a pawn; to get it back, however, he must adequately perform a task assigned by the other players.'

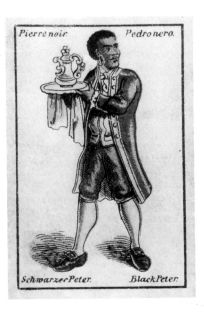

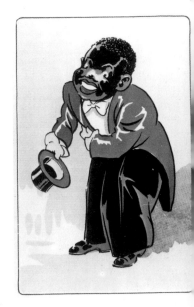

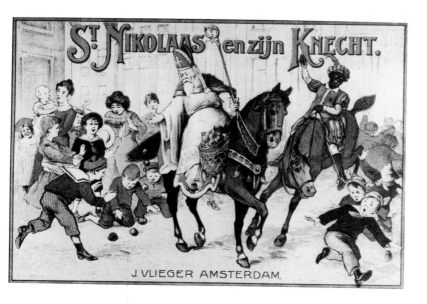

J. VLIEGER AMSTERDAM.

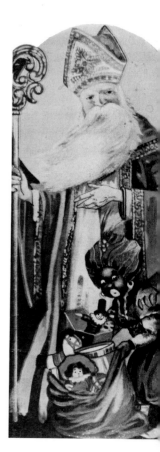

'St. Nicholas and his Servant.' Well-known lithograph by Braakensiek, Amsterdam (pre-war). Note Black Peter's oriental costume, also below.

Cover of a booklet with St. Nicholas songs. (Netherlands)

huge inkpot, from which they emerge blacker than the Moor. The moral: 'It was only because of their wicked mockery / That they landed in the pot / So, dear children! do not mock / If about others you see something odd.'[33] A fine moral, although it also bears out the notion that being black is a punishment.

Yet a closer examination of the records reveals a much deeper connection between St. Nicholas and Black Peter. St. Nicholas himself, the avatar of Santa Claus, is a composite of Germanic (Wotan on his white horse and Oel his helper roaming through the sky on the Wild Hunt) and Christian elements (Greek and Latin). About this lineage one author, referring to Nordic devil imagery, notes: 'Curious connections exist between Satan and Santa Claus (St. Nicholas). The Devil lives in the far north and drives reindeer; he wears a suit of red fur. . . . The Devil's nickname "Old Nick" derives directly from St. Nicholas. Nicholas was often associated with fertility cults, hence with fruit, nuts, and fruitcake, his characteristic gifts.'[34] Accordingly, St. Nicholas and Black Peter would *both* be representations of those pagan forces which the Christian tradition later categorized as 'the devil'. But whereas Nicholas has been transfigured into a bishop and canonized as a saint, Black Peter has remained unredeemed and has retained many of his demonic attributes and habits.

Black Peter represents profound ambivalences intrinsic to European culture. The figure is an allegory of the process of Christianization and of the domestication of pagan forces, sometimes referred to as a 'civilizing process'. From his origins in early Christian demonology down through the Middle Ages, Black Peter appears to have little to do with Africa or black people. On the other hand, the points at which Christian demonology overlap with the imagery of black people are of course not without significance nor without their ramifications. The feast itself, too, may be viewed as a safety valve for a Calvinist culture casually worshipping ('only for the children') the last of the saints. Thus the feast of St. Nicholas is an annual psychodrama which unfolds on several levels.

11 KIDSTUFF

Prejudices are often said to be emotionally based, and therefore education and information are credited with having relatively little impact. Early socialization is usually regarded as particularly influential in the formation of a child's attitudes. Thus what happens in the nursery has a double importance: because it takes place in the emotional sphere and because early socialization carries so much weight, events there are both trivial and crucial.

Certain changes seem to take place more slowly there than elsewhere. In the western world the culture of the nursery, of children's stories and songs, toys and games, is still in many respects that of colonialism and not that of the 'Third World'. As a consequence, adults reared on this diet may find critical voices and views about what happens in the Third World relatively unreal, lacking in persuasiveness, because they do not correspond to emotional patterns formed during early years. Such views lack emotional resonance because they do not fit with the early imagery of heroes and villains; thus statements made about the Third World, be they factual, rational or ethical, seem 'empty' because they originate from another emotional wavelength. As Roland Barthes noted, we live in the midst of a Boy Scout civilization.

Early on, children in the western world learn to count by causing little blacks to disappear. The counting rhyme 'Ten Little Niggers' was allegedly written by an Englishman, Frank J. Green, in 1864; but there was already an earlier rhyme, 'Ten Little Injuns', by which American children still learn to count. For more than a hundred years, then, children in the West have been learning to count by making non-western children disappear, usually in not such pleasant ways. 'Ten little nigger boys went out to dine; one choked his little self, and then there were nine.'

This violent vanishing act is reminiscent of a notion common in nineteenth-century racial thinking, which held that non-white races, as inferior and/or degenerate, were not well equipped for the struggle for survival, and hence destined not only to be subjugated but ultimately to disappear. Thus a common representation of Native Americans in the United States was as a 'vanishing race', a view that was particularly congenial at the time of the westward expansion.[1]

An analysis of images of blacks in German variations on 'Zehn kleine Negerlein' yields these findings: (1) The rhyme is always about little blacks or black boys – they always remain little. (2) Blacks don't learn from experience – even when there are fewer and fewer of them, they continue to make mistakes. (3) Blacks are clumsy – when they saw they saw themselves in two, and so on. Thus they have themselves to blame for their fate.[2] In fact, the lessons of the Ten Little Negroes parallel the prescriptions of what was termed 'black pedagogy', a sombre pedagogic perspective which prevailed between 1850 and 1910, in which children, like blacks, were considered creatures of 'brute naturalness', who had to learn to control their drives and lusts, had to learn

through punishment, and had to be disciplined and made to work. What goes wrong for the Ten Little Negroes is usually a consequence of lack of moderation (eating or dancing too much, laughing too hard, and so on); the same lack of moderation is also the reason children like to identify with the little blacks.

The world which adults shape for children reflects the logic of the adults' world. It is no wonder then that it is no easier being black in the children's world than in the adults' world. The hierarchy in the children's world is evident from the cover of *The Wonder Book of Children of All Nations*, where an English lad plants the Union Jack on top of the world while children of other nationalities trudge round. A verse on the title page asks proudly,

> Little Indian, Sioux or Crow,
> Little frosty Eskimo,
> Little Turk or Japanee,
> Oh! don't you wish that you were me?

The colonial hierarchy in the nursery appears on countless occasions. When there is a mention of friendship between white and black it is rarely a relationship of equality. The lessons of virtue are not always entirely one way, but the paternalism of the world of adults is usually faithfully reproduced. As when the black girl Topsy (in *Uncle Tom's Cabin*) sadly deviates from the white model of virtue: 'Poor Topsy, why need you steal?'

In western children's culture non-western peoples are often presented as negative examples, symbolizing 'wrong' or 'inappropriate' conduct. This happens consistently in the highly acclaimed Mary Poppins books. A few examples from *Mary Poppins* (1934), *Mary Poppins Comes Back* (1935) and *Mary Poppins in the Park* (1952):[3]

'You will *not* behave like a Red Indian, Michael.'

'Not one step will you go out of this room this afternoon, or I'm a Chinaman.'

'Walk beside me, please, like a Christian.'

Mary Poppins: 'I would rather,' she remarked with a sniff, 'have a family of Cannibals to look after. They'd be more human!'

'A *Zulu* would have better manners.'

Mary Poppins to the grimy children: 'You look like a couple of Blackamoors!'

Mary Poppins to an upset and excited Michael: 'I understand that you're behaving like a Hottentot.'

Mary Poppins with a disapproving look at the children: 'A pair of Golliwogs – that's what you are!'

The author, Pamela Travers, revised the Mary Poppins books in their paperback editions of 1972 to temper their racism.

The *Doctor Dolittle* stories by Hugh Lofting, published between 1920 and 1948, will also be revised in new editions as a reaction to criticism from libraries and schools. Prince Bumpo, the African who wants to become white because he is in love with a white princess (*The Story of Doctor Dolittle*, 1920),

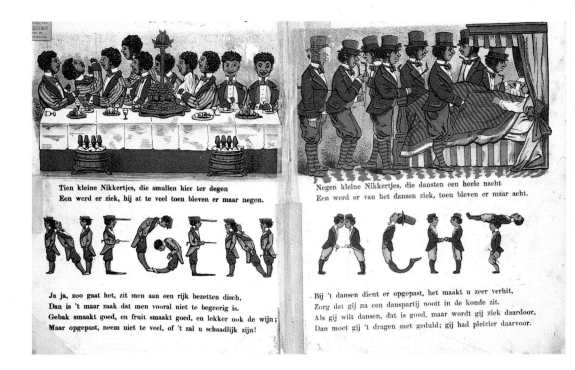

Tien kleine Nikkertjes, die smullen hier ter degen
Een werd er ziek, hij at te veel toen bleven er maar negen.

NEGEN

Ja ja, zoo gaat het, zit men aan een rijk bezetten disch,
Dan is 't maar zaak dat men vooral niet te begeerig is.
Gebak smaakt goed, en fruit smaakt goed, en lekker ook de wijn;
Maar opgepast, neem niet te veel, of 't zal u schaadlijk zijn!

Negen kleine Nikkertjes, die dansten een heele nacht
Een werd er van het dansen ziek, toen bleven er maar acht.

ACHT

Bij 't dansen dient er opgepast, het maakt u zeer verhit,
Zorg dat gij na een danspartij nooit in de koude zit.
Als gij wilt dansen, dat is goed, maar wordt gij ziek daardoor,
Dan moet gij 't dragen met geduld; gij had pleizier daarvoor.

Pages from a Dutch version of 'The Ten Little Niggers' published by J. Vlieger (Amsterdam, 1910)

is to disappear. 'Bumpo speaks mainly in malapropisms – once more, the ridiculous African trying unsuccessfully to be white, this time by imitating the speech pattern of a cultured, educated Englishman.'[4]

Another classic favourite, Helen Bannerman's *The Story of Little Black Sambo* (1899), has evoked this comment: 'As a black Briton, born and educated in this country, I detested *Little Black Sambo* as much as I did the other textbooks which presented non-white people as living entirely in primitive conditions and having no culture.'[5]

In the United States one of the classic stereotypes of a black child is the 'plantation piccaninny'; others are miniature adult stereotypes, little entertainers or dandies, little mammies with little kerchiefs. In European depictions of African children, the classic iconography includes the palm tree.

To play is to learn, and in the children's world stories and toys, candy and games interact with each other. Dolls, puzzles, card games, objects from the novelty shop and picture postcards all echo the same white-black constellations, as for instance, in the American 'Jolly Nigger Puzzle' or a French card game 'Les 9 Métiers de Chocorêve' (Chocorêve, or 'choco-dream', is a little black boy). Sometimes colour has itself been the theme, as in many picture postcards. 'Blackmail' was a 1917 postcard from the United States, featuring a little black boy on top of a mailbox. 'Like the Germans I'm coming out in my true colours – black' was printed in London in 1915, a date which sheds light on the text. 'Dusky Mischief' is the caption on one in a series of black kiddy postcards from South Africa. In pre-war picture postcards showing children on the beach the white-black colour contrast leads to friction which is intended to be amusing. These are signals from a time when it was

Twee kleine Nikkertjes. Toen 't zonnetje helder scheen
Smolt de eene als een sneeuwbal weg en bleef er nog maar één.

Van al die kleine Nikkertjes bleef er nu nog maar één.
Hij trouwde met een negerin, en toen, toen bleef er geen.

EEN GEEN

Een sneeuwbal smelt, dat ziet men steeds, maar dat een Nikker smelt
Is vreemd, dan moet het met zoo'n man vreemdsoortig zijn gesteld.
't Is zeker dan een Nikkertje van was en niet van been,
Want anders bleef hij wel bestaan hoe fel het zonlicht scheen!

Wanneer men van tien Nikkers zoo alleen op aard blijft staan,
Wat kan men dan ooit beter doen dan spoedig trouwen gaan.
De Nikker zoekt een Negerin, hij denkt bij zwart hoort zwart,
En 't zwarte Jufje troost den man in zijne diepe smart.

held that difference in skin colour had to give rise to some kind of conflict, or would be a likely source of a kind of nervous entertainment.

While stereotypes are being removed from children's stories, they are being reinstated elsewhere in the children's world. American television programmes for children make ample use of stereotypes. 'The heroes are all mainstream-American looking and the bad guys are Russians, Arabs or dark-skinned people.'[6] Part of this is the logic of exclusion. 'In our society', according to Michael Barnes, an American clinical psychologist, 'black and Latino children are bombarded with images – in movies, toys, books – that tell them theirs is not the preferred race. Most heroes, like Rambo and He-Man, and most authority figures, like police and teachers, are white. The message is that authority, beauty, goodness and power most often have a white face.'[7]

What is the children's world without bugaboos and bogeymen, indeed what is any human group without enemy images? While ethnocentrism (i.e., using one's own culture as a yardstick) is regarded as a problem in all sorts of areas, in the children's world on the contrary the tendency is to find it re-

Picture postcard with the caption, 'God made the little niggers, He made them in the night, He made them in a hurry, and forgot to make them white!' From a series by the popular illustrator F.G. Lewin (1861-1933). (England, 1922)

God made the little niggers, He made them in the night,
He made them in a hurry, and forgot to make them white!

169

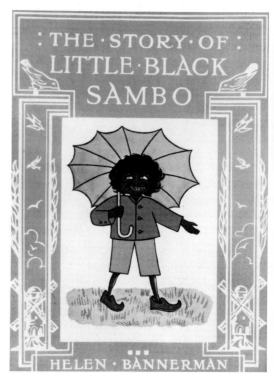

'Poor Topsy, why need you steal?' Illustration in Harriet Beecher Stowe's *Uncle Tom's Cabin* (London, 1883)

Cover of Helen Bannerman, *The Story of Little Black Sambo* (London, 1899)

assuring to remain 'close to home'. It gives parents satisfaction to pass on to their children the songs, stories and sayings they learned from their own parents. Africa appears in those as a dangerous puppet show. The colonial moral of children's songs and stories is diametrically opposed to contemporary views on the Third World, at least to the enlightened ones. There is a growing literature critical of stereotyping in children's books, textbooks and televison programmes.[8]

Comic strips were introduced in the American press in the 1890s, a time of increased racial segregation. 'In the comics section, Blacks were the principal comic figures, having surpassed the Irish at the turn of the century as the butt of American jokes.'[9] American comics 'classed Negroes as "frightened darkies", shoeshine boys, railway porters, and watermelon-stealers'.[10] The first strip with a black as its principal character was R. F. Outcault's *Lil' Mose*, which appeared in the New York *Herald* in 1901, with a portrayal of the black that was sympathetic for its time.[11] The English 'funny papers', most of which also came into circulation in the 1890s, largely followed the American tradition of the minstrelized black. Tintin, the young reporter from Belgium – Tim in Germany and Kuifje in the Netherlands – has been called 'the first genuinely pan-European hero of modern times'; accordingly, his exploits are a true barometer of the fundamental assumptions of European civilization.[12] In the Tintin books native peoples of most varieties fare almost as badly as women.

The recurrent theme of the savage as a child – which we encountered earlier as a corollary both of mature colonialism and of white-black patron-client relations in the American South – also points to the other side of the equation, the child as savage. This raises the underlying question of the

representation of childhood itself or, so to speak, the politics of innocence.

The affinity of racism with ageism [prejudices regarding age] has several ramifications. Ageism is frequently associated with racism in discussions of relations between the West and the Third World: 'The concept of childhood . . . being developed between the seventeenth and eighteenth centuries introduced specific determinations of dependency which are bound up with a mercantilist phase of territorial expansion. Childhood, in short, is exportable well beyond the confines of the family, as it may be attributed to entire races presumed not to have reached a civilized status.'[13] The hierarchy of age overlaps with and reinforces the hierarchy of race: 'Consequently Third World nations are *young* and *immature*, and have to be guided by the "older" nations of the West.'[14]

Children may be regarded as miniature adults, as *tabulae rasae* or clean slates, or as wild, savage, in need not merely of growing and learning but of being 'tamed', and so on. In Victorian anthropology, the psychology of the child and of the savage were seen as twin themes. This perspective lives on in contemporary popular culture, as Dorfman and Mattelart show in their discussion of the Donald Duck comics.[15] Our images of childhood (as wildness or as purity) extend over into our images of non-western peoples and races, and interact with our images of nature (as threatening or as paradisiac) and of femininity (Lilith or Eve); together they constitute a larger cultural politics of innocence. The definition of culture lies in the assessment of nature as an existential canvas upon which the non-natural takes shape.

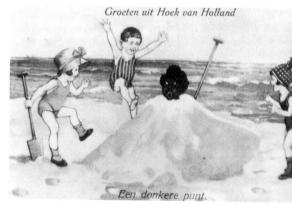

Postcard 'Greetings from Hook of Holland'. 'A dark point'. (Netherlands, 1910)

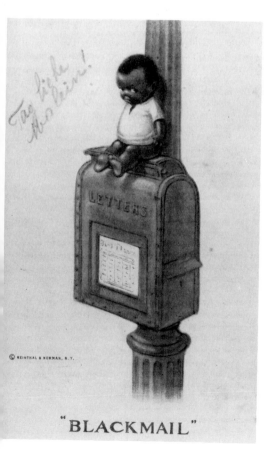

'Blackmail.' Picture postcard (USA, 1917)

12 LIBIDO IN COLOUR

It has been suggested that 'sex' is at the root of many problems in the racial field.

John Dollard (1937)

The 'white man's burden' thus becomes his sexuality and its control, and it is this which is transferred into the need to control the sexuality of the Other, the Other as sexualized female. The colonial mentality which sees 'natives' as needing control is easily transferred to 'woman' – but woman as exemplified by the caste of the prostitute.

Sander Gilman (1986)

That western attitudes towards the non-western world are fundamentally ambivalent has often been observed. The most sensitive area of this ambivalence lies, possibly, in attitudes towards sexuality. The non-western world – whether the warm South or the sensual Orient – is idealized and eroticized on the one hand as a paradise on earth, and on the other hand rejected and condemned. Such attitudes play a part in the *amor et timor*, love and fear, which often characterizes relations that cut across cultural frontiers. The contradictory western attitudes towards the non-western world seem to culminate in contradictory attitudes towards non-western sexuality, and these in turn reflect ambivalent feelings on the part of westerners about their own sexuality. On one hand 'Others' are sexualized, and on the other, declared sexually taboo. The uninhibited, extroverted sexuality which westerners attribute to 'primitives' also serves as a reason for rejecting the primitive as a stage that is past, condemned, and even feared – as in the metaphor of the German anthropologist J. J. Bachofen, who called this stage the 'morass'. In this forcefield of attraction and repulsion, an ambivalence towards one's own sexuality is experienced and projected on to the outside world, which appears the more primitive and uninhibited the greater one's fears as to one's own sexuality. Under such pressure subliminal sexuality takes on larger, more extravagant forms. Subsequently, a connection can arise between the control and repression of one's own sexuality and the control and repression of 'Others'.

In Europe the belief that people from the south are more lascivious than northerners goes back a long way. European sexualization of the non-western world, notably of Africa, dates from at least the Middle Ages. In the twelfth century the Jewish traveller Benjamin of Tudela described a people 'at Seba on the river Pishon . . . who, like animals, eat of the herbs that grow on the banks of the Nile and in the fields. They go about naked and have not the intelligence of ordinary men. They cohabit with their sisters and anyone they can find. . . . And these are the Black slaves, the sons of Ham.'[1]

In *The Fardle of Fashions* (1550), William Waterman wrote of the after-dinner habits of the Ichthyophagi, or fish-eaters, in 'Affrike': 'They eat as I have said in the savage field together abroad, rejoicing with a semblance of merriness and a manner of singing full untuned. That done they fall upon their women, even as they come to hand without any choice: utterly void of care, by reason they are always sure of meat in good plenty.'[2] In the sixteenth century Leo Africanus characterized the morals of West Africans: 'They have among them great swarmes of Harlots; whereupon a man may easily conjecture their manner of living.'

From early on uncontrolled sexuality formed part of the profile of savagery. In Shakespeare's *Othello* there are several allusions to stereotypes of black sexuality. Thus Rodrigo speaks of Desdemona as in 'the crude embrace of a

scivious Moor', and Desdemona's father refers to the coupling of a black
am and a white ewe. Leo Africanus' work was among Shakespeare's sources.
But in Elizabethan England there were few blacks, so that racial mixture
ould hardly have been a social problem. Hence it has been argued that
Shakespeare, to judge by his metaphors, was alluding to 'a contrast between
he relatively open and earthy sexuality which was traditionally associated
with rural England and the conventions of respectibility and restraint which
egan to be introduced among the urban middle class. As would happen in
ther times and other places, blacks could be used to symbolize tensions and
ears in the creation of which they had had little or no part.'[3] Figures from
ther cultures were invoked to symbolize internal tensions.

This perspective reached its apogee in the nineteenth century, both in
Luropean repression of sexuality in the Victorian age and in racist attitudes
owards the non-western world. The psychiatrist Dominic Mannoni has re-
erred to the tendency of Europeans 'to project on to . . . colonial peoples the
bscurities of their own unconscious – obscurities they would rather not
enetrate'.[4] In European colonial fiction and adventure stories Africa is re-
resented either as an unspoilt paradise or as a dark labyrinth. The continent
s also represented as a seductive, destructive woman, while Europeans are
ombatting dark, evil forces. Whether the image of Africa is a benevolent or
 derogatory one, it remains bound up in certain conventions; as Hammond
nd Jablow conclude: 'The image of Africa remains the negative reflection,
he shadow, of the British self-image.'[5]

What was the myth of Africa as 'the Dark Continent' but a symbol of the
Victorians' own dark subconscious, projected upon a continent? What was
he terminology applied to explorers who were said to 'penetrate' the 'in-
erior' of Africa but a cryptogram for European expansion subliminally pre-
ented as sexual penetration?[6] From time to time colonial abuses are cast in
he allegory of rape – the rape of a continent, the rape of Bengal, the rape of
he Congo. But, conversely, metaphors of the Dark Continent and the
oyage of 'discovery' also occur in the terminology of psychoanalysis:

> Thus when Freud, in his *Essay on Lay Analysis* (1926), discusses the igno-
> rance of contemporary psychology concerning adult female sexuality, he
> refers to this lack of knowledge as the 'dark continent' of psychology. In
> using this phrase in English, Freud ties the image of female sexuality to the
> image of the colonial black and to the perceived relationship between the
> female's ascribed sexuality and the Other's exotism and pathology. . . .
> Freud continues a discourse which relates the images of male discovery to
> the images of the female as the object of discovery.[7]

There is a parallel between Victorian anthropology and its view of 'primitive
eoples' as 'contemporary ancestors', and psychoanalysis, in which the un-
onscious is regarded as a stratum that is both older and infantile. In C. G.
ung's view, the unconscious is identified with the collective and the unin-
ividualized. Thus Jung writes: 'he [the black] reminds us – in not so much our
onscious but our unconscious mind – not only of childhood but of our pre-
istory, which would take us back not more than twelve hundred years so far
s the Germanic races are concerned.'[8]

Childhood or prehistory: this is a recurring doubt in European narratives
bout Africa. Europeans view Africa either as the original unspoilt land, un-

spoilt like a child, or as a land of evolutionary regression or stagnation (of 'contemporary ancestors', peoples 'without history').

One does not have to be a psychoanalyst or a Freudian to be aware of the importance of sexuality also in white-black relations. Generally, as Sander Gilman puts it, sexuality is the most salient marker of otherness.[9] Psychoanalysis itself, however, is part of the process of 'othering': psychoanalysis, in the words of Karl Kraus, is a symptom of the disease of which it claims to be the cure. This is unquestionably true of the deeply entrenched racism of the epoch, whose anthropological commonplaces psychoanalysis both reflected and reproduced.[10]

Over time this complex of attitudes has found increasingly divergent expression in America and in Europe. While there was no significant black presence in Europe (although Europe has an 'Africa complex'), the American situation has been entirely determined by the relationship of whites to the black minority.

America: Libido and Lynching

Black bodies swinging in the Southern breeze; Strange fruit, hanging from the poplar trees.

Billie Holiday, 'Strange Fruit' (1941)

An important reason for the institutionalization of slavery in America and the West Indies was, according to several authors, the regulation of sexual relations. In North America slavery was made legal for the first time in Virginia in 1661 and in Maryland in 1663. In Maryland this was preceded in 1661 by a statute aimed specifically at white women who showed a preference for black men: the white woman who married a black slave had as a disincentive to serve the slave's master for as long as her husband lived; all children of the union had the status of slaves. Legal restrictions were imposed on interracial relations in several states between 1691 and 1725.[11]

> Many white men viewed the black male, slave or free, as a serious threat to their own sexual prerogatives. Many white women not only believed themselves disgraced by the brazen affairs conducted by their husbands with black women but that their own social position and authority over the household were jeopardized by the extra-marital affairs of their husbands. Hence, both white men and women were convinced of the necessity to impose serious legal restraints to control, if not prevent, cohabitation across the color line.[12]

The Black Code or *code noir* which defined the social status of blacks as black, i.e. slave, therefore also served as a code for regulating sexual conduct. The ambivalence referred to earlier – the sexualization and tabooization of the Other – here took a form aimed specifically at controlling the sexuality of the black man. It was the black man who was declared taboo, not the black woman: especially because a mulatto born of a black woman who remained with his mother was not as threatening to the status quo as a mulatto born of a white woman – a woman who would be able to give her children an upbringing and education that would afford them access to social opportunities, and would thus disrupt and undermine the colour-based social hierarchy.

For white males this situation meant a sexual gain, because it gave them access to white women as well as black.[13] Also black women could have either black or white partners, but they were the disadvantaged party in gender hierarchy. So it was black men and white women who were restricted in their

sexual choice. To justify these restrictions, certain myths were propagated, such as that of the black male as being hypersexed and of the white woman on the pedestal – the idolization of the white female in the American south. Black men were said to have an exceptionally large penis, as well as an insatiable animal sexuality. 'The black male was variously described as a "walking phallus"; an animalistic satyr possessed with insatiable sexual appetites, . . . a sexually uninhibited man preoccupied with sex.'[14]

The myth of the large penis had a history. English authors in the seventeenth century explained the vehement sexual activity which they attributed to Africans by the size of the African penis. Mandingo men, according to Richard Jobson in 1623, were 'furnisht with such members as are after a sort burthensome unto them'.[15] Medical research has long since established that as regards penis size there is the usual variation *within* ethnic groups, but no uniform difference from one ethnic group to another. The black man as 'walking phallus' and 'super-stud' was both sexualized and made taboo, and was thus promoted to being 'America's fearsome sex symbol'.

The sexualization of black men may also have its roots in the guilty conscience of whites. 'The presence of large numbers of mulatto children betrayed the sins of white men', according to Ronald Takaki. 'Not only did whites classify the mulatto as "Negro" and thereby try to deny that sexual intercourse had ever taken place between whites and blacks; they also transferred their own lusts and their anxieties of black male retaliation to their fear of black men as sexual threats to white women.'[16]

We see here a link between sexual politics and racial politics. This forms part of a larger complex. As D'Emilio and Freedman observe in their history of sexuality in America,

> Ever since the seventeenth century, European migrants to America had merged racial and sexual ideology in order to differentiate themselves from Indians and blacks, to strengthen the mechanism of social control over slaves, and to justify the appropriation of Indian and Mexican lands through the destruction of native peoples and their cultures. In the nineteenth century, sexuality continued to serve as a powerful means by which white Americans maintained dominance over people of other races. Both scientific and popular thought supported the view that whites were civilized and rational, while members of other races were savage, irrational, and sensual.[17]

Wilhelm Reich in his interpretation of Nazism focused on the interface between sexual repression, racial oppression, and power. He saw a connection between race and class oppression: areas that are often kept separate or played off against each other. In the views of Nazi ideologues such as Alfred Rosenberg, Reich noted,

> Members of the suppressed class are equated with those who are racially alien. . . . behind the idea of the interbreeding with alien races lies the idea of sexual intercourse with members of the suppressed class. . . . sexual interbreeding between classes means an undermining of class rule; it creates the possibility of a 'democratization'. . . . [18]

The connection between sexual repression and power also plays an important role in Michel Foucault's work. Foucault identified two divergent and competing views of power: the tradition of Hegel, Freud, Reich, in which power is

Every thing you ever heard about black men...

is TRUE!

Caption on a folding picture postcard showing a black man in a suit who, when the card is opened out, exposes his large penis. (USA, 1986)

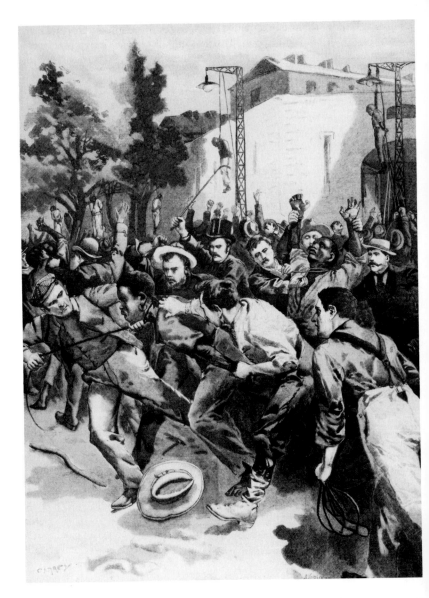

'In the United States the mob lynches negroes, accused of the murder of a white woman.' *Le Petit 'Parisien'*, 1901. A French view of an American lynching seems sensationalized in several respects: the accusation was likely to have been rape and not murder, the man in the top hat does not belong in this crowd, and the victims depicted are rather too numerous.

viewed as repression, and that of Nietzsche and Clausewitz, where it is viewed in terms of force and conflict.[19] But is there not also a connection between the dimension of violence and that of sexual repression? Not necessarily a direct, but a perverse, connection.

In the United States the twin myths of the 'black beast' and the 'white goddess', and the social structure based on the two, were upheld by means of force – a use of force which after Emancipation and Reconstruction turned into violence. In the United States between 1884 and 1900 more than 2,500 blacks were lynched. While the lynchings were in themselves perverse, they were often coupled with additional manifestations of perversity. According to Gunnar Myrdal, the fact that in a lynching the black man was often castrated indicated 'a close link between lynching and repressed sexual drives'. 'When a white feels so personally involved with a Negro', noted the actor

James Earl Jones, 'that he takes the time to cut off his penis and torture him, then it has to be something sexual, the result of repressed sex. . . . Everywhere in the world men kill each other, but nowhere do they cut off penises and lynch each other.'[20]

The turning-point came in 1889, according to Joel Williamson, a historian of the American South. Prior to that lynchings took place mainly in the Western states and among whites, with cattle thieves as the main victims. By the 1890s lynchings had shifted to the South and blacks became the victims. Before that the main fear among whites had been that the blacks would massively rebel and attack the whites or their property. Now the accusation of rape emerged, the 'new crime' which was the motive (rather than murder) for most lynchings of blacks. The myth of the black rapist of white women may have surfaced as a reaction to the status insecurities of white Southern males.[21] White males in the South identified with the Victorian code of morality which dictated that they had to be breadwinners, but the economic depression of the 1890s, the vulnerability of the Southern plantation economy and the advance of industrialization, coupled with their losing the Civil War, undermined their position. The political and economic insecurities of the South found a psychic outlet in the inflammable combination of 'race' and sexuality, the myth of the black rapist and the collective ritual of lynching. Between 1889 and 1899 a person was lynched every other day, and in nine cases out of ten the victim was a black who had been accused of rape. Books like *The Leopard's Spots* (1902), an instant bestseller (the title refers to the passage in Jeremiah about the leopard who cannot change his spots), and *The Klansman* by Thomas Dixon, jr., voiced the new myth of the 'black beast'. D. W. Griffith's film *Birth of a Nation* (1915), based on the latter book, glorified the development of the Ku Klux Klan. By that time lynchings of blacks accused of rape had peaked, although they were not over: one took place as recently as 1946. But the 'second KKK', which grew up after 1915, was aimed not at blacks but at Jews and Catholics.

(Repressed) sexuality, white male domination and violence are so closely interwoven here that they merge with one another. The regulation of white male sexuality goes along with the sexualization of the female and with the repression of female sexuality, with the sexualization of the black male and with his castration. Jealousy and fear of the black man's sexuality, and the inability or unwillingness to accept the masculinity, the virility of black men, play a key part in the American racial psycho-drama. The castration of the black man takes various forms – not in the first place physical, through murder and lynching, but chiefly through his humiliation as a man, economically in the labour market and in his role as breadwinner, socially in terms of status and prestige, legally in *de facto* restrictions on his right to self-defence or to carry arms, politically by withholding, until recently, the vote from him. The black male's access to the white man's world is conditional: as servant or entertainer who does not threaten the status quo; as desexualized figure such as a minister, a notable, a scholar; or, conversely, if he conforms to the stereotype of the bestial black, as the brainless athlete or super-stud.

The social and psychological castration of the black male is a concrete as well as a subtle reality, which is experienced at various levels: 'Because he must act like a eunuch when it comes to white women, there arises within the Negro an undefined sense of dread and self-mutilation. Psychologically he experiences himself as castrated.'[22]

Big headlines in the black press about an event in Georgia: 'a Negro had failed to help a desperate white woman escape from the flaming wreckage of an automobile, because he had been afraid of the consequences of laying his black hands on her flesh in order to pull her free. The woman had perished.'

Everything indicates that this principle of emasculation has 'inverted' consequences. It destabilizes black male-female relations because the black man cannot function as breadwinner, has little status socially, is thus in a weak position *vis-à-vis* the black woman – all of which can lead to more relations being formed between black men and white women.[23] The African-American question of the fatherless or 'matrifocal' family is directly related to the emasculation of black men: because of this he cannot function as a father either – a role withheld from him since the days of slavery, when the figure of the black 'Uncle' first appeared.

The American complex about race is geared chiefly to suppressing black males, and in this context two stereotypes predominate alternately: Sambo, the black eunuch (clown, buffoon, entertainer, happy to serve), and the black man as brute, the 'brute nigger' (virile to the point of bestiality). At the bottom of the social hierarchy is the black woman, suppressed both as woman and as black woman, the cheapest item on the labour market, manipulated as sexual object or as servant.[24] Here also two images predominate: the black woman who is regarded as sexually available and equated with the prostitute – 'Brown sugar'; and the desexualized mammy of the Aunt Jemima type. In American iconography the former virtually invisible and the second ubiquitous. In American art and advertising black female beauty has rarely been depicted, while European artists painted black female nudes and European poets sang of the black Venus, Americans, although black women were obviously far more numerous in America than in Europe, did not.[25] This is one of the notable differences between Eruopean and American imagery about Africa and blacks. In America this did not change until after the 1950s and '60s. In the '60s 'black is beautiful' changed the landscape of fashion and style. In 1984 Vanessa Williams became the first black Miss America.

Europe: Venus and Eunuch

In Europe ambivalence towards the non-western world developed in a different manner. For Europe it was not slavery but colonialism that was the central process through which the eroticization and tabooization of other cultures took shape. This was an intensive involvement which yet, for Europe, took place at a distance. These features alone were to give greater play to fantasy, along with domination, in the European 'othering' complex. Immigrants from the plantation colonies of the West Indies and from Africa become numerous only in the second half of the twentieth century.

The perspective on the black *male* is not really different on the two sides of the Atlantic. In the terms of a popular pamphlet published in England in 1772: 'The lower class of women in England, are remarkably fond of the blacks, for reasons too brutal to mention.'[26] The Moorish servant of old bore erotic connotations, and in eighteenth-century art there was a symbolic association of the Moor with deviant sexual behaviour and with illicit relationships.

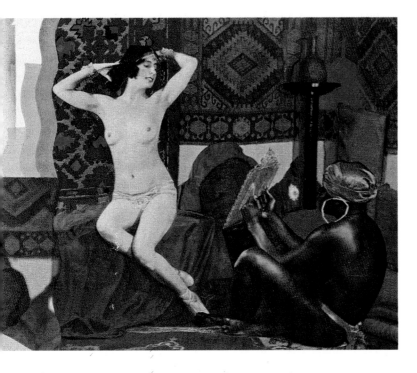

French harem fantasy with a black eunuch servant. The link between popularized orientalism and libidinization is obvious. 'Les petits voyages de Paris-Plaisirs.' – *Paris Plaisir*, Feb. 1930.

In Mozart's *Die Zauberflöte* (1791) the black overseer Monostatos, with his free sexuality, is contrasted with the Egyptian philosopher Sarastro. According to a Masonic interpretation of the opera, Monostatos, the 'black symbol of subterranean darkness', stands for the element earth.[27] In Europe this kind of 'spiritual' discourse about Africa in esoteric and occult traditions deviated neither from scientific nor from Christian missionary discourse: the biological categories arrived at on the grounds of race allegedly corresponded with a 'metaphysical' position. This was true of any of the 'spiritual' movements, whether Freemasonry, the Theosophy of Madame Blavatsky, or Rudolf Steiner's Anthroposophy – they all reproduced, and embroidered upon, the racial thinking of nineteenth-century anthropology.

The actual situation in Europe was simpler and more controllable than that created in America by slavery. In Europe the black man posed no direct threat, was not a rival. Yet a comparison with the American lynch- and castration complex can deepen our insight into European relations. After all, Africa is the 'South' of Europe. Attitudes similar to those of Anglo-Americans towards black slaves we encounter in European attitudes towards Africa.

The equivalent of the 'black brute' of the American South is the 'primitive savage' of Europe's Africa. The profile of the African 'primitive' or 'savage' in his 'impenetrable jungle', in his nudity and with his 'wild dancing', formed part of a European metaphor for uninhibited sexuality. In scientific discourse and in the imagination of Victorian Europe, the black (or 'blackness') served as a symbol for the repressed libido; these views in fact reproduced a much older Christian pattern the antecedents of which date back to St. Anthony and his temptations.

In this light, the cannibal humour of Europeans served to establish a psychological distance from Africans, who were eroticized on the one hand and

bestialized as cannibals on the other. European mockery of African 'west ernization' may be the equivalent of the American mockery of the black dandy. The diminution which characterizes most European images of black men thus appears as a European method of symbolic castration of the black male. The 'little Moor' is Europe's Sambo: the Sarotti-Mohr, Black Peter, the advertising Moor, the Belgian Publiciné, 'Le Petit Nègre' of the brand o Swiss cheese, Fromalp, the little Moor who comes running to serve coffee - all form part of a series of castrated black males imagined in other cultures: the Arabic harem servant, the European Moor, the African-American eunuch So the sexual element symbolized and projected in the black is admitted, but in controlled, small doses, while the ambivalence survives in that of the little black phallus: it brings sweetness, gifts, gives joy, but is also grotesque (Golli wog), infantile (Sarotti-Mohr), and brings the rod (phallus) as punishmen (Black Peter).

An interesting but drastic working hypothesis may be that the way in which a European culture repesents blacks reveals that culture's unconsciou attitudes towards sexuality. In western culture, at least in this period, 'the black' serves as a cryptogram for one's own discomfort with sexuality. Accordingly, the more deformed, caricatured, dehumanized or repulsive the images of blacks, the more intense the culture's fear of sexuality and the more distorted its attitudes towards sexuality.

In the criminological anthropology of the time the profiles of the savage and the criminal closely resembled each other. That the criminological pro files of Cesare Lombroso (*L'homme criminel*, 1874) and of colonial racism were so similar was by no means coincidental, because they were tracing the same hierarchy:

> The lips of rapists and murderers he [Lombroso] found to be 'fleshy, swol len and protruding as in Negroes'. The teeth were usually huge, irregular, and far apart, as in gorillas and orang-utans. The examination of the tho rax of criminals revealed an increase or decrease in the number of ribs, 'an atavistic character common to animals and lower or prehistoric human races'. He found the upper limbs of criminals generally longer, 'an ape-like character'. The palms were prone to have simian creases, the toes farther apart, as in apes that use the toes for climbing trees, and 'the foot is often flat, as in Negroes'.[28]

This is the context in which blacks were presented, alongside monkeys, apes and criminals. These same bestial and criminal features up to today provide a source of entertainment in cartoons and comic strips, toys and novelty items which caricature blacks.

Whether we are considering the iconography or criminology, anthropol ogy or biology, mass psychology or depth psychology of this period, time and again the discourses converge: the profiles of savages, the primitives, blacks match those of animals, criminals, mad people, degenerates, lower-class per sons, crowds, and so on. The accounts of the various scientific disciplines appear to represent as many facets or strata of a syndrome of western fear: an inventory of anxiety and alienation projected on to all the 'dark' regions of society and the world. A dangerous world, a world of monsters and demons, which therefore must be controlled. St. George and the Dragon revisited, now on a global scale.

'The Female Hottentot, with natural Apron.' The 'Hottentot apron, a late-eighteenth and early-nineteenth-century medical myth of grossly overdeveloped labia, is here represented as fact. (Lithograph by J. Pafs, Great Britain, 1795)

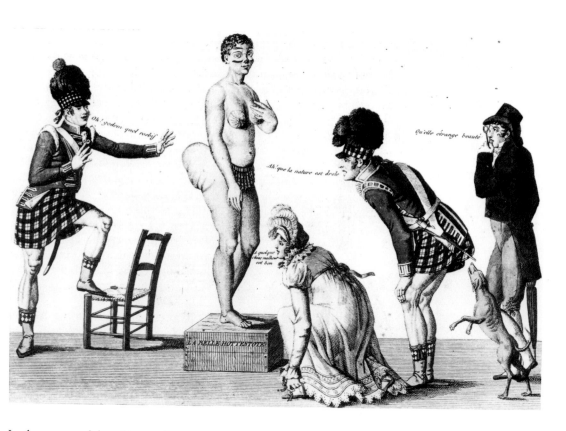

In the image the following text fragments appear: "Oh! goddam quel rosbij", "Ah'que la nature est drole", "Qu'elle etrange beaute", "A quelque chose malheur est bon", "LA BELLE HOTTENTOT."

In the course of the nineteenth century, Europeans began to show a deeper interest in the African woman. The overriding image was that of the black woman as sexualized woman – as it was in America, but the European views were more complex. There were several stages and facets to this process of imaging. Initially the Hottentot female was regarded as the prototype of the African or black woman. African female sexuality was equated thereafter with female sexuality generally, which in accordance with nineteenth-century medical views was considered 'pathological'.

At the beginning of the century the 'Hottentot Venus' caused a medical and popular sensation. The so-called 'Hottentot apron' – which referred to an enlarged clitoris – and *steatopyga*, or large behind, which had been described by eighteenth-century travellers in South Africa, could now be viewed by all and sundry in the figure of Saartjie Baartman, the 'Hottentot Venus', who was on display in London in 1810. She occasioned anatomical medical treatises by Cuvier and Virey who, by studying the 'primitive genitalia', the strongly developed labia of Bushmen and Hottentot women, and the 'primitive sexuality' of African women, sought to obtain a deeper insight into female sexuality in general.

An adjacent area of research concerned prostitutes, who were seen as prototypes of the sexualized woman. Again it was Lombroso who, with Guillaume Ferrero, published a study of the criminal woman (*La donna delinquente: la prostituta e la donna normale*, 1893), which drew an analogy between the prostitute and the Hottentot woman, both associated with unrestrained sexuality. In Lombroso's earlier study the profile of the criminal man fitted

'La belle Hottentote.' 'The curious in ecstacy, or the shoe laces'. Dialogue *from left to right*: 'Oh! Goddam, what roast beef'; 'From every misfortune may come some good'; 'Ah! how comical is nature'; 'How strangely beautiful!' A satire on the 'Hottentot Venus', a pastiche of Saartjie Baartman from the Cape Colony who was seen as a medical curiosity in London and Paris in the early 1800s. She was afflicted with an out-sized behind, but was considered an average Hottentot female and further medical proof that Africans were 'different'. (France, n.d.)

with that of the Negro; is it any wonder that the profile of the 'criminal woman' matched that of the Hottentot woman? Besides, the African woman and the prostitute were associated with syphilis (the nineteenth-century AIDS). In time the association of the prostitute with the black woman became a popular theme, alluded to whenever the appearance of white women with black suggested a similarity in their sexual nature. A familiar instance is Manet's painting *Olympia* (1863), with the young white prostitute reclining on a bed and her black companion or servant standing by.[29] Thus the feminine mystique and the black mystique merged. Another example is the painting *Les Amies*, by Jules-Robert Auguste, a delicate erotic fantasy of a black woman in love play with a white woman.[30] The white odalisque side by side with black women was also a frequent feature of harem scenes in French orientalism.[31] Sometimes the black women in these scenes were servants, sometimes companions. Illustrations in French popular magazines between 1890 and 1920 reproduced and paraphrased this imagery. In *Le Rire* prints showing the black domestic naked and intimate with the mistress of the house seem to suggest not so much lesbianism as the sexualization of the white woman by the black – '*la transfusion de la peau*', as it is called in one of the captions.

In addition, there is a European tradition of admiration for the African woman – particularly in France, where the black woman is often represented as appealing, even though her appeal is not devoid of ambiguity. The poem '*La Vénus noire*' by Baudelaire (1821-67), for which his friend Jeanne Duval ('Strange goddess, dark as the nights') served as the model, is an example of this tradition.[32] Victor Hugo sang the praises of '*Les vierges aux seins d'ébènes,/ Belles comme les beaux soirs . . .*'. Initially the African woman was situated in

'Life in the Altogether'. 'And then, my dear, with what you will be saving on my toilette, you will be so kind as to have a pretty nudarium installed for me.' *Le Sourire* (France)

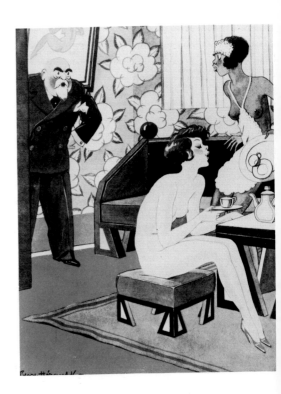

the margins of orientalism, but gradually she came into the foreground and in the course of the century she was portrayed with increasing frequency, as in the paintings *La Nubienne* (1935) by Charles Gleyre and *La Sultane Noire* by Prosper Marilhat. Charles Cordier made his famous bust *Vénus africaine* in 1851. Black nudes – like Frank Buchser's *Negermädchen im Bach* (1867) and *Nackte Sklavin* (1880), the former painted in Virginia and the latter in Morocco – were of a later date. Typically, in America there was no market for them.[33] Adolphe Belot devoted a play (inspired by a recent travelogue by the German anthropologist Schweinfurth) to *La Vénus noire* (1879), who was to symbolize the 'heart of Africa'. Was she a modern version of the Queen of Sheba? Paul Gauguin's paintings of Tahitian beauties and Picasso's version of *Olympia* (1901) as a black woman also belong to this tradition. In the words of Sander Gilman, 'Picasso saw the sexualized female as the visual analogue of the black. Indeed, in his most radical break with the impressionist tradition, *Les demoiselles d'Avignon* (1907), he linked the inmates of the brothel with the black by using the theme of African masks to characterize their appearance.'[34]

This lyrical view of the Black Venus was not fundamentally different from the medical perspective: the black woman was sexualized and equated with the prostitute in Picasso's work as well. But the attitude towards sexuality itself was different – not hostile; nor was the prostitute made a criminal. Baudelaire associated the black woman with darkness ('Child of black midnights'), but the darkness was enchanting, intriguing rather than threatening. To the extent that the African woman is represented as the 'primal woman', the question of how she is valued reflects the attitude towards women and sexuality in general. In English adventure stories she acted as a dark, demonic force, a counter-image to Britannia, whereas in French novels the appeal of the African Venus was often clearly evoked.

Pierre Loti, in his *Roman d'un spahi* (1881), traces the full spectrum of European views of African women in his description of Fatou-Gaye, his Senegalese heroine. She displays 'the mysterious beauty of an idol in shining ebony . . . a black grace, a sensual charm, a physical seductive power, something undefinable which seemed to stem at the same time from the ape, the young virgin, and the tigress.'

The black women who were being cultivated in this way in Europe were scarce and rarely available as partners. There was a marked difference between the image held by Frenchmen in France and by Frenchmen in Africa: witness the novels and travelogues from colonial Africa. A characteristic of exoticism is that often it does not survive proximity: 'Beautiful from afar, horrible from close by, Africa deceives the white: this theme of "lost illusions" is ubiquitous.'[35] Also the adoration of the Black Venus is sometimes a long-distance affair. In French colonial literature a distinction is drawn between the negress and the dark Islamic Peul woman. The attractiveness of the Peul woman is rated higher than that of the negress, who is characterized as 'primal woman', but also described and instrumentalized as a sexual object. Sometimes she is described in animal terms, not without ambiguity – 'animal sauvage et plein de grâce'. Thus Pierre Loti wrote about Fatou-Gaye. Thus the media wrote about Josephine Baker, as a 'gracious animal'. The 'Other' as 'magnificent animal' is one of the categories of western hedonism.

Loti's novel is now on record as a classic of racism and sexism. Still, the way Grace Jones was stylized in the 1980s, in advertising, album covers, photo-

Varying reactions to the mistletoe. (Postcard, Great Britain, n.d.) 'Awful!!!' 'Infuriated amateur nigger minstrel, with horrid black face, rushing madly in, double-locking the door, and waving aloft a sprig of mistletoe. "Now I've got you!" Consternation of affrighted Maidens.' The mistletoe, symbol of erotic intimacy, in the hands of a 'nigger minstrel', amidst shocked young English ladies. Very risqué. *Judy Annual*, 1880.

graphy books and postcards, by the French photographer and designer Jean-Paul Goude (her ex-husband), is a variation on the theme of 'savage grace' and animal appeal.[36] Meanwhile the commercial appeal has been widened by incorporating other forms of ambiguity, such as transsexuality. In general, the 'construction of the exotically and erotically dangerous black woman is also an important thread running through the stage personae of a whole range of popular singers, e.g. Eartha Kitt, Shirley Bassey, Tina Turner, Grace Jones.'[37]

In the imagery of 'others' there are marked differences between English and French popular culture. For instance, depictions of black man/white woman encounters 'under the mistletoe' in the English 'funny papers' suggests consternation and even panic. A print in *Judy* (1880) mentions a 'horrid black face, rushing madly in, double-locking the door' (the black man thrice disqualified) and 'Consternation of affrighted Maidens', revolted or prudish gazes, an impression reinforced by the high-collared and firmly buttoned dress of the woman in the centre of the drawing (white women thrice vindicated). A picture postcard on the theme of the mistletoe shows the nervous eagerness of an unattractive black man, knee pulled up in frustration, and the disparaging looks of the young ladies. Cartoons of mixed couples, a black man and a white woman, are not complimentary to the man while the woman is presented as naïve (*Punch*, 1902 and 1909). French representations in *La Caricature* (1897), *Journal amusant* (1899), *Le Rire* (1900-14), *La Vie parisienne* (1924), *Paris Plaisirs* (1930), give a similar image of the black man. Most of them concern black man/white woman situations, in which the black man is almost invariably depicted as grotesque (swollen lips, sweet as chocolate, primitive barbarian, colossal brute, or dandy) and usually in a position socially or physically inferior to that of the woman. In white man/black woman representations the social position of the man is superior and the woman is usually not particularly attractive. The black woman in French

'Chochotte prend son chocolat dans son lit.' (Chochotte, or easy woman, has her chocolate in her bed.) *Le Rire*, 7 July 1900.

magazines is virtually always a *bonne*, a domestic servant, usually from the French West Indies. In depictions of black woman/white woman situations, however, the black woman is represented as attractive and shapely. Many light-hearted cartoons concern the offspring of mixed relations: white women with black and black women with white children.

The black woman played a role in the eroticism of the *fin de siècle* and the *belle époque* in other continental cultures, but in France the current was the widest. This hedonistic and aesthetic preoccupation did not necessarily mean that there was genuine interest in African women.[38] In most depictions of her in the French satirical magazines, Queen Ranavalona of Madagascar, who paid a state visit to France in 1899, was grotesquely caricatured and un-

French couple at a colonial exhibition. *'La belle negresse.'* Wife's comment: 'Don't you see she's wearing last year's hat?' *Journal Amusant.*

A white male fantasy of domination on the cover of *The Mahound*, a tale set in the American South. (London, 1981)

attractive, despite her unusual situation, as an African woman of high rank, visiting a European country.

The trail also led to *l'art nègre*, the admiration for African art. Here too there was a pronounced difference of view between England and the Continent, in particular France. In England John Ruskin held that there was 'no art in the whole of Africa, Asia or America'.[39] In France exhibits of African masks and objects made a deep impression. When the Berlin Museum für Völkerkunde opened its doors in 1886 its collections already included 10,000 African tribal objects. Picasso saw African objects in the spring of 1907 at the Trocadéro museum in Paris. Shortly afterwards, Guillaume Apollinaire, the chief promoter of *l'art nègre*, began his collection. Between 1908 and 1914 Matisse, Picasso, Braque, Vlaminck, Derain were all collecting African objects. In 1919 at the Théâtre des Champs-Elysées a *Fête nègre* took place, organized by the collector Paul Guillaume for *tout Paris*. The master of ceremonies declared that 'the intelligence of modern man must become *nègre*'. Derain argued that tribal art, as the 'first among the classicisms', should be housed in the Louvre.[40] So the stage was set for Josephine Baker to make her *entrée* at the same theatre in 1925. The role of the *Vénus noire* was tailor-made for her. Later Matisse made a painting of her as *La Négresse* (1952).

In this way the Victorian complex of sexual repression and racism began to come apart at the seams. Freud's *Civilization and its Discontents* became a discontent with the culture and the psychological interior of western colonial-

ism. A re-sexualization took place, first of French and then of western culture. The Victorian shell had been displaying cracks; now it broke. The epicentre of the upheaval was Paris, and from under the cracked edges emerged orientalism, avant-garde art (cubism, later Dada and surrealism), the influence of African art and of Afro-American art and entertainment – the cake walk, the charleston, *La Revue nègre*, jazz and gospel singing. The re-sexualization of the European *monde*, beginning in Paris, set the stage for the Roaring Twenties. The lid came off the western pressure chamber.

So the separate lines of development of American and European racism, with their divergent castration complexes – the former preoccupied with the sexuality of the black man, the latter with the sexuality of the black woman – began to reconverge. Paris developed into a mecca for black jazz musicians and writers such as Richard Wright and James Baldwin, and a centre of African and West Indian *négritude* and *Présence Africaine*.

If the general hypothesis is valid, that a correlation exists between sexual politics and racial politics, then changes in gender relations and race relations would tend to occur together or simultaneously. This seems, at least to a certain extent, to have been confirmed. Eras of black emancipation in the United States have been, among others, the late nineteenth century, when it went along with the rage for the cake walk, which also reached Europe and caused controversy there; the Harlem Renaissance, which coincided with the 'loose' Twenties, to the accompaniment of jazz; and the civil rights movement of the 1950s and '60s, which overlapped with the 'sexual revolution' and the era of protest and activism.

The recurring coincidence in time of black emancipation and white sexual liberalization may well be significant. To the extent that 'black' denotes libido, in the subliminal code of western culture, if libido is allowed freer rein, colour may not be such an issue either. But this is not necessarily a sign of general emancipation. For working-class movements in the western world the 1920s and '30s were hardly a flourishing period – on the contrary; but for many of the colonized peoples those years were a period of recovery and emancipation – for nationalist movements in colonized countries, and for Native Americans and Australian Aborigines, whose birth-rates showed an increase for the first time in decades.

The objection of the powers that be to jazz and other forms of non-western entertainment – such as Kaiser Wilhelm prohibiting the tango – are not without logic in this context. Popular activities such as social dancing and the urban sub-culture seen in music-hall art have been linked to the growing emancipation of women.[41] Power, as Wilhelm Reich argued with his thesis of 'character armour', and as Michel Foucault pointed out in his analysis of the 'society of normalization', is also reproduced in countless 'micro-mechanisms' which form part of the 'micro-physics' of power.[42]

There may, then, be a nexus between sexual liberation, the emancipation of women and that of blacks and 'others' generally. Or, to phrase it differently, there may be a correlation between rigid power structures and libidinal repression and, conversely, between the breaking down of societal fortresses and libidinal decompression.

Opposite: French soldier back in his village with an African spouse. (Cover by Steinlen for *Gil Blas*, 2 April 1893)

Cover of the Belgian edition of a novel by Virgil Gheorghiu, *Do Not Ask for Miracles.*

13 BLACKS IN ADVERTISING

'Promise – large promise – is the heart of advertising', wrote Dr Johnson in the eighteenth century. In the colonial era European advertising promised nothing less than world power, while in America advertising was a display window for white supremacy. Western advertising has borne the imprint of hegemony of one kind or another ever since.

The development of modern advertising towards the close of the nineteenth century was interwoven with the onset of mass production and intensive industrialization, and with the integration of colonial and dependent areas into the western economies. This period, when many popular trade marks originated in packaging, posters and magazine ads, was also a time of sharp social and political cleavages. European hegemony, then at its height, was reflected in advertising along with colour, class and gender hierarchies.

In consuming colonial products westerners were also consuming the subjection of the colonized, a process that began with the packaging and marketing of the products: the hierarchy of the world economy was matched by and mirrored in a cultural pecking order. As non-western areas were integrated politically under imperialism, and economically through the international division of labour, the *cultural* incorporation of the non-western world took form in western exoticism. In advertising ethnic features were incorporated as 'product image elements', to use the language of the trade. 'The racial elements have been mainly included to imbue the image of the product with the romantic atmosphere evoked by these [non-western] peoples'.[1] For 'romantic' read: subjected and rendered assimilable by means of European control.

How to explain otherwise that, at a time when Africans and blacks were represented in the prevailing theories of race as primitive, degenerate and repulsive, they yet figured amply in European and American advertising? Logic alone suggests that they would be portrayed from a particular angle. Thus, according to the German writer von Kornatzki, after palms and beasts of prey, Negroes were the favourite 'exotic' subject in pre-war advertising.[2] From the European point of view blacks were external and therefore exotic figures, whereas in the United States they were familiar, one of the nation's minorities. There too, at the same time as blacks were being segregated and subjected to Jim Crow laws in the American South, images of them circulated widely by means of advertising. Again, it is logical to find segregation inscribed in the code under which blacks were represented, and that these images were not naïve but reflected the political and economic conditions under which they were devised.

Assimilation of blacks into the western consumer universe on western terms has meant, among other things, that black men be represented differently from women. Black men are desexualized while black women are eroticized (except in the United States, where until recently black women were desexualized as well). The primary condition for the commerical

epresentation of black men is that they be shown as non-threatening, in
clearly recognizable, usually marginal positions – as 'hewers of wood and car-
iers of water' in colonial Africa, servants and entertainers in the West.

Advertising imagery can also serve as a kind of test of the findings formu-
ated thus far. If those findings are correct, we will encounter blacks in west-
rn advertising time and again in the role of servants or entertainers. Images
which deviate from this pattern will require additional and alternative ex-
planation, notably in the case of pre-modern forms of advertising, such as
gapers' and Moors, the advertising of tobacco products, and forms of con-
emporary advertising. The examination begins with the earliest commercial
epresentations of blacks, and ends with contemporary trends in commercial
imagery.[3]

Gapers, Moors

The 'gaper' as a trade sign on apothecaries' shops and drugstores in the Low
Countries dates from the sixteenth century. This head of a male with a wide-
open mouth comes in several varieties, but most common is the Moor or Mus-
ulman, usually in a turban and with a dark face. The sign is a reference to
medicinal herbs which originate in 'the Orient'. The pharmacists' street was
sometimes called the Street of the Moors, as is the Kleine Moriaanstraat in
Antwerp.[4] (As mentioned above, 'Moor' and 'Mussulman' were then syn-
onymous; only in the seventeenth century did 'Moor' take on the meaning of
Negro, 'blackamoor' in English.) The gaper as an emblem of healing power is
still common in the Netherlands on old-fashioned druggists' signs.

Another version of the Moor's head is seen on the coat of arms of Corsica –
the head of a black man in profile, wearing a headband. Allegedly it repre-
sents a decapitated Moor and refers to the Christian reconquest of the island
from the Moors. In northern Europe, however, the Moor as heraldic symbol
on the shields of the military élite, and later on the coat of arms of the lesser
nobility and well-off merchants, carries a different meaning. The popularity
of the Moor in heraldry coincided with his revaluation in religious art and
symbolism during the late Middle Ages. The Moor, standing for 'King of the
Moors' as an emblem on taverns and inns in Europe north of the Alps, came
to be used as an emblem for breweries. 'Tucher Bier', for instance, was made
by the Tucher family of Nuremberg, who rose to prosperity and prominence
after 1326 through commerce with Italy. In the family chronicles a coat of
arms featuring the Moor's head occurred frequently and so became the basis of
the Tucher Bier emblem.[5] The Moor's head appears prominently in the
World Chronicle or *Liber Chronicarum*, also known as the Nuremberg Chron-
icle (1493). The Moor figured as a civic emblem as well, as in the Swiss city of
Schaffhausen with its Mohrenbrunnen. The identity of the symbol is further
elucidated by the local white wine with its trademark 'Mohrenkönig'. The
Moor in these guises clearly carries positive connotations.

Tobacco Products

When during the seventeenth century the tobacco trade established itself in-
dependently from apothecaries' shops and taverns, the first emblem by which
it identified itself was what came to be known as the cigar-store or Tobacco

A 'gaper', late-medieval
emblem of healing
power. (Copy,
Netherlands, 1985)

Tucher Bier and 'Mohrenbräu' beermats, old trade marks which hark back to the popularity of black Africans ('Moors') in the late Middle Ages in north-western Europe.

Indian – a figure, often negroid, in a feather headdress and a skirt of tobacco leaves. This image, known as 'the Virginian', became common in England during the seventeenth century, and in America during the eighteenth. It was an assemblage of all those involved in the production of tobacco: the black slave who worked in the fields, the 'Virginian' who owned the plantation, and the Indian who first introduced the colonists to the smoking and cultivation of tobacco.[6] The actual appearance of the cigar-store Indian might vary: he could be a blackamoor, a white, an Indian or a Turk. Images of blacks in skirts of tobacco leaves were common on European tobacco packaging, as in the Dutch brand De Drie Moorianen. In America the figure of the Indian became popular in tobacco advertising only in the period from 1850 to 1880.

Tobacco advertising made ample use of the 'southern myth', the amiable ambience of the 'old-time plantation' with its contented black workers. In a series of pre-war cigarette cards advertising Players, the role of black labour in the whole production process, 'From Plantation to Smoker', is displayed. On the back of one of the cards we find this description of cheerful labour relations in the 'Hand Stemming Room':

> Colored labour is employed in these Plants, supervised by experienced *white* foremen. The Southern negroes are particularly *happy* when working with tobacco. They *delight* to work in large numbers, and are always *happier* when they can sit surrounded by their friends and relatives and talk and sing at their work. They have very good voices, and while away the long summer hours with oldtime plantation songs. [Italics added, JNP]

In most product advertising blacks are shown as producers (workers, cooks) or servants, or as decorative elements, but *not* as *consumers* of the product. Quite a number of ads for tobacco products, however, fall outside this pattern; here blacks are shown as consumers. Tobacco products are an area where not just black labour but also black taste and style count. The first blacks to appear in American cigar ads, from about 1850, are Sambo types, buffoons.[7] Black buffoons and rogues are also featured in nineteenth-century Cuban advertising prints, while the role of the dandy is performed by a Creole or a white.[8] A little later the black dandy makes his appearance in cigar ads in America and Europe. This is striking also because the character who is an object of satire in the minstrel show here parades as role-model for white smokers. The fashionable black gentleman exuding authority in his taste in cigars, serving as a

model to be emulated, is a noteworthy exception to most modern western representations of blacks, which are virtually unanimous in emphasizing black servitude. To what do we owe this striking exception?

As an exotic foreign product, tobacco had traditionally been popularized by means of exotic role-models, like the Indian with his pipe. There was also an older tradition of the 'smoking Moor', a standing wooden figure in tobacconists', and a figure adorning tobacco jars. But the smoking black dandy of the nineteenth and twentieth centuries calls for a different explanation, involving another product, the cigar (the 'burning torch of herbs', as Columbus described it). Cigars began to be mass-produced from the mid-1800s onwards, and in order to open up new consumer markets new emblems were required. At this juncture of market expansion, advertising was particularly important. 'A well-chosen brand name, combined with a sharp advertising slogan, could contribute to the success of a factory.'[9] Perhaps an explanation may be found in the saying: 'Here, have a cigar. Light up and be somebody!'[10]

Expansion of the market for cigars was sought in the middle- and lower-income groups, mainly on the grounds of life-style: the wish for prestige and satisfaction. Cigar smoking has been surrounded by the rhetoric of status and the aroma of chic. Classic brand names tend to be at the least aristocratic and preferably royal, like Royal Brand or those named after monarchs (like William II). A remote and unlikely figure carrying status as a model may lend the product an aura of chic without the air of exclusivity which the image of a European gentleman would give. Thus, a black dandy, elegant and fashionable, poised and well-dressed, may serve as a cigar emblem precisely because he is a model of *unlikely* success. This explanation would apply in Europe as well as in the United States.

As 'Mr Cadena' put it, in a series of ads for a well-known pre-war brand of Dutch cigar, it's a matter of having 'An eye for a good cigar'. Cadena was the principal brand made by the United Dutch Cigar Factories (Vereenigde Hollandsche Sigarenfabrieken) in Culemborg. W. C. Dresselhuys, who founded

Flor de St. Felix, cover of a wooden cigar case, featuring a cigar-smoking white planter and a black worker.

A black 'Tobacco Indian', smoking, wearing a feather headdress and a skirt of tobacco leaves. Cover of a pouch of smoking tobacco from the manufacturers. B. Werners of 's-Hertogenbosch, Netherlands, 1840.

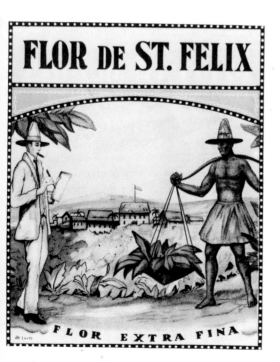

FLOR DE ST. FELIX

FLOR EXTRA FINA

Half zware Shag

Tobacco jar featuring a
pipe-smoking black
dandy. (US, 1880)

Tobacco jar in Delft
blue china, featuring a
cigar-store Indian and a
white colonist, both
smoking, presumably in
the West Indies.
(Netherlands, Delft,
Porseleine Fles, n.d.)

Pre-war brand of Dutch
Havanas, displaying a
black dandy as a cigar-
smoker's role-model.

the firm in 1853, thought of the name after a trip to Portugal. As a sixteen-
year-old he had visited America and American images and sayings slipped
into the Cadena ads.[11] Mr Cadena's advertising career is interesting. Whereas
on an early package he was depicted as a half-naked black slave on a West
Indian island, in later images he was transformed into 'Cadena Chic'. A series
of ads in the *Haagsche Post* (December 1921) shows the metamorphosis of 'I,
the Great Cadena' from a half-naked black to an impeccably dressed gentle-
man journeying to Rotterdam. The savage can be a gentleman: the meta-
morphosis is only a matter of style and taste, and the key to this is his choice of
the right cigar – a symbol for having gone up in the world. This is an early in-
stance of set-breaking advertising for marketing reasons.

Since World War II cigar ads have dwindled and blacks have disappeared
from tobacco ads. Still in circulation in Germany are Palm Cigarren, a brand
that goes back to 1906 and was named after the entrepreneur Eduard Palm
who at the time owned twenty stores in Berlin. With a palm to start with,
what is more logical than to add a grotesque little negro?[12]

Advertising card of
German Palm cigars,
Cologne (1910). This
image is still in
commercial use.

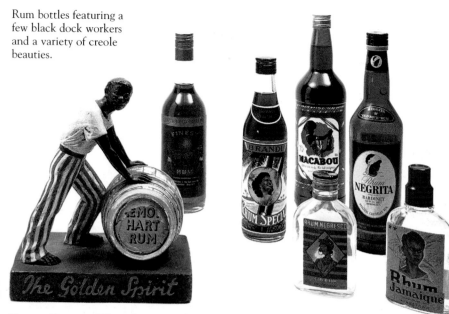

Rum bottles featuring a few black dock workers and a variety of creole beauties.

Rum, Cocoa, Chocolate, Coffee

Sugar, rum, tobacco, coffee, cocoa – all used to be products of slave labour as well as luxury items, delicacies which only came into general consumption thanks to slave labour. Originally they were available only to the élite (except for tobacco and the sailor's drink, rum). A whiff of luxury and indulgence, a luxuriousness to which black slave labour used to be the hidden flip side, still clings to these products, and their packaging tends to tie in with this. What the western world owes to African slave labour in the New World is still being paraded in the packaging of some products.

Rum labels often depict black dock workers carrying casks, with tall ships moored in West Indian ports in the background, and above all, Creole beauties serving rum.

In the eighteenth century chocolate was a highly esteemed product which loomed large in the economy of Spanish America. Most of the cocoa imported into Europe since the late nineteenth century has come from colonial Africa. Particularly instructive is a slogan such as that on the Bensdorp brand of Dutch chocolate: 'Cacao pur Hollandais' (pure Dutch cocoa). Chocolate is often shown being offered to Europeans by a little black servant, usually with large eyes like the Sarotti Mohr, his littleness and wide eyes both suggesting a lap-dog. A black represented as candy, as chocolate or liquorice, is a cliché as old as that of the little black page serving chocolate. In Germany a chocolate cake such as Mohrkopfe or Negerküsse is referred to as the 'edible negro': 'Before one has seen a negro one has already eaten ten of them.' Allusions to blacks as candy are legion: 'Some Elegant Chocolate Screams'. 'Assorted Chocolates'. 'Chocorêve'. In 1932, in the comic stories *Chocolate Drops from the South*, Edward V. White pointed out that the negro was 'the [American] nation's greatest source of laughter and good humour'. Why? 'Because he looks funny, he acts funny, he is funny. Moreover, he is serious about it all.'[13] Between the wars *'petite chocolatière'*, or little chocolate bon-bon, was a term of endearment for brown women.

Black labour in one form or another, is always part of the aura of coffee, either field work such as carrying the beans, or the little black servant who comes running to offer the final product. Cream specially for coffee is advertised in several countries under names which connote *métissage*, such as the Dutch brand Brazil, featuring a Creole beauty.

Over the years the role of blacks in the advertising and packaging of rum, cocoa, chocolate and coffee has hardly changed. As tropical products these things seem to be permanently associated with the colour black and with black labour. The range of 'black' tropical products is being expanded with 'tropical drinks' (Africoco) and new brands of sweets (Afrikitas).

Assorted Chocolates

Postcard, Assorted Chocolates, London (n.d.)

'Have you chosen a colour?' Advertisement of a Dutch grocery chain, Albert Hein, featuring the black actor, Donald Jones, offering a variety of types of coffee (colour-coded). (Zaandam, 1950s)

Coaster for coffee cup, featuring a black in a Turkish fez. (Switzerland, 1988)

A tin of Katuka Kaffee featuring an 'Oriental' black drinking coffee. (Germany, 1930)

CAFE KOLANDA
Allschwil, Tel. 061/63 50 00

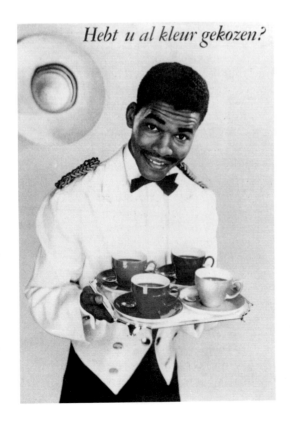

Hebt u al kleur gekozen?

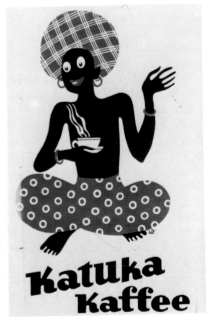

Katuka Kaffee

Washing the Moor White

Washing blacks white has been a popular motif in the advertising of soap. Playing on connotations of the distinction black/white, such as dirty/clean, dark/light, it gets at the foundations of racial thinking.

In 711 when Tarik invaded the Iberian peninsula, Negroes were relatively unknown in some parts of the region. In that year, according to an Arabic source, a negro from the Muslim army was taken prisoner by the Goths at the siege of Cordoba. Because, according to the chronicler, they had 'never seen a black man before', they tried to scrub off his black colour.[14]

So begins the problem, with the inability of Europeans to accept a negro as he is. By washing the negro they try to make him like themselves. What is at issue is the inability or unwillingness of one party to accept the other as he is without attempting to transform him and to eliminate the difference. The first attempts to assimilate blacks were of a religious nature. In the New Testament the first baptism of a non-Jew took place when Philip the Deacon met an Ethiopian eunuch, the treasurer of the Ethiopian Queen Candace, in the Gaza desert.[15] Philip's baptizing of the Ethiopian eunuch became an enduring symbol for the Christianization of the world. It entered Christian iconography in the third century and became particularly popular in north-west Europe in the sixteenth and seventeenth centuries. Here conversion and baptism were a means of assimiliating the Other. In the Adoration of the Magi, another popular representation of Christianity's place in the world, worship is the gesture which obviates Otherness. But both the eunuch and the Magi are bowing to Christianity. The forces that triumph are still Christian imperialism and Christian supremacy. These icons played a fundamental ideological role in the period of transition between the Crusades and the Renaissance and the Reformation.

In the course of the sixteenth century, notably in Elizabethan England, other motifs came to the fore. These concerned the alleged *unassimilability* of the 'other' and the 'other's' inferiority. The point of reference is again biblical, after Jeremiah 13:23: 'Can the Ethiopian change his skin, or the leopard his spots? *then* may ye also do good, that are accustomed to do evil' (King James).

The Italian illustrator Andrea Alciati (1492-1550) depicted the same scene of whitewashing: two whites who try to change a negro's colour by scrubbing him. The caption ran: '*Abluis Aethiopiem; quid frustra? Ah desine. Noctis illustrare nigrae nemo potest tenebras*' [You wash an Ethiopian; why the vain labour? Desist. No one can lighten the darkness of black night].[16] Alciati's emblem books were quite popular and imitated throughout Europe. This scene was used to illustrate the idea 'Impossible', for instance in Geoffrey Whitney's *A Choice of Emblems* (Leiden, 1586). The association henceforth became proverbial, so common and popular that it would rarely be referred to in full but abbreviated as 'You wash an Ethiop' or 'You labour in vain (to wash an Ethiop white)'. In French this ranks as one of *Les Grandes Vérités*: '*A vouloir blanchir un nègre, Le barbier perd son savon*' (Wanting to bleach a Negro, the barber loses his soap). In Dutch, in the eighteenth century and after, the saying 'Washing the Moor' simply meant, to undertake something impossible.[17]

The statement in Jeremiah mixes hereditary and acquired traits: pigmentation and morals. It joins what would later be differentiated as genetic

The first step towards lightening the White Man's Burden is through teaching the virtues of cleanliness.

Pears' Soap, *Harper's Weekly*, 30 September 1899

Now this is the road that the White Men tread when they go to clean a land.

Rudyard Kipling

and environmental factors (as in the nature/nurture debate). As such the saying takes the fundamental intellectual step in the direction of racism: mixing and confounding biology and culture, nature, in the sense of heredity, and milieu.

It's a vain labour to teach a fool wisdom, is one of the meanings of this saying, and so the notion extends to educating and civilizing blacks – a vain labour, just like trying to wash them white. By now we are far removed from the King of the Moors and from the heraldic Moor; we are dealing now with ineducable, unassimilable 'blackamoors'. A transformation which is proverbially *impossible* has become the *condition* for blacks to be acceptable. The difference has become a curse. The dark other is now irrevocably different and inferior. Whether he is black and cannot change his colour, *or* whether he is a son of Ham and thus accursed, amounts to the same thing. Thus, gradually, the psychological and cultural sea change took place, from the proud and popular King of the Moors to the blackamoors who were chased out of Elizabeth's England by decree (1601), and to the Africans who were traded and put to work in the New World.

In a social-cognitive perspective in which 'clean', 'white', 'fair', 'light', 'good' go together as the foundation of aesthetics and civilization, it is obvious that 'dark', 'black', 'dirty', 'sinful', 'evil' will be grouped together as well. This is where soap and hygiene come in, in accordance with the historic conjunction of *Cleanliness and Godliness*.[18] Thus, Francis Burton Harrison, governor of the Philippines (1913-21) under American control, when visiting the Igorots, a native people, 'had carried with him a cake of carbolic soap and had washed himself whenever possible after shaking hands with an Igorot'. 'Sane living', said the American Secretary of Internal Affairs of the Philippines, Dean Worcester (1900-13), 'means sanitary living.'[19] It is no wonder then that soap became both a symbol and a yardstick of civilization.

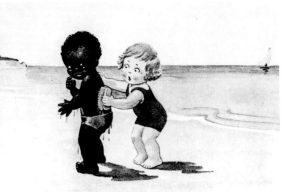

Iemand bij wien alles vergeefsch is!

Picture postcard of a white boy washing a black. Caption: 'Someone for whom all is in vain!' (Netherlands, 1932)

Poster with the reading text: 'If only you too had washed with Dobbelmann's Buttermilk Soap'. (Netherlands, 1910)

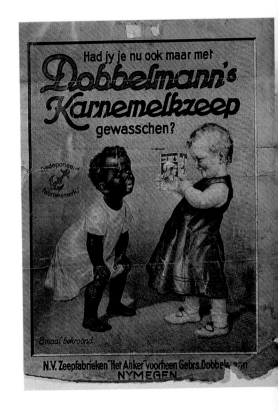

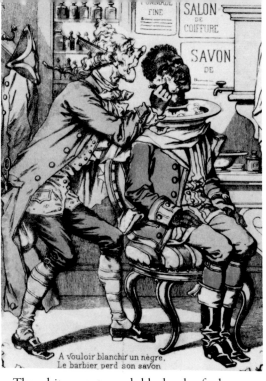

A vouloir blanchir un nègre.
Le barbier perd son savon

One in the series 'Great Truths': 'In trying to bleach a Negro,/The Barber loses his soap.' *Imagerie d'Épinal*, 1860.

The white urge to wash blacks also finds expression in whites' projection that blacks *wish* to be white. This theme we encounter in stories about 'the negro who wanted to be white' and in pre-war soap advertising. A classic is an ad for Dreydoppel Soap (1892):

> A mite of queer humanity,
> As dark as cloudy night,
> Was displeased with his complexion,
> And wished to change from black to white.
>
> He built an air-tight sweat box with the
> Hope that he would bleach;
> The sweat poured down in rivers, but the
> Black stuck like a leech.

'Wonders are not claimed for Dreydoppel Soap.' Nevertheless, 'Light and Shade Use Dreydoppel Soap.'

This motif also presents itself on the part of blacks who want to be taken for white ('passing') in a society dominated by whites. The notion that light skin colour carries prestige, the sale of skin-bleaches and hair-straighteners, we encounter in Ian Smith's Rhodesia, in the American South in the 1950s, and generally in societies where the hierarchy is that of colour and where 'white' values set the tone.[20] If blacks have to wear a mask in any case, the mask of servant or entertainer, then may it not just as well be a white mask?[21] In Brazil a saying is that 'money bleaches'.

Do whites also have a desire to be black? In children's books to turn black is usually a punishment, a terrible misfortune. But is there also a desire, secret and repressed, to pass for everything that is branded savage and unfettered? This would depend on the cultural climate. In the 1920s black music and dance were so popular in Paris and Berlin that 'Negro balls' were held to

Advertising flyer for 'Snowwhite Soap':

He reads what it says, and Presto: one-two-three
He jumps into the middle of the stream
From far off he shouts to the little niggers:
"Hurrah! I finally have my wish!"

They look at him in astonishment,
Examine him from all sides,
Touch, feel and even smell him,
And roll frolicking in the sand.
Our little nigger just lets them do it,
Quickly he has told them all,

And when he lets them see the packet of 'Snowwhite',
Then their joy knows no bounds.
W.A. Timmerman, *Modderstad/Het Nikkertje* (Baarn, 1928)

which the guests came dressed up and in blackface so as to dance the charleston authentically. In Germany this was called '*Negern*', and in France '*faire nègre*.' 'Negrophilia as idolization of the original-animalistic was another form of racist prejudice.'[22]

Black, on the other hand, can also rub off, and that is a profitable notion when it comes to oven and shoe polish,[23] ink and wax. As in the case of '"Swan" Ink, Dries Black for Ever', and as in Thomas Carlyle's observation: 'With a pennyworth of oil, you can make a handsome glossy thing of Quashee. . . .'.

Dreydoppel Soap advertisement (The Netherlands, 1892).

A mite of queer humanity,
As dark as a cloudy night,
Was displeased with his complexion,
And wished to change from black to white.

He built an air-tight sweat box with the
Hope that he would bleach;
The sweat poured down in rivers, but the
Black stuck like a leech.

One trial was all he needed;
Realized was his fondest hope;
His face was as white as white could be
There's nothing like Dreydoppel Soap

Fruit

Europeans traditionally believe that the natural fertility of the soil in the tropics makes agriculture easy, if not altogether unnecessary. Africans, so it was believed, had little more to do than eat what grew naturally around them. This blissful notion was extended to the West Indies. In the words of Thomas Carlyle in 1849, 'by working about half an hour a day [the Negro] can supply himself, by aid of sun and soil, with as much as will suffice'. The West Indian negro, reported Anthony Trollope after a tour of the West Indies in 1858,

> is idle, unambitious as to wordly position, sensual and content with little. . . . He lies under the mango-tree, and eats the luscious fruit in the sun; he sends his black urchin up for breakfast and behold the family table is spread. He pierces a cocoa-nut and lo! there is his beverage. He lies on the grass surrounded by oranges, bananas and pine-apples.[24]

The imagery of natural abundance was used as an argument to justify slavery or other forms of labour under coercion. Given their natural laziness and indolence, negroes and other native peoples were in dire need, it was said, of externally imposed discipline. Slavery or forced labour, Christendom or colonialism – without some form of European discipline they would regress into a condition of chaos. Indeed by imposing control Europeans were actually doing them a favour.

Fruit was the classic symbol of plenty, commonly used to denote the natural fertility of the tropics, and hence the 'natural laziness' of blacks. For the West Indies, pumpkins and melons were the common signifiers of tropical abundance. In American folklore blacks are beset by an uncontrollable desire for water-melons. It is one of the attributes of the child/savage image. The water-melon suggests sloth, gluttony, lack of self-control, childlike needs; additionally, it may carry sexual overtones. Bananas and coconuts have also been associated with blacks. Again the connotation is tropical abundance; in addition, the banana is the classic phallic symbol.[25] Blacks also figure repeatedly on wrappings of oranges from Italian firms such as Il Moro of Sicily; a traditional association seems to be lacking.

In the good old South. Postcard 'In the good old summer time', featuring watermelon folklore. (USA, 1907)

Advertisement for grapefruit, USA. (Waverley, Florida, 1930s)

Fruit is an appealing symbol in advertising. Its association with sexuality is obvious.[26] A familiar instance is the advertising for Chiquita, a trade mark of the multinational United Brands (formerly United Fruit), a corporation that is dominant in Central America. In the 1950s Chiquita's advertising for the American market featured the Brazilian film star Carmen Miranda, who had been recruited to cheer up the product. Bananas were presented as both festive and nourishing. '. . . Miranda personified a culture full of zest and charm, unclouded by intense emotion or political ambivalence. Like the bananas she wore on her head, Miranda was exotic yet mildly amusing.'[27] Carmen Miranda was also an American version of Carmen, who since Bizet's opera has been the main Old World stereotype of the *femme fatale*. Here the female danger was domesticated, brought into the family household while at the same time externalized and kept at bay as representing an exotic culture. In television advertising of the '60s 'Chiquita Banana' was transformed into a more overtly sexual figure, doing the rumba and singing in a heavy Spanish accent the famous catch-phrase with which she is identified: 'I'm Chiquita Banana . . .'.[28] This Hispanic beauty is still seen, stylized, on the Chiquita logo.

In Europe in the late 1980s, Chiquita used a nude black woman dancing in a skirt of bananas for a well-known series of magazine and TV ads. This illustrates the come-back made by blacks in advertising in the '80s. Many people found the ads denigrating and racist. Why? We can isolate certain aspects of this ad campaign. It is a pastiche of Josephine Baker's banana-skirt dance of 1925. Josephine's dance, which was itself built on a cliché, signified at the time the loosening of the Victorian harness on sexuality, a liberation associated with the Roaring Twenties. Now, however, it no longer carries such a 'liberating' connotation. The fact that it involves a black woman sets her apart, suggesting more about black women than about sexual mores in general. One of the campaign slogans informs us that Chiquita bananas are 'Favourites of Mother Nature'. By implication this holds true for the black woman as well. A naturally gifted creature – a creature of nature? Her nudity except for the skirt of bananas, and extrovert postures, along with the abundance of bananas, seem to suggest promiscuity (and possibly: 'All they care about is sex').

An ad campaign for Turbana, a Dutch brand of bananas, which ran in the same period also made use of a black woman, but was more modest in tone and design. The black woman is not anonymous but a well-known sport personality, a runner of Surinamese descent, Nelli Cooman. Sitting eating a banana, one of her lines is 'Finally time for my Turbana'. She addresses the public directly, whereas in the Chiquita ads the talk goes on over the woman's head. The association of domesticity with relief ('finally') is characteristically Dutch. The sexual connotations have not disappeared, but the ads show the woman with a single banana, subliminally suggesting monogamy. Besides, a wedding ring on her finger is in full view. With the slogan 'The pride of the Netherlands runs well on Turbana' ('Neerlands trots loopt warm for Turbana') Nelli Cooman is presented not in terms of pigmentation but in terms of achievement: she is the 'fastest woman in the world'. It is not ethnic identity that is emphasised but her role as 'pride of the Netherlands'.

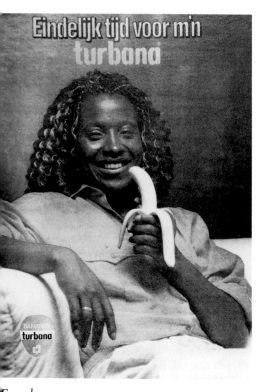

Trends

The logic of media communication in an age of image-saturation is different from that in an age of image-scarcity. The pre-war images discussed above must be seen in their historical context of an environment where images and information were in short supply. They may appear transparent and simple now, but a transparent world made a black and white view of white-black relations possible. A clear hierarchy could be coded and represented in simple schemata and scenarios (which had complex ramifications). At present, while western hegemony continues, global configurations are more complex, and white-black relations too are no longer so black and white.

Under these conditions advertising as well tends to operate differently, at least in certain respects. The key question with regard to current commercial imagery is whether stereotypes are being recycled or whether they and the mental sets or schemas underlying them are being broken. An elementary example of a set-breaking image is a black Santa Claus. Often in advertising, schemas are undermined *as well as* confirmed: like portraying a black man as a social equal, but showing him with, for instance, a saxophone, which harks back to the schema of the marginal black entertainer. This is to leave out of consideration *why* schemas are perpetuated and whether this happens deliberately. A lack of awareness of stereotypes *as* stereotypes is part of the problem, just as in the case of sexism, where ignorance does not eliminate the problem but rather relocates it.

In recent years the overall pattern of the manipulation of exotic attributes and ethnic features in advertising has not changed, but its complexity and ambiguity have increased. The spectrum of ways in which blacks are pre-

'Finally time for my Turbana.' Ad for a Dutch brand of a banana featuring the runner Nellie Cooman. (Netherlands, 1987)

Orange wrapping featuring mixed imagery, a black in top hat. (Moro, Italy; recent)

sented has broadened. Ambiguity and a variety of possible interpretations are intrinsic to certain forms of advertising, and deliberate where the objective is to appeal to multiple audiences through a single message or campaign. Innovation and a breaking of mental sets and images may be necessary in order to attract attention in an image-saturated environment. Juggling with the 'pictures in people's heads', playing around with mental structures may now be a basic requirement for attracting any attention at all. On the other hand, the advertisers cannot afford to stray too far off the beaten path. How much leeway there is depends on the product, on the target audiences, and on the cultural context.

Let us preface this concluding section with a brief *tour d'horizon* of post-war developments in white-on-black representations. In Western popular culture of the 1950s cannibal jokes and ridicule of Africa as a land of savages and apes were routine – witness the humour pages of illustrated magazines, the popularity of Tarzan, etc. This began to change in the wake of the American civil rights movement and of decolonization in Africa. In the former colonial countries (England, France, Belgium, Portugal) the image of Africa became politically sensitive (although this did not deter the tabloid press). In countries which did not maintain relations with Africa, such as West Germany, popular images of Africa were not subject to restriction and have remained, down to the present, welcome items of low-brow humour.

In the United States, studies of blacks appearing in TV commercials in the 1960s indicated that 'when blacks were used, they usually were in the background, were out of focus, did not speak or handle the product, and were Anglicized to the extent that they were made to resemble whites both in appearance and speech'.[29] Consequently, organizations such as CORE and the NAACP appealed to the Federal Communications Commission to end discriminatory advertising. Follow-up studies in the late '70s showed that more blacks were used in commercials than in the '60s and in more active roles. What did not change was that 'When blacks are portrayed, there is a larger number of total people in the ad than when there are no blacks.'[30]

Civil rights organizations protested against derogatory and negative stereotyping as they did against institutional racism. Black emancipation movements had many faces – Black is Beautiful, Black Power, Buy Black – which are reflected in the popular imagery of the '60s and '70s. Derogatory images of blacks were in retreat and along with a stronger presence of blacks, different images emerged. They were no longer represented simply as servile types but also as emblems of beauty, elegance, soul, authority. Images became more assertive, reflecting both the increasing importance of black purchasing power and the political moment of black organization. Images of 'integration' came into circulation. In the US this has been an important, in many respects irreversible, turning-point; a number of clichés have been eliminated which do not come back.

A 1980 study of the portrayal of Afro-Americans on television distinguished three stages in that portrayal: the age of stereotypes (to 1965); the period of new awareness (1966-72), when blacks were given very positive traits; and the period of stabilization (1973 onwards) in which blacks were presented in a presumably more 'realistic' manner. The author of this study, however, also cautioned against new stereotypes of the black community arising on American television which perpetuate old biases in more subtle

form. Among these are the irresponsibility of the black male, as demonstrated by his absence from the black family; the aggressiveness of black women; the lack of positive attributes of the black community; the esteem given 'bad', flashy characters by the black community; and the use of 'Black English Vernacular' as a sign of the moral or educational inadequacy of blacks.[31]

Indeed, hygiene in public images and discourse has its limitations: racism takes on more subtle and underground forms, and now tends to differentiate between middle-class blacks and those of the underclass. Since 1974 there has been a standstill, even a decline in the social position of blacks in the United States, with a shrinking black middle class divided by a widening gulf from the growing black underclass.[32] In this context, the public image of African-Americans has bifurcated, with Good Blacks on the one hand, and Bad Blacks on the other. Good Blacks display the profile of success and conform to mainstream American standards in terms of education, life-style and patterns of consumption, whereas Bad Blacks inhabit the ghettos, fitting the general profile of unemployment, school drop-outs, broken homes, drugs, crime and violence. Good Blacks are displayed in advertising, sit-coms and public forums, whereas Bad Blacks populate the ragged margins of society, on the outside looking in. Bad Blacks are featured on the cop shows, rap videos and news programmes, with 'badness' serving as a badge of honour or sign of disapproval, depending on where one stands in relation to 'the system'. These two sets of images interact, in that Good Blacks are portrayed as spokespersons for the Bad, while the apparent success of one category defeats the claims to special treatment (positive or affirmative action) on the part of the other. This forms part of what has been termed 'the paradox of integration'.[33]

Another feature of the contemporary multi-ethnic scene is that minorities are played off one against the other. Thus, Asian Americans are eulogized in

An example of set-breaking. Black Santa Claus: 'I'm dreaming of a . . . ' (Postcard, 1986)

the United States as the 'model minority'. A parallel in Britain are stereotypes of Afro-Caribbeans as 'aggressive, excitable and truculent; maintained by being played off against images of Asian people as meek, passive and docile'.[34] In Europe, many clichés about blacks are being casually reproduced, in the absence of black minorities powerful enough in terms of numbers and organization to put a stop to them. Though the commercial manipulation of images of blacks declined in the '70s, in recent years these have made a come-back, albeit in new guises.

Blacks have largely disappeared from advertisements for soap and ink, and for waxing and polishing products, to name a few of the typical pre-war associations. There has been no change with respect to other items, for instance candy. The brands of liquorice Like, from Italy, and Fazer, from Finland, are packaged in stylized abstract representations of blacks. Skin colour and product colour apparently go in tandem. In Spain Conguitos, chocolate-coated peanuts, are a popular candy packaged in a naked little black savage with a spear whose big belly holds the peanut.

As part of the fashionable nostalgia for styles of the past, ornaments in the form of blacks are back in fashion, as well as useful items such as blacks who carry lamps, trays or ashtrays. (It is a selective nostalgia, for certain items do not come back, such as blacks on tobacco jars or on piggy banks, either because the items are no longer in use or the symbolism no longer appeals.) Decorative little black servants in wood are 'in' again. If the reintroduction of this servile item of décor provokes no resistance, or engenders no friction, does it mean there has been little change in social relations and cultural perceptions? On the other hand, it may mean that there has been such a great change that for some people this is a means of regaining lost certainty.

Package of a brand of liquorice, Like, featuring a stylized abstract image of a black, the quintessence of a caricature. (Italy, 1987)

Box of Fazer, Finnish liquorice, featuring a stylized black with earrings (1980s).

A bag of Conguitos, chocolate-covered peanuts, (popular in Spain, 1989), featuring a little black savage with a spear.

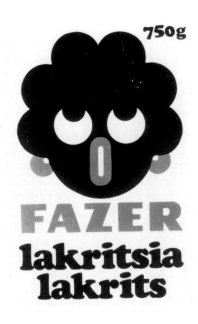

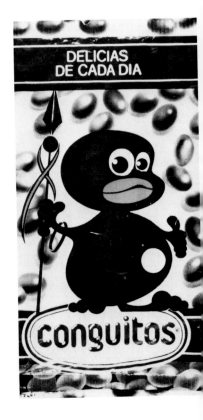

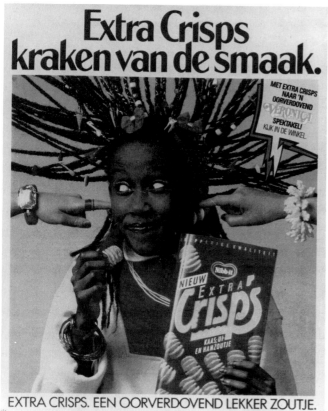

Extra Crisps kraken van de smaak.

MET EXTRA CRISPS NAAR 'N OORVERDOVEND VERONICA SPEKTAKEL! KIJK IN DE WINKEL

NIEUW EXTRA Crisps

Nibb-it

KAAS-UI- EN HAMZOUTJE

EXTRA CRISPS. EEN OORVERDOVEND LEKKER ZOUTJE.

Ad for a Dutch brand of crisps – Extra Crisps, by Nibb-it. (Netherlands, 1987)

Some advertising is mysterious in its associations. For instance, the connection between chips and blacks, as in an English TV ad for Hula-Hoop crisps featuring a black girl with an Afro hairdo. The figure is reminiscent of Kornelia Kinks with her peak coiffure, a familiar character in pre-war American advertising.[35] On the package of the Fromalp brand of Swiss cheese a little black boy scurries towards us, *Le petit Nègre* – possibly a guarantee of unbounded service to the consumer, though otherwise the link between blacks and Swiss cheese remains obscure.

A recent example of successful pressure against stereotyping is Darkie Tooth Paste. Before the war several brands of toothpaste carried blacks with shining teeth in their emblems. One that remained is the Darkie Tooth Paste of the Hawley & Hazel Chemical Co. Ltd. (Hong Kong), a brand which has the largest market share in several Asian countries. For over sixty years its trade mark has been based on Al Jolson in blackface with a row of shining white teeth; only the standard minstrel feature of the wide whitened mouth was omitted, in order to highlight the contrast between the white teeth and the black visage. Since 1985, when the American firm Colgate acquired a 51 per cent share in Hawley & Hazel, several American groups have objected to the name and the image. The firm experimented with changing the name to 'Dakkie'; the emblem was to remain the same. Recently a new name was selected, 'Darlie', along with a new drawing – of a gentleman 'of ambiguous race' in a silk top hat.[36]

Grace Jones in a Citroën ad: 'I DEMAND PERFECTION'. Anomaly is achieved through the crew cut and GI outfit, down to the military ID tag hanging from her neck, in contrast to the make-up and black gloves. (Netherlands, 1987)

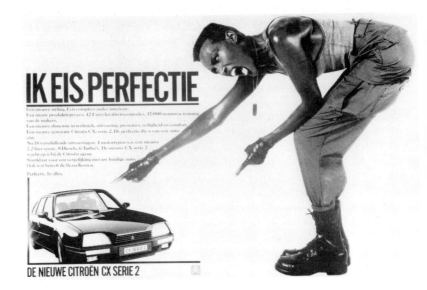

IK EIS PERFECTIE

Een nieuwe styling. Een compleet ander interieur.
Een nieuw produktieproces. 42 Extra kwaliteitscontroles. 17.000 manuren training van de makers.
Een nieuwe dimensie in techniek, uitvoering, prestaties, veiligheid en comfort.
Een nieuwe generatie Citroën CX: serie 2. De perfectie die u van een auto eist.
Nu 18 verschillende uitvoeringen. 4 motortypen o.a. een nieuwe 2.2 liter serie. 8 Diesels, 6 Turbo's. De nieuwe CX serie 2 is echt op z'n best bij de Citroën agent.
Startklaar voor een vergelijking met uw huidige auto. Ook wat betreft de flexaselkosten.
Perfectie. In alles.

DE NIEUWE CITROËN CX SERIE 2

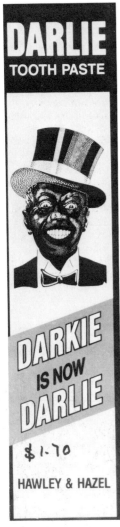

DARLIE TOOTH PASTE

DARKIE IS NOW DARLIE

$1.70

HAWLEY & HAZEL

Darkie Tooth Paste, renamed 'Darlie' but still featuring the minstrel Al Jolson. (Hong Kong, 1989)

Since 'Black is Beautiful', black women have come to the fore in fashion advertising. Often this involves light-skinned black women dressed according to white norms. But overtures are also being made in the direction of alternative black styles of elegance and poise; sometimes in the tradition of the Black Venus, sometimes a mestiza beauty transcending ethnicity. A new image in advertising is that of the dangerously seductive black woman, the black vamp or *femme fatale* in the line of Josephine Baker – a 'wild', aggressive type as exemplified by Tina Turner, following the schema of libido unlimited. This reflects a popular image of black women as aggressive – previously this applied chiefly to the black matriarch, now it extends to younger women and not just mothers.[37]

A variation on this theme is an ad campaign by the French car-maker Citroën featuring Grace Jones; the ads ran in several European countries in the mid-1980s. Again the model is a black entertainer, confirming a schema. A novel feature is how aggresssively she is presented, with lines such as 'I demand perfection', 'I demand prestige', 'I demand force'. The campaign was built on the image of Grace Jones as a former disco queen. Transsexuality seemed to be a more important feature than colour; the sexual ambiguity of a woman with an aura of masculinity, in commanding postures, wearing GI boots and a military outfit, is the aspect that comes across most strongly, presumably targeted at an audience with an 'innovator' life-style.

Images of mixed couples are more accepted nowadays and are sometimes invoked as appealing. Usually this goes along with the recycling of established colour and gender hierarchies. In a Dutch poster advertising a fast-food chain, 'Free Time', a white boy, shown in the company of a black girl, is offered, with the purchase of a hot dog, a 'free hot choco drink'. Male/female, white/black pecking orders are reproduced here, and in addition, one surmises, there is a subliminal allusion to the sexual reputation of black women ('hot choco') and their availability ('free').

While we see other mixed couples on display, in fashion advertising as well, certain patterns remain intact, so that the transition is not complete.

Often the black figure is placed in the background, denoting its decorative status. Or an attribute such as a trumpet is added, involving the schema of the musician. The black is often light-skinned, so that the colour contrast is not so great, particularly when the white partner in the combination is of a dark complexion. The figure occupying the lower position in the ethnic hierarchy tends also to do so in ads, regardless of gender. Thus when a black man is shown in conjunction with a white woman, we do not often see him in a 'typically masculine', dominant posture, but rather in a decorative or sub-servient pose. Often a 'feminine' kind of black man is represented, along the lines of the Black Eunuch, non-threatening as a sexual rival. When *a masculine* black man is shown in an ad together with a white woman, he is often re-presented in a socially inferior position, with the emphasis on physical strength or servitude, so that he does not come across as a rival to white males. Variations of a perverse nature are less frequent. For instance, an ad for Seiko watches shows a white woman being carried by a black bearer; she is depicted as being overtly sexually available. In general, hierarchies of colour and gender tend to be reproduced in this advertising imagery, with colour hierarchies prevailing over and showing less flexibility than gender hierarchies.

That the sexualization of blacks and the use of blacks as sexual objects still goes on is confirmed by the importation into the West of increasing numbers of non-western and black prostitutes. Western sex tourism to non-western countries adds to this trend.[38]

Well established in North America but new in several European countries is a market of blacks, a consumer market as well as a labour market. In adver-tising targeted at this market, blacks are shown in normal ways for a change, and not as savages, servants, hypersexual creatures, criminals, or whatever. This kind of advertising breaks with existing schemas but to the extent that it is directed at a black audience and not at the mainstream public it does not necessarily detract from mainstream stereotyping.

In the 1950s Afro-American magazines such as *Ebony* carried ads for creams to bleach the skin, for hair straighteners, and for consumer goods in

Advertising brochure of the fashion house Mexx, 'Lifestyle in Love City'. A man of the black eunuch type handled, fondled as a toy. (Netherlands, 1987)

Magazine ad for Seiko watches. A half-naked black man of a masculine type shown with a white woman displayed as sexually available. The man obviously has his hands full and is not presented as a partner. (France, 1980s)

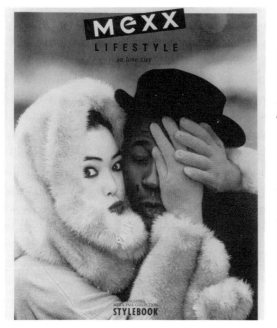

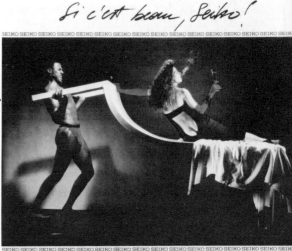

BLACKS IN ADVERTISING 207

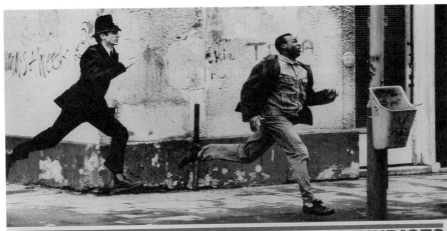

ANOTHER EXAMPLE OF POLICE PREJUDICE?
OR ANOTHER EXAMPLE OF YOURS?

Do you see a policeman chasing a criminal? Or a policeman haras sing an innocent person? Wrong both times. It's two police officers, one in plain clothes, chasing a third party. And it's a good illustra-tion of why we are looking for more recruits from ethnic minorities. **Photograph by Don McCullin**

Police recruitment advertisement. The point of the image is that both figures are police officers – the white in uniform, the black in plain clothes – chasing a common target. Great Britain, 1990. (*Photo: Don McCullin, courtesy COP International and the Metropolitan Police*)

'Togetherness'. Black/white male bonding, in the sphere of physical competition. Cover of an anti-discrimination leaflet issued by the Commission for Information on Minorities, The Netherlands, 1987.

SAMENHEID

which blacks were portrayed as identical in style and dress with whites. White middle-class norms set the tone. Cultural differences were eliminated and only a difference in pigmentation remained. Since then, magazines such as *Essence* have begun also to feature black styles.

Governmental or governmentally-subsidized institutions mount campaigns aimed at fostering integration and breaking down stereotypes about minorities. That this is a slow process is evident from the ads we often encounter in which certain stereotypes are demonstratively demolished while others are stealthily reaffirmed, or in which the good intentions proclaimed in the words of the ad are contradicted by the imagery. Thus, in a publication of the Dutch Commission for Information on Minorities, on the theme of *Togetherness*, we see next to an edifying text a picture of a black man and a white one who are trying to force each other's hands down.[39] Ostensibly the picture is about a ritual of male bonding and fraternal rivalry in sport; the subtext, however, says that when it comes to muscle power black and white are on a par, thus unintentionally perpetuating the stereotype that blacks excel in physical strength and prowess.

Fund-raising campaigns by agencies for relief aid for Africa also often recycle stereotypes. The appeal of children and victim imagery are clichés of the genre, a matrix exploited by organizations ranging from Oxfam to the Leprosy Foundation, and well entrenched in the popular media. The dominant images of Africa are of famine, disaster, war or military *coup*; an imagery of danger, ill fate and apathy. The effect of this imagery is reinforced in the media through the selection of pictures and television reporting – often from such an angle that one is literally looking down on people, which reinforces the impression of their passivity and, on the part of the viewer, the sensation of power and control.[40] As the Ghanaian journalist Cameron Duodu remarked, who ever heard of raising funds for cancer victims by showing cancer patients dying?[41] Yet, fund-raising for famine relief in Africa over and over

again shows people starving, down to the flies in their eyes. The macabre reverse effect of this imagery is that while it shows 'the Third World' in a state of utter destitution, thus instilling the false sense of a gulf yawning between North and South, it nourishes the complacency and narcissism of the West. Rather than producing human solidarity this kind of imagery tends to foster estrangement.

The images of Africa that are most effective and lucrative from the point of view of fund-raising organizations are not necessarily the right ones. The bureaucracy and the rhetoric of aid and relief stand in the way of solidarity and empowerment, or rather, channel them in a single direction and in the process promote a reverse empowerment, the empowerment of the West. The agency that comes off best in this kind of advertising is the relief agency itself – catering to western stereotypes and recycling the imagery of blind passivity. An example is a book on famine in Africa which includes a map showing disaster areas indicated by means of skulls. [42] The closest parallel is the imagery employed in pre-war Christian missionary work, whose centre was the mission itself.

A seemingly new kind of ad campaign is 'United Colours of Benetton' which was launched by the clothing firm in 1984 in 14 countries under the heading 'All the Colours of the World', featuring young people of a variety of colours and countries. The objective of the campaign is to establish Benetton's reputation as a global firm and its product as global fashion. Coca Cola and Pepsi-Cola produced this kind of international 'rainbow' advertising in the 1970s with the same objective. Benetton is introducing a concept of 'world fashion' – which in reality is, of course, not so global. In the first ads the young people of various nationalities were identified by little flags and symbols – not so much a matter of 'united colours' as of 'united nations', which however is too dull a concept. Several posters and magazine ads in the United Colours campaign feature white/black combinations. Almost invariably the white figure in these is presented in the dominant, active position (in some instances blatantly so, as in the poster of a white girl with a whip in her hand, next to a black girl). In 1989 several Benetton ads provoked protests from blacks in the United States – a picture of a black woman wet-nursing a white baby reminded people of the days of slavery, and was quickly withdrawn; a picture of the arms of a black and a white man handcuffed together, might suggest that the black had been arrested by the white, although they were identically dressed. The United Colours campaign is a marketing strategy which does not shift frontiers in inter-ethnic image-making, but merely recycles them.

How virulent certain stereotypes of blacks still are is apparent from their adoption in non-western cultures which themselves have little or no direct experience of Africa or of blacks. Stereotypes of blacks current in the United States circulate in Japanese advertising and packaging. Black dolls with big eyes, Sambo and Hannah, and a black doll with thick lips and big earrings, Bibinda, were selling well in Japanese department stores until protests from the United States put a stop to their manufacture. In recent years certain Japanese politicians, such as Yasuhiro Nakasone and Michio Watanabe, have made denigrating and in effect racist references to American blacks. None the less, blacks are featured in Japanese advertising, which follows

Still of a TV advertisement for Ariel washing-powder. Great Britain, 1991. (*Illustration courtesy Proctor and Gamble*)

American patterns in so many respects. Japanese advertising experts say that 'viewers react favourably to blacks because they seem more full of energy than whites'; 'blacks appear to have a wild side which seems beyond normal human strength'.[43] The association of blacks with 'wildness', here used 'positively', indicates a mimesis of western attitudes. The stereotypes of blacks in Japan have been copied directly from the United States, and again there is no role for blacks other than sport or entertainment. In the 1986 annual of Japanese ad productions there are seven images of blacks; four of them are of musicians, one of a soccer player, one is an elegantly-dressed black woman (in a style meeting white standards), and one a woman who falls outside the pattern.[44]

All this is part of a wider trend that includes the adoption of colonial imagery within the colonized countries – cannibal jokes about Africa are as common in the popular culture of the Philippines or Thailand as they are in Europe and the US. Japanese culture absorbs western stereotypes not only about Africa and the Third World generally but also about Asia and even about Japan itself. Following in the footsteps of western hegemony may be easier when one also adopts western stereotyping and 'othering'.

In recent years the spectrum of commercial images of blacks in western culture has broadened. For instance, since the 1970s black males appear in fashion ads as models and not merely as decorative features. There are more ads featuring blacks in which ethnicity plays no significant part, in which blacks are represented in 'normal' ways, or in which white cultural norms are side-stepped. More often, however, existing stereotypes are fine-tuned and made to look new as they are recycled. The general pattern is the reproduction of stereotypes, or variations on a theme, along with a gradual expansion of the repertoire.

III POWER AND IMAGE

14 WHITE NEGROES

Virtually every country in Europe had its equivalent of 'white Negroes' and simianized men, whether or not they happened to be stereotypes of criminals, assassins, political radicals, revolutionaries, Slavs, gypsies, Jews, or peasants.

L. Perry Curtis, jr. (1971)

In order to deepen our understanding it is necessary to widen the horizon. The label 'racism' particularizes and isolates issues. If our point of departure is that 'race' is a mythical concept, a social construct devoid of substance, why should we study the social relations in question only under the label 'racism'? Comparisons with social relations structured by similar dynamics (prejudices, stigmatizing stereotypes, discrimination, exclusion) may deepen our insight into both racism and stereotyping.

How does the stereotyping of Africa and of blacks fit within the larger framework of western patterns of exclusion? This chapter is an enquiry into the western world's underside. The interplay of race, class and gender, the main systems of domination, or the 'Big Three',[1] is a well-established theme; but most discussions concern the way these systems intersect rather than the way they interact. Comparisons are rare between racism, classism and sexism in terms of their histories, ideologies, imageries and underlying logic; we are offered a wealth of vignettes but systematic explorations are lacking. However brief an excursion into a large and difficult area, the focus here on images and stereotypes may shed new light.

The chapter also considers the complex ramifications of mirroring: how Eurocentrism, as it projects its own shadows, creates 'others' overseas whose construction in turn affects the reproduction and reconstruction of hierarchies within Europe and the western world.[2] While 'others' mirror Europe's negative self or split-off shadows, European hierarchies re-emerge with the internal 'others' reconstructed in the image of the overseas shadows. In the process, domestic and imperial hierarchies and similes become interdependent. I will look first at situations in which overt comparisons between blacks and other groups figure, and next at perspectives in which such comparisons relate to a wider world view.

Situations: Irishmen, Chinese, Jews

Before we treat the Negroes as whites, we must cease treating whites as Negroes.

Emiel Vandervelde (1894)

Statements in which comparisons are made between blacks and other groups, without a reason why being given, seem to be relatively simple; presumably the comparison is in terms of status, treatment or appearance. Thus Chamfort, in the eighteenth century: 'The poor are the negroes of Europe.'[3] The British in India often referred to Indians as 'niggers', mostly on the basis of skin colour. Of a similar nature is the statement quoted above by the Belgian socialist leader Emiel Vandervelde, who compared the way the working class was treated with the treatment of negroes.[4] John Lennon said, 'Women are the niggers of the world.' A little more complex is a statement by Francisco Cabral, superior of the Portuguese Jesuit mission in Japan (1570-81), about the Japanese: 'After all, they are Niggers, and their customs are barbarous.'[5]

So to the pious Portuguese, after a hundred years of Portuguese experience in Africa, the Japanese were put in the same category as Africans.

In some cases comparison of blacks with other groups goes much further. In 1880 the Belgian essayist Gustave de Molinari noted, in a series of articles about Ireland, that England's most important newspapers and magazines 'allow no occasion to escape them of treating the Irish as a kind of inferior race – as a kind of white negroes – and a glance in *Punch* is sufficient to show the difference between the plump and robust personification of John Bull and the wretched figure of lean and bony Pat.'[6]

English views of Ireland display an interesting zigzag pattern. In the early Middle Ages Ireland was famed as a centre of Christian civilization: several English kings went there to be educated. Ireland's reputation declined, however, as England's interest in conquering and colonizing it increased. In the wake of the Anglo-Norman invasion and after the classic description of Ireland by Gerald of Wales in the twelfth century, which set the tone for later descriptions, Ireland was considered savage and barbarous. Down to the present this notion of the 'wilde Irish' has hardly changed, although there have been marked shifts of emphasis. The distinction between Celtic and Anglo-Saxon 'races' in the British Isles is one of long standing, but from the mid-nineteenth century onward the British image of the Irish was recast in biological racial terms.[7] In addition, from about 1840, the standard image of the good-natured Irish peasant was revised, becoming that of a repulsive ape-like creature.

In cartoons and caricatures as well as prose, Paddy began to resemble increasingly the chimpanzee, the orang-utan, and, finally, the gorilla. The transformation of peasant Paddy into ape-man or simianized Caliban was completed by the 1860s and 1870s, when for various reasons it became necessary for a number of Victorians to assign Irishmen to a place closer to the apes than the angels.[8]

'Dutch Girl' cleanser. The most familiar American stereotype of the Dutch. (USA, 1905). From Morgan, *Symbols of America*, 1984.

TWO FORCES.

Aluminium bottle-opener, 1930s. Denigrating representations of women are even more common in the western world than those of blacks. (From Strang, *Working Women*, 1984)

'Two Forces'. With the sword of the Law, Britannia shields a frightened Hibernia from a stone-throwing Irish 'Anarchist'. One of a series of anti-Irish cartoons by Sir John Tenniel (1820-1914) in *Punch*, 29 Oct. 1881.

Irishmen were depicted with low foreheads, prognathous features and an ape-like gait by cartoonists such as Sir John Tenniel of *Punch*. In 1862 a satire in *Punch* attacked Irish immigration under the title 'The Missing Link': 'A creature manifestly between the Gorilla and the Negro is to be met with in some of the lowest districts of London and Liverpool by adventurous explorers. It comes from Ireland, whence it has contrived to migrate; it belongs in fact to a tribe of Irish savages: the lowest species of Irish Yahoo.'[9]

What prompted the metamorphosis of Paddy the peasant to Paddy the ape was the stream of Irish immigrants, in the wake of the famines of the 1840s, along with the mounting Irish resistance to British domination. The 'Fenian outrages' of the 1860s involved anti-English acts of sabotage and subversion. Thus, English images of the Irish hardened in the context of colonialism, migration and resistance. About this time the first apes were brought to Europe (the first live adult gorilla arrived at the London Zoo in 1860), and as they made their first appearance in zoos, they began to appear in cartoons and as a new metaphor in popular imagery.

During the sixteenth and seventeenth centuries English writers often drew a comparison between the 'wilde Irish' and Native American 'savages', in the context of the English 'plantations', or settlements, in North America and those in the north of Ireland.[10] In the nineteenth century comparisons between the Irish and other 'natives' became common. Irishmen were caricatured alongside Africans under the heading of 'annual imperial problems'. In 1886 Lord Salisbury, arguing against Home Rule for Ireland, said: 'You would not confide free representative institutions to the Hottentots, for instance.'[11] Renewed manifestations of Fenianism during the Irish struggle for independence, from the 1880s to 1921, sparked off further hostile caricatures and stereotypes in the English press.[12] Resistance since 1968 to the British presence in Northern Ireland has occasioned anti-Irish cartoons and jokes which have a lot in common with racist stereotypes.[13]

Underlying these comparisons is the colonial situation and the colonizer's enemy imagery of the colonized. What is striking is how consistent the colonizer's cultural politics are, regardless of geography or ethnicity. Like Africans and blacks, the Irish have been referred to as 'savages' and likened to 'apes', to 'women', and to 'children', just as the Celts were often described as a 'feminine' race, by contrast with the 'masculine' Anglo-Saxons.

From the mid-nineteenth century, anti-Irish stereotypes flourished among Anglo-Americans in the United States as well.

> Despite the pressing need for servants, 'No Irish Need Apply' was a common line in advertisements for help wanted. This scorn was so widespread that an archetypal 'Paddy' was often accompanied by the incompetent serving maid 'Bridget' – a stock character for ridicule in the popular press. Despite these prejudices, household workers were predominantly Irish. In 1846, of the 10,000 to 12,000 domestic servants in New York City, over 7,000 were Irish.[14]

Cartoons in periodicals such as *Harper's Weekly* (*A Journal of Civilization*) made the hostile equation of Irishmen with blacks a routine part of American culture.[15]

These comparisons, in England between Irish people and Africans, and in the United States between the Irish and blacks, were made under the heading of race, but this only serves as a reminder that, until fairly recently, the terms

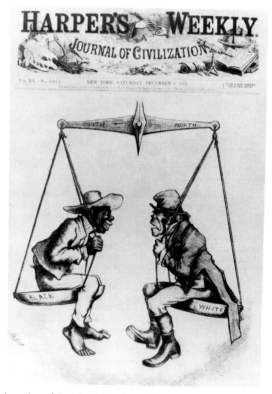

HARPER'S WEEKLY.
A JOURNAL OF CIVILIZATION

Vol. XX.—No. 1041.] NEW YORK, SATURDAY, DECEMBER 9, 1876. [PRICE TEN CENTS.

'The ignorant vote:
Honors are easy.'
Blacks and Irishmen
equated in a cartoon
on the balance of
forces in post-
Reconstruction
America, where
freed blacks in the
South have as much
political weight as
the despised Irish
voters in the North.
The clay pipe in the
hatband signifies
that the white man
is Irish. *Harper's
Weekly*, 9 Dec. 1876.

'race' and 'nation' (or 'people') were synonymous. The peoples of Europe, within regions as well as within countries, were viewed as much as rungs on the racial 'ladder' as were peoples or 'races' outside Europe. Indeed, virtually all the images and stereotypes projected outside Europe in the age of empire had been used first within Europe. However, when they were *re-used* within Europe the repertoire was infused with the imagery of empire, with other, wider logics of exclusion, of which the imperial construction of 'race' was one. Thus in 1885 the English physician John Beddoe devised an 'index of nigrescence', a formula for identifying a people's racial components. 'He concluded that the Irish were darker than the people of eastern and central England, and were closer to the aborigines of the British Isles, who in turn had traces of "negro" ancestry in their appearances. The British upper classes also regarded their own working class as almost a race apart, and claimed that they had darker skin and hair than themselves.'[16]

This profile could be extended to other minorities. An example is the Chinese who entered the western United States in the nineteenth century as a cheap labour force, following in the footsteps of blacks. Imported on a contract basis to work on the railroads, the 'coolie' had in common with the black slave that both were perceived as enemies of free labour and republicanism; what ensued has been termed the 'Negroization' of the Chinese.

Racial qualities that had been assigned to blacks became Chinese characteristics. Calling for Chinese exclusion, the editor of the *San Francisco Alta* claimed the Chinese had most of the vices of the African: 'Every reason that exists against the toleration of free blacks in Illinois may be argued

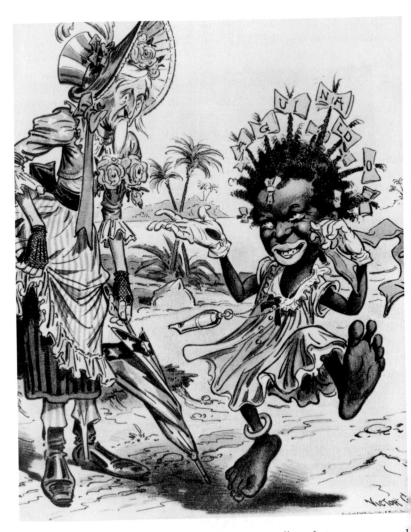

'Niggering' as part of the imagery of imperialism. General Emilio Aguinaldo (1869-1964), leader of the Philippine resistance to American colonialism after 1898, presented as a black dancing girl, with a stupefied Uncle Sam as a white old lady. (Cartoon by Victor Gillam in *Harper's Weekly*, 1899)

against that of the Chinese here.' Heathen, morally inferior, savage, and childlike, the Chinese were also viewed as lustful and sensual. Chinese women were condemned as a 'depraved class' and their depravity was associated with their almost African-like physical appearance. While their complexions approached 'fair', one writer observed, their whole physiognomy indicated 'but a slight removal from the African race'. Chinese men were denounced as threats to white women. . . .[17]

Thus virtually the whole repertoire of anti-black prejudice was transferred to the Chinese: projected on to a different ethnic group which did, however, occupy a similar position in the labour market and in society. The profile of the new minority was constructed on the model of the already existing minority.

Americans often drew comparisons between national minorities (blacks or Native Americans) and peoples overseas. When the US annexed or colonized Hawaii, the Philippines, Puerto Rico and Cuba at the turn of the century, the American popular press characterized the native populations by

nalogy with either 'red Injuns' or blacks. The *Literary Digest* of August 1898 poke casually of 'Uncle Sam's New-Caught Anthropoids'.[18] On the American conquest of the Philippines, Rudyard Kipling, the bard of imperialism, characterized the native inhabitants as 'half devil and half child'. The American press regularly presented Filipinos and other peoples *as blacks* – images which suggest graphically that the sensation of power and supremacy was the same, whether on the American continent or overseas, and was being expressed through the same metaphors. Again, it is not ethnicity, or 'race', that governs imagery and discourse, but rather, the nature of the *political relationship* between peoples which causes a people to be viewed in a particular light.

A similar dynamic was at work during the Vietnam war. A common expression among American GIs in Vietnam was 'The only good gook is a dead gook', with 'gook' (the term of abuse for Vietnamese) replacing 'nigger' or Indian ('Injun') in the existing formula.[19] The underlying logic of dehumanizing the enemy by means of stereotyping is the same. These examples of dehumanization and victimization illustrate what Ron Dellums has called, in a phrase, the 'niggering process'.[20] With respect to anti-Semitism, a similar point has been made; in the words of Adorno and Horkheimer: 'it is not the anti-Semitic label which is anti-Semitic, but the labelling mentality as such'.[21] What these 'niggering' processes have in common is the labelling and stigmatization of despised and subjected minorities.

In any comparison of anti-black racism and anti-Semitism, one's first thought aside from the victimization of a minority, is of differences rather than similarities. The time frame, to begin with, is quite different: anti-Semitism extends from the eleventh to the twentieth century, while anti-black attitudes (after an early medieval episode) are mainly a phenomenon of

'Do not become a musician. Occupation dying out for Dutch people.' 'Mechanical music' and foreigners are shown as threats, along with a black and Jewish musician. (Poster for the Dutch musicians' union, by Meyer Bleekrode, 1930)

the eighteenth to twentieth centuries. Moreover, the social relations giving rise to stigmatization and discrimination were quite different – Jews were discriminated against and made scapegoats mainly as a trading minority in Europe. Finally, while several of the mechanisms of prejudice were similar (stereotyping, stigmatization, discrimination against, exclusion), the stereotypes themselves were quite different – Jews, while envied for their success at money-making, were hated for their religion and their clannishness. Yet, as far apart as the imaginary prototypes of Shylock and Othello may have been, there are overlapping factors as well as historical affinities between anti-black racism and anti-Semitism.

In the first place, both groups were regarded as non-Christian. The early medieval tripartite division of the world based on Sem, Ham and Japhet, as the ancestors of Asia, Africa and Europe respectively (discussed in Chapter 1), portrayed Semites and Hamites, although both were descendants of Noah, as peoples 'external' to Christendom, and later as external to 'Europe'. The nineteenth-century theory of Aryan race, from the Comte de Gobineau to Houston Stewart Chamberlain, again excluded both 'Semites' and 'Africans' from the hallowed ground of the Nordic, or Indo-European race.[22] 'Africans' were placed at the foot of the human ladder and 'Semites' were cast in the role of historical counterparts to the Aryans. In several respects this was a reconstruction of a medieval Christian world view, recast in terms of race and reinscribed in the mythic panorama of imperial ideology. The 'Japhetic' race was now renamed 'Aryan', to make room for the distinction between northern and southern Europeans. Eurocentrism at this stage meant that Europe, and Empire, was for Europeans only; Asia (of which the Jews or Semites, according to the medieval script, were in effect the representatives in Europe) and Africa were excluded, to be imperialized.

Ideologies of race often established a connection between Jews and blacks, for instance in the 1920s when African soldiers in the service of France were stationed in the Rhineland. Adolf Hitler referred to this in *Mein Kampf*:

> It was and it is Jews who bring the Negroes into the Rhineland, always with the same secret thought and clear aim of ruining the hated white race by the necessarily resulting bastardization, throwing it down from its cultural and political height, and himself rising to be its master.[23]

The reference is to France which, according to Hitler, was both 'systematically led by the Jew' and 'becoming more and more negrified'. In Germany at the time, the Jew was said to have an insatiable sexual appetite and a large penis, the same as was said of blacks in America.[24] An association between Jews and blacks was also made in the context of art and music, as in the Nazi exhibits *Entartete Kunst* and *Entartete Musik*. Jews and blacks formed part of the Nazis' extended family of enemies which also included Communists, Freemasons, gypsies and homosexuals. It is deeply significant in the light of this that each of these exclusions has led to a holocaust on a world scale – the centuries of African slave trade followed by colonial domination, and the recurrent pogroms against the Jews culminating in the Shoah – in the first of which millions of Africans, and the second millions of Jews, lost their lives.

Perspectives: Sexism, Classism, Racism

The Nazi ideology is an example of a 'total' theory in which ethnicity, nationality, political affiliation, sexual preference, and other attributes all became the basis for the hostile categorization of groups and individuals. A consideration of other such theories demonstrates that some notions about Africa and blacks do not stand alone.

Aristotelianism is part of the infrastructure of western thought, and a specific element in the nineteenth-century perspective. Aristotle attributed different places in the human hierarchy to slaves, women and children. Slaves in his view stood to their masters as animals stand to humans and the body to the soul.[25] The usefulness of slaves he compared to that of tamed animals. He considered slaves to be human beings, but with the proviso that while they possess the ability to react emotionally they lack the ability to reason. In this respect there is a similarity between slaves and women. Men, according to Aristotle, are better able to lead than women; woman's role is not physical labour, as in the case of slaves, but the 'custodianship of goods acquired by men'. This hierarchy is based on the distinction between the logical and the alogical (emotional) halves of the soul, and on the capacities of slaves and of women on this score. Slaves, according to Aristotle, are completely lacking in the ability to reason; women possess that ability, but without authority (akuron); and children possess it incompletely.

Aristotelian thought thus forms a hierarchical complex in which social status (free or slave), gender and age are the determining characteristics. Another example of hierarchical thought is Victorian anthropology which, as underpinning to the ideology and practice of empire-building, served as the framework for much of the imagery of Africa and of blacks.[26] It would be misleading, however, to focus on racial thinking alone, without regard for the way the same logic was applied to views of women, children and the working class, in the wider context of ideas about evolution, progress, civilization. It was no accident that Victorian anthropology saw racism, classism and sexism as facets of the same world view and expressions of the same logic. In the outlook of the Victorians, older notions of aristocratic and élite thinking mingled with those of the emerging bourgeoisie; the sources of Victorian anthropology range from the classics to the theory of race and to ideas about savages. These influences are significant because it was in this period that academic disciplines were formed which were to leave their mark on the twentieth century.

We may consider here the interplay between race and class. The concept of race grew up as an *extension* of thinking in terms of class and status, as an alternative and additional mode of hierarchical ordering applied, initially, outside the social boundaries of region and country. Once the theory of race had taken shape its adherents usually argued that class differences originated in racial differences:[27] in other words, in a characteristic mixture of social metaphors with biological ones, class distinctions were biologized.

One vehicle by which hierarchical thinking was transmitted was the classics, a crucial element in the educational curriculum of the nineteenth-century élites.[28] But what gave Victorian anthropology its particular character was the study of non-European peoples: it used concepts of race and notions about savages and primitive peoples as a basis for ideas about women, lower classes, criminals, mad people and deviants. So Dr Charles Meigs, in

his work on *Females and Their Diseases* (1848), found that a woman was in possession of 'a head almost too small for intellect but just big enough for love'.

A comparison between women and slaves was often drawn, also by women who took part in the anti-slavery movement, as by Harriet Martineau in 1837 – admittedly with a different intent. It became an element in the discourse of women's emancipation: 'If we have no right to act, then may we well be termed "the white slaves of the North".'[29] English suffragettes too used the image of 'White Slaves'.[30] The metaphor has rightly been criticized. Yet the links between racism and sexism cannot be entirely dismissed – even as regards physical mobility. In Victorian America, according to Ronald Takaki, the subjection of blacks according to the ideology of the 'child/savage' and the confinement of women as part of the cult of 'true womanhood' were inter-related, and resulted in a restriction on the physical mobility of both blacks and women.[31] America was the 'white man's country', in which institutional and ideological patterns of the supremacy of white over black, and of men over women, supplemented and reinforced one another. For white males suffering from status insecurity images of black 'child/savages' and of 'true women' served as steadying anchors in a troubled sea.

In the discourse of race, darker peoples were thought of as 'female'. In behavioural Darwinism, for instance in Francis Galton's study of sex differences, women were viewed as inferior to men and dark-skinned peoples to the British.[32] This means that there was a recurrent cross-referencing of hierarchies encoded in metaphors: first, 'others' were seen in the image of 'females', as empire was viewed in the image of patriarchy writ large; then, by way of feedback, females were re-coded in the image of the 'others'. What was denied all these 'others', shadows of the western male subject, was above all the power to 'make history'.

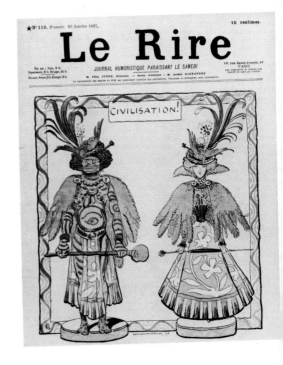

'Civilisation!' Caption at left under the savage: 'Feathers, beaded ornaments, cloth with barbaric flowers, and animal skins.' At right, under the woman: 'Animal skins, cloth with barbaric flowers, beaded ornaments, and feathers.' The symmetry in posture and dress suggests the relativity of 'civilisation' or, actually, the savage nature of women. (Cover by L. Mètivet, *Le Rire*, 23 Jan. 1897)

Another set of comparisons, operative in the European theatre of Victorian anthropology, concerned women and savages, particularly in the fields of medicine and psychiatry (as mentioned in Chapter 12 on sexuality). These comparisons functioned not merely in the stratosphere of science but also in popular culture. Thus, a turn-of-the-century cover of the French satirical magazine *Le Rire* mocked similarities in the costumes of savages and women, both composed of animal skins, feathers, barbaric flowers and glass trinkets. The drawing was intended humorously, but we often encounter humour as marking out social boundaries and as an ideological device. This cartoon whispers: women are savage, out of control. In fact, was that not part of woman's appeal? Comparisons between women and natives figured also in the fine print of colonialism.[33]

A continuity between racism and sexism is apparent also in the congruence of actual images of women with those of blacks. Chapter 8 ended with a profile of the iconography of servitude which characterizes western images of blacks as servants: in fact, this profile has been derived not from depictions of blacks, but from a study of the way women are portrayed in contemporary advertising; the signs of subjection have been taken from Erving Goffman's *Gender Advertisements*.[34] The body language and the positions in which women are portrayed commercially turn out to match closely the ways in which servile blacks are routinely presented: the language of servitude can be applied generally. There is a further parallel between the ways in which blacks have been portrayed in decoration (from gargoyles to ashtrays) and on useful objects, and the decorative role assigned to women, whom we see depicted as ornaments on houses and buildings, in the role of servants on packaging, as lamp bases, swizzle sticks, nutcrackers.[35]

Not only have women been seen as analogous to slaves, savages and blacks, blacks too have been defined by analogy with women. The 'femininity' or 'passivity' attributed to the 'darker races' has often been mentioned.[36] In the 1920s Robert E. Park, founder of the Chicago school of sociology and widely regarded as a 'friend of the Negro', characterized blacks as 'the lady among the races . . . by natural disposition'. The Negro was not an 'intellectual', nor a 'pioneer' or an 'idealist', but possessed a talent for 'expression rather than for action'.[37] This is a genteel version of Victorian anthropology.

For children too there is a place in the order of nature and on the ladder of evolution – a place, according to several Victorian experts, not far removed from that of the savages. A. C. Haddon, one of the founders of anthropology as an academic discipline at Cambridge and London, shuttled between zoology, his original interest, and anthropology, and in both fields he applied similar notions of order and hierarchy.

Anthropology, as the study of 'otherness', never disengaged itself from Eurocentric narcissism; but as the 'others' were mirrors, in them Europe too was seen with a new inflection. The growing interest in rural customs in Europe in the eighteenth century was influenced directly by the study of 'savage' peoples overseas. For French intellectuals, it was but a short step from the study of the folkways and mores of Tahiti or among the Iroquois to studying their own peasants.[38] Some of the Romantic notions about rural and folk Europe are the product of this nexus of reverse anthropology. In the Romantic era these notions were applied to Europe's countryside and carried a positive ring; in the course of the nineteenth century, the comparisons were extended to the urban areas of Europe and to its working class, using

metaphors made routine under colonialism, and now they carried negative overtones.

William Booth, founder of the Salvation Army, published a book to England's slums under the title *In Darkest England and the Way out* (1890). In answer to the question 'Why Darkest England?', Booth recounted Stanley's experiences in the Congo and asked: 'As there is a darkest Africa, is there not also a darkest England?' Englishmen could 'discover within a stone's throw of our cathedrals and palaces similar horrors to those which Stanley has found existing in the great Equatorial forest'.[39] Cecil Rhodes, a friend of William Booth's, had spoken earlier of the connection between the social question in England and the Empire.[40] In turn-of-the-century European fiction and journalism a comparison with savages was common in 'naturalistic' descriptions of Europe's slums. The later American metaphor of the 'asphalt jungle' is a variation on this trope. The comparison also entered socialist discourse, where it served to make a different point. Thus, in comparing the British poor with the Inuit of Alaska, the socialist writer Jack London noted, in *The People of the Abyss* (1903), that the Inuit did not know chronic starvation because the available food was commonly shared; only in the civilized world did people starve in the midst of plenty.

More frequently, anthropology was applied along conservative lines, as building an empire overseas was interdependent with the arena of class forces on the home front. In the crowd psychology of the late nineteenth century, 'crowds' (which made trouble for the bourgeoisie and the nobility) were classified, coded and defined by comparison with primitive peoples, savages, criminals, and women. What all these had in common were infantile traits and lower levels of consciousness.[41] Thus imperial and domestic hierarchies converged in identical imagery.

This *tour d'horizon* of 'white Negroes' could be filled out with many more examples, but a more important question is what these parallels among different kinds of stereotypes tell us. First, however, a proviso: in the United States, there have been objections to a comparative approach to ethnicity if the object is to equate the oppression of black Americans with that of other minorities. For no matter what the similarities are, the Chinese and other minorities in the US do not have a history of three hundred years of slavery behind them. In addition, Jews, Catholics, Chinese, and other ethnic and/or disadvantaged groups, women included, have over time achieved a degree of emancipation, while the majority of African Americans still belong to an underclass which seems only to consolidate itself. A comparative approach would, it is argued, be misleading here, because it ignores the specific historical pattern and features of white-black racism, while positing an 'equality of oppression', of deprivation, which in fact does not exist. While such objections are quite valid, on the other hand, 'racism' full stop is not an explanation. A comparative approach is indispensable for an understanding of racism itself. The objective of such comparisons is to dismantle racism, to make its dynamics visible by means of comparison.

What do the parallels between racism, sexism, classism and other forms of stereotyping tell us? In the first place, that racism never comes alone. It forms part of a hierarchical mental set which also targets other groups. In the second place, the features attributed to groups defined by 'race', such as blacks, are not peculiar to racism, but are also attributed to entirely dif-

ferent categories defined according to social status, gender, age, nationality, and so forth. The similarities to other forms of stereotyping in terms of structure, content, even down to details, are so far-reaching that we must conclude that it is not racial phenotype, colour, or ethnicity that is the decisive factor, but the *relationship* which exists between the labelling and the labelled group. Irish people may as readily be branded as 'human chimpanzees' as Africans. This says nothing about Africans nor about Irish people; rather it says something about the British and the relationship that existed, exists, or is being constructed, between the British and Africans and Irish people respectively.

This then is a beginning to the demystification of 'racism': but by the same token the problem shifts. Now the question arises, what is the nature of this relationship? What racism, classism, sexism all have in common is social inequality: the key to all the social relations discussed above is the pathos of hierarchy. While the common denominator is power – the power that arises from a hierarchical situation and the power required to maintain that situation – it is also a matter of the anxiety that comes with power and privilege. Existing differences and inequalities are magnified for fear they will diminish. Stereotypes are reconstructed and reasserted precisely when existing hierarchies are being challenged and inequalities are or may be lessening. Accordingly, stereotyping tends to be not merely a matter of domination, but above all, of humiliation. Different and subordinate groups are not merely described, they are *debased*, degraded. Perceptions are manipulated in order to enhance and to magnify social distance. The rhetoric and the imagery of domination and humiliation permeate society. They concern processes in which we all take part, as receivers and senders, in the everyday rituals of impression management, in so far as taking part in society means taking part in some kind of status-ranking.

As the negative of the denigrating images sketched above, there emerges the top-dog position, whose profile is approximately as follows: white, western, civilized, male, adult, urban, middle-class, heterosexual, and so on. It is this profile that has monopolized the definition of humanity in mainstream western imagery. It is a programme of fear for the rest of the world population.

15 IMAGE AND POWER

Western hegemony also means the hegemony of western culture. Over the centuries this cultural hegemony has taken shape in science and in fiction and in a mixture of the two. Initially, nautical and geographical knowledge were of particular strategic importance, but in the course of time non-western societies and cultures were mapped as well. Knowledge and power advanced in tandem. In the colonial era ethnology served the interests of the colonial administrators. Western hegemony was further manifest in works of art and literature depicting the non-western world, in which fresh impressions mingled with medieval fables and notions drawn from the Bible and the classics. In painting, poetry, theatre, opera, popular prints, illustrated magazines, novels, children's books – a broad range of imaginative work – non-European worlds were represented as part of European scenarios. Scientific observation and fiction were interwoven as in Orientalism, and took shape in paintings and novels as well as in scholarly works on Asia and the Middle East. In the course of the nineteenth century, along with western expansion, methods of image-production were developed that included photography and later film. Cheaper methods of printing contributed to the wider circulation and popularization of images, which were also used in advertising and packaging. Many of these images, the harvest of five hundred years of western expansion and hegemony, are still current.

To round off this discussion of depictions of Africa and of blacks in western popular culture, we now look at the wider politics of intercultural representation, exploring the relations between representations of 'otherness' and the dynamics of power. Since the assessment of what representation means in terms of power and hierarchy depends on how representation is analysed in the first place, a few observations on method are in order.

Imagologic

Enquiries into the representation of 'otherness' first figured in analyses of western literature about the non-western world. As a consequence, the leading approaches in literary analysis – structuralism, semiotics, deconstruction – have become dominant in the examination of representations of otherness.

Of the social sciences, anthropology, sociology and social psychology have all made significant contributions to this field. Lévi-Strauss adapted structural linguistics to the analysis of societies in the form of structuralism. Later critical anthropology introduced reflections on anthropological theory and practice. While focusing primarily on minorities in the western world, social psychology has identified such key concepts as prejudice and ethnocentrism, and has employed such terms as 'attitude', 'stereotype' or 'schema', 'prototype' and 'script', while focusing primarily on minorities in the western world;

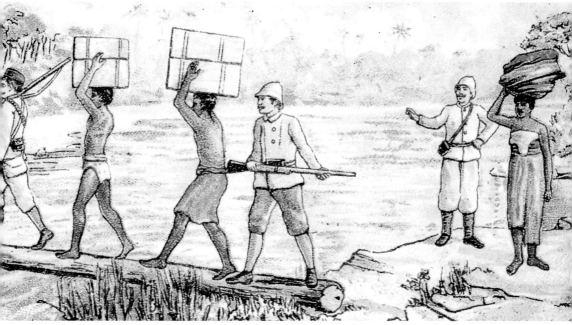

in the 1950s anti-Semitism in Europe and 'racial' tensions in the United States were the prime subject-matter of social psychology. Political psychology looks at propaganda and the formation of enemy images. Sociological studies of deviance have produced relevant analysis of the process of 'labelling'. In addition, there is an increasing body of media studies and research into photography, film, comic books, illustrated magazines, advertising, and communications media generally; these lines of research deal primarily with the logic of the medium itself rather than with representation and 'othering' as such.

Magic-lantern picture. (Early 1900s)

Over the past decades, several of these lines of thought have come together in cultural studies, which form a loosely coherent ensemble combining the methodologies of Marxism, psychoanalysis, anthropology, feminism and deconstruction.[1] The context in which cultural studies have been developing embraces the aftermath of decolonization on the one hand, and 'multiculturalism' in the western world on the other.

The representation of 'otherness' is part of the general question of representation and stereotyping in human cognition, perception, memory and communication. The concept of stereotypes, or oversimplified mental images, is well established in cognitive psychology and phenomenological sociology. Alfred Schutz uses the term 'typification', and observes that 'our knowledge of the world is always in the form of typifications. . . . The process of typification consists of ignoring what makes a particular object unique and placing that object in the same class with others that share some trait or quality. Types are always formed in relation to some purpose at hand, and it is this immediate interest that determines which traits will be equalized and what "individuality" will be ignored.'[2] Sander Gilman notes, 'Everyone creates stereotypes. We cannot function in the world without them.'[3]

Thus representations of 'otherness' are a special instance of the general problem of stereotyping. Otherness, or alterity, is constituted on the one

hand by *identity* – boundaries of inclusion and exclusion for the individual or group – and on the other by *hierarchy*, for the *difference* between identity and alterity, or self and others, is not neutral but charged with meaning and value.

Obviously, the analysis of representation and otherness is itself historically and culturally determined. There is no Archimedean point, no objective position beyond history, from which historical processes of imaging and othering can be monitored and interpreted. Analyses of representation themselves carry or imply certain forms of representation – which, hopefully, reflect a more inclusive collective awareness. Also the methodologies of analysis reflect particular resources and interests. It is not uncommon for analyses of stereotypes to produce new stereotypes – for instance, simplifications and clichés regarding 'the Third World' or 'western culture'.

The literature has frequently devoted more attention to the analysis of conquest than to domination. Studies of the Spanish conquest of America and the subjugation of the Indians abound,[4] but there would appear to be far less interest in the institutionalized and routinized exercise of power which followed conquest, although the conquest took place over a relatively brief span of time, and domination went on for centuries and extends into the present.

Does this bias stem from the general fascination with the sixteenth century, the encounter with the New World, following in the footsteps of Columbus? Is it that the act of conquest, with its violence and penetration, is more dramatic and thus more interesting than the routines of institutionalized domination? Does the interest apply to newness rather than otherness? Is the new, the unknown other, more interesting because full of promise and possibility than the subjugated and known other? Is the onset of occidental hegemony, and the threshold of modernity, a more rewarding problematic than the actual, and ongoing, exercise of occidental hegemony?

Does it make a difference that enquiries into the representation of otherness have generally been patterned on the analysis of representation in texts? Every picture tells a story: visual imagery too has a narrative character and structure. To Roland Barthes it made no difference whether popular ideologies took shape in words or in images.[5] Even so, it is worth noting that quantity of literature on representation in texts and documents far exceeds that on visual imagery, and that enquiries into visual representation tend to be modelled on the study of texts and documents. The basis for research into the visual aspects of imagery is art history with iconography and iconology.[6] One approach to the study of representation is referred to, presumably by analogy with iconology, as 'imagology'; this too is a genre of literary analysis.[7]

In structuralist approaches, representation is seen as structured in terms of binary oppositions, such as male/female, young/old, light/darkness, civilization/nature, clothed/naked, and so forth, possibly in combination with a third, mediating term. Thus images of Africa may be broken down into cognitive coordinates and ultimately accounted for as a matter of thinking in terms of oppositions.[8] There are several disadvantages to this kind of approach. First, it tends to be ahistorical – it would be as attractive to think in terms of opposites in 1600 as in 1900; in other words, under this approach it is difficult to monitor and account for change. The protean character of representations, the shifts in imagery and/or meaning over time, tend to be underplayed in structuralist approaches because of the inclination to resolve every difference into a binary opposition. Second, structuralism has an idealist

bias, in the sense that ideas and icons are explained in terms of ideas and not of social relations and interests. Third, the results may be tautological, in that cognitive patterns are explained in terms of cognitive patterns. Structures (presumably of a mental character) are at the centre of this approach, and history is marginalized. Barthes once defined the basic principle of myth as being the conversion of history into nature (myth as 'depoliticized speech'). In structuralism, the tendency is towards the conversion of history into structure; this is, of course, the classic argument against structuralism. Thus, structuralist discourse may produce a view of 'western culture' more homogeneous and more static than is valid, and a view of 'other' cultures in terms of universal cognitive structures abstracted from historical vicissitudes.

Other approaches to the analysis of intercultural representation are discourse analysis and deconstruction. Foucault's view, that power is exercised by means of discourse rather than simply by force, has been influential in the development of the former as a means of examining the reproduction of social relations through discourse. Originally a mode of intracultural analysis, the method has been used for intercultural analysis as well in the work of Edward Said, who applied Foucault's perspective to orientalism.[9] Deconstruction is concerned, in a phrase of Jacques Derrida, with 'a complete overturning of cultural domination'.[10] Whereas structuralism is preoccupied with the search for the structure behind the representation, deconstruction pursues the ambiguities of representation and structure. Deconstruction proceeds *ad infinitum*: there's no end of the line, only transfers are possible. The final point of deconstruction is that there is no final point. There are 'no facts, just interpretations', according to Paul de Man. Deconstruction is based on the premises of 'the unavailability of a unified solution'.[11]

Is this indeterminacy not in conflict with the aims of the *Kulturkritik* of domination? The recognition of complexity, and the decentring of analysis, is an asset, but at the risk of ornate sophistry and complexity for complexity's sake.[12] Deconstruction has in common with structuralism that everything is converted into text, as if the narrative structures of reality were more important than 'reality itself'. The predilection for textuality underrates the power of images, and misses the point of the media's dominance over contemporary popular culture, in which image and power interact in many ways. Traditionally the management of impressions and images has been as much a part of politics as propaganda; now image-manipulation has been institutionalized, for instance in the participation of advertising agencies in political campaigns. *Kulturkritik* does not just take place in texts, it is not the domain of the literati only: there is also the cultural criticism of social movements and changes in mentality which operate as fermenting agents within cultures. To arrive at a complete picture, a combination of the methods of cultural criticism and historical analysis is required.

Otherness is Historical

The approach followed here to images of Africa and of blacks in western popular culture builds on the approaches described above and combines them within the context of comparative historical analysis. Historical, because a significant feature of representation of others is their historicity, the fact that stereotypes change over time; comparative, in view of the diversity among

stereotypes according to their cultural context; and analysis, on the assumption that these variations tend to correlate with modes of domination, and modes of defiance, which differ according to time and place.

With respect to images of Africa and of blacks, then, there are significant variations among western countries, in particular between North America and western Europe, and our findings reveal patterns of stereotyping and of hegemony that are both divergent and similar. In the United States, between roughly 1800 and 1950, key images of black males are the Brute Nigger, Sambo and Uncle, and of black females the Mammy. The Brute Nigger is the black male stereotyped as beast, who is 'tamed' by means of lynching (emasculation), either physically or symbolically, and transformed into Sambo, the clownesque figure of the harmless entertainer or fool, or into the easygoing Uncle. The Mammy is the type of the desexualized black female represented in figures such as Aunt Jemima, Dinah the cook, and so on. (Bette Davis, in one of her movies: 'Beulah, peel me a grape.') Images of sexually attractive black females were absent until fairly recently in American popular culture; not because their charms were not noticed, but because to acknowledge these culturally would have gone against the grain of ethnic stratification.

While for America the decisive episode in white-black relations was slavery, for Europe it was colonialism and relations with Africa. The decisive arena of white-black relations in the United States used to be the South; the 'south' of Europe is Africa. The equivalent of the American image of the Brute Nigger is the European image of the African savage. If in America the Brute Nigger is transformed into Sambo, in Europe the savage is transformed into the Moor. In America this was manifested by means of actual lynching, in Europe through symbolic castration and domestication, in particular the

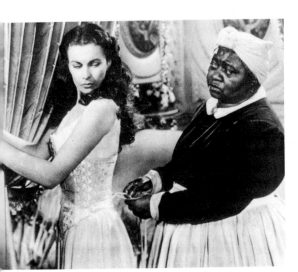

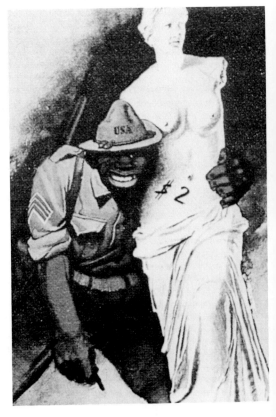

Stereotypes of black females: the Mammy, and black males: the Brute. (See pp. 146 and 85.)

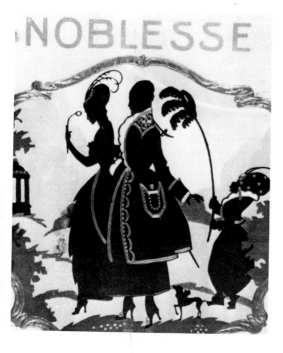

NOBLESSE

European cigar advertisement with an image of 'nobility' featuring a little black servant in Moorish costume and a poodle. (1930s)

diminution and marginalization of blacks in representations that follow traditions long pre-dating colonialism. Popular black types in European cultures are typically childlike little servant types. The quasi-oriental costume worn by Moors in many European images (harem pants, pointed shoes, turban) suggests that the figure was adopted from Arabic, Moorish or Turkish cultures. The black Moor, representing a form of European orientalism, thus reflects the fact that relations between Europe and sub-Saharan Africa have been mediated by 'oriental' traditions and examples. The eunuch prominent among occidental depictions of black males is another instance of this. Black Uncles and Mammies do not figure in European popular culture, because the proximity of and quasi-familial relationships with black people that developed in the context of slavery in America did not exist in Europe. Images of the Black Venus, however, the sexualized black female, do occur in Europe, while not in the United States, for precisely the same reason. In France, the *Vénus noire* is amply represented in literary and iconographic tradition. In European culture the appeal of African and black females could be acknowledged because there were few of them, they posed no threat to the social structure. The sexual gains of colonialism could find cultural expression in metropolitan Europe, while the sexual gains accruing from domestic ethnic stratification in the United States had to remain hidden.

'We have met the enemy and he is us'

In this work I stress the historicity and the diversity of images of others, while arguing that the variations tend to accord with specific patterns of hegemony. The main points in this argument may be formulated briefly as follows:

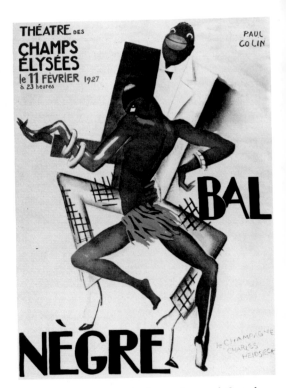

Bal Nègre. One of Paul Colin's famous posters featuring Josephine Baker as a Black Venus in Europe. (Paris, 1927)

All the attributes assigned to non-European peoples have also, and first, been assigned to European peoples, in a gradually expanding circle, from neighbouring peoples to those farther removed. This applies to the whole complex of savagery, bestiality, promiscuity, incest, heathenism, cannibalism, and so forth. Therefore these attributes are in no way specific to non-European peoples.

Already in ancient times there was mention of man-eating – does not Herodotus speak of the Androphagi? But where were they located? A map of the world drawn on the basis of Herodotus' account indicates that the area where the Androphagi typically occur, that is, in northern Europe, is centred on present-day Poland.[13] If we were to take into account only the period of European colonialism and render a structural analysis of images then current, we would as it were be immortalizing what was merely a temporary configuration, and be searching for deep cognitive patterns behind what are in reality historical relations.

Assigning attributes of otherness serves multiple functions for the labelling group. It may be a critical expression of social distance, of a claim to status on the part of the labelling group, or it may serve to negotiate internal group relations by reference to an out-group.

We may often find similar negative imagery at work in the labelling group as well as among those labelled. It is however the view of the dominant group that prevails, and survives. Power also means cultural power. Thus, enslaved and colonized Africans suspected Europeans of being cannibals. Besides, how were they to know, for instance, that the Vatican was not located in Transylvania? In this sense as well, images of otherness are not specific to a particular group.[14]

Generalizations are inevitable and nuances imperative. *A basic precaution in intercultural studies is to avoid taking the singular for the plural.* The singular suggests uniformity and is static; thus, we are concerned here not with 'the image of the black', but with 'images of blacks'. This also applies to 'western culture' – the concept is necessary and adequate for a certain level of analysis, but if we are to extend the analysis, we must speak in the plural, of 'western cultures'.

Different circles and levels of analysis, then, include a global plane and the global hegemony of western culture, the various national cultures and their particular projects of 'othering', and, next, differentiations within each national culture, down to intra-group dynamics.

Mainstream culture is not cut from one cloth – there are distinctions between élite and popular culture, among urban, suburban and rural culture, and between subcultures and counter-cultures. 'Popular culture' is itself a patchwork, an arena in which different tendencies jostle for prominence. Images of otherness, of minorities and foreign peoples, may be among the issues in conflict. These are not always central issues, but episodes such as the American Civil War, the French Dreyfus affair and the Nazi epoch (not to mention international conflicts) are a sufficient reminder of what may be at stake in images of otherness. Anthropologists remind us that every form of group cohesion is defined by its exclusions.

Subcultures may be regionally based, related to differences of class or age, or to specific occupational or interest groups. Instances of the latter are colonial interests and the missions. While the missions were influential producers of propaganda about the non-western world in word and image, they were not identical with hegemonic western culture. In fact, missionary representations of otherness, of deeply sunk heathen in far-off places, were also a means of polemicizing against secularizing tendencies within European culture. It was by means of missionary activities that the European churches rejuvenated themselves and tried to stem the tide of secularization.

In addition to subcultures, there are counterpoints to hegemonic culture, expressions of subaltern consciousness in the form of enclaves, 'new beginnings', or institutionalized counter-currents.[15] Thus, political satire mocks the pretensions, or at least some of them, prevailing in the dominant culture. Abolitionism, on the other hand, was a counterpoint which became a counter-current and, ultimately, the hegemonic pattern.

Accordingly, representations of otherness may reflect global hegemonic culture, national mainstream culture, subcultures or counterpoints.

When hegemonic culture shifts and the counter-current becomes the mainstream, other effects may come into operation; subgroups may be mobilized to assert their views. Thus, the nineteenth century was for the most part a period of clashing and contending images of blacks in western culture – images based on prevailing prejudices, offset by abolitionist propaganda, and that again by counter-propaganda from Southern planters (in the United States) and West Indian interests (in Europe). These contending images of otherness corresponded with divergent views on and social forces at work in the political economy and in labour relations (industrialization or plantation economy, free labour or slavery). Representations of otherness form part of the social construction of reality and the negotiation of the future. Images of others are

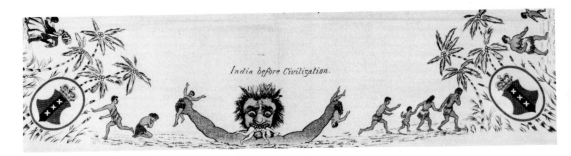

India before Civilization.

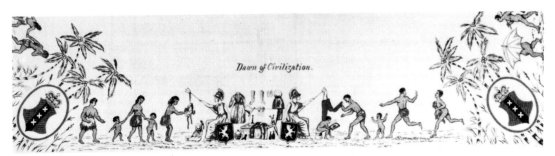

Dawn of Civilization.

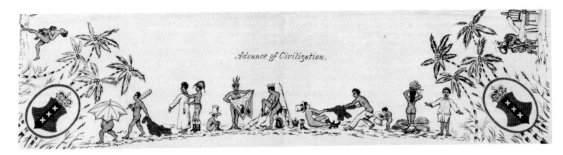

Advance of Civilization.

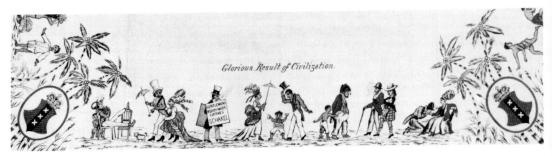

Glorious Result of Civilization.

Civilisation equated with colonialism. The four edges of a scarf designed by Adriaan Schakel for *Gentleman's Magazine* on the occasion of the Colonial Exhibition of 1883 in Amsterdam. (Municipal Archive, Amsterdam)

a form of cultural polemics; they are contested and are themselves forms of contestation.

It is not only images themselves that change but also their meaning or function, sometimes radically. Some images of abolitionist emancipation (such as 'Uncle Tom') later became vehicles of segregationist oppression.

An ideology of alter involves an ideology of ego.[16] Representations of otherness are therefore also indirectly representations of self. Accordingly, images of Africa and of blacks in western cultures must be interpreted primarily in terms

of what they say about those cultures, not in terms of what they say about Africa or blacks. It is not that they do not convey any information regarding Africa or blacks, but that this information is one-sided and perverse.

Images of 'others' do not circulate because of their truthfulness but because they reflect the concerns of the image-producers and -consumers. Some images owe their currency precisely to their distortion of reality, as if they were magic formulae, or talismans in the pathologization of difference. Sambo, Jim Crow and Rastus were antidotes to the spectre of the rebellious slave, antidotes to Nat Turner and Denmark Vesey, and to the spectre of Santo Domingo, which generated hysterical fears in the planter community.

Images of otherness relate not merely to control over others but also to self-control. Thus, representations of others relate to power, not merely in the sense of imperial power but also of the disciplinary power exercised by the bourgeoisie within metropolitan society, or power as it permeates the 'society of normalization'[17] Images of otherness as the furthest boundary of normality exert a disciplinary influence, as reverse reflections, warning signals. The savage is indispensable in establishing the place of civilization in the universe. The cannibal represents a counter-image to bourgeois morality – in the seventeenth century Caliban signalled that the New World was *not* Paradise; in the late 1800s in Europe, popular lore about cannibals reaffirmed this with respect to Africa and the Pacific; twentieth-century cannibal humour articulates the difference between westernization and civilization in the post-colonial world. In all these instances an identity is constituted: the identity of the civilized as against the savage, and all that implies.

Otherness is historical. The process character of images of otherness is an indication of shifting social relations and patterns of hegemony. Changes in the representations of otherness according to time and place tend to reflect, not changes in the characteristics of the labelled group but rather, in the circumstances of the labelling group, or in the relationship between the labelling group and the labelled.

Thus, the 'savage' has undergone many changes corresponding to his different position and to shifts in European culture and stages in European colonialism: the 'noble' savage (carrying aristocratic connotations) and the 'good' savage (a bourgeois notion), the savage cannibal (a counter-utopia) the 'ferocious' savage and the warrior (enemy images of incipient and early colonialism), the 'childlike' savage (the savage turned subject, an image of mature colonialism), the 'westernized' savage (late colonialism or post-colonialism). The image of the childlike savage corresponds to the child/savage image of blacks in the United States, suggesting a symmetry of patterns of domination in mature European colonialism in Africa and white hegemony in the United States, with different inflections of paternalism and patronage. Corresponding representations of otherness in different social circumstances may indicate similar modes of domination.

'Others' are plural. Many analyses, by focusing on 'the other' in the process of generalizing, objectify and reify otherness.[18] But the point is precisely that there is no 'the other': for 'the other' would imply a stable 'we'. There are *others* – they are many, and their identities vary according to time, location, and the status, gender, relationships and so on of the labelling groups. To

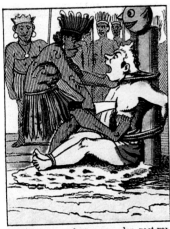

Kikkertje werd toen aan den voet van den grooten Manitou gebonden; de kok steekt hem het mes in de borst, Kikkertje uit een verschrikkelijke kreet en......

Ontwaakt, want dit alles was slechts een droom geweest die Kikkertje geheel van zijn' zin tot reizen genas.

Een jaar daarna, trouwde Kikkertje met de jonge jufvrouw Patachon en zette de zaak van zijn schoonvader voort. Na verloop van tijd kocht hij óok verscheidene Kikkertjes.

Adventures of a French lad which turn out to be a dream. In fact, a nightmare, in which the Savage (see the signboard in the last frame) turns out to be a cannibal. Thus cannibal tales serve to keep one away from savagery. (See p. 118)

generalize and pontificate about 'the other' means losing sight of this multiplicity and complexity, homogenizing the process of othering, introducing an essentialism of otherness, and creating a static dualistic relationship between Self and Other, us and them.

Power likewise is varied, multiple, heterogeneous, ambiguous, and comes in different packages and configurations of domination, hegemony, control, authority. Patriarchy, social status, and empire (rudimentary as such concepts are) are different logics of power which roughly correspond to current categories of gender, class, and race. Several displacements occur between the historical configurations and the abstract categories. There are structural family resemblances between the Athenian constellation of patriarchy/aristocracy/ empire, of which Aristotelian thinking is a reflection, and the Victorian complex of masculinism/status and class/empire, of which Victorian anthropology is a reflection; but along with the affinities, there are discontinuities as well.

Probably the single most important feature of representations of otherness is the role they play in establishing and maintaining social inequality. Stereotypes are in a general way a function of social inequality, but since there are different degrees of inequality there will be different kinds of stereotypes. Two main varieties are *outcasts* and *competitors*. Stereotypes of outcasts refer to those outside the arena of competition. They are construed as 'other' to the point of being entirely excluded and beyond the pale – as are, in India, the untouchables, in Europe the (metaphorical) 'gypsies', in the contemporary United States the homeless. (But note that these descriptions refer to stereotypes not necessarily corresponding to reality.) Competitors take part in competition and are therefore far more menacing: they threaten to step out of the circle of otherness and to interfere with the lifelines of identity; as, for instance, the Jews in medieval Europe. The stereotyping and scapegoating of Jews – the blood libel, the pogroms, the mob cry of 'Hep, hep' – spread and intensified at precisely the point at which Jews became serious economic competitors (between the twelfth and sixteenth centuries), because as non-

Christians (i.e., outsiders) they were exempt from the injunction against charging interest on loans. Stereotyping and persecution sought to push Jews out of the arena of competition; literally a process of 'ghettoization', for it is at this time that the concept of the 'ghetto' arose.[19]

The 'niggering' process displays a similar logic and timing: stereotyping *increased* in the wake of black emancipation. Prior to emancipation, slavery itself ensured that blacks were excluded from competition; after emancipation blacks were 'niggered' in order to 'ghettoize' them, to safeguard their being excluded from competition by cultural and discursive, or if necessary physical, means (KKK intimidation, rioting, lynching). The Chinese who entered the American labour market in the nineteenth century were 'niggered' for a similar reason, to keep them from becoming competitors in that market.

Image and power interact on a global scale as well. Postcolonial imagery presents the Third World as spectacle. The exploitation of the non-western world of western sensory gratification, a practice begun in nineteenth-century art, has been extended and refined in the media culture of the twentieth century leading to a kind of 'cannibalism by connoisseurs'. Next to Bacardi-rum beaches, images of suffering, starvation and bloodshed circulate through the media networks of the world's electronic Colosseum. The abnormal is the norm in the representation of the non-western world. The logic of centre and periphery is mirrored in the dual imagery of stability and crisis, life and death, with death, famine, disaster and upheaval expelled to the margins. The conventional formula of the North-South divide transforms this imagery into received wisdom. It is a deceptive formula, which territorializes poverty, ignores the similarities between North and South, and conceals global economic and political links. The images of aid to the Third World are variations on this formula; fundamentally patronising, they are ahistorical, preoccupied with symptoms and oblivious to causes, and, for all their global scope, parochial. Africa is one of the recipients of aid and targets of this imagery; but the question of how Africa, once a producer of food surpluses, ended up in its present condition is rarely addressed. The role of colonialism, the consequences of export agriculture and the effects of the agricultural and trade policies of western countries are issues that remain outside the framework of the advertisements of western charity. For people living in the best of possible worlds, complacency is nourished by a message that undermines the awareness of common humanity. For all the wealth of information provided in the media age, we are living in a world largely cut from cardboard images. Ours is a planetary age, but we live in a world of false horizons.

Oxfam advertisement, 1991. Are famished children and the suffering shown in fundraising appeals really conducive to human solidarity? (*Oxfam*)

NOTES

Introduction

1 E.g., Fukuyama (1989).
2 Sartre (1946).
3 Jordan (1968). See also the sequel study by Frederickson (1987).
4 An exhibition devoted to African images of Europeans was held in the Munich Stadtmuseum in 1983; see Jahn (1983). On African images of Africa, see, e.g., Mazrui (1986). On black on black, Harris et al. (1974)
5 See Gombrich (1972).
6 Described in Wertheim (1948), p. 54. With thanks to the author.
7 B. Carter, 'Black Americans Hold a TV Mirror up to Their Life', New York Times, 27 Aug 1989.
8 A schema is a 'cognitive structure that represents an organized knowledge about a given concept or type of stimulus'. Fiske and Taylor (1984), p. 140.
9 Moscovici (1981).
10 'Indeed, the very language of racism and discrimination is proving too crude to capture the insidious complexity of the subject, and is even becoming a hindrance to an adequate understanding of the changing reality.' Parekh (1991a), p. 24.
11 See, e.g., Nederveen Pieterse (1991) and Escobar (1984-85).
12 Parekh (1991b).
13 As regards images of blacks in western art, see the series of expansive volumes published under the auspices of the Menil Foundation: Bugner, ed. (1976/1989); and also McElroy (1990).

Chapter 1

1 Degenhardt (1987).
2 This imperial imagery is apparent, for instance, in a text by the famous mapmaker Abraham Ortelius of Antwerp, who in 1571 comments on a representation of 'Europa as Empress with a crown and sceptre' in control of the sphere of earth not merely because of her wealth 'but also, or rather, because, through her power over the Roman Empire, she controlled the whole world': 'Europa siet ghy als Keyserinne van waerden/ met croone ende scepter int opperste ghestelt;/ de slincke handt metten roere op den cloot der aerden,/ niet alleene omdat sy besitt goudt, silver, ghelt,/ constig zebaar volck, vruchtbaer landt, menich schoon velt,/ wel se onder haer ghewelt/ door 't Roomsche Rijck de heele werelt heeft ghehouwen;/ Ommers soo verre als syse t'dyer tijdt mocht beschouwen;/ Ende nu noch door cloecke inwoonders regeert/ in alle dander deelen eenighe landouwen;/ Te recht wordt sy dan bovenal gheexalteert.' Ortelius, Theatrum Orbis Terrarum (1571), quoted in Van den Boogaart, (1982).
3 Poeschel (1985), p. 102.
4 E.g., for Germany see Reallexikon (1967), pp. 1174-1200.

5 For details see the Dutch edition of the present work; Fremantle (1959), pp. 171-88; Leeuwenberg (1973) p. 213.
6 'Hier komt de Weereld, van vier Oorden aangedrongen,/ Bekoord door haare faam, die roemstof aller tongen,/ Haar, staatig, hulde doen, of vallende op de kniên,/ Haar Schatten, en Gewas, en Kunstgewrogten biên . . . ' Pieter Huisinga Bakker, 'Op de Titelprent', in AMSTERDAM, in zijne Opkomst, Aanwas, Geschiedenissen, Voorregten, Koophandel, Gebouwen, Kerkenstaat, Schoolen, Schutterye, Gilden en Regeeringe, beschreven door Jan Wagenaar (Amsterdam: Isaak Tirion, MDCCLX). Cf. Beschryvinge der Stadt Amsterdam, in editions of 1663, 1664, 1665 and 1726, Archief van de Gemeente Amsterdam.
7 F. Ryk, 'Verklaring des Tytelprints,' in Beschryvinge van AMSTERDAM door Casparus Commelin (Amsterdam, 1726, second printing).
8 See Schama (1987).
9 The book (n.d.) must date from after the second Opium War, because the author, R. Montgomery Martin, Esq., identifies himself as 'Member of her Majesty's Legislative Council' in China.
10 J. S. Bratton, (1986), p. 77.
11 An example is a sculpture group in the Parc du Cinquantenaire in Brussels bearing the inscription: 'La race noire est accueillié par la Belgique' (Thomas Vincotte, 1921). Belgium as a woman with arms outstretched looks benevolently down upon Africa as a woman carrying a child, looking up towards her. See Vincke (1985), p. 36. With thanks to the author.
12 Vercoutter, in Bugner, ed. (1976); Leclant, in id.
13 Bugner, Preface in Bugner, ed. (1976), p. 6.
14 E.g., 2 Kings 19:9 and Isaiah 37:9.
15 E.g., by Hecataeus of Miletus (500 BC). Degenhardt (1987), p. 10.
16 Snowden (1971) and in Bugner, ed. (1976).
17 D. B. Davis (1984), pp. 36-8.
18 Debrunner (1979), p. 24.
19 Ibid., pp. 25 ff.
20 'It is more than an accident that the living traditions of Ethiopia about the Queen of Sheba as an ancestor of the royal dynasties of Ethiopia were written down among the Copts in Egypt at the beginning of the thirteenth century (the 'Kebra Nagast' = the Glory of the Kings).' Debrunner (1979), p. 29.
21 Ibid., p. 28. See also Ch. 13, 'Advertising'.
22 Pope-Hennessy (1967/1988), pp. 8-9. Cf. Boxer (1963); Parry (1963/1973).

Chapter 2

1 Braudel (1966 / 1972), p. 25.
2 North and Thomas (1973), p. 26. Cf. Lopez (1962 / 1967).
3 Lombard (1972). Cipolla, 2nd edn. (1980).
4 For an extensive discussion see Frazer (1922 / 1957 abridged edn.).
5 Bernheimer (1952). Dudley and Novack, eds. (1972). Tinland (1968). Taverns and breweries sometimes carried an image of the Wild Man as their emblem; some still do.
6 See Hechter (1975). Images of the Irish are also discussed in Ch. 14, White Negroes.
7 This perspective is discussed in Nederveen Pieterse (1989 / 1990), Ch. 5, Crusades and Empire, and Ch. 11, Empire and Race.

8 Jordan (1968), p. 25.

9 White (1972), p. 31.

10 Although that might better be said of Tacitus' *Germania*, with its praise for the 'pure' virtues of the Germaanse tribes in the north.

11 Boas (1966).

12 Kohl (1981) interprets this (pp. 26-9), while referring to the theory of Norbert Elias, as a 'aus der Umsetzung von Fremd- in Selbstzwänge resultierenden "zivilisatorischen Affektmodellierung".'

13 Quoted in Honour (1975), p. 66.

14 Hobbes's formulations are classic: 'During the time men live without a common power to keep them all in awe, they are in that condition which is called war. . . . In such condition there is no place for industry, because the fruit thereof is uncertain: and consequently no culture of the earth . . . and the life of man, solitary, poor, nasty, brutish, and short.' Hobbes, *Leviathan* (1955). A pertinent discussion is Ashcraft, 'Leviathan Triumphant: Thomas Hobbes and the Politics of Wild Men' (1972).

15 Locke (1924), p. 119, quoted in Weston (1981), p. 222.

16 Vaughn (1980), pp. 10-11. 'Locke's version of the virtuous Indian was to be more useful to the Age of Enlightenment, which needed a basic belief in the goodness of human nature and of men in a state of nature to justify its assault on feudalism and the Ancien Régime.' Sinclair (1977), p. 72.

17 Parry (1973), p. 413.

18 Cited in Marshall and Williams (1982).

19 Quoted in Debrunner (1979), p. 301.

20 Hodgen (1964), pp. 199-200.

21 (London, 1877).

22 A classic is the study by Gourou (1953 / 1961, tr 1966).

23 E.g., Louango, depicted in a lithograph in the classic seventeenth-century study of Africa by Olfert Dapper, *Naukeurige Beschryvinge der Afrikaensche Gewesten* (Amsterdam, 1668).

24 We find the same view expressed much earlier, e.g., in Adam Ferguson's *Essay on the History of Civil Society* of 1767: 'It is in their [the Indians'] present condition that we are to behold, as in a mirror, the features of our own progenitors.' Quoted in Marshall and Williams (1982), p. 191.

25 White (1972), p. 7.

26 See White (1972), pp. 7-8. Cf. Corbey (1989), ch.6. Dalal (1988).

27 See Hughes (1958) and Van Ginneken (1989).

28 Mannoni (1950), p. 13.

29 See Rubin, ed., 'Modernist Primitivism: an Introduction' (1984), pp. 1-18. This episode is discussed further in Ch. 12, 'Libido in colour'.

30 Jordan (1968). p. 29. Comparison of black Africans with monkeys had a much longer history, dating back to sixteenth-century Portugal. See Van den Boogaart (1982), p. 8. On this theme see also de Rooy (1990).

31 See Hodgen (1964), pp. 410-11.

32 Houston (1725). This comparison still refers to monkeys and not, as in later discourse, to apes.

33 Schwartz (1987), p. 20.

34 Quoted in Marshall and Williams (1982), p. 245.

35 Schwartz (1987), pp. 20-1.

36 David Hume, 'Of National Characters' (1742/1754). Cited in Curtin (1964), p. 42. Lord Kames also formulated a polygenetic theory in his *Sketches of the History of Man* of 1774.

37 'Although . . . the Chain of Being was a key eighteenth-century concept, its application to race was extremely rare until there were strong polemical reasons for declaring the Negro less than human. As far as can be ascertained, there were only three fleeting and speculative references of this kind before the 1770s.' Barker (1978), p. 47. Here the emphasis is placed differently than, for instance, by Philip Curtin (1964, pp. 33-6), who regards the 1780s as the turning-point.

38 Long (1774).

39 Cuvier (1817), in Curtin, ed. (1972).

40 'Extinction follows chiefly from the competition of tribe with tribe, and race with race. When civilised nations come into contact with barbarians the struggle is short, except when a deadly climate gives its aid to the native race. Man in wild condition seems to be in this respect almost as susceptible as his nearest allies, the anthropoid apes, which have never yet survived long, when removed from their native country. Hence if savages of any race are suddenly induced to change their habits of life, they become more or less sterile, and their young offspring suffer in health, in the same manner and from the same cause, as do the elephant and hunting-leopard in India, many monkeys in America, and a host of animals of all kinds, on removal from their natural conditions.' Darwin (1871), quoted in Curtin, (1964), p. 24.

41 Knox (1850), cited in Curtin (1964), p. 18.

42 E.g., *Punch*, 12 Sept 1863, prints a comic illustration of a black African and a crocodile side by side in the same bodily posture. Beneath the photograph of an African boy with a leopard, a missionary in Uganda scribbles: *je vous recommande le contraste entre les 2 têtes*.

43 See Van den Boogaart (1982b); Isaac (1980); Davis (1984), p. 36; Jordan (1968), pp. 18, 36.

44 How this was interpreted in the seventeenth-century Netherlands, for instance by the minister Johan Picardt in Coevorden, is documented in Paasman (1984), p. 101.

45 Stepan (1982), p. 1, quoted in Brantlinger (1986), p. 187.

46 'From the 1790s to the 1840s, the most influential kind of writing about Africa was abolitionist propaganda.' Brantlinger (1986), p. 187.

47 E.g., Condorcet, *Réflexions sur l'esclavage des nègres* (Paris, 1781). Revd James Ramsay, *Essays on the Treatment and Conversion of African Slaves in the British Sugar Colonies* (1784) – 'the best anti-racist tract of the eighteenth century'. Curtin (1964), pp. 55, 51.

48 Quoted in Gay (1969/1977), p. 413.

49 Hunting (1978), pp. 405-18; Cook (1936), pp. 294-303. A recent controversial critique of the views of Enlightenment thinkers on race is Sala-Molin's book, *Le Code noir* (1988).

50 'Wy zyn witte Mooren, of liever, wy zyn menschen in alles gelyk aan de Zwarten.' Cited in Paasman (1987), pp. 95-8.

51 Quoted in Debrunner (1979), p. 141.

52 Blumenbach (1799), pp. 141-7. Cf. Debrunner (1979), pp. 141-5; Curtin (1964), p. 47.

53 Debrunner (1979), p. 143.

54 Bernal (1987), pp. 304-5, 340-3.

55 Poliakov (1982), p. 59.

56 'In contrast to the French brand of race-thinking as a weapon for civil war and for splitting the nation, German

race-thinking was invented in an effort to unite the people against foreign domination.' Arendt (1951/1986), p. 165.

57 Poliakov (1967), p. 223.

58 Knox was 'the real founder of British racism', according to Curtin (1964), p. 377.

59 Cf. Gobineau's contemporary David Livingstone, on Africa: 'It is probable that there will be a fusion or mixture of the black and white races in this continent, the dark being always of the inferior or lower class of society.' N. R. Bennett, 'David Livingstone: Exploration for Christianity', in Rotberg, ed. (1970), p. 55.

60 See Arendt (1951/1986), Part 2, ch. 6; 'Race-thinking before Racism'.

61 E. Renan, *L'avenir de la science* (Paris, 1890), quoted in Poliakov (1982), p. 62.

62 'In Gobineau's opinion, the Semites were a white hybrid race bastardized by a mixture with blacks.' Arendt (1951/1986), p. 174 and n. 39. On the 'blackness' of Jews see also Ch. 14 below.

63 For the Netherlands see Biervliet et al. (1978).

64 Rich (1986), p. 3.

65 'In England nationalism developed without serious attacks on the old feudal classes.' Arendt (1951/1986), pp. 175-6.

66 Ibid., pp. 160-1.

67 Anderson (1983), p. 136. On the 'aristocratic principle' in race thinking see Nederveen Pieterse (1989/1990). Ch. 11, 'Empire and Race'.

Chapter 3

1 Figures of 10, 12 and 15.4 million persons respectively are given in Curtin (1969); Rawley (1981); and Ade Ajayi and Imkori (1979).

2 D. B. Davis (1984), p. 73.

3 Blackburn (1988).

4 Williams (1944).

5 E.g., Klein (1986, p. 146) calls 'the so-called triangular trade' a myth because the ships which transported cargo to Africa, took on slaves for the West Indies, and from there transported commodities to North America or Europe were not the same ships. However, the thesis of the triangular trade concerns the general momentum of intercontinental traffic and is not at all undermined by this argument. Cf. Eltis (1987).

6 'Though the trade was an integral part of empire, it is instructive to read conventional histories of empire and consult their indexes, noting how little heed is given to the slave trade.' Rawley (1981), p. 424.

7 Quoted in Hallie (1982), p. 104.

8 'Of great financial interest to Amsterdam was the contract (*asiento*) for supplying Negro slaves to the Spanish colonies in America. Curaçao, occupied by the Dutch West India Company in 1634, became a staple point where Negroes transported by the company were delivered to agents of the *asientistas*. . . . In the second half of the century Amsterdam seems to have been the business headquarters of the slave trade, and contracts for deliveries of Negroes were drawn up there. Successive holders of the *asiento*, though they bought slaves of English and Portuguese companies, depended in the main on the Dutch West India Company for supplies.' Barbour (1950/1963), pp. 109-10. Cf. van Dantzig (1968), p. 110. Van den Boogaart and Emmer (1979).

9 Rawley (1981), pp. 81-6.

10 Craven (1982).

11 Quoted in Groenhuis (1980), p. 222.

12 Eekhof (1917). Bontinck (1978).

13 *Staatkundig Godgeleerd Onderzoeksschrift over de Slavernij als niet-strijdig tegen de Christelijke Vrijheid etc.* (Leiden, 1742).

14 Curtin (1964), p. 14.

15 Boxer (1978), pp. 31, 36.

16 Boxer (1965), p. 240

17 Stedman (1796).

18 See D. B. Davis (1984), Part Two, chs. 3 and 4.

19 See D. B. Davis (1975). Palmer (1964).

20 Cf. D. B. Davis (1984). Holt (1982).

21 See Honour (1989). Rosen and Zerner (1984).

22 Christopher Lasch quoted in Fields (1982), p. 152.

23 Quoted in Paasman (1984), p.123.

24 Two Dutch examples of the discourse of the pro-slavery lobby. From an anonymous pamphlet by a planter in Surinam: 'Men ziddere Slavernij en abolitionisme dan met reden het ogenblik te zien naderen, waarop aan de Negers de Rechten van de Mensch verkondigd worden.' Anon., *Vrymoedige gedachten* (1795). And the famous Dutch poet Isaac da Costa in 1823: 'Ik houd het daarvoor dat de afschaffing van de slaverny der Negers almede behoort tot die hersenschimmige menschelijke wijsheid, welke de Almacht wil vooruitlopen, en niets uit zal richten ten goede, maar veeleer eindeloos veel ten kwade.' Quoted in Paasman (1984).

25 Quoted in Gay (1969), p. 412.

26 E.g. in England: 'abolitionists were clashing with a powerful economic lobby able to defend its ground with astute propaganda, lavish funds and the energies of well-placed parliamentary spokesmen. Resistance centred on, and was organized by, the West India Committee, which coordinated the wide range of West Indian and slave trading interests. . . . Each abolitionist move was scrutinized and countered by the slave lobby, which answered assertions by rebuttal, evidence by counter-evidence and accusations by denials.' Craton, Walvin and Wright (1976), p. 233.

27 Quoted in Brantlinger (1986), p. 193.

28 Blake, *Songs of Innocence* (1905 edn.), p. 50. A Dutch poem on abolition by Nicolaas Beets includes the lines: 'Wij zijn wel zwarten,/ Maar hebben harten,/ Zoo goed as gij./ En zoo uw harten beter zijn,/ Verlost dan de onzen van de pijn!' (We may be blacks, but we have hearts, as good as thine. And if yours are better, then release ours from the pain!). 'Nog een lied om bevrijding', 1853, *Dichtwerken van Nicolaas Beets* (Amsterdam, 1876), III p.159. Quoted in Blakely (1986), p. 7.

29 Kraditor (1969).

30 On the basis of research on the imagery of American Civil War period envelopes Michel Fabre concludes: 'It is clear that the scoundrel, the ape, the beast, the black man are near equivalents in the minds of the men who were fighting to free the slaves as well as to save the Union.' Fabre (1980), p. 233, and id. (1979).

31 Litwack (1979), p. 223.

32 E.g. 'The Question of Colour', *Punch*, 28 Nov 1863.

33 Walvin (1982), p. 69.

34 Litwack (1979), p. 224.

Chapter 4

1 Rodney (1972/1983), pp. 103-12.
2 Rotberg (1970), p. 8.
3 Brantlinger (1986). Hammond and Jablow (1970). Curtin (1964), p. 9.
4 Coquery-Vidrovitch, in Gutkind and Waterman, eds. (1977).
5 'Europese ontdekkingsreizigers hadden gewoon de weg kunnen vragen', Internationale Samenwerking, Sept 1988. Cf. Mazrui (1986).
6 Cf. Rotberg (1970), p. 8.
7 Bennett (1970), p. 56.
8 Coupland (1928), p. 107.
9 Cf. Bernal (1987), pp. 183-4.
10 Jeal (1973/1985), pp. 89-90.
11 Cairns (1965), p. 148.
12 Jeal (1983), ch. 22 'Stanley and the Livingstone Myth'. Cf. Hibbert (1982), ch. 12.
13 See Chinweizu (1975).
14 Bühlmann (1977).
15 Killingray (1973), p. 59.
16 Kiernan (1982), pp. 147-53
17 Ela (1980), pp. 31-3.
18 Vints (1984), p. 63.
19 See Smith, 2nd edn. (1985), pp. 147, 317.
20 Okot p'Bitek (1970). On the other hand, as mentioned above, there was also a tradition of Christian Ethiopianism, at least until the seventeenth century.
21 Ustorf, in Hinz, Patemann, Meier, eds. (1986), p. 30.
22 Roes (1974), p. 41.
23 Vints (1984), p. 66.
24 Ustorf (1986), p. 34.
25 Eerden, Oosterbeek (Gld), Societeit voor Afrikaanse Missiën (1952). Spoor, Rhenen, Paters van de Heilige Geest (1949). Versteeg, Tilburg, Een serie leesboekjes voor de roomse jeugd (1948).
26 Thiel, in Exotische Welten (1987), p. 84.
27 E.g. among the Ewe in Togo. See Ganslmayr in Weiss auf Schwarz (1986), p. 39. Cf. Lan (1985).
28 Cf. a comment by the African-American author Richard Wright: 'The longer I thought about the work of the missionaries, the stranger I found it. These men, driven by a neurotic inclination, had destroyed the whole philosophy of life of a people, without replacing it by another one, yes even without knowing what they were doing.'
29 Riepe (mimeo, n.d., with thanks to the authors). This practice was still in effect in West Germany into the 1970s. As regards Belgium, see Vints (1984), p. 63.
30 Philip Hughes, quoted in Marty (1959), p. 328. 'Only about three or four new Catholic missionary centres were opened in Africa in each of the decades between 1850 and 1880, compared with six in the 1840s, fourteen in the 1880s and seventeen in the 1890s.' Hobsbawm (1979), pp. 304-5.
31 Roes (1974). Cf. Kunst met een missie (1988).
32 Perry (1983).
33 'Heb medelij, heb medelij, ik heb een ziel lijk gij.' Ela (1980), p. 39, and Vints (1984), p. 67.
34 Hobsbawm (1975/1979), p. 304.
35 See Fields (1982).
36 See Gifford (1988). Diamond (1989). Nederveen Pieterse, ed. (1991).

Chapter 5

1 Quoted in Davidson (1978), p. 75.
2 Cf. Nederveen Pieterse (1990), ch. 9.
3 E.g. Black (1975). For alternative views see Knightley, rev. edn. (1982), ch. 3; Kiernan (1974), ch. 3.
4 See Springhall (1986).
5 Victims of the Mem-Hoo-Wo, Dahomey, Illustrated London News, 2 Aug 1873.
6 Chinweizu (1975), p. 44.
7 Kiernan (1982), p. 89. Bowle (1974/1977).
8 Ellis (1975), p. 84.
9 Hobson (1901).
10 Wells (1961). Cf. Raskin (1967), p. 126.
11 Ellis (1975), p. 97.
12 Enloe (1980).
13 Pakenham (1985), p. 201.
14 Davidson (1978), pp. 84-8, 114-15. Debrunner (1979), pp. 343-4. Farwell (1987).
15 Rich (1986), pp. 41-2, 202-3.
16 Smith (1987).
17 See Mulder (1985), pp. 168-71, and Ch. 14 below.
18 Robinson and Gallagher (1961).
19 Stengers (1972).
20 Wehler (1969).
21 Doyle (1986).
22 The illustration was reprinted from the Lustige Blätter. It is a parody of the painting Le Cauchemar by Johann Heinrich Füssli (1741-1825). See Starobinski (1987), pp. 82, 76. A peculiarity, by the way, is that the caption erroneously mentions a succubus, i.e. a female demon supposed to have sexual intercourse with sleeping men (OED), whereas the figure depicted is an incubus, a male demon, in comformity with the conventions of the genre, in which the figures represented are always cross-gender.
23 Rich (1986), p. 36.
24 Belgian sources on the Congo include Delathuy (1989), and, as regards popular images and propaganda, Zaïre 1885-1985 (1985) and Vints (1984). Cf. Taussig (1984); Breman (1990).
25 Symonds (1966), p. 76. Cf Memmi (1957/1965).
26 Quoted in Porter, 2nd edn. (1984), p. 72.
27 Takaki (1970).
28 Danco (1896). Vints (1984), p. 23.
29 Eigen Haard (1883), p. 405, in Oostindie and Maduro (1986), p. 24.
30 Golbéry (1803).
31 Oostindie and Maduro (1986), p. 23. Cf., for Asia, Alatas, The Myth of the Lazy Native (1977).
32 Marx, Grundrisse (1973 edn.), pp. 325-6, 409-10. The formulation is also a reaction, not without irony, to the complaint of a Jamaican planter, in the vein of Carlyle's Nigger Question.
33 Emer de Vattel (1714-67) (1758). Cf. Curtin, ed. (1971), pp. 42-5.
34 John Julius Norwich in MacKenzie, 'Introduction' (1986), p. 8.
35 On the title-page the Führer des Dritten Reiches informs us: 'Die Stellung des Nationalsozialismus zur Kolonialfrage ist im allgemeinen durch den 3. Punkt des nationalsozialistischen Programms bestimmt. Wir fordern Land und Boden (Kolonien) zur Ernährung unseres Volkes und Umsiedlung unseres Bevölkerungsüberschusses.'
36 In contrast to production, trade appears to play only a minor part in colonial iconography. By European standards

apparently it did not belong to Europe's civilizing mission, and depictions of trade, native or European, seem relatively scarce.

37 Bhabha (1986), p. 156.
38 See Monti (1987). Corbey (1987).
39 Rydell (1984), p. 8.
40 Preedy (1984), p. 3.
41 'Der Kolonialismus der Jahrhundertwende gibt sich exotisch. Die Mannigfaltigkeit der Welt stellt sich ihm als Leckerbissen dar, und man will den anderen nicht nur ausbeuten, sondern ihn so, wie er ist, auch noch geniessen. . . . Die exotische Inspiration und die wissenschaftliche Neugier sind die doppelte Kompensation des Imperialismus.' Zippelius (1987), p. 87.
42 Goldmann (1987).
43 Pott (1962), pp. 125-6. Cf. Avé (1980).
44 Debrunner (1979), p. 345.
45 Martin and O'Meara, eds., 2nd edn. (1986), pp. 128, 131.
46 JanMohamed (1986), p. 81.
47 See Hodgkin (1972); Gordon (1989); Curtin, ed. (1972).
48 E.g. Emery (1986). Meinertzhagen in Pakenham (1985), pp. 200-2.

Chapter 6

1 As Vernie February points out, 'Bantu' means 'people', and thus the combination 'Bantu people' does not make sense. February (1981), p. 3. Moreover, while the term refers to a linguistic category, a group of languages, in South Africa it is often erroneously used as a 'racial' category. I am indebted in this chapter for valuable pointers given me by Vernie February, Maria van Diepen, Robert Ross and Samten de Wet.
2 The Dutch edition of Bernard Picard's book is by Abraham Moubach, with drawings by Picard (Amsterdam, Rotterdam, 's Gravenhaage, 1729).
3 Boxer (1965), ch. 9, 'The Tavern of the Two Seas'.
4 Culture with a capital C is discussed by Brink (1983), 'On Culture and Apartheid'.
5 An argument elaborated by Ross (1982).
6 W. A. Newman, Biographical Memoir of John Montagu (London, 1855), quoted in van Zyl Smit (1984), p. 153.
7 F. Galton, Narrative of an Explorer in Tropical South Africa (London, 1853), quoted in Fabian (1987), p. 43.
8 Dr C. J. Uys (of the Departement van Naturellesake), Die lewenswyse van die Suid-Afrikaanse inboorlinge (Pretoria: Die Administrasie van die Suid-Afrikaanse Spoorweë en Hawens, 1935), pp. 8 and 9 (trl. JNP).
9 Angas (1849). Klopper(1989).
10 See the illustrations in Muller (1978), esp. p. 59.
11 Park (1934), p. 70.
12 This passage follows Lelyveld (1986), pp. 61-2.
13 A thorough and nuanced comparative study is Frederickson (1981). Cf. id., 'Can South Africa Change?', New York Review of Books, 26 Oct 1989.
14 According to a novel by G. R. von Wielligh, Jacob Platjie (Pretoria/Amsterdam, 1918), published serially in 1896. See February (1981), ch. 1.
15 Lelyveld (1986), p. 63.
16 Magubane (1979).
17 Cf. Ashford (1990).
18 See Bunting (1964), ch. 4, 'Followers of Hitler'.

19 Minter (1986), p. 95.
20 Zuid-Afrikaanse vraagbaak (1958), p. 29, trl. JNP.
21 See Davis (1987).
22 See Frederikse (1986), pp. 60-6.
23 ' "I make pictures about the way blacks wanna be, not the way they are," says Ronnie Isaacs. . . . "I've shot about 20 films, not one of them depicting the African way of life. The films I shoot are the guys in nice houses, they drive nice cars, they dress nicely. There's no Soweto, no witchdoctors, no huts. That's exactly what they don't like. I don't do political. What for you wanna?" ' G. Silber, 'Dream Factory', Frontline, June 1986.
24 Nathanson-Moog (1984), p. 19.

Chapter 7

1 Fabb (1987), p. 5.
2 An interesting analysis of Defoe's novel is Hill (1980). Cf. Kohl (1981), pp. 37-8.
3 Rosen and Zerner (1984), pp. 41-6.
4 See Dabydeen, ed. (1985). Hammond and Jablow (1970), pp. 100-14.
5 Porges (1976), p. 135.
6 See Newsinger (1986).
7 In Dutch and Belgian comic books white-black duos are – among others – Sjors and Sjimmie, Meelmuts and Roetkop, Witje and Gitje. The French version of Sjors is Bichon. Sjors and Sjimmie are also a variation on one of the American 'kids' comics', Perry and the Rinkydinks. See Gifford (1984).
8 Roosevelt (1909).
9 Fabb (1987), p. 12.
10 Cf. F. Galton, Memories of My Life (London/New York, 1908/1974), ch. 7, 'Hunting and Shooting'. Mentioned in Fabian (1987). p. 39.
11 L. Morrow, 'Africa', Time, 23 Feb 1987. 'Sometimes when talking to the older Kenya whites, people who had been around in the older colonial days and stayed on after independence, the visitor caught the vibration of a nostalgia so radical that it strained all the way back to the Pleistocene. They had no use for people any more.'
12 Marnham (1980), pp. 28, 32.
13 J. Wilde, 'In Tanzania: Stalking the Buff', Time, 19 Jan 1987.
14 Quoted in Jones (1971), pp. 5-6.
15 Arens (1979). For a counter-argument see Brown and Tuzin, eds. (1983).
16 Négripub (1986), p. 11.
17 See Le Goff (1987), pp. 286-310. Arens (1979). The devastation of the Thirty Years War in Germany also led to famine and cannibalism.
18 Berge (1988).
19 Jordan (1968), p. 25. Cf. Rabasa (1987).
20 See Todorov (1982/1985).
21 Hammond and Jablow (1970), pp. 94-5.
22 Davies (1981), p. 158.
23 See Davies (1981), pp. 157-65.
24 E. Boussenard, Le Tour du Monde d'un Gamin de Paris (Elbeuf-Paris: Ed. Duval, n.d.).
25 Brantlinger (1986), p. 203.
26 An example of this dilemma is a book by Susanne McConnaughey about Tahiti, based on nineteenth-century documents of evangelical missions, which originally appeared under the title Tropic of Doubt (Philadelphia,

1953), and then as the more risqué *Pagan in Paradise* (1955). (In Dutch translation it became *Heidens Paradijs [Heathen Paradise]*, Amsterdam, 1963.)

27 One can see this rhetoric at work in, e.g., Davies (1981), ch. 8, 'The Other Side of Paradise'.

28 Marcus, ed. (1984).

29 This tendency is discussed further in Ch. 12 below.

30 'The African's Complaint on Board a Slave Ship', *Gentleman's Magazine*, 1793. Quoted in Gratus (1973), p. 267.

31 Arens (1979), pp. 10-13.

32 Forbes (1979).

33 Spencer (1902), pp. 122f. Quoted in Raskin (1967), pp. 125-6.

34 'En Afrique, il n'y a plus d'autres cannibales que les blancs.' In *Negripub* (1986), p. 13.

35 In Vints (1984), p. 82.

36 Vints (1984), p. 101.

37 E.g., Kyemba (1977).

38 Johnson (1983), ch. 15.

39 Cf. Hildebrand (1980), with thanks to the author, for information. There are still other variations in current German cannibal cartoons, for instance with female sexual assertiveness as a sub-theme. A woman holding testicles in her hands next to a troubled-looking man steaming in a cooking pot – caption, 'Bring some salt for the eggs!'

Chapter 8

1 On relations between Moorish Iberia and black Africa see Bovill (1978); On Moorish influence on European culture, Boase (1977).

2 See, e.g., van Loon and van Eeghen (1984) pp. 29-34. Debrunner (1979), pp. 92-8, gives a partial list of 27 European paintings depicting black servants. Several others are reproduced in Berger (1972), pp. 95, 114-17.

3 Otte (1987). As Samuel of Hoogstraten wrote in 1678 (*Inleyding tot de Hooge Schoole der Schilderkonst*): 'bywerk geeft de dingen/Een luister: zoo m'ook enich tam Gediert/Te pas brengt, of gepluimt gevogelt, 't siert/Het werk: zoo vind het oog ook een vernoegen/Somtijts een Moor by maegdekens te voegen.'

4 See Oostindie and Madura, II (1986), p. 148.

5 E.g. Nicolas de Largillière's painting of Comtesse de Ruppelmonde with black page, *c.* 1707. The contrast is alluded to in a verse by Gaçon written about another painting, by Simon de la Vallée:

Sous le riant aspect de Flore
Cette beauté touche les coeurs,
Et par le contraste d'un More
Relève ses entraits vainqueurs.
Mais que disje! des dons de flore
Son teint augmente la fraicheur,
Et la noirçeur même du More
Tire un éclat de sa blancheur.

[Italics added]. See Kopplin (1987), p. 323.

6 Cowhig (1985).

7 Debrunner (1979), p. 97.

8 Ibid., pp. 96-7.

9 Klessman (1987), p. 238.

10 Dabydeen (1985), p. 32.

11 Gilman (1986), p. 228.

12 Ibid. Cf. Dabydeen (1985).

13 See Honour (1989), Part II, 'Black Models and White Myths', ch. 3, 'The Seductions of Slavery'.

14 See Battersby (1974/1984).

15 See, e.g., the black slave in the painting *Salomé* (1913) by Martin van Monnickendam in the Frans Hals Museum, Haarlem.

16 See Diaghilev (1978) and *The Decorative Art of Léon Bakst* (1913/1972) with various illustrations of 'oriental Negroes'.

17 Oostindie and Maduro, II (1986), p. 86.

18 *The Nigger Question* (1849).

19 Quoted in Takaki (1980), pp. 142-3.

20 A black American author refers to the metaphor of the harem as follows: 'Is it not possible that the white man sees his own lust reflected in the black man's eyes? A guilt constructed out of centuries of playing the role of Sheik in the Great White Harem, where black men were eunuchs and black women were concubines, and though Number One wife was always white, she was merely a figurehead, a wife and mistress in name only.' Killens (1965/1970), p. 140.

21 Barthes (1957), 'Bichon chez les nègres'.

Chapter 9

1 Quoted in Rawick (1972), p. 48.

2 See Woodward (1966); Kennedy (1973).

3 *The Langston Hughes Reader* (1958), p. 500.

4 See Toll (1974), Boskin (1986).

5 Saxton (1983), p. 19.

6 Quoted in Alexander (1987), p. 44.

7 Oberfirst (1980).

8 Kemble (1897).

9 23 March 1961, quoted in Fordham (1974), p. 61.

10 Notably on Gluck, Mozart, Haydn, Handel, and on the so-called 'Turkish music' which inspired the 'Ode to Joy' in Beethoven's Ninth Symphony. See Abrahams and Zwed (1983), pp. 27-8; Alexander (1987), p. 44.

11 Jean Genet's play *Les Nègres* (1958) refers to this, and has been translated as *The Blacks: A Clown Show* (1960).

12 Quoted in Walvin (1982), p. 68.

13 Carlyle, *The Nigger Question*, 1849.

14 Walvin (1982), p. 68.

15 Quoted in Bernal (1987), p. 343.

16 Thompson (1988), p. 244.

17 Eichstedt and Polster (1985), pp. 13-15.

18 Ewen (1982), pp. 212-13.

19 Leonard (1962), p. 49. Cf. Chambers (1986). Shepherd (1982).

20 Leonard (1962), p. 71. The scene has been romanticized in a recent film by Francis Ford Coppola. It has also inspired a recent theatrical production under the same name, *The Cotton Club*.

21 Williams (1983), p. 106.

22 Stearns (1956), pp. 183-4.

23 Day (1972), p. 3. For another view see Collier's biography of Louis Armstrong (1983).

24 In his personal life Gobineau was 'torn between a rigid noble father and an "adventuress" mother'. Bernal (1987), p. 343.

25 Eichstedt and Polster (1985), p. 58. Cf. Sauvage (1927), pp. 12-19.

26 A. Kisselgoff, 'Josephine Baker and Balanchine', *International Herald Tribune*, 3 April, 1987. Cf. Hammond and O'Connor (1988). Flanner (1972).

27 Cf. Jahn (1968).
28 See Rennert (1977).
29 Flanner (1972). Laqueur (1974).
30 See Oostindie and Maduro, II (1986), pp. 50-2. Kagie (1989).
31 Gilbert (1979), p. 84.
32 Quoted in Alexander (1987), p. 46.
33 'Das Antideutsche, in welcher Form es auch auftritt, bekämpft unsere Kultur nach allen Seiten. Jazzwelt bedeutet die Niedrichkeit, die Aharmonik, den Wahnsinn. Es quiekt und schreit und tobt: Ein Laboratorium für Negerbluttransfusion! Die heiligsten Güter sind in Gefahr! Geht ihm zu Leibe, diesem "Drecksbazillus", dieser "Schmutztransfusion", dieser "Pest", die die gesamte, sich kulturell verantwortlich fühlende Musikwelt in Deutschland als eine Seuche, als eine elende Plage empfindet.' Eichstedt and Polster (1985), p. 70.
34 Vints (1984), p. 69.
35 Reproduced in colour in *Meyer Bleekrode* (1983).
36 Cf. Mulder (1985), pp. 19-20, 22, 168.
37 'Vom Deutschtum in der Musik', 'Das Judentum in der Musik' and 'Musik und Rasse'; see Dümling and Girth, eds., *Entartete Musik* (1988).
38 'Ein sehr aufschlussreicher rassischer Querschnitt' in Schuster, ed., *Nationalsozialismus und 'Entartete Kunst'* (1987). Cf. Mosse (1966).
39 Zwerin (1985), Eichstedt and Polster (1985), pp. 76-88.
40 See Leab (1976); Pines (1970).
41 Kotlarz (1983), p. 22.
42 Vints (1984) is a study of Belgian colonial propaganda in film.
43 Poitier (1980), and *Newsweek* 7 Mar 1988.
44 Quoted in Sherard (1985), p. 385. 'A survey conducted in March 1966 by the American Civil Liberties Union showed that blacks had 3.36 per cent of the speaking roles and 8.49 per cent of the non-speaking roles in regular television programs; less than 1 per cent of the roles in television commercials went to black performers.' Ibid., p. 389.
45 Sherard (1985), p. 386.
46 'Blacks on Television', *The Economist*, 17 May 1986.
47 Jansz (1986).
48 See Russel (1982)
49 Cf. Nederveen Pieterse (1988) and (1989), Ch. 14.
50 Boskin (1986), p. 218.
51 Ashe Jr. (1988).
52 'Probably no single man ever enraged so many people as prize-fighter Jack Johnson, who persisted in defeating white challengers and marrying white women (he had four white wives). Laws were created to stop him; a white champion, Jess Willart, was enticed out of retirement to fight (and hopefully to kill) him. Johnson was exiled, chased with writs and subpoenas.' Day (1972), p. 3. Cf. Jack Johnson, in the Ring and Out (1927). Debrunner (1979), pp. 346-9.
53 Mead (1985), ch. 9.
54 'It is appropriate that the post-World War II civil-rights movement began in baseball when the Dodgers fielded Jackie Robinson in 1947. Despite resistance from players and fans, the moralistic myth of equality was invoked: like any American, Robinson had the right to compete fairly in the game of baseball or life.' Part of a section on 'Sports and the Moralistic Myth' in Combs (1984), p. 60.
55 See Lapchick (1975); Espy (1979). E.g. 'Soccer is vital to the African cause against apartheid'. R. Hughes, 'Amid conflict, Africa Cup spawns hope', *International Herald Tribune*, 30 Mar 1988.
56 Hart-Davis (1986), p. 230.
57 A recent example is Jimmy the Greek, a popular American television sports commentator, who said in a CBS television interview: 'The black is a better athlete to begin with because he's been bred that way. . . . Because of his high thighs that go up into his back. This goes back to the Civil War when, during the slave trade, the slave owner would breed his big black to this big woman so that he would have a big black kid. That's where it all started.' *The Guardian*, Jan 1988. Cf. Edwards (1977 /1982).
58 'Racism at Bat', *Time*, 20 Apr 1987. A discussion with respect to England is Cashmore (1982).
59 Edwards (1969).

Chapter 10

1 Brown (1937); Bogle (1973).
2 *Ethnic Notions* (1982). Cf. Ross Barnett (n.d.).
3 Hallie (1983), p. 120.
4 According to another reading, 'Sambo' referred rather to a black-Indian mixture. Forbes (1984).
5 Elkins (1963). Cf. Ringer (1983), pp. 170-2.
6 Davis (1984).
7 Takaki (1980), pp. 121 f.
8 Cf. Herskovits (1966).
9 Cf. Inez Hogan, *Nicodemus and his Gran'pappy* (London, 1936).
10 Banfield (1980), p. 18.
11 Boskin (1986), p. 139.
12 Morgan (1987).
13 Gomez (1986), pp. 14-15.
14 But not of course out of American life. E.g., 'President Ronald Reagan's first secretary of education, Terrel H. Bell, says in a new book [*The Thirteenth Man: A Reagan Cabinet Memoir*] that midlevel administration officials made racist jokes and other "scurrilous" remarks during discussions on civil rights. Mr. Bell said the slurs included references to the Reverend Martin Luther King Jr. as "Martin Lucifer Coon" and to Title IX, a federal law guaranteeing women equal educational opportunities, as "the lesbians' bill of rights".' *International Herald Tribune*, 21 Oct 1987.
15 See 'The Press, the Jam Jar, and the Gollywog', *Searchlight*, September 1984. 'The Gollywog: 1984 and Beyond', *Insight. Newsletter of Southwark Council for Community Relations*, 5 May 1986.
16 Faulkner (1988). Fraser (1972). *Pollock's Dictionary of English Toys* (1982).
17 *Bo-Peep* (1911).
18 Scholz-Hansel (1987).
19 Grasskampf (1978), pp. 5 f.
20 Fritz (1985), p. 137.
21 For more extensive discussion of German views see Becker (1977); Lester (1982); Paeffgen (1976).
22 Fanoudh-Siefer (1968).
23 Cf. Shattuck (1968).
24 See Jahn (1968), ch. 14; Arnold (1981).
25 See Betts (1982); Cohen (1980); Collins (1970).
26 An example is B. Lembezat (1952). See Finn (1988), pp. 172-84. See also Ch. 12 below.
27 Borger and Van der Vloet (1984), ch. 2.

28 See *Négripub* (1986). In 1920 Francis Picabia composed a parody of the Banania ads under the title *Dada Portrait*, with the texts *y'a bon* and IA BANA N. Short (1980).
29 See also Chs. 1 and 13. Useful discussions of Dutch imagery are Blakely (1986); Preedy (1984); Pott (1962).
30 Meisen (1931/1981). Hassankhan (1988). A. van den Berg, 'De Zwarte Piet', *NRC Handelsblad*, 5 Dec 1987.
31 Russell (1989), p. 114.
32 Another form the devil takes is that of a huge giant living in the air. Russell (1989), p. 86. Johnson (1971).
33 'De historie met den Zwarten Jongen', F. H. van Leent, 'De ware Geschiedenis van Piet Smeerpoes en andere verhalen' (Alkmaar: Kluitman, n.d.). In L. de Vries, *Het pretentboek van tante Pau* (1974).
34 Russell (1989), p. 114.

Chapter 11

1 Cf. Drinnon (1980); Jacobs and Landau (1971), vol. I.
2 Künkler-Kehr (1985), pp. 172-85. Cf. Fritz (1986).
3 See Schwartz (1979).
4 Suhl (1979). R. B. O'Brien, 'Dr Dolittle's black mischief is edited out', *Daily Telegraph*, 2 Feb 1988.
5 Quoted in Hill (1979), p. 37.
6 The psychiatrist Carole Liebermann, quoted in 'In All Seasons, Toys Are Us', *Time*, 22 Dec 1986.
7 Quoted in Daniel Goleman, 'Racial Pride Called Low Among Black Children', *International Herald Tribune*, 1 Sept 1987.
8 See Becker (1977) and (1980). On textbooks see Preiswerk and Perrot (1978); Dijk (1987); Berg and Reinsch (1983); Cheng-Henp (1984).
9 Loring Jones (1986), p. 21.
10 'Black Comics: From Poor Li'l Mose to Black Goliath', in Gifford (1984), pp. 220-1.
11 Robinson (1974).
12 Savkar Altinel, 'A Pan-European Hero', *Times Literary Supplement*, 1-7 Apr 1988. Cf. Goddin (1988) and Ch. 7 above.
13 Appignanesi (1979) p. 189, quoted in Alvarado, Gutch and Wollen (1987), pp. 228-9.
14 Alvarado, Gutch and Wollen (1987), p. 229.
15 Dorfman and Mattelart (1975), esp. chs. 2 ('From the Child to the Noble Savage') and 3 ('From the Noble Savage to the Third World'). This discussion is taken up further in Ch. 14 below.

Chapter 12

1 Quoted in Gilman (1986), p. 228.
2 Quoted in Jones (1971), p. 7.
3 Frederickson (1981), p. 100.
4 Mannoni (1956). Cf. Baudet (1959/1965).
5 Hammond and Jablow (1970), p. 197. Cf. JanMohamed (1986).
6 Patrick Brantlinger (1986) devotes an insightful essay to this theme.
7 Gilman (1986), p. 257.
8 Quoted in Dalal (1988), p. 14.
9 Gilman (1986).
10 See the critique of Jung in Dalal (1988), and of Freudian psychoanalysis in Corbey (1989), ch. 6.
11 Lightfoot (1977), pp. 86-7.

12 Blackwell (1977/1982), p. 223.
13 Dollard (1937; 3rd edn. 1957), ch. 7.
14 Blackwell (1971), p. 226.
15 Quoted in Walvin (1982), p. 62.
16 Takaki (1980), p. 59.
17 D'Emilio and Freedman (1988), p. 86 and ch. 5 on 'Race and Sexuality' generally. The affinities between gender politics and race politics, and the parallels between stereotypes of blacks and stereotypes of women are discussed further in Ch. 14 below.
18 Reich (1972), p. 127.
19 Foucault (1980).
20 James Earl Jones, interviewed in Halsell (1972).
21 See Williamson (1986), pp. 82-98. Cf. Carby (1986).
22 Hernton (1965).
23 Downs (1982).
24 Clinton (1984), pp. 33-9. Davis (1982).
25 See Honour (1989).
26 Quoted in Curtin (1964), p. 46.
27 Chailley (1968/1972), pp. 99-100. Cf. Kreidt (1987), pp. 60-4.
28 Drinka (1984), p. 162. Cf. Lorimer (1978).
29 'The association of figures of the same sex stresses the special status of female sexuality. In "The Servant" [Franz von Bayros, 1890] the overt sexuality of the black child indicates the covert sexuality of the white woman. . . .' Gilman (1986), pp. 228-31. Cf. Weideger (1986).
30 Honour (1989), pp. 152-5.
31 Cf. Alloula (1987). Thornton (1983).
32 On Baudelaire, see Finn (1988), pp. 174-8.
33 See Honour (1989), pp. 164-71.
34 Gilman (1986), pp. 251-3.
35 Martinkus-Zemp (1973), p. 61.
36 See J.-P. Goude, *Jungle Fever* (New York: Xavier Moreau, n.d.). On the cover is a photograph of Grace Jones in a cage. A chapter in the book is devoted to her. Cf. Ch. 13, on advertising, below.
37 Alvarado, Gutch and Wollen (1987), p. 215.
38 On African women see, e.g., *Femmes d'Afrique* (1989). Sweetman (1984).
39 Rubin (1984), p. 6.
40 See Paudrat (1984).
41 Hobsbawm (1983), p. 306.
42 Reich (1942/1961); Foucault (1976).

Chapter 13

1 Werkman (1974), p. 107.
2 Von Kornatzki (1987), p. 226.
3 Several commercial images have been dealt with in previous chapters, notably Ch. 10, *Popular Types*.
4 Reichwein and Jas (1988).
5 Devisse and Mollat (1979), pp. 215-16 and figs. 226-7.
6 Reno (1986), p. 68. Cf. Brongers (1978), pp. 37-8.
7 Boskin (1986), pp. 138-9.
8 Nunez Jimenez (1985).
9 Eillebrecht, Grimbergen and Schipper (1986), p. 126.
10 'Pete Kelly's Blues', quoted in Cabrera Infante (1985). I am indebted to Lawrence Jones for this interpretation.
11 Eillebrecht *et al.* (1986), pp. 32-3, 154-7.
12 A recent book on posters expresses admiration for the graphic design, by Julius Klinger, of the Palm Cigarren poster in which image and lettering have been so elegantly interwoven. Not a word as to the presence of the little

Negro in this elegant design. The year is 1987, and the black is still only a decorative element. Scholz-Hansel (1987).

13 Quoted in Boskin (1986), p. 113.

14 Debrunner (1986), p. 3.

15 Acts 8: 26-39.

16 Jones (1971). Id., 'Washing the Ethiop White: the African in English Poetry 16th-18th Century' (n.d., copy). I am indebted to Vernie February for alerting me to this theme.

17 'De moriaan wassen/schuren'. Martinus Koning, Lexicon hieroglyphicum sacro-profanum, of Woordboek . . . (Dordrecht, 1722-3), under 'Moor'. The saying is still in use, as noted in the standard Dutch dictionary, the Van Dale (1984).

18 Cf. Reynolds (1946/1974), ch. 9; 'Concerning the Nastiness of Natives and the Filthiness of Foreigners'.

19 Drinnon (1980), p. 349.

20 Frederikse (1983), p. 118 ('Wherever they're seen Ambi people look great'). And see 1950s Ebony ads in the US, in Harris et al. (1974), p. 103.

21 Cf. Fanon (1952/1967).

22 Eichstedt and Polster (1985), p. 61.

23 Dutch examples are given in Stakenborg and van Zadelhoff (1979).

24 Quoted in Walvin (1973). On the general theme of the laziness of natives, see Alatas (1977).

25 Vulgarity is displayed in a series of cards, intended to be amusing, featuring the amply built New York model Jean King; one is captioned, 'Oooooh, Baby . . . I Want To Be Your Top Banana!'.

26 Cf. Thompson and Davenport (1980), p. 107.

27 Enloe (1990), p. 127.

28 Rashap (1984), pp. 9-10.

29 Bush, Solomon and Hair (1977), p. 21. One of the earlier studies referred to is Dominick and Greenberg (1970).

30 Bush, Solomon and Hair (1977), p. 25.

31 Berry (1980). Cf. Berry and Mitchell-Kernan (1982).

32 See e.g. Common Destiny (1989). Fact Sheets on Institutional Racism (1984).

33 Marable (1991).

34 Mercer (1986), p. 140. Cf. Wallman, ed. (1979).

35 Used in 1907 for H-O Oats. See Morgan (1987), p. 54.

36 I. Ball, 'Colgate Removes a Racist Stain', Daily Telegraph, 26 Jan 1989. M. Richardson, 'Across Asia, a Misunderstanding in a Tube', International Herald Tribune, 19 Nov 1987.

37 Cf. Bond (1975). Cf. 'This construction of the exotically and erotically dangerous black woman is also an important thread running through the stage persona of a whole range of popular singers, e.g. Eartha Kitt, Shirley Bassey, Tina Turner, Grace Jones.' Alvarado, Gutch and Wollen (1987), p. 215.

38 Van Ammelrooy (1989). Launer (1987).

39 Netherlands: Ministerie van Binnenlandse Zaken (Ministry of Internal Affairs), Aug 1987.

40 See 'The Image of Africa' (1988).

41 Duodu (1991).

42 Timberlake (1985), p. 7.

43 'Prejudice and Black Sambo', Time, 15 Aug 1988. 'Little Black Sambo Products Removed from Japan Market', International Herald Tribune, 29 July 1988.

44 Annual of Ad Production in Japan (1986).

Chapter 14

1 The expression is Spivak's (1988).

2 'Eurocentrism' is here taken broadly to refer to the successive eras of Christianity, mercantile expansion, imperialism, colonialism and post-colonialism.

3 Chamfort (1963).

4 Quoted in Vints (1984), p. 26.

5 Boxer (1978), p. 23.

6 Quoted in Curtis, jr. (1971), p. 1.

7 A classic source is J. Beddoe, The Races of Britain (1885). See MacDougall (1982), Rich (1986), pp. 13-20.

8 Curtis, jr. (1971), p. 2.

9 Ibid., p. 100. See cartoons by Tenniel and others, pp. 55, 56, 57, 58, 59, 60, 62.

10 See Calder (1981) and Hechter (1975).

11 The Fabian socialists Beatrice and Sidney Webb, staying in Dublin in 1892, wrote to a friend: 'We will tell you about Ireland when we come back. The people are charming but we detest them, as we should the Hottentots – for their very virtues.' Curtis (1984), p. 57.

12 For an analysis of Northern Ireland in terms of colonizer and colonized, see O'Dowd (1990).

13 For recent caricatures see Curtis (1984).

14 Clinton (1984), p. 32.

15 During a visit to America in 1881, the English historian Edward Freeman wrote: 'This would be a great land if only every Irishman would kill a Negro, and be hanged for it. I find this sentiment generally approved – sometimes with the qualification that they want Irish and negroes for servants, not being able to get any other.' Curtis (1984), p. 58.

16 Ibid., p. 55. Beddoe (1885).

17 Takaki (1980), pp. 217-18. 'The "Negroization" of the Chinese reached a high point when a magazine cartoon depicted [one of] them as a bloodsucking vampire with slanted eyes, a pigtail, dark skin, and thick lips. White workers made the identification even more explicit when they referred to the Chinese as "nagurs".' Cf. Caldwell (1971). One may add that there were also differences between the stereotypes of Chinese and blacks.

18 See Drinnon (1980), pp. 276-7; Jacobs and Landau (1971).

19 Lifton (1973/1985), p. 204.

20 Dellums (1978).

21 Adorno and Horkheimer (1968).

22 The careers of both forms of racism might be pushed further back in time. On anti-Semitism see Mosse (1978); Van Arkel (1982) and (1984).

23 Hitler (1927), p. 325. Of France, Hitler says, 'France is and remains by far the most terrible enemy. This people which is basically becoming more and more negrified, constitutes in its tie with the aims of Jewish world domination an enduring danger for the existence of the white race in Europe. For the contamination by Negro blood on the Rhine in the heart of Europe is just as much in keeping with the perverted sadistic thirst for vengeance of this hereditary enemy of our people as is the ice-cold calculation of the Jew thus to begin bastardizing the European continent at its core and to deprive the white race of the foundation for a sovereign existence through infection with lower humanity.' Ibid., p. 624 (italics in original). Also in the 1920s, protests against the deployment of African troops on the Rhine were heard in England.

24 Dollard (1957), p. 161. On stereotyping of Jews in Nazi German films see Hollstein (1983).
25 See Fortenbaugh (1977). Cf. Nye (1990).
26 See, e.g., Fabian (1983). Other instances of 'totalizing' views in western history include Christianity, but it would lead us too far afield to discuss that here – also because the historical variations within Christian thought would require detailed discussion.
27 Cf. Jacquard (1986); Bernal (1987), p. 303.
28 Jenkyns (1980); Clarke (1959).
29 The Grimké sisters in 1837 in New England, quoted in Lerner (1979), p. 98.
30 Bland (1987) and Tickner, L., 'The political imagery of the British Women's Suffrage Movement', in J. Beckett and D. Cherry, eds., *The Edwardian Era*, London, 1987, pp. 100-16.
31 Takaki (1980), pp. 136-44.
32 Ungar (1988), p. 126.
33 E.g. Stoler (1990).
34 Goffman (1976/1985): 'The Ritualization of Subordination', pp. 40-56. Only the last item mentioned in Chapter 8, physical distance, does not match the way women are portrayed.
35 See Strang (1984).
36 An example of such imagery is seen in what Lord Acton wrote of the Celts, in 1862: 'The Celts are not among the progressive, initiative races, but among those which supply the material rather than the impulse of history, and are either stationary or retrogressive. The Persians, the Greeks, the Romans, and the Teutons are the only makers of history, the only authors of advancement. Other races possessing a highly developed language, a speculative religion, enjoying luxury and art, attain to a certain pitch of cultivation which they are unable either to communicate or to increase. They are a negative element in the world. . . . The Chinese are a people of this kind. . . . So the Hindoos . . . So the Slavonians . . . ' Quoted in Curtis (1984), p. 57.
37 Quoted in Banfield (1980), p. 20.
38 Burke (1978), pp. 14 f.
39 Lindsay (1977), pp. 6-7.
40 Cecil Rhodes, 1895: 'If you want to avoid civil war you must become imperialists.' Nederveen Pieterse (1989/1990), p. 184.
41 Cf. Van Ginneken (1989) and Cieraad (1988).

Chapter 15

1 See Brantlinger (1990), Punter (1986).
2 Schutz (1970), pp. 111-22. Cf. Berger and Luckmann (1971).
3 Gilman (1985), p. 16. I am indebted to Guus Meijer for alerting me to this general aspect of stereotyping and to the observations of Schutz and Gilman. In his essay, 'The Logic of Stereotypes Revisited' (unpub., 1990), Meijer notes: 'Any and every specific stereotype may and should be attacked and eliminated (or "deconstructed"), but stereotyping as a socio-cognitive practice is there to stay.'
4 E.g. Todorov (1976); Bucher (1977/1981).
5 Barthes (1957).
6 Panofsky (1962); Freedberg (1989).
7 Steins (1972).
8 Examples of a structuralist approach are Todorov (1976), Bucher (1977/1981), Mudimbe (1988) and Corbey (1989).

9 Said (1978/1985).
10 Derrida (1981).
11 Spivak (1987), p. 78.
12 See Ellis (1989).
13 Arens (1979), p. 10.
14 Cf. Forbes (1979).
15 Nederveen Pieterse (1988).
16 Cf. Therborn (1980).
17 Cf. Foucault (1980) and (1975).
18 E.g. Todorov (1976).
19 Roth (1975).

BIBLIOGRAPHY

Ade Ajayi, J. F. and J. E. Imkori, *The African slave trade from the 15th to the 19th century*, Paris, 1979.

Adorno, T. W. and M. Horkheimer, *Dialektik der Aufklärung: Philosophische Fragmente*, Amsterdam, 1968.

Adu Boahen, A., ed., *Africa under colonial domination 1880-1935, General history of Africa*, Vol. VII, Paris and London, abr. ed. 1990.

Alatas, S. H., *The myth of the lazy native*, London, 1977.

Alexander, Z., 'Black entertainers', in J. Beckett and D. Cherry, eds., *The Edwardian era*, London, 1987, pp. 44-7.

Alloula, M., *The colonial harem*, Manchester, 1987.

Alvarado, M., R. Gutch and T. Wollen, *Learning the media*, Houndmills, Basingstoke, 1987.

Ammelrooy, A. van, *Vrouwenhandel: De internationale seksslavinnenmarkt*, 's-Gravenhage, 1989.

Anderson, B., *Imagined Communities: Reflections on the origin and spread of nationalism*, London, 1983.

Angas, G. F., *The Kafirs Illustrated*, London, 1849.

Anne Frank Stichting, *Vreemd gespuis*, Amsterdam, 1987.

Annual of Ad Productions in Japan, Rikuyo-sha, 1986.

Appignanesi, R., 'Some thoughts on Freud's discovery of childhood', in M. Hoyles, ed., *Changing childhood*, London, 1979.

Arendt, H., *The origins of totalitarianism*, London, 1st ed. 1951/1986.

Arens, W., *The man-eating myth: Anthropology and anthropophagy*, New York, 1979.

Arkel, D. van, 'Racism in Europe', in R. Ross, ed., *Racism and colonialism*, The Hague, 1982, pp. 11-32.

Arnold, A. J., *Modernism and Negritude*, Cambridge, MA, 1981.

Ashcraft, R., 'Leviathan triumphant: Thomas Hobbes and the politics of Wild Men,' In E. Dudley and M. E. Novak, eds., *The Wild Man within: an image in western thought from the Renaissance to Romanticism*, Pittsburgh, 1972, pp. 141-82.

Ashe, Jr., A. R., *A hard road to glory*, 3 Vols., New York, 1988.

Ashford, A., *Politics of official discourse in South Africa*, Oxford, 1990.

Avé, J. B., 'Ethnographical museums in a changing world', in W. R. van Gulik et al., eds., *From field-case to showcase*, Amsterdam/Uithoorn, 1980, pp. 11-28.

Banfield, B., 'Racism in children's books: an Afro-American perspective', in R. Preiswerk, ed., *The slant of the pen: racism in children's books*, Geneva, 1980, pp. 13-25.

Banton, M., *Race relations*, London, 1967.

Barbour, V., *Capitalism in Amsterdam in the 17th century*, Ann Arbor, MI, 1950, reprint 1963.

Barker, A.J., *The African link: British attitudes to the Negro in the era of the Atlantic slave trade, 1550-1807*, London, 1978.

Barker, F. et al., eds., *Europe and its Others*, 2 Vols, Colchester, 1985.

Barker, M., *The new racism*, London, 1982.

Barthes, R., *Mythologies*, Paris, 1957.

Battersby, M., *Art Deco Fashion: French designers 1908-1925*, London/New York, 1974/1984.

Baudet, H., *Paradise on earth*, New Haven, CT, 1959 original Dutch ed., trl. 1965.

Baynes, K., *Art in society*, London, 1975.

Becker, J., *Alltäglicher Rassismus*, Frankfurt/M, 1977.

Becker, J., 'Some specific issues in German children's books and school texts', in R. Preiswerk, ed., *The slant of the pen: Racism in children's books*, Geneva, 1980, pp. 72-81.

Becker, P., *The pathfinders: The saga of exploration in Southern Africa*, New York, 1985.

Beckett, J. and D. Cherry, eds., *The Edwardian era*, London, 1987.

Beddoe, J., *The Races of Britain*, London, 1885.

Bennett, N. R., *Africa and Europe*, New York and London, 1975, 2nd ed. 1984.

Bennett, N. R., 'David Livingstone: Exploration for Christianity', in R. I. Rotberg, ed., *Africa and its explorers*, Cambridge, MA, 1970.

Berg, H. van en P. Q. Reinsch, *Racisme in schoolboeken*, Amsterdam, 1983.

Berge, H. C. ten, *De verdediging van de poëzie en andere essays*, Den Haag, 1988.

Berger, J., *Ways of seeing*, Harmondsworth, 1972.

Bernal, M., *Black Athena: The Afroasiatic roots of classical civilization*. Vol. 1, *The fabrication of Ancient Greece, 1785-1985*, London, 1987.

Bernheimer, R., *Wild men in the Middle Ages: A study in art, sentiment and demonology*, Cambridge, 1952.

Berry, G. L., 'Television and Afro-Americans: past legacy and present portrayals', in S. B. Withey and R. P. Abels, eds., *Television and social behavior: Beyond violence and children*, Hillsdale, NJ, 1980, pp. 231-48.

Bettany, G. T., *The World's Inhabitants or Mankind, Animals and Plants*, London, New York, 1888.

Betts, R. F., 'The French colonial empire and the French worldview', in R. Ross, ed., *Racism and colonialism*, the Hague, 1982, pp. 65-76.

Bhabha, H. K., 'The other question: difference, discrimination and the discourse of colonialism', in F. Barker et al., eds., *Literature, politics and theory*, London, 1986.

Biddiss, M. D., *Father of racist ideology: the social and political thought of Count Gobineau*, London, 1970.

Biervliet, H. et al., 'Biologisme, racisme, eugenetiek in de antropologie en de sociologie van de jaren dertig', in F. Bovenkerk et al., red., *Toen en thans: De sociale wetenschappen in de jaren dertig en nu*, Baarn, 1978, pp. 208-35.

Black, J. B., *Organising the propaganda instrument: the British experience*, The Hague, 1975.

The Black image in the mass media, New York, 1974.

Blackburn, R., *The overthrow of colonial slavery, 1776-1848*, London, 1988.

Blackwell, J. E., 'Social and legal dimensions of interracial liaisons', in D. Y. Wilkinson and R. L. Taylor, *The black male in America: Perspectives on his status in contemporary society*, Chicago, 1977, pp. 219-43.

Blake, W., *The Poems of William Blake*, London, 1905.

Blakely, A., 'The image of blacks in Dutch popular culture to 1900', Leiden, 1986, unpublished seminar paper.

Bland, L., 'Sex and morality: sinning on a tiger skin or keeping the beast at bay', in J. Beckett and D. Cherry, eds., *The Edwardian era*, London, 1987, pp. 88-99.

Bleekrode, M., *Tentoonstellingscatalogus Amsterdams Historisch Museum*, Amsterdam, 1983.

Blumenbach, J. F., 'Observation on the bodily conformation and mental capacity of the Negroes', *Philosophical Magazine* (New York), III, 1799.

Bo-Peep: A picture book annual for little folks, London, New York, Toronto, Melbourne, 1911.

Boas, G., *The Happy Beast in French thought of the seventeenth century*, New York, 1966.

Boase, R., *The origin and meaning of courtly love*, Manchester, 1977.

Bogle, D., *Toms, Coons, Mulattoes, Mammies, and Bucks*, New York, 1973.

Bogers, K. en P. Wymeersch, *De Kongo in de Vlaamse fiktie- en reisverhalen*, Brussel, 1987.

Bond, J. C., 'The media image of black women', *Freedomways*, 15, 1975, pp. 34-7.

Bontinck, F., 'Le prédicant Africain Jacobus Capitein (1717-1747)', *Revue Africaine de Théologie*, II, 4, 1978, pp. 219-43.

Boogaart, E. van den, 'Colour prejudice and the yardstick of civility: the initial Dutch confrontation with black Africans, 1590-1635', in R. Ross, ed., *Racism and colonialism*, The Hague, 1982, pp. 33-54.

Boogaart, E. van den, 'Europeanen en niet-Europeanen in zestiende-eeuws Nederlands perspectief', *De Gids*, Vol. 145, 1, 1982, pp. 6-25.

Boogaart, E. van den and P. C. Emmer, 'The Dutch participation in the Atlantic slave trade 1596-1650', in H. A. Gemery and J. S. Hogendorn, eds., *The uncommon market: Essays in the economic history of the Atlantic slave trade*, New York, 1979.

Borger, B. en R. van der Vloet, *Jazzdans: Oude vormen, nieuwe stijlen*, Amsterdam, 1984.

Boskin, J., *Sambo: The rise and demise of an American jester*, New York/Oxford, 1986.

Boussenard, E., *Le tour du monde d'un gamin de Paris*, Elbeuf-Paris (n.d.).

Bovill, E. W., *The golden trade of the Moors*, Oxford, rev. ed. 1978.

Bowle, J., *The imperial achievement*, Harmondsworth, 1974, reprint 1977.

Boxer, C. R., *The Dutch seaborne empire 1680-1800*, London, 1965.

Boxer, C. R., *Race relations in the Portuguese colonial empire 1415-1825*, Oxford, 1963.

Boxer, C. R., *The Church Militant and Iberian expansion, 1440-1770*, Baltimore, 1978.

Brantlinger, P. *Crusoe's Footprints: Cultural studies in Britain and America*, New York and London, 1990.

Brantlinger, P., *Rule of Darkness: British literature and imperialism, 1830-1914*, Ithaca and London, 1988.

Brantlinger, P., 'Victorians and Africans: The genealogy of the myth of the Dark Continent', in H. L. Gates, Jr., ed., *"Race", writing, and difference*, Chicago, 1986, pp. 185-222.

Bratton, J. S., 'Of England, Home and Duty: The image of England in Victorian and Edwardian juvenile fiction', in J. M. Mackenzie, ed., *Imperialism and popular culture*, Manchester, 1986.

Braudel, F., *The Mediterranean*, Vol 1, New York, 1966 orig, ed., trl. 1972.

Breman, J., 'Primitive racism in a colonial setting', in J. Breman, ed., *Imperial Monkey Business: Racial supremacy in Social Darwinist theory and colonial practice*, Amsterdam, 1990, pp. 89-122.

Brink, A., *Mapmakers: Writing in a state of siege*, London, 1983.

Brongers, G. A., *Van gouwenaar tot bruyere pijp*, Amerongen, 1978.

Brown, S., *The Negro in American fiction*, Washington, DC, 1937.

Brown, P. and D. Tuzin, eds., *The ethnography of cannibalism*, Washington, DC, 1983.

Bucher, B., *La sauvage aux seins pendants*, Paris, 1977. *Icon and conquest: A structural analysis of the illustrations of de Bry's Great Voyages*, Chicago, trl. 1981.

Bugner, L., ed., *The image of the Black in western art: From the Pharaos to the fall of the Roman Empire*, Vol. 1, Paris and Lausanne, 1976.

Bühlmann, W., *Missionsprozess in Addis Abeba*, Frankfurt/M, 1977. *Afrika eist: Afrikaans christendom*, Hilversum, trl. 1980.

Bunting, B., *The rise of the South African Reich*, Harmondsworth, 1964.

Burke, P., *Popular culture in early modern Europe*, New York, 1978.

Bush, R. F., P. J. Solomon and J. F. Hair, Jr., 'There are more Blacks in TV commercials', *Journal of Advertising Research*, 17, 1, 1977, pp. 21-5.

Cabrera Infante, G., *Holy smoke*, London, 1985.

Cairns, H. A. C., *Prelude to imperialism: British reactions to Central African society 1840-1890*, London, 1965.

Campbell, M. B., *The witness and the other world: Exotic European travel writing, 400-1600*, Ithaca, NY, 1988.

Camper, P., *Verhandeling over het natuurlijk verschil der wezenstrekken in menschen van verschillende landsaart*, Groningen, 1791.

Capitein, J. E. J., *Staatkundig-Godgeleerd Onderzoekschrift over de Slavernij, als niet strijdig tegen de Christelijke Vrijheid*, Leyden, Amsterdam, 1742.

Carby, H. V., ' "On the threshold of woman's era": Lynching, empire, and sexuality in black feminist theory', in H. L. Gates Jr., ed., *"Race," writing, and difference*, Chicago, 1986, pp. 301-16.

Carlyle, T., 'Occasional discourse on the Nigger Question', *Critical and miscellaneous essays*, Vol. 7, London, 1872.

Cashmore, E., *Black sportsmen*, London, 1982.

Chailley, J., *The Magic Flute: Masonic opera*, London, orig. French ed. 1968, trl. 1972.

Chambers, I., *Popular culture: the metropolitan experience*, London, 1986.

Chinweizu, *The West and the rest of us*, New York, 1975.

Cieraad, I., *De elitaire verbeelding van volk en massa*, Muiderberg, 1988.

Cipolla, C. M., *Before the industrial revolution: European society and economy, 1000-1700*, New York, 2nd ed., 1980.

Clarke, M. L., *Classical education in Britain*, Cambridge, 1959.

Clinton, C., *The other Civil War: American women in the nineteenth century*, New York, 1984.

Cohen, W. B., *The French encounter with Africans: White response to blacks, 1530-1880*, Bloomington, IN and London, 1980.

Collier, J. L., *Louis Armstrong*, London, 1983.

Collins, R. O., ed., *Problems in the history of colonial Africa*, Englewood Cliffs, NJ, 1970.

Combs, J., *Polpop: Politics and popular culture in America*, Bowling Green, OH, 1984.

Commelin, C., *Beschryvinge van Amsterdam*, Amsterdam, 2nd ed. 1726.

Condorcet, *Réflexions sur l'esclavage des nègres*, Paris, 1781.

Cook, M., 'Jean Jacques Rousseau and the Negro', *Journal of Negro History*, XXI, July 1936.

Corbey, R., 'Alterity, the colonial nude', *Critique of anthropology*, VII, 2, 1987, pp. 75-92.

Corbey, R., *Wildheid en beschaving: de Europese verbeelding van Afrika*, Baarn, 1989.

Coquery-Vidrovitch, C., 'Research on an African mode of production', in P. C. W. Gutkind and P. Waterman, eds., *African social studies*, London, 1977, pp. 77-92.

Coupland, R., *Kirk on the Zambesi*, Oxford, 1928.

Cowhig, R., 'Blacks in English Renaissance drama and the role of Shakespeare's Othello', in D. Dabydeen, ed., *The black presence in English literature*, Manchester, 1985, pp. 1-25.

Craton, M., J. Walvin and D. Wright, *Slavery, abolition and emancipation: Black slaves and the British Empire*, London, 1976.

Craven, W. F., ' "Twenty Negroes to Jamestown in 1619?",' in B. A. Glasrud and A. M. Smith, eds., *Race relations in British North America, 1607-1783*, Chicago, 1982.

Cunard, N., ed., *Negro: an anthology*, orig. ed. 1934, ed. and abridg. by H. Ford, New York, 1970.

Curtin, P. D., ed., *Africa and the West: Intellectual responses to European culture*, Madison, WI, 1972.

Curtin, P. D., *The Atlantic slave trade: a census*, Madison, WI, 1969.

Curtin, P. D., *The image of Africa: British ideas and action, 1780-1850*, Madison, WI, 1964.

Curtin, P. D., ed., *Imperialism*, London, 1972.

Curtis, L., *Nothing but the same old story: The roots of anti-Irish racism*, London, 1984.

Curtis, L. P., Jr., *Apes and angels: The Irishman in Victorian caricature*, Newton Abbot, 1971.

Dabydeen, D., *Hogarth's Blacks: Images of blacks in eighteenth century English art*, Kingston-upon-Thames, 1985.

Dabydeen, D., ed., *The black presence in English literature*, Manchester, 1985.

Dalal, F., 'The racism of Jung', *Race & Class*, XXIX, 3, 1988, pp. 1-22.

Danco, P., *Ook een ideaal*, Brussel, 1896.

Dantzig, A. van, *Het Nederlandse aandeel in de slavenhandel*, Bussum, 1968.

Dapper, O., *Beschrijving van Afrika*, Amsterdam, 1670

Darwin, C., *The Descent of Man*, London, 1871.

Davidson, B., *Africa in modern history*, Harmondsworth, 1978.

Davies, N., *Human sacrifice in history and today*, New York, 1981.

Davis, A., *Women, race and class*, New York, 1982.

Davis, D. B., *Slavery and human progress*, New York and Oxford, 1984.

Davis, D. B., *The problem of slavery in the age of revolution, 1770-1823*, Ithaca, NY, 1975.

Davis, S. M., *Apartheid's rebels: Inside South Africa's hidden war*, New York, 1987.

Day, B., *Sexual life between blacks and whites*, New York, 1972.

Debrunner, H. W., 'Blacks in the Mediterranean before 1700', Leiden, 1986, unpublished seminar paper.

Debrunner, H. W., *Presence and prestige: Africans in Europe*, Basel, 1979.

Degenhardt, U., *Entdeckungs- und Forschungsreisen im Spiegel alter Bücher*, Stuttgart, 1987.

Delathuy, A. M., *Jezuïeten in de Kongo met zwaard en kruis*, Antwerpen, 1986.

Delathuy, A. M., *De Kongostaat van Leopold II: Het verloren paradijs 1876-1900*, Antwerpen, 1989.

Dellums, R. V., *The link between struggles for human rights in the United States and Third World*, Washington, DC, 1978.

D'Emilio, J. and E. B. Freedman, *Intimate matters: A history of sexuality in America*, New York, 1988.

Derrida, J., *Positions*, Chicago, trl. 1981.

Devisse, J. and M. Mollat, 'Africans in the Christian ordinance of the world (fourteenth to the sixteenth century)', in L. Bugner, ed., *The image of the Black in Western art*, Pt. II, Vol. 2, New York, 1979.

Diaghilev, *Costumes and designs of the Ballets Russes*, New York, 1978.

Diaghilev, *The decorative art of Léon Bakst*, New York, orig. ed. 1913, trl. 1972.

Diamond, S., *Spiritual warfare: The politics of the Christian Right*, Boston, 1989.

Dijk, T. van, *Schoolvoorbeelden van racisme in maatschappij-leerboeken*, Amsterdam, 1987.

DiLeonardo, E. M., ed., *Towards an anthropology of gender*, Los Angeles, 1990.

Diop, C. A., *Civilization or barbarism: An authentic anthropology*, New York, 1991.

Diop, C. A., *Black Africa*, Westport CT, 1987.

Dollard, J., *Caste and class in a Southern town*, Garden City, NY, 1937, 3rd ed. 1957.

Dominick, J. R. and B. S. Greenberg, 'Three seasons of Blacks on television', *Journal of Advertising Research*, X, 2, 1975, pp. 21-7

Donne, J. B., 'African art and Paris studios 1905-20', in M. Greenhalgh and V. Megaw, eds., *Art in society: studies in style, culture and aesthetics*, London, 1978, pp. 105-20.

Dorfman, A. and A. Mattelart, *How to read Donald Duck*, New York, 1971/1975.

Douglass, F., *The life and times of Frederick Douglass written by himself*, rev. ed., 1892; reprint, New York, 1962.

Downs, J., 'Black/white dating', in D. Y. Wilkinson and R. L. Taylor, eds., *The black male in America*, Chicago, 1982, pp. 207-18.

Doyle, M. W., *Empires*, Ithaca, NY, 1986.

Drinka, G. F., *The birth of neurosis: myth, malady and the Victorians*, New York, 1984.

Drinnon, R., *Facing West: The metaphysics of Indian-hating and Empire-building*, New York, 1980.

Dudley, E. and M. E. Novack, eds., *The Wild Man within: An image in Western thought from the Renaissance to Romanticism*, Pittsburgh, 1972.

Dümling, A. and P. Girth, Hg., *Entartete Musik: Eine kommentierte Rekonstruktion*, Düsseldorf, 1988.

Duodu, C., 'The image of Africa in the media', *The Decolonization of Imagination*, Amsterdam, 1991 (unpubl. conference paper).

Edwards, H., *The revolt of the black athlete*, New York, 1969.

Edwards, H., 'The sources of the black athlete's superiority', in D. Y. Wilkinson and R. L. Taylor, *The black male in America*, Chicago, 1977, pp. 159-173.

Eekhof, A., *De negerpredikant Jacobus Elisa Joannes Capiteijn*, Dan Haag, 1917.

Eerden, B., SMA, *Kobina, de zoon van de slavendrijver*, Oosterbeek, 1952.

Ehrenreich, B. and D. English, *For her own good: 150 years of the experts' advice to women*, Garden City, NY, 1979.

Eichstedt, A. und B. Polster, *Wie die Wilden: Tänze auf der Höhe ihrer Zeit*, Berlin, 1985.

Eillebrecht, A., J. Grimbergen en P. Schipper, *De sigarennijverheid in Culemborg*, Culemborg, 1986.

Ela, J-M., *Le Cri de l'homme africain – questions aux chrétiens et aux églises d'Afrique*, Paris, 1980.

Elkins, S. M., *Slavery: a problem in American institutional and intellectual life*, New York, 1963.

Ellis, J., *The social history of the machine gun*, New York, 1975.

Ellis, J. M., *Against Deconstruction*, Princeton, NJ, 1989.

Eltis, D., *Economic growth and the ending of the transatlantic slave trade*, Oxford, 1987.

Emery, F., *Marching over Africa: Letters from Victorian soldiers*, London, 1986.

Enloe, C., *Bananas, beaches and bases: Making feminist sense of international politics*, Berkeley and Los Angeles, 1989.

Enloe, C., *Ethnic soldiers*, Harmondsworth, 1980.

Escobar, A., 'Discourse and power in development: Michel Foucault and the relevance of his work to the Third World', *Alternatives*, X, winter 1984-85, pp. 377-400.

Espy, R., *The politics of the Olympic Games*, Berkeley, 1979.

Ethnic Notions: black images in the white mind, Berkeley, 1982.

Ewen, S. and E. Ewen, *Channels of desire: mass images and the shaping of American consciousness*, New York, 1982.

Fabb, J., *The British Empire from photographs: Africa*, London, 1987.

Fabian, J., 'Hindsight', *Critique of Anthropology*, VII, 2, 1987, pp. 37-49.

Fabian, J., *Time and the Other: How anthropology makes its objects*, New York, 1983.

Fabre, M., 'Popular Civil War propaganda: the case of patriotic covers', *Journal of American culture*, summer 1980, pp. 223-37.

– , 'La représentation du Noir sur les enveloppes de propagande patriotique pendant la Guerre de Sécession', *Revue française d'études américaines*, 7, avril 1979, pp. 9-16.

Fairchild, H., *The Noble Savage: a study in Romantic naturalism*, London, 1972.

Fanciful Victorian Initials: 1,142 decorative letters from Punch, ed. by C. B. Grafton, New York, 1984.

Fanon, F., *Peau noire, masques blancs*, Paris, 1952, *Black skin, white masks*, trl. New York, 1967.

Fanoudh-Siefer, L., *Le mythe du nègre et de l'Afrique noire dans la littérature française, de 1800 à la 2e Guerre Mondiale*, Paris, 1968.

Farwell, B., *The Great War in Africa 1914-1918*, New York, 1987.

Faulkner, J., 'Golliwoggs', *Black Ethnic Collectibles*, I, 4, 1988.

February, V. A., *Mind your colour: The 'coloured' stereotype in South African literature*, London, 1981.

Femmes d'Afrique, Bruxelles, 1989.

Fennema, M., 'Racisme en politieke theorie', in M. Hisschemöller, red., *Het bleke bolwerk*, Amsterdam, 1988.

Fields, B. J., 'Ideology and race in American history', in J. M. Kousser and J. M. McPherson, eds., *Region, Race, and Reconstruction*, New York/Oxford, 1982, pp. 143-178.

Fields, K. E., 'Christian missionaries as anti-colonial militants', *Theory and Society*, 11, 1982.

Finn, J., *Voices of négritude*, London, 1988.

Fiske, S. T. and S. E. Taylor, *Social cognition*, New York, 1984.

Flanner, J., *Paris was yesterday*, New York, 1972.

Forbes, J. D., 'Mustees, Half-breeds and Zambos in Anglo North America: aspects of Black Indian relations', in idem, *Black Africans and Native Americans: Racial classification systems and red-black people*, Rotterdam, 1984.

Forbes, J. D., *A world ruled by cannibals: the wétiko disease of aggression, violence and imperialism*, Davis, CA, 1979.

Fordham, P., *The geography of African affairs*, Harmondsworth, 4th ed. 1974.

Fortenbaugh, W. W., 'Aristotle on slaves and women', in J. Barnes et al., eds., *Articles on Aristotle*, Vol. 2, London, 1977, pp. 135-9.

Foucault, M., *Power/Knowledge*, ed. by C. Gordon, New York, 1980.

– , *La volonté de savoir*, Paris, 1976.

Fraser, A., *A history of toys*, London, 1972.

Frazer, J. G., *The Golden Bough: A study in magic and religion*, London, 1922, abr. ed. 1957.

Frederickson, G. M., *White supremacy: A comparative study in American and South African history*, New York/Oxford, 1981.

Frederikse, J., *None but ourselves. Masses and media in the making of Zimbabwe*, London, Ibadan, Nairobi, 1983.

Frederikse, J., *South Africa: a different kind of war*, London/Johannesburg/Gweru, 1986.

Freedberg, D., *The power of images: studies in the theory and history of response*, Chicago, 1989.

Fremantle, K., *The baroque Town Hall of Amsterdam*, Utrecht, 1959.

Fritz, H., 'Negerköpfe, Mohrenküsse: Der Wilde im Alltag', in T. Theye, Hg., *Wir und die Wilden*, Reinbek, 1985.

Frost, T., *Modern explorers*, London, Paris, New York, 1884.

Fukuyama, F., 'The end of history?', *The National Interest*, IV, summer 1989, pp. 3-18.

Galton, F., *Narrative of an explorer in tropical South Africa*, London, 1853.

Ganslmayr, H., 'Weg mit den Fetischen und anderem Zauberzeug', in M. O. Hinz, H. Patemann und A. Maier, Hg., *Weiss auf Schwarz: Kolonialismus, Apartheid under afarikanischer Widerstand*, Berlin, 1986, pp. 38-40.

Gates, H. L., Jr., ed., *'Race', writing, and difference*, Chicago, 1986.

Gay, P., *The Enlightenment: an interpretation*, New York, 1969.

Gemery, H. A. and J. S. Hogendorn, eds., *The uncommon market: essays in the economic history of the Atlantic slave trade*, New York, 1979.

Gifford, D., *The international book of comics*, London, 1984.

Gifford, P., *The religious Right in Southern Africa*, Harare, 1988.

Gilbert, F., *The end of the European era, 1890 to the present*, New York, 2nd ed. 1979.

Gilman, S. L., *On blackness without blacks: essays on the image of the black in Germany*, Boston, 1982.

– , 'Black bodies, white bodies: toward an iconography of female sexuality in late nineteenth-century art, medicine, and literature', in Gates Jr., H. L., ed., *'Race', writing, and difference*, Chicago, 1986, pp. 223-61.

– , *Difference and pathology: Stereotypes of sexuality, race, and madness*, Ithaca and London, 1985.

Ginneken, J. van, *Crowds, psychology, and politics, 1871-1899*, Amsterdam, 1989.

Glasrud, B. A. and A. M. Smith, eds., *Race relations in British North America, 1607-1783*, Chicago, 1982.

Goff, J. Le, *La civilisation de l'Occident médiéval*, Paris, 1985.

Goffman, E., *Gender advertisements*, orig. ed. 1976, London, 1985.

Golbéry, S. M. X. de, *Travels in Africa performed in the years 1785, 1786 and 1787*, trl. London, 1803.

Goldberg, D., 'Images of the Other: cinema and stereotypes', in *Race and representation: Art/film/video*, New York, 1987, pp. 29-37.

Goldmann, S., 'Zur Rezeption der Völkerausstellungen um 1900', in *Exotische Welten: Europäische Phantasien*, Stuttgart, 1987, pp. 88-93.

Gombrich, E. H., *Art and illusion: a study in the psychology of pictorial representation*, Princeton, NJ, rev. ed. 1961.

– , *Symbolic images: studies in the art of the Renaissance*, London, 1972.

Gomez, J., 'Showing our faces: a century of Black women photographed', *Ten. 8*, 24, 1986, pp. 13-9.

Gordon, D. C., *Images of the West: Third World perspectives*, New York, 1989.

Goude, J-P., *Jungle Fever*, New York, Xavier Moreau (n.d.).

Gourou, P., *Les pays tropicaux*, Paris, 1953/1961, trl. *The tropical world*, London, 1966.

Grasskampf, W., *Triviale Negerbilder*, Köln, 1978.

Gratus, J., *The great white lie: slavery, emancipation, and changing racial attitudes*, New York, 1973.

Hallie, P. P., *Cruelty*, Middletown, CT, 2nd ed. 1982.

Halsell, G., *Black/white sex*, New York, 1972.

Hammond, D. and A. Jablow, *The Africa that never was: four centuries of British writing about Africa*, New York, 1970.

Hammond, B. and P. O'Connor, *Josephine Baker*, London, 1988.

Hargreaves, A. G., *The colonial experience in French fiction: a study of Pierre Loti, Ernest Psichari and Pierre Mille*, London, 1981.

Harris, M. et al, *The Black Book*, New York, 1974.

Hassankhan, R., *Al is hij zo zwart als roet. . . .*, Den Haag, 1988.

Hauser, S., 'Van koloniaal tot idealist: Kuifje en de derde wereld', *Onze Wereld*, Aug 1988, pp. 20-6.

Hay, D., *Europe, the emergence of an idea*, New York, 1966.

Hechter, M., *Internal colonialism: the Celtic fringe in British national development, 1536-1966*, London, 1975.

Hernton, C., *Sex and racism in America*, Garden City, NY, 1965.

Herskovits, M. J., *The New World Negro: selected papers in Afroamerican studies*, New York, 1969.

Heydenreich, L. H. und K-A. Wirth, Hg., *Reallexikon zur Deutschen Kunstgeschichte*, Bd. V, Stuttgart, 1967.

Hibbert, C., *Africa explored: Europeans in the dark continent 1769-1889*, London, 1982.

Hildebrand, K., 'Wer macht angst vorm schwarzen mann?', *kultuRRevolution. Zeitzchrift für angewandte Diskurstheorie*, 1, Oct 1980, pp. 43-5.

Hill, C., 'Robinson Crusoe', *History Workshop Journal*, 10, autumn 1980.

Hill, J., 'Oh! Please Mr Tiger', in J. Stinton, ed., *Racism and sexism in children's books*, London, 1979.

Hirschfeld, M., *Racism*, London, 1938.

Hobbes, T., *Leviathan*, Ed. by M. Oakeshott, Oxford, 1955.

Hobsbawm, E. J., *The age of capital, 1848-1875*, New York, 1975/1979.

– 'Mass-producing traditions: Europe, 1870-1914', in E. J. Hobsbawm and T. Ranger, eds., *The invention of tradition*, Cambridge, 1983, pp. 263-307.

Hobson, J. A., *The psychology of Jingoism*, London, 1901.

Hodgen, M. T., *Early anthropology in the sixteenth and seventeenth centuries*, Philadelphia, 1964.

Hodgkin, T., 'Some African and Third World theories of imperialism', in R. Owen and B. Sutcliffe, eds., *Studies in the theory of imperialism*, London, 1972.

Hogan, I., *Nicodemus and his Gran'pappy*, London, 1936.

Holland, P., 'Save the children . . . How the newspapers present pictures of children from the Third World', *Multiracial education*, IX, 2, 1981.

Holt, T. C., ' "An Empire over the mind": Emancipation, race, and ideology in the British West Indies and the American South', in J. M. Kousser and J. M. McPherson, eds., *Region, race, and reconstruction*, New York/Oxford, 1982, pp. 283-314.

Honour, H., *The images of the Black in western art*, Vol. IV, *From the American Revolution to World War I*, Part 1, *Slaves and liberators*, Cambridge, MA and London, 1989.

Honour, H., *The image of the Black in western art*, Vol. IV, *From the American Revolution to World War I*, Part 2, *Black models and white myths*, Cambridge, MA and London, 1989.

Honour, H., *The new Golden Land: European images of America from the discoveries to the present time*, New York, 1975.

Houston, J., *Some new and accurate observations . . . of the Coast of Guinea . . . for the advantage of Great Britain in general, and the Royal African Company in particular*, London, 1725.

Hughes, L., *The Langston Hughes reader*, New York, 1958.

Hughes, H. S., *Consciousness and society: the reorientation of European social thought 1890-1913*, New York, 1958.

Hull, G. T. et al., eds., *But some of us are brave: Black women's studies*, Old Westbury, NY, 1982.

Hunting, C., 'The Philosphes and black slavery', *Journal for the history of ideas*, XXXIX, 1978, pp. 405-18.

Hunt-Davis, D., *Hitler's Games: the 1936 Olympics*, London, 1986.

Husband, C., ed., *'Race' in Britain*, London, 1982.

Illich, I., *Gender*, New York, 1982.

'Image of Africa, The', *Ifda Dossier*, 67, Sep/Oct 1988.

Isaac, E., 'Genesis, Judaism and the "Sons of Ham" ', *Slavery and Abolition*, 1, 1980.

Jacquard, A., 'Biologie et théorie des "élites" ', in *La science face au racisme*, Paris, 1986.

Jacobs, P. and S. Landau, *To serve the devil*, 2 Vols, New York, 1971.

Jahn, J., Hg., *Colon: das schwarze Bild vom weissen Mann*, München, 1983.

Jahn, J., *Neo-African literature: a history of black writing*, orig. ed. 1966, trl. New York, 1968.

JanMohamed, A. R., 'The economy of Manichean allegory: The function of racial difference in colonialist literature', in H. L. Gates, Jr., ed., *'Race', writing, and difference*, Chicago, 1986, pp. 78-106.

Jansz, J., 'Etnocentrisme en discriminatie', in J. van Ginneken en R. Kouijzer, red., *Politieke psychologie*, Alphen aan de Rijn, 1986.

Jeal, T., *Livingstone*, Harmondsworth, orig. ed. 1973, reprint 1985.

Jenkyns, R., *The Victorians and ancient Greece*, Oxford, 1980.

Johnson, P., *Modern times: The world from the twenties to the eighties*, New York, 1983.

Johnson, J., *In the ring and out*, New York, 1927.

Johnson, L. A., *The devil, the gargoyle and the buffoon: The negro as metaphor in western literature*, Port Washington, NY, 1971.

Jones, E. D., *The Elizabethan image of Africa*, Virginia University Press, 1971.

Jones, E. D., 'Washing the Ethiop white: the African in English poetry 16th-18th century' (published article, photocopy, no data).

Jones, G., *Social Darwinism and English thought: the interaction between biological and social theory*, Brighton, 1980.

Jones, S. L., 'From "Under Cork" to overcoming: Black images in the comics', in C. Hardy and G. F. Stern, eds., *Ethnic images in the comics*, Philadelphia, 1986, pp. 21-30.

Jordan, W. D., *White over Black: American attitudes toward the Negro, 1550-1812*, Williamsburg, VA, 1968.

Jurt, J., 'L'image de l'Afrique et des africains dans la littérature française', *Oeuvres & Critiques*, III, 2 – IV, 1, 1978-1979, pp. 219-28.

Kames, L., *Sketches of the History of Man*, London, 1774.

Karenga, M., *Introduction to Black Studies*, Los Angeles, 1982.

Katznelson, I., *Black men, white cities: Race, politics, and migration in the United States, 1900-30, and Britain, 1948-68*, Chicago and London, 2nd ed. 1976.

Keen, S., *Faces of the enemy: reflections of the hostile imagination*, San Francisco, 1986.

Kemble, E. W., *Kemble's Coons: A collection of Southern sketches*, New York, 1897.

Kennedy, S., *Jim Crow Guide to the U.S.A.*, Westport, CT, 1959, reprint 1973.

Kiernan, V. G. *European empires from conquest to collapse, 1815-1960*, Edinburgh, 1982.

Kiernan, V. G., *Lords of humankind*, London, 1969.

Kiernan, V. G., *Marxism and imperialism*, London, 1974.

Killens, J. O., *Black man's burden*, New York, 1965/1970.

Killingray, D., *A plague of Europeans*, Harmondsworth, 1973.

Klein, H. S., *African slavery in Latin America and the Caribbean*, New York/Oxford, 1986.

Klessman, E., 'Der Mohr in der Literatur der Aufklärung', in *Exotische Welten: Europäische Phantasien*, Stuttgart, 1987, pp. 236-41.

Klopper, S., 'George French Angas' (Re)presentation of the Zulu in 'The Kafirs Illustrated', *South African Journal of Culture and Art History*, III, 1, 1989, pp. 63-73.

Knightley, P., *The first casualty, from the Crimea to Vietnam: the war correspondent as hero, propagandist and mythmaker*, London, rev. ed. 1982.

Knox, R., *The Races of Man*, London, 1850.

Kohl, K-H., *Entzauberter Blick: Das Bild vom Guten Wilden und die Erfahrung der Zivilisation*, Berlin, 1981.

Koning, M., *Lexicon hieroglyphicum sacro-profanum, of Woordboek. . .*, Dordrecht, 1722-1723.

Kopplin, M., ' "Amoenitates exoticae": Exotische Köstlichkeiten im Zeitalter des Barock', in *Exotische Welten: Europäishce Phantasien*, Stuttgart, 1987, pp. 318-29.

Kornatzki, P. von, 'Pack den Tiger aufs Plakat', in *Exotische Welten: Europäische Phantasien*, Stuttgart, 1987, pp. 220-9.

Kotlarz, I., 'The birth of a notion', *Screen*, XXIV, 2, March-April, 1983, pp. 21-9.

Kraditor, A. S., *Means and ends in American abolitionism*, New York, 1969.

Kreidt, D., *Exotische Figuren und Motive im europäischen Theater*, Stuttgart, 1987.

Künkler-Kehr, I., 'Der immerwährende Tod der "Zehn kleinen Negerlein",' in *Der Afrikaner im deutschen Kind- und Jugendbuch*, Oldenburg, 1985.

Kunst met een missie, Maarheze, 1988.

Kyemba, H., *A state of blood: the inside story of Idi Amin*, New York, 1977.

Lambourne, L., *An introduction to caricature*, London, 1983.

Lan, D., *Guns and rain: Guerillas and spirit mediums in Zimbabwe*, London, 1985.

Lapchick, R. E., *The politics of race and international sport*, New York, 1975.

Laqueur, W., *Weimar: A cultural history 1918-1933*, London, 1974.

Launer, R. und E. Launer, 'Sexotik – Biedermann im Paradies', in *Exotische Welten: Europäische Phantasien*, Stuttgart, 1987, pp. 106-13.

Leab, D. J. *From Sambo to Superspade: The Black experience in motion pictures*, Boston, 1976.

Leclant, J., 'Kushites and Meroites: iconography of the African rulers in the ancient Upper Nile', in L. Bugner, ed., *The image of the Black in western art: From the Pharaohs to the fall of the Roman empire*, Vol. 1, Paris/Lausanne, 1976.

Leerssen, J. T., 'The cracked looking-glass of a servant: cultural decolonization and national consciousness in Ireland and Africa', in H. Dyserinck and K. U. Syndram, Hg., *Europa und das nationale Selbstverständnis: Imagologische Probleme in Literatur, Kunst und Kultur des 19. und 20. Jahrhunderts*, Bonn, 1988, pp. 103-18.

Leeuwenberg, J., ed., *Catalogus Rijksmuseum*, The Hague/Amsterdam, 1973.

Lelyveld, J., *Move your shadow: South Africa, Black and white*, New York/Harmondsworth, 1986.

Lemaire, T., red., *Antropologie en ideologie*, Groningen, 1984.

Lembezat, B., *Eve noire*, Neuchâtel/Paris, 1952.

Leonard, N., *Jazz and the white Americans*, Chicago, 1962.

Lerner, G., *The majority finds its past: Placing women in history*, Oxford and New York, 1979.

Lester, R., *Trivialneger: Das Bild des Schwarzen im westdeutschen Illustriertenroman*, Stuttgart, 1982.

Lifton, R. J., *Home from the war: Vietnam veterans: neither victims nor executioners*, New York, 1973, 1985.

Lightfoot, C. M., *Human rights U.S. style*, New York, 1977.

Lindsay, J., 'Introduction', in J. London, *The people of the abyss*, London, 1977, pp. 3-8.

Lips, J. E., *The savage hits back*, New York, 1966.

Litwack, L. F., *Been in the storm so long: The aftermath of slavery*, London, 1979.

Locke, J., *Second treatise of government*, London, 1681, 1924.

Lombard, M., *Espaces et réseaux du haut moyen âge*, Paris/La Haye, 1972.

Long, E., *The History of Jamaica*, 3 Vols, London, 1774.

Loon, M. N. van en I. H. van Eeghen, *Het huis met de paarse ruiten en de familie Van Loon in Amsterdam*, Alphen aan de Rijn, 1984.

Lopez, R. S., *The birth of Europe*, New York, 1962/1967.

Lorimer, D. A., *Colour, class and the Victorians: a study of English attitudes toward the Negro in the mid-nineteenth century*, Leicester, 1978.

MacDougall, H. A., *Racial myth in English history*, Montreal/Hannover, 1978.

MacKenzie, J. M., ed., *Imperialism and popular culture*, Manchester, 1986.

Magubane, B. M., *The political economy of race and class in South Africa*, New York, 1979.

Mannoni, D. O., *Psychologie de la colonisation*, Paris, 1950, trl. *Prospero and Caliban: the psychology of colonization*, London, 1956.

Marable, M., 'The paradox of integration: Race, ethnicity, and power since the Civil Rights movement', Amsterdam, May 1991, unpublished conference paper.

Marcus, L. S., ed., *An Épinal album: Popular prints from nineteenth century France*, Boston, 1984.

Marnham, P., *Fantastic invasion: Dispatches from contemporary Africa*, London, 1980.

Marshall, P. J. and G. Williams, *The Great Map of mankind: British perceptions of the world in the age of Enlightenment*, London, 1982.

Martin, P. M. and P. O'Meara, eds., *Africa*, Bloomington, IN, 2nd ed. 1986.

Martinkus-Zemp, A., 'Européocentrisme et exotisme: l'Homme blanc et la femme noire, dans la littérature française de l'entre-deux-guerres', *Cahiers d'Etudes Africaines*, 49, 1973, pp. 60-81.

Marty, M. E., *A short history of Christianity*, New York, 1959.

Marx, K., *Grundrisse*, New York, 1973.

Mattelart, A., *Mass media, ideologies, and the revolutionary movement*, Brighton, 1974/1980.

Mazrui, A. A., *The Africans: A triple heritage*, London, 1986.

McConnaughey, S., *Tropic of doubt*, Philadelphia, 1953. *Pagan in paradise*, 1955 (paperback). *Heidens paradijs*, Amsterdam, 1963.

McElroy, G. C., *Facing history: The Black image in American art 1710-1940*, Washington, DC, 1990.

Mead, C., *Champion: Joe Louis, Black hero in white America*, Harmondsworth, 1985.

Meier, A. and E. Rudwick, *From plantation to ghetto*, New York, rev. ed. 1970.

Meisen, K., *Nikolauskult und Nikolasbrauch im Abendlande*, Düsseldorf, 1931, reprint 1981.

Memmi, A., *The colonizer and the colonized*, Boston, orig. French ed. 1957, trl. 1965.

Mercer, K., 'Racism and transcultural psychiatry', in P. Miller and N. Rose, eds., *The power of psychiatry*, Oxford, 1986, pp. 111-42.

Michelet, J., *L'Histoire romaine*, Paris, 1827.

Minter, W., *King Solomon's Mines revisited: Western interests and the burdened history of Southern Africa*, New York, 1986.

Mol, B., *Koningin Zingha*, Rhenen, 1960.

Montesquieu, *De l'esprit de lois*, Paris, 1748.

Monti, N., ed., *Africa then: Photographs 1840-1918*, New York, 1987.

Morgan, H., *Symbols of America*, London, 1987.

Morgan, R., 'Planetary feminism: the politics of the 21st century', in R. Morgan, ed., *Sisterhood is global: The international women's movement anthology*, Harmondsworth, 1984, pp. 1-37.

Moscovici, S., 'On social representations', in J. P. Forgas, ed., *Social cognition: perspectives on everyday understanding*, London, 1981, pp. 181-209.

Mosse, G. L., *Nazi culture*, New York, 1966.

— , *Toward the final solution: a history of European racism*, London, 1978.

Moubach, A., *Naaukeurige beschryving der uitwendige godtsdienst-plichten, kerk-zeden en gewoontes van alle volkeren der waereldt*, Amsterdam, Rotterdam, 's Gravenhaage, 1729.

Mudimbe, V. Y., *The invention of Africa*, Durham, NC, 1988.

Mulder, H., *Een groote laars, een plompe voet: Nederland en de Nazi's in spotprent en karikatuur, 1933-1945*, Amsterdam, 1985.

Muller, C. F., *Die Groot Trek in beeld: Visuele dokumente uit en voor die Groot Trek*, Tafelberg, 1978.

Nathanson-Moog, C., 'The psychological power of ethnic images in advertising', in *Ethnic images in advertising*, Philadelphia, 1984, pp. 19-22.

Nederveen Pieterse, J. P., ed., *Christianity and hegemony: religion and politics on the frontiers of social change*, New York and Oxford, 1991.

Nederveen Pieterse, J. P., 'Dilemmas of development discourse: The crisis of developmentalism and the comparative method', *Development and Change*, Vol. 22, 1991, pp. 5-29.

Nederveen Pieterse, J. P., *Empire and Emancipation: Power and liberation on a world scale*, New York and London, 1989 and 1990.

Nederveen Pieterse, J. P., 'Slavery and emancipation', *Race and Class*, XXX, 2, 1988, pp. 1-21.

Négripub: L'image des Noirs dans la publicité depuis un siècle, Paris, 1986.

Nelson, C. and L. Grossberg, eds., *Marxism and the interpretation of culture*, Houndmills, Basingstoke, 1988.

Newman, W. A., *Biographical memoir of John Montagu*, London, 1855.

Newsinger, J., 'Lord Greystoke and Darkest Africa: the politics of the Tarzan stories', *Race & Class*, XXVIII, 2, 1986, pp. 59-72.

North, D. C. and R. P. Thomas, *The rise of the western world*, Cambridge, 1973.

Nunez Jimenez, A., *Cuba as portrayed in 19th century cigarette lithographs*, Havana, 1985.

Nye, A., *Words of power: a feminist reading of the history of logic*, New York and London, 1990.

Oberfirst, R., *Al Jolson: You ain't heard nothin' yet!*, New York, 1980.

O'Dowd, L., 'New introduction', in A. Memmi, *The colonizer and the colonized*, London, re-issue 1990, pp. 29-66.

Okot p'Bitek, *African religions in western scholarship*, Nairobi, 1970.

Oostindie, G. en E. Maduro, *In het land van de overheerser*, Vol. II, Dordrecht, 1986.

Otte, M., ' "Somtijts een Moor": de neger als bijfiguur op Nederlandse portretten in de zeventiende en achttiende eeuw', *Kunstlicht*, VIII, 3, 1987, pp. 6-10.

Paasman, A. N., *Reinhart: Nederlandse literatuur en slavernij ten tijde van de Verlichting*, Diss. University of Amsterdam, 1984.

Paasman, B., 'Mens of dier? De beeldvorming over negers in de tijd voor de rassentheorieën', in Anne Frank Stichting, *Vreemd gespuis*, Amsterdam, 1987, pp. 92-107.

Paasman, B., *Het boek der Verlichting*, Amsterdam, 1986.

Paeffgen, M., *Das Bild Schwarz-Afrikas in der öffentlichen Meinung der Bundesrepublik Deutschland 1949-1972*, München, 1976.

Pakenham, V., *Out in the noonday sun: Edwardians in the tropics*, New York, 1985.

Palmer, R. R., *The age of the democratic revolution*, Princeton, NJ, 1964.

Panofsky, E., *Studies in iconology*, New York, 1962.

Parekh, B., 'Rethinking racism', *The New Statesmen and Society*, 14 June 1991 [a], pp. 23-4.

Parekh, B., 'New forms of racism', Paris, June 1991 [b], unpublished paper.

Park, R. E., 'Race relations and certain frontiers', in E. B. Reuter, ed., *Race and culture contacts*, New York, 1934.

Parry, J. H., *Trade and Dominion*, London, 1973.

– *The age of reconnaissance: Discovery, exploration and settlement 1450-1650*, London, 1963/1973.

Paudrat, J. L., 'The arrival of tribal objects in the West: from Africa', in W. Rubin, ed., *"Primitivism" in twentieth century art*, New York, 1984.

Pemble, J., *The Mediterranean passion: Victorians and Edwardians in the South*, Oxford, 1987.

Penny Dreadfuls and comics: English periodicals for children from Victorian times to the present day, ed. by K. Carpenter, London, 1983.

Perry, C. and A. Aldridge, *The Penguin book of comics*, Aylesbury, 1975.

Perry, J., *Roomsche kinine tegen roode koorts: Arbeidersbeweging en katholieke kerk in Maastricht 1880-1920*, Amsterdam, 1983.

Pirotte, J., éd., *Stéréotypes nationaux et préjuges raciaux aux XIXe et XXe siècles*, Louvain-la-Neuve, 1982.

Pitkin, H. F., *The concept of representation*, Berkeley, 1967.

Poeschel, S., *Studien zur Ikonographie der Erdteile in der Kunst des 16.-18. Jahrhunderts*, München, 1985.

Poitier, S., *This life*, New York, 1980.

Poliakov, L., 'Racism from the Enlightenment to the age of imperialism', in R. Ross, ed., *Racism and colonialism*, The Hague, 1982, pp. 55-64.

Poliakov, L., 'Racism in Europe', in A. de Reuck and J. Knight, eds., *Caste and race: comparative approaches*, London, 1967.

Pollock's dictionary of English toys, ed. by M. Hiller, London, 1982.

Pope-Hennessy, J., *Sins of the fathers: A study of the Atlantic slave traders, 1441-1807*, London, 1967.

Porges, I., *Edgar Rice Burroughs: the man who created Tarzan*. Provo, Utah 1976.

Porter, B., *The lion's share. A short history of British imperialism 1850-1983*, London, 2nd ed. 1984.

Pott, P. H., *Naar wijder horizon*, Den Haag, 1962.

Preedy, S. E., *Negers in de Nederlanden 1500-1863*, Nijmegen, 1984.

Preiswerk, R., ed., *The slant of the pen: racism in children's books*, Geneva, 1980.

Preiswerk, R. and D. Perrot, *Ethnocentrism and history: Africa, Asia and Indian America in western textbooks*, New York/London/Lagos, 1978.

'The press, the jam jar, and the Gollywog', *Searchlight* (London), September 1984.

Punter, D., ed., *Introduction to contemporary cultural studies*, London, 1986.

Rabasa, J., 'Dialogue as conquest: Mapping spaces for counter-discourse', *Cultural Critique*, 6, spring 1987, pp. 131-60.

Ramsay, Rev. J., *Essays on the Treatment and Conversion of African Slaves in the British Sugar Colonies*, London, 1784.

Rashap, A., 'The American Dream for sale: Ethnic images in magazines', in *Ethnic images in advertising*, Philadelphia, 1984, pp. 7-12.

Raskin, J., 'Imperialism: Conrad's Heart of Darkness', in W. Laqueur and G. L. Mosse, eds., *Literature and politics in the twentieth century*, New York, 1967, pp. 109-27.

Rawick, G., *The American slave: a composite autobiography*, Vol. 6, Westport, CT, 1972.

Rawley, J. A., *The Atlantic slave trade*, New York, 1981.

Redmond, R., *Zwarte mensen in kinderboeken*, Den Haag, 1980.

Reich, W., *The function of the orgasm*, London, 2nd rev. ed. 1947, trl. 1961.

Reich, W., *The mass psychology of fascism*, Harmondsworth, 3rd rev. ed. 1942, trl. 1972.

Reichwein G. en J. Jas, *'t Achterste van de tong: De gaper als uithangteken van apotheker en drogist*, 's Gravenhage, 1988.

Rek, J. de, *Opnieuw in de vaart der volkeren*, Vol. 10, Baarn, 1985.

Renan, E., *L'avenir de la science*, Paris, 1890.

Rennert, J., *100 posters of Paul Colin*, New York, 1977.

Reno, D. E., *Collecting Black Americana*, New York, 1986.

Reynolds, R., *Cleanliness and godliness*, New York, 1946, reprint 1974.

Rich, P. B., *Race and Empire in British politics*, Cambridge, 1986.

Ridge, S. G. M., 'The construction of colonialist discourse and the eclipse of the black voice: evidence from the Langalibalele affair', unpublished paper, Utrecht, 1990.

Riepe, R. und G. Riepe, 'Nickneger – Heidenkinder – und der Deutsche Spenderwille', Düsseldorf, unpublished article, n.d.

Ringer, B. B., *'We the people' and others: duality and America's treatment of its racial minorities*, New York and London, 1983.

Ripa, C., *Iconologia of Uytbeeldinghe des Verstands*, Amsterdam, 1642.

Robinson, J., *The comics: an illustrated history of comic strip art*, New York, 1974.

Robinson, R. and J. Gallagher, *Africa and the Victorians*, London, 1961.

Rodney, W., *How Europe underdeveloped Africa*, London, 1972, reprint 1983.

Roes, J., *Het groote Missie uur, 1915-1940*, Bilthoven, 1974.

Roosevelt, T., *African game trails*, London, 1909.

Rosen, C. and H. Zerner, *Romanticism and realism: the mythology of nineteenth century art*, London, 1984.

Ross, R., 'Pre-industrial and industrial racial stratification in South Africa', in idem, ed., *Racism and colonialism*, The Hague, 1982.

Ross, R., ed., *Racism and colonialism*, The Hague, 1982.

Ross Barnett, M., 'Negative stereotypes of African-Americans in American popular culture', *Distorted images*, Brooklyn, NY (n.d.).

Rotberg, R.I., ed., *Africa and its explorers*, Cambridge, MA, 1970.

Roth, C., *A history of the Jews in Venice*, New York, 1975.

Rubin, W., ed., 'Modernist primitivism: an introduction', in *"Primitivism" in 20th century art: Affinity of the tribal and the modern*, Vol. 1, New York, 1984.

Russel, M., 'Slave codes and liner notes', in G. T. Hull et al., eds., *But Some of Us Are Brave: Black women's studies*, Old Westbury, NY, 1982, pp. 129-40.

Russell, J. B., *The prince of darkness: radical evil and the power of good in history*, London, 1989.

Rydell, W., *All the world's a fair: Visions of Empire at American international expositions, 1876-1916*, Chicago, 1984.

Said, E. W., *Orientalism*, Harmondsworth, orig. ed. 1978, reprint 1985.

Sala-Molins, L., *Le Code Noir, ou le Calvaire de Canaan*, Paris, 1988.

Sartre, J-P., *Réflexions sur la question juive*, Paris, 1st ed. 1946, 1954.

Sauvage, M., *De memoires van Josephine Baker*, trl. H. van Gelder, Amsterdam, 1927.

Saxton, A., 'Blackface minstrelsy and Jacksonian ideology', *American Quarterly*, 1983.

Schama, S., *Embarassment of riches: An Interpretation of Dutch Culture in the Golden Age*, New York, 1987.

Schermelé, W., *Het groote Negerboek*, Amsterdam, 1939.

Schneider, W., *An empire for the masses, 1870-1900*, London, 1982.

Scholz-Hansel, M., *Das Exotische Plakat*, Stuttgart, 1987.

Schuster, P-K., Hg., *Nationalsozialismus und "Entartete Kunst": Die "Kunststadt" München 1937*, München, 1987.

Schwartz, A. V., 'Mary Poppins revised', in J. Stinton, ed., *Racism and sexism in children's books*, London, 1979.

Schwartz, J. H., *The red ape: Orang-utans and human beings*, London, 1987.

Searle, C., 'Your daily dose: racism and the *Sun*', *Race & Class*, XXIX, 1, 1987, pp. 55-71.

Shattuck, R., *The banquet years: The origins of the avant-garde in France, 1885 to World War I*, New York, rev. ed. 1968.

Shepherd, J., *Tin Pan Alley*, London, 1982.

Sherard, R. G., 'The emergence of blacks on television', in R. E. Hiebert and C. Reuss, eds., *Impact of mass media: current issues*, New York and London, 1985, pp. 384-93.

Shirer, W. L., *The rise and fall of the Third Reich*, New York, 1962.

Short, N. R., *Dada and surrealism*, Secaucus, NJ, 1980.

Shufeldt, R. W., *America's greatest problem: The Negro*, Philadelphia, 1915.

Silber, G., 'Dream factory', *Frontline*, June 1986.

Sinclair, A., *The Savage*, London, 1977.

Smith, B., *European vision and the South Pacific*, New Haven and London, 2nd ed. 1985.

Smith, G., *When Jim Crow met John Bull: Black American journey, soldiers in World War II Britain*, London, 1987.

Smitherman-Donaldson, G. and T. van Dijk, eds., *Discourse and discrimination*, Detroit, 1988.

Snowden, F. M., Jr, 'Iconographical evidence on the black population in Greco-Roman antiquity', in L. Bugner, ed., *The image of the Black in western art*, Vol. 1, Paris/Lausanne, 1976.

Snowden, F. M., Jr, *Blacks in Antiquity: Ethiopians in the Greco-Roman experience*, Cambridge, 1971.

Spencer, H., *Facts and comments*, London, 1902.

Spivak, G. C., 'Can the subaltern speak?', in C. Nelson and L. Grossberg, eds., *Marxism and the interpretation of culture*, Houndmills, Basingstoke, 1988, pp. 271-313.

Spivak, G. C., *In other worlds*, New York and London, 1987.

Spoor, P., *Soeti, de Katechist*, Rhenen, 1949.

Springhall, J. O., ' "Up Guards and At them!" British imperialism and popular art, 1880-1914', in J. M.

Mackenzie, ed., *Imperialism and popular culture*, Manchester, 1986.

Strakenborg, J. en J. van Zadelhoff, *Emaille borden: De geschiedenis van een ijzersterk reclamemedium*, Aarlanderveen, 1979.

Stam, R. and L. Spence, 'Colonialism, racism, and representation', *Screen*, XXIV, 2, 1983, pp. 2-20.

Stanley's reizen, ontdekkingen en lotgevallen in Midden-Afrika: Zes jaar aan de Congo, Amsterdam/Brussel, 1886.

Starobinski, J., *L'invention de la liberté 1700-1789*, Genève, 1964/1987.

Stearns, M. W., *The story of jazz*, New York, 1956.

Steadman, J. M., *The myth of Asia*, New York, 1969.

Stedman, J. G., *Narrative of a five years' expedition against the revolted Negroes of Surinam*, London, 1796.

Steins, M., *Das Bild des Schwarzen in der europäischen Kolonialliteratur 1870-1918: Ein Beitrag zur literarischen Imagologie*, Frankfurt/Main, 1972.

Stengers, J., 'King Leopold's imperialism', in R. Owen and B. Sutcliffe, eds., *Studies in the theory of imperialism*, London, 1972.

Stepan, N., *The idea of race in science: Great Britain, 1800-1960*, Hamden, CT, 1982.

Stern, G. F., 'Packaging: container as context', in *Ethnic images in advertising*, Philadelphia, 1984, pp. 13-8.

Stinton, J., ed., *Racism and sexism in children's books*, London, 1979.

Stoler, A., 'Carnal knowledge and imperial power: sex, race and morality in colonial Asia', in E. M. DiLeonardo, ed., *Towards an anthropology of gender*, Los Angeles, 1990.

Strang, J., *Working women: an appealing look at the appalling uses and abuses of the feminine form*, New York, 1984.

Street, B., 'Reading the novels of empire: race and ideology in the classic "tale of adventure",' in D. Dabydeen, ed., *The black presence in English literature*, Manchester, 1985, pp. 95-111.

Suhl, I., 'Doctor Dolittle – the Great White Father', in J. Stinton, ed.,. *Racism and sexism in children's books*, London, 1979.

Sunday Reading for the Young, London, 1877.

Sweetman, D., *Women leaders in African history*, London, 1984.

Symonds, R., *The British and their successors*, London, 1966.

Takaki, R. T., *Iron cages: Race and culture in 19th century America*, London, 1980.

Takaki, R. T., 'The Black child-savage in Ante-Bellum America', in G. B. Nash and R. Weiss, eds., *The great fear: race in the mind of America*, New York, 1970.

Taussig, M., 'Culture of terror – Space of death. Roger Casement's Putumayo Report and the explanation of torture', *Journal for the Comparative Study of Society and History*, 1984, pp. 467-97.

Taussig, M., *Shamanism, colonialism and the Wild Man: A study in terror and healing*, Chicago, 1987.

Thackara, J., 'The mass media and racism', in C. Gardner, ed., *Media, politics and culture: a socialist view*, London, 1979, pp. 108-18.

Therborn, G., *The ideology of power and the power of ideology*, London, 1980.

Theye, T., Hg., *Wir und die Wilden: Einblicke in einer kannabalische Beziehung*, Reinbek, 1985.

Thiel, F. J., 'Der Exotismus in bezug auf Mission und Kolonialismus', in *Exotische Welten: Europäische Phantasien*, Stuttgart, 1987, pp. 82-7.

Thompson, J. R., 'The Black as ironic immigrant: self-perception in the early Republic', in S. Ickringill, ed., *The early Republic: the making of a nation – the making of a culture*, Amsterdam, 1988, pp. 243-60.

Thompson, P. and P. Davenport, *The Dictionary of visual language*, London, 1980.

Timberlake, L., *Famine in Africa*, London, 1985.

Tinland, F., *L'homme sauvage: Homo ferus et Homo sylvestris*, Paris, 1968.

Todorov, T., *La conquête de l'Amérique: la question de l'Autre*, Paris, 1982, trl. R. Howard, *The conquest of America: the question of the other*, New York, 1985.

Toll, R. C., *Blacking up: The Minstrel show in nineteenth-century America*, New York, 1974.

Tucker, C. D., 'The impact of the American Civil Rights movement on the abolishment of black stereotypes', Amsterdam, 1989 (unpublished paper).

Turner, W., 'Myths and stereotypes: the African man in America', in D. Y. Wilkinson and R. L. Taylor, *The black male in America*, Chicago, 1977, pp. 122-32.

Unger, R. K., 'Psychological, feminist, and personal epistemology: transcending contradiction', in M. McCanney Gergen, ed., *Feminist thought and the structure of knowledge*, New York, 1988, pp. 124-141.

Ustorf, W., ' "Komm herüber und hilf uns" oder Missionarische Identität im Konflikt', in M. O. Hinz, H. Patemann, A. Meier, Hg., *Weiss auf Schwarz: Kolonialismus, Apartheid und afrikanischer Widerstand*, Berlin, 1986, pp. 30-7.

Uys, C. J., *Die lewenswyse van die Suid-Afrikaanse inboorlinge*, Pretoria, 1935.

Vangroenweghe, D., *Rood rubber: Leopold II en zijn Kongo*, Antwerpen/Brussel, 1985; French ed., *Du sang sur les lianes*, Bruxelles, 1986.

Vaughn, K. I., *John Locke: Economist and social scientist*, London, 1980.

Vercoutter, J., 'The iconography of the black in ancient Egypt: from the beginnings to the 25th Dynasty', in L. Bugner, ed., *The image of the Black in western art: From the Pharaohs to the fall of the Roman Empire*, Vol. 1, Paris/Lausanne, 1976.

Versteeg, M. C., *Vlugge Slang: Missie-verhaal uit Midden-Afrika*, Tilburg, 1948.

Vincke, E., *Géographes et hommes d'ailleurs: Analyse critique de manuels scolaires*, Bruxelles, 1985.

Vints, L., *Kongo: Made in Belgium*, Leuven, 1984.

Vries, L. de, *Het pretenboek van tante Pau*, Amsterdam, 1974.

Wagenaar, J., *Amsterdam, in zijne Opkomst, Aanwas, Geschiedenissen, Voorregten, Koophandel, Gebouwen, Kerkenstaat, Schoolen, Schutterye, Gilden en Regeeringe*, Amsterdam, MDCCLX.

Wallman, S., ed., *Ethnicity at work*, London, 1979.

Walvin, J., 'Black caricature: the roots of racialism', in C. Husband, ed., *'Race' in Britain*, London, 1982, pp. 59-72.

Wehler, H-U., *Bismarck und der Imperialismus*, Köln/Berlin, 1969.

Weideger, P., *History's mistress: A new interpretation of a 19th-century ethnographic classic*, Harmondsworth, 1986.

Wells, H. G., *The outline of history*, London, rev. ed. 1961.

Werkman, C. J., *Trademarks: Their creation, psychology and perception*, Amsterdam, 1974.

Wertheim, W. F., *Het rassenprobleem: De ondergang van een mythe*, Amsterdam, 1948.

West, C., *Toward a socialist theory of racism*, New York, 1988.

Weston, P. J., 'Some images of the primitive before 1800', *History of European Ideas*, I, 3, 1981, pp. 215-36.

White, H., 'The forms of wildness: archaeology of an idea', in E. Dudley and M. E. Novak, eds., *The Wild Man within: an image in western thought from the Renaissance to Romanticism*, Pittsburgh, 1972, pp. 3-38.

Wielligh, G. R. von, *Jacob Platjie*, Pretoria/Amsterdam, 1918.

Wilkinson, D. Y., 'The stigmatization process: the politicization of the black male's identity', in D. Y. Wilkinson and R. L. Taylor, *The black male in America*, Chicago, 1977, pp. 145-58.

Williams, E., *Capitalism and slavery*, London, 1944.

Williams, M., *The jazz tradition*, Oxford, 1983.

Williams, R., *Culture and society, 1780-1950*, Harmondsworth 1958, reprint 1963.

Williamson, J., *A rage for order: Black-white relations in the American South since Emancipation*, New York/Oxford, 1986.

Young, R., *White mythologies: Writing history and the West*, London and New York, 1990.

Zaïre 1885-1985: Cent ans de regards Belges, Bruxelles, 1985.

Zuid-Afrikaanse vraagbaak, Pretoria, 1958.

Zyl Smit, D. van, 'Public policy and the punishment of crime in a divided society: a historical perspective on the South African penal system', *Crime and Social Justice*, 21-22, 1984.

Zwerin, M., *La tristesse de Saint Louis: Swing under the Nazis*, London, 1985.